From t
of a Weaver

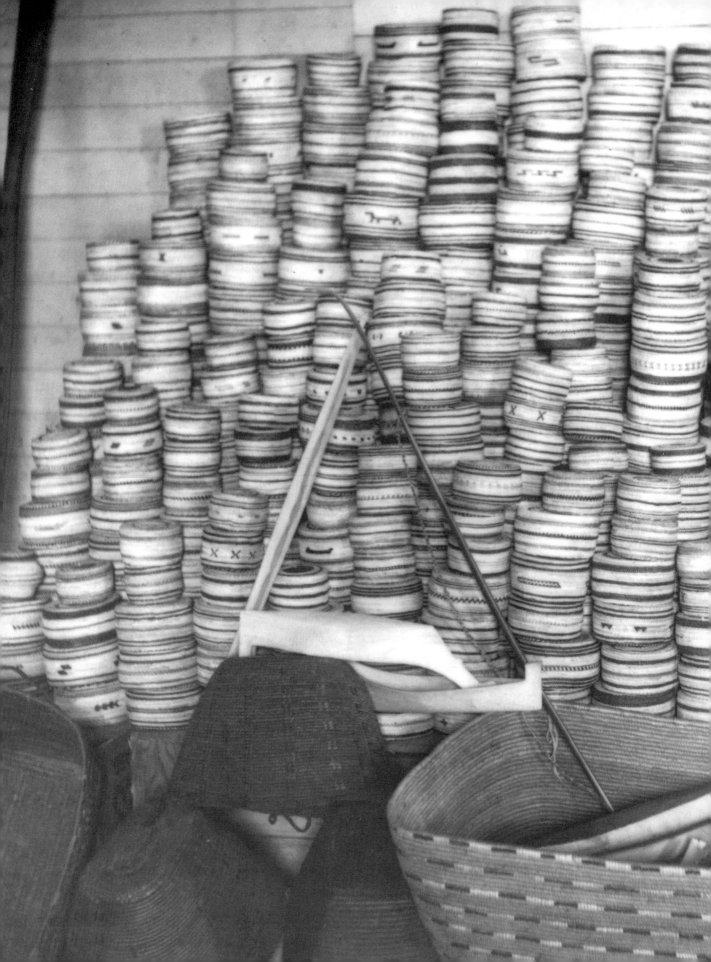

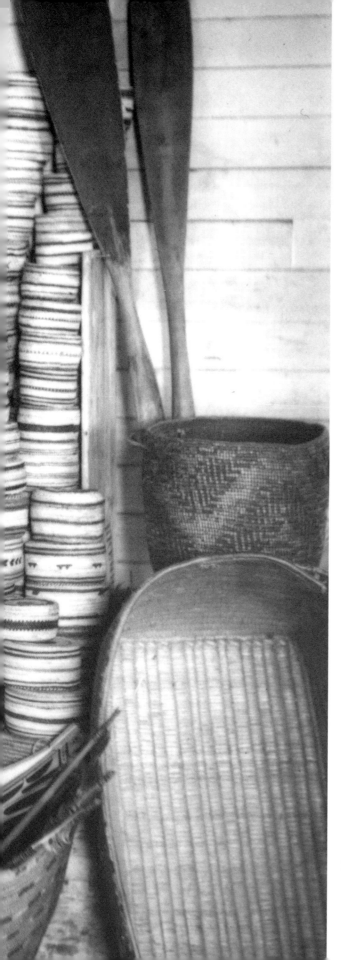

From the Hands
of a Weaver

Olympic Peninsula
Basketry through Time

EDITED BY
Jacilee Wray

FOREWORD BY
Jonathan B. Jarvis

UNIVERSITY OF OKLAHOMA PRESS
NORMAN

Also edited by Jacilee Wray

Native Peoples of the Olympic Peninsula: Who We Are, by the Olympic Peninsula
 Intertribal Cultural Advisory Committee (Norman, Okla., 2002)

(co-ed.) *Postmistress—Mora, Wash., 1914–1915: Journal Entries and Photographs of
 Fannie Taylor* (Seattle, 2006)

This book is published with support funding from the National Park Service,
Pacific Northwest Region, Anthropology Program, through the assistance of Regional
Anthropologist Frederick F. York, and from the Olympic Peninsula Intertribal Cultural
Advisory Committee.

Photograph of Forest Service officer Kristine Fairbanks (p. v) courtesy of
Keith Thorpe/Peninsula Daily News. Copyright 2008. Photograph of Pansy Howeattle
Hudson, Quileute/Hoh (p. v), by Jacilee Wray, 1991. Courtesy of Olympic National
Park.

Library of Congress Cataloging-in-Publication Data

Wray, Jacilee.
 From the hands of a weaver : Olympic Peninsula basketry through time / edited by
Jacilee Wray ; foreword by Jonathan B. Jarvis.
 p. cm.
Includes bibliographical references and index.
ISBN 978-0-8061-4245-6 (cloth)
ISBN 978-0-8061-4471-9 (paper)
1. Indian baskets—Washington (State)—Olympic Peninsula—History. 2. Basket making—
Washington (State)—Olympic Peninsula—History. 3. Indian women—Washington (State)—
Olympic Peninsula—History.
4. Olympic Peninsula (Wash.)—History. 5. Olympic Peninsula (Wash.)—Social life and
customs. I. Wray, Jacilee. II. Title.
 E78.W3F76 2012
 979.7'94—dc23 2011038039

To Forest Service officer Kristine Fairbanks and Hero

July 4, 1957–September 20, 2008

and to the basket weaver

Pansy Howeattle Hudson (Quileute) of Hoh
September 13, 1909–April 2, 1994

[The basket weaver] somehow squeezed out of her daily round a spiritual ichor that kept the skill in her knotted fingers long after the accustomed time.

Mary Hunter Austin, "The Basket Maker" (1903)

Contents

CHAPTER 9. *Weaving Cultural and Ecological
Diversity: Beargrass and Sweetgrass 156*
Daniela Shebitz and Caren Crandell

CHAPTER 10. *Basketry Today 170*
Janine Bowechop, Vicki Charles-Trudeau, Dale Croes, Charlotte Kalama,
Chris Morganroth III, Theresa Parker, Viola Riebe, Leta Shale, and Jacilee Wray

Illustrations

Figures

Tables

Foreword

Olympic Peninsula Basketry through Time

In my thirty-plus years with the National Park Service, my most rewarding experiences have been those with First Americans. Therefore I welcome the opportunity to acknowledge this important book on the Native American art form of basketry among the Olympic Peninsula tribes.

On one bright Montana morning, I sat among those in the circle and watched as they prepared the pipes for the smoke ceremony at Bear Paw Battlefield, to honor the Nez Perce. In 1877, led by Chief Joseph, the Nez Perce had been caught and bombarded here, on this ground, only forty miles from the safety of the Canadian border. I drew on the pipe in honor of those who had died and those of us now circled, who had the responsibility to keep the story alive. A few months later, standing before many large, tattooed Hawaiian men who bore shark-toothed war clubs, and feeling rather vulnerable in the lavalava I was wearing, I had the honor of being chanted into the circle for the annual 'awa ceremony at Pu'ukohola Heiau on Hawaii. As I partook of the mildly numbing 'awa, I was asked to speak. I said I was both honored and humbled with the responsibility to care for this sacred place. We are the stewards, but it is the Native people who keep such places alive.

Just as Pu'ukohola Heiau is sacred to the Native Hawaiians, Mount Tahoma and the Olympic Mountains are sacred to the area's tribes. Most have their own Native names and legends regarding these important spiritual places. I have learned that though the connection runs deep, many elders have not felt welcome back to the parks. When the National Park Service welcomes back Native people, the First Americans, to these lands, perhaps to carry out a ceremony, or to collect a bag of beargrass or spruce roots, we offer a reconnection to the land and to a people who want to be our partners in park preservation today, tomorrow, and into future generations. One evident example today is the partnership we have had with the Elwha Klallam Tribe in the dam removal on the Elwha River and the river's restoration. Without the persistence of the elders who remembered and gave voice to the fish, the political and funding support for the restoration would not have happened.

This book about Native basketry and weaving traditions is a metaphor for a renewed relationship between Native Americans and national parks. Like the grasses, bark, and roots collected from nature and lovingly intertwined into baskets of enduring beauty and utility, so is the relationship between First Americans and the land that is now within Olympic National Park. Like these baskets, that relationship must be protected, honored, and celebrated so that its value will only grow.

Jonathan B. Jarvis
National Park Service Director

Preface and Acknowledgments

JACILEE WRAY and JOAN MEGAN JONES

Start with a tree root or a piece of bark; add plant stems, water, and meticulous skill; and the end result is an exquisitely woven basket. It is from these seemingly intractable materials—roots, bark, plant stems—that the basket weavers of the Olympic Peninsula have woven or coiled their baskets for millennia.

Basketry has persisted in some of its original forms for thousands of years and is a diagnostic feature among western Washington Native cultures, as well as others. Basketry has an interesting intercultural history as well, one that has brought Native and non-Native cultures together in profound ways. Basketry showcases the roles, responsibilities, traditions, and artistry of women. The weaver who blended sensitive imagination, dexterous skill, and precise technique created works of great artistic quality and enduring appeal, with value that non-Indian women also appreciate. Basketry as a fiber technology is simple, yet extraordinarily complex. The features and dimensions encompass form, function, cultural meaning, representation, Native American terminologies, and a wide range of materials and techniques used in construction.

The weaver's artistic expression surfaces when she develops her own designs and patterns. Often these skills are learned from elders who are family members, friends, or tribal neighbors who have been handed down this knowledge through the generations. Today weaving baskets continues to be a vital link between past and future artists.

Pansy Howeattle Hudson, the daughter of Quileute Chief Charles Howeattle, left her large basket collection in the care of Olympic National Park until such time that a Quileute Museum is constructed. Pansy's grandson David Rock Hudson is Quileute hereditary chief *Howiyał* and because of this status, Pansy attended potlatch ceremonies throughout her life and was often the recipient of many gifts, especially basketry and art. The park currently has no museum in which to exhibit these or its own collection of baskets, and the idea arose among the Olympic Peninsula Intertribal Cultural Advisory Committee (OPICAC) to showcase some of these baskets in a book on traditional basket weavers of the Olympic Peninsula.[1]

Olympic National Park is the repository of hundreds of other baskets made by Olympic Peninsula weavers whose names we do not know and may never know. Many of these baskets were donated directly to the park. For instance, in 1950 Fannie Taylor—an early postmistress at Mora, across from the Quileute Reservation—gave the park six baskets that she had collected in the early 1900s (she had previously donated more than a hundred Quileute baskets to the Smithsonian Institution, in 1917). The park also possesses baskets that were transferred from other national

parks after Olympic National Park was established in 1938. A large collection, formerly belonging to Portland socialite Mrs. J. B. Montgomery and donated to Mount Rainier National Park, was transferred to Olympic National Park in 1941. Montgomery's baskets were collected around the turn of the twentieth century, as her husband was surveying Puget Sound for the Northern Pacific Railway.

The Book at Hand

This book was written in order to consolidate knowledge about Olympic Peninsula basketry. The authors of these chapters had already written most of the contemporary accounts on peninsula tribal basketry that appear in journal articles, dissertations, and books not widely available; their knowledge is now easily accessed within these chapters. Field notes from early researcher James Swan and anthropologists Leo Frachtenberg, Livingston Farrand, T. T. Waterman, Albert Reagan, and Hermann Haeberlin—all of whom collected information on basketry of the peninsula—have been thoroughly researched for this book as well.

The chapter authors found many areas of basketry where research was lacking, and they hoped to fill in these gaps with new research. There are many extensive basketry collections in national and regional museums, but little information about the weavers or the designs is found associated with these collections. This book includes photographs of some of the baskets in the Olympic National Park collection, as well as collections in the Smithsonian, the Burke Museum, the National Museum of the American Indian, and elsewhere.

The extensive research and incredible expertise of the authors and tribal members has been brought together here through the OPICAC. We are very grateful and fortunate to have so many insightful and highly regarded professional contributions. The OPICAC is proud to bring the basketry knowledge of the peninsula tribes together in a single compilation for basketry collectors, basket weavers, educators, and scholars in the fields of anthropology, art, art history, and ethnobotany, as well as visitors to the Olympic Peninsula.

Acknowledgments

This book is presented by the Olympic Peninsula Intertribal Cultural Advisory Committee and would not have come to fruition without the OPICAC's contributions, editing, and guidance. The volume editor wishes to personally thank the members of the committee who have been so supportive throughout this endeavor: Jamie Valadez (Elwha Klallam), Kathy Duncan (Jamestown S'Klallam), Marie Hebert (Port Gamble S'Klallam), Kris Miller (Skokomish), Justine James (Quinault), Viola Riebe (Hoh), Chris Morganroth III (Quileute), and Janine Bowechop (Makah).

I also want to thank the following people who have been overburdened by my endless requests for information yet continue to patiently and good-humoredly share their knowledge and guidance: Caren Crandell, Dale Croes, Elaine Grinnell, Vickie Jensen, Megan Jones, Carolyn Marr, Timothy Montler, Theresa Parker, Jay Powell, Daniela Shebitz, Nile Thompson, and especially Karen James.

And there are so many wonderful contributors to thank. Hopefully no one has slipped through my memory banks. They are M. Kat Anderson, Rebecca Andrews,

Elizabeth Barlow, Barbara Bretherton, Bernice Byrne, Vicki Carroll, Leilani Chubby, Bonita Cleveland, Zetha Pulsifer Cush, Brian Fairbanks, Lester Green, Cheryl Gunselman, Kristin Halunen, Roger Hoffman, Gay Hunter, Charlotte Kalama, Grant Keedie, Andrea Laforet, Gweneth Langdon, Theresa Langford, Kjerstin Mackie, Emily Mansfield, Elaine Miller, Gerald Bruce Miller, Lela Mae Morganroth, Rae Munger, Larry Nickey, Nisqually National Wildlife Refuge, Northwest Horticultural Society, Olympic National Park, Pat Parker, Michael Pavel, Melissa Peterson, Felicia Pickering, Alvira Cush Pulsifer, Nellie Ramirez, Marie Riebe, Balumna'ech Loa Ryan, Teresa Ryan, Mary Schlick, Brian Seymour, Leta Shale, Florine Shale-Bergstrom, Maria Stentz, Eileen Trestain, Vickie Charles-Trudeau, Nancy Turner, U.S. Fish and Wildlife Service, Christina Williams, Nellie Williams, and Frederick F. York.

Finally, Forest Service Officer Kristine Fairbanks, who was shot and killed in the line of duty on September 20, 2008, deserves special recognition. Kris worked with her dog Radar to protect the Olympic National Forest from poaching of cedar, beargrass, salal, and other forest products used for traditional basketry—but often illegally harvested for the floral industry.

From the Hands
of a Weaver

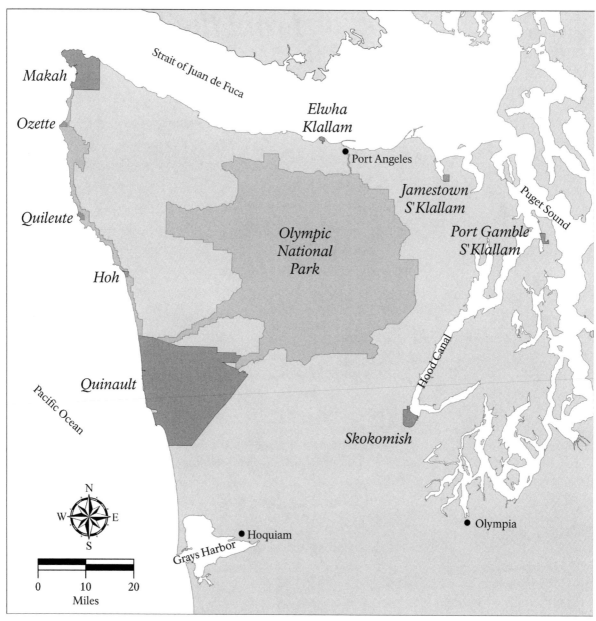

Figure I.1. Map of reservations of Olympic Peninsula tribes discussed in this volume.

Introduction

JACILEE WRAY

The tribes represented in this book are the Elwha Klallam, the Jamestown S'Klallam, the Port Gamble S'Klallam, the Skokomish (Twana), the Quinault, the Hoh, the Quileute, and the Makah, who ceded their land on the Olympic Peninsula to the federal government as a result of three treaties in 1855–56, by which the tribes retained specific rights. Tribal reservations were established at Neah Bay, Skokomish, and Quinault, but eventually a reservation was established for each of the peninsula tribes.

These tribes represent three language families: Salishan, Chemakuan, and Wakashan. Quinault, Klallam, and Twana are Coast Salish languages. Salishan is the most widespread language family in Washington State (Wray 2002). The Makah language is in the Wakashan language family and is most closely related to the languages Nuuchahnulth and Ditidaht on the west coast of Vancouver Island. The Quileute and the Hoh both spoke the Quileute language, which is in the Chemakuan language family. Only one other group spoke a language in the Chemakuan language family: the Chemakum Tribe, who once occupied the area around Port Townsend. The Chemakum were recognized by the United States in the 1855 Treaty of Point No Point, but their numbers were severely diminished as the result of warfare and epidemics by the 1900s. Members of the limited Chemakum population that remained either married into other tribes or were absorbed into them.

Tribal legends on the Olympic Peninsula refer to a supernatural origin for basket making: A culture hero—Raven, Crow, or an ancestor in the form of a cedar tree—imparted the knowledge and skills to the first people. The weavers who acquired this insight used branches, roots, bark, and grasses as their weaving fibers not only for baskets but also for mats and clothing. Like the whaler and the hunter, the basket weaver had guardian spirits. For the Quileute these included *Bäq!ots*,[2] who keeps the basket weaver from getting tired (Frachtenberg 1916d:7:21). The Quileute also had guardian spirits in the form of a redwing blackbird, because that bird frequents cattail marshes, and the wren and oriole, because they weave elaborate nests (see chapter 6). Among the Puget Sound Salish, Crow was a basket maker before animals were changed by Transformer into what they are today. The Twana sought the Crow spirit in order to become exemplary basket weavers (Marr 1991; Waterman 1973 [1921]:18).

We know from baskets preserved in water-saturated archaeological sites that weavers among the Olympic Peninsula tribes have developed and refined their techniques over several thousand years, passing the traditions and skills from generation to generation. The archaeological record at Hoko River on the Strait of Juan de Fuca and on the coast at Ozette reveals information about the origins of basketry. Basket fragments found at the Hoko River archaeological site date back 2,750 years. The type of basket most

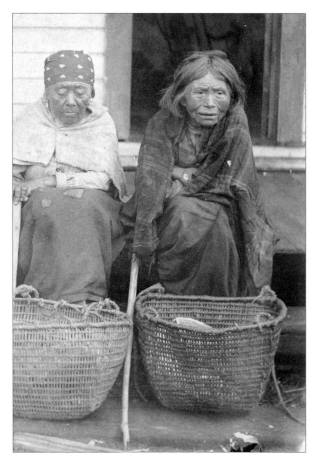

Figure I.2. Unknown women with burden baskets, probably at La Push. From an early postcard dating around the 1890s. COURTESY OF JACILEE WRAY.

frequently found in these sites is the carrying basket, or burden basket, with wrapped elements spaced several centimeters apart; it was used for backpacking and for storing food items (Marr 1988:57). This weaving technique may have originated from the basic fish trap or fish weir, both of which resemble a large-scale burden basket (Mason 1904:417; Marr 1988:57). The open weave of the burden basket allowed air circulation to prevent molding, and it lessened the weight of freshly harvested clams or mussels because the sand, mud, and water just drained through. The burden basket was most often made with cedar and spruce boughs and roots. It was carried with a tumpline over the forehead to distribute the weight of the load, just as a backpack distributes the weight on the back.

After settling in the Quinault Valley with her husband in 1855, Phoebe Goodell wrote about a Quinault woman carrying a burden basket. Goodell recalled the image many years later: "A long lariat, or rope of woven cedar bark, wide enough in the center to fit the flat forehead . . . , tapering at the ends to the size of a small cord, was used to secure the load on her head and back. To this load frequently dangled a child, laced to a shoe-shaped board, and sometimes another [child] was perched on the top of the load" (Goodell Judson 1984 [1925]:108). It's as if Goodell had been recalling Quileute weaver Beatrice Black, who used to place her babies in a pack basket with a long, woven tumpline strap on her forehead and walk ten miles to pick strawberries (*Oregonian* 1986).

Large fragments of such a carrying basket or burden basket were found in Olympic National Park's high country by a park visitor in 1993. The basketry fragment was radiocarbon-dated to 2,880 years ago, plus or minus 70 years. The elements were made of cedar: the warp (vertical elements) came from a bough of cedar, the weft (horizontal elements) from the root, and the twining was also of cedar root (Hawes 2009). We know that the Olympic Mountains were a major travel route be-

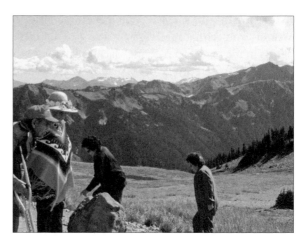

Figure I.3. Elwha Klallam tribal members—*left to right*, Ed Sampson, Hazel Sampson, Adeline Smith, and Beatrice Charles—visit the Olympic high country to search for additional fragments of the ancient burden basket found by a park visitor in 1993. PHOTO BY JACILEE WRAY.

tween Native groups on the peninsula, as tribal members today recall stories of entire families staying in the mountains for long periods of time. Here they collected berries, beargrass, and wild onions, and hunted elk and bear, as they hiked through the mountains to visit their neighbors and relatives throughout the Olympic Peninsula.

Basketry dating back three thousand years appears, from archaeological evidence, to have been made for utilitarian purposes, but archaeologists have found decorative effects on them. Traditionally baskets were household utensils used as cookware, for storage, and for carrying wood, clams, or berries; and large mats functioned as sails, room dividers, and bedding. The archaeological record provides examples of ancient basketry with decoration made by varying weaving techniques to create different effects. At the Hoko River archaeological site, Dale Croes found color contrast made from different weaving materials on baskets dating to about 2750 B.P. It is also possible that natural dyes were used but have been leached out of these ancient finds. Special baskets probably held food at feasts and were given away as gifts at potlatches. Family members undoubtedly handed down heirloom pieces from generation to generation.

By the time of first contact with European maritime explorers in the late eighteenth century, distinctive decorated basketry styles were well established among the peninsula tribes. The maritime trade brought foreign-made goods, such as metals, into the area, and Native peoples used or adapted them for their own utilitarian needs. The Olympic Peninsula began to be homesteaded by non-Natives in the 1860s, and by the 1890s hundreds of homesteaders had found their piece of land in and among tribal holdings. The homesteaders brought manufactured goods that were soon adopted by Native people for use in daily life, having far-reaching effects on basketry traditions. Women no longer had to spend time making a clam basket or a cooking basket; now they could easily buy or barter for gunnysacks, copper kettles, and iron cookware and then spend more time on the production of fancy, decorated baskets that would earn an income. Adventurous weavers used the newly acquired trade items as models for basketry innovations.

Is it possible to suggest a developmental history for a specific type of baskets? In a work on Thompson Indian coiled basketry by Haeberlin, Teit, and Roberts (1928), the author of the introduction writes that the coiled basket originated with the Thompson and Lillooet Indians in Interior British Columbia. From them, the tribes on the Olympic Peninsula learned the skill of coiled basketry, some earlier than others, according to Haeberlin et al. The earliest to gain this knowledge on the peninsula were the Twana. Although the date when they acquired the knowledge is unknown, they have "practiced this art for as long as can be remembered" (ibid.: 136). Haeberlin et al. (ibid.) also state that the Klallam and the Lummi have been making coiled basketry "for a long time." Leo Frachtenberg, an anthropologist who worked with the Quileute, said that he was told the Klallam taught the Quileute how to make the coiled watertight basket (Smithsonian 1917).

Haeberlin et al. (1928:136) write that it might be possible to trace the route of basketry introduction by looking at the names used for specific baskets. In the case of the coiled basket, though, this isn't straightforward. The words for a coiled, watertight basket used by the Twana, Klallam, and Quileute, while all related, are from the same ultimate source as the words used by the Kwakiutl and Coast Salish of Southwestern British Columbia (Kuipers 2002:146). When a word

has been so widely borrowed, it is difficult to determine the origin of the cultural item it represents (Montler 2008). A word can be borrowed from a language different from that used where the cultural item originated. Many examples of this are found in the English language, especially with items that are widely used. Even though a connection between the origin of the word and the origin of the art would be valuable for a very strong premise, there are no clear lines of evidence. The archaeological record appears to support the ethnographic record better in this case.

The Ozette archaeological site contained three complete coiled baskets that were quite similar to some found at the Fraser River. Archaeologist Dale Croes (1977:362) believes the coiled basket was a more recent introduction to the southern Northwest Coast. Interestingly, Croes found many pieces of coiled basketry intentionally cut into shapes of ribbons, trapezoids, and rectangles at Ozette, and he believes they were potlatch gifts. We know that woven blankets were cut up and given away as potlatch gifts because wool weavings were prestige items. It is highly likely that these pieces of coiled basketry were prestige items as well, and they may have been used as teaching samples for the coiled basket weave.

The origins of basketry types are often speculative. The information supplied by early anthropologists allows us to follow their leads, adding linguistic and archaeological lines of evidence to see if their theories are still accurate. In many instances, there is just not enough diagnostic information to make the case that one tribe introduced a particular type of basketry into an area or invented a basket, probably because basket weaving began independently all over. However, if a weaver found a technique she liked among another group, she might have adopted it. It is enticing that there is both ethnographic and archaeological information to suggest an origin for the coiled watertight basket. However, for most types of basketry produced by the peninsula tribes, we can simply surmise that aboriginal origins for features from each culture complex have probably been lost to time, to tribal movements because of intermarriage or slavery, or to cultural borrowing.

Baskets were made in various forms to accommodate many uses: cooking, containing stored goods, carrying gear, backpacking, collecting, and processing food. Each basket would have a specific weave for its particular use.

It is not known when the small, plain-twined basket that became a popular sales item began to be made, but it could have originally been given away to guests at potlatches. When James Swan moved to Neah Bay in 1861, he was offered a number of items for sale, including a small, plain-twined basket. Swan may have helped the Makah to establish basketry at Neah Bay as a cottage industry (Andrews and Putnam 1999:2). He believed the small twined basket developed independently from traditional baskets and was designed specifically for the tourist trade. Ethnologist Otis Mason called the small Makah basket a "trinket basket" (ibid.). These baskets have been labeled "tourist baskets," as well as "trinket baskets," "trade baskets," and "souvenir baskets." While these terms refer to who was purchasing the basketry, they do not adequately characterize the artistry of the weaver. Some weavers called these items "fancy baskets," which is a preferred term because it is a better expression of the artistic achievement involved.

Kate Duncan found in her research on Ye Olde Curiosity Shop in Seattle that Makah basket weavers taught the neighboring Quileute women how to make "trin-

ket boxes" early on. Joseph Standley, the owner of Ye Olde Curiosity Shop, listed the names of the women who supplied baskets to his shop (these women are included in appendix B). In a 1912 image of the merchandise in his store, almost all of the designs on both Makah and Quileute baskets feature "schematic birds or canoe and whale figures" (Duncan 2003:201). Unless a unique characteristic or motif of a known weaver is identified, most people would find it nearly impossible to distinguish the maker of a basket.

Peninsula basket weavers probably began to use commercial dye not long after the first aniline dyes were invented in 1856. They acquired the dye from the Hudson's Bay Company in Victoria, and it might be possible to date some of the early baskets by their colors, since we know that the dyes were patented and put on the market as soon as each color was developed, beginning in the 1860s through the 1890s (Langford 2008). In 1902 Dr. C. F. Newcombe of the British Columbia Provincial Museum (now the Royal BC Museum) reported that the weavers were frequently using brightly colored aniline dyes on beargrass and other basket materials because of "the demands of the average collector for gaudy shades" (Turner 1998:112). These colors produced striking patterns, in contrast to subtler patterns in the softer, natural colors derived from plants (Turner 2008). Many collectors preferred the muted colors obtained from native plants.

Increased basket production from the 1890s through the 1930s provided museum collectors with huge quantities of baskets to add to their collections. In addition, more and more individuals purchased baskets for their private collections. This period of intense productivity was also a time of great stylistic experimentation and diversity, as can be seen in the basket collections of James Swan of the late nineteenth century and those of Leo Frachtenberg, Hermann Haeberlin, Clara Young, Fannie Taylor, and Livingston Farrand in the early twentieth century.

During the Great Depression the market for basketry began to decline. Native American women had to seek other means of employment, so there was little incentive for young women to acquire basketry skills, especially when they were sent off to boarding schools. Only a handful of traditional weavers continued to weave baskets, and some traditions were lost as older women passed away. Fortunately a renewed interest in Native basketry occurred, beginning with the New Deal and the 1935 Indian Arts and Crafts Act, followed by a revitalization of Native American culture. By the 1970s a new generation of basket weavers had established themselves. Traditional skills persisted, but changes in styles, techniques, and materials had also occurred—evidence of an enduring, vitally alive, and complex art form that may be one of the oldest arts practiced in North America (McNickle 1941:16).

This book examines basketry from a variety of perspectives. Chapter 1, "The Weaver as Artist" and chapter 2, "Marketing Olympic Peninsula Basketry and the Indian Arts and Crafts Act," were written by Jacilee Wray, a park anthropologist and the volume's editor. The chapter on the artist addresses basketry as an art form that has been seriously undervalued. Specifically, the names of weavers are seldom noted or documented, and some of the possible reasons that this is the case are addressed by examining the history of collecting. In chapter 2, basketry is explored as an art from that has been sold for more than a century. The chapter takes an extensive look at the federal Indian Arts and Crafts Act of 1935, which was enacted to gain wider attention,

appreciation, and sales opportunities for Indian basketry, among other works of Indian art.

Each of the chapters on the peninsula tribes focuses on the importance of basketry and analyzes the techniques, styles, and materials that are distinctive or are common to all of the tribes. Chapter 3 was written by members of the three Klallam tribes: Jamie Valadez (Elwha Klallam), Kathy Duncan (Jamestown S'Klallam), and Marie Hebert (Port Gamble S'Klallam), who share the same language and cultural traditions. The chapter was cowritten by Karen James, a highly respected anthropologist who has done extensive research on the Klallam. The three Klallam tribes reside on separate reservations, as a result of holding onto traditional areas and homelands. The chapter discusses the archaeological record and presents individual perspectives of Klallam weaving (with interviews from early weavers among the Port Gamble S'Klallam), the early works of weavers, both basketry and wool weaving among the Jamestown S'Klallam Tribe (including views on contemporary basketry by weaver Elaine Grinnell), and the present-day importance of basketry to the Elwha Klallam Tribe—all brought together by James.

Nile Thompson and Carolyn Marr are the authors of chapter 4, on Twana basketry. Thompson was the tribal linguist for the Skokomish Tribe during the late 1970s and conducted interviews with master basket weavers Louisa Pulsifer and Emily Miller; and Marr is an anthropologist, photo archivist, and librarian. Thompson and Marr (1983) wrote *Crow's Shells*, a highly acclaimed book on Twana basketry. The book is no longer in print, so this chapter is very important for today's researcher. The term "Twana" is used for the traditional language and people of the Hood Canal watershed, while "Skokomish" is used for both a precontact division of the Twana and the federally recognized tribe. The Twana are renowned for their soft twined basketry, woven in overlay twining from beargrass dyed yellow, red, and black and often with warps and wefts made from twisted cattail leaves. Twana baskets usually have a band of animal designs right below the rim, most often either the dog or wolf motif.

Joan Megan Jones wrote chapter 5, on Quinault basketry. She is also the author of *Basketry of the Quinault*, written for the Quinault Tribe in 1977. In her chapter here, Jones presents the reader with some of the unique characteristics of Quinault basketry that she learned from weavers who are no longer with us, preserving important details about the creation of basketry that might otherwise have been lost, such as how decoration is applied and how to perfect a technique. Without her intimate knowledge of weaving, we would likely not know that the finest weaving is so expert that "the entire surface of the basket recedes, becoming a background for the design." Jones's anthropological career has been devoted to basketry research.

Jay Powell, a linguistic anthropologist who authored *Quileute: An Introduction to the Indians of La Push* (1976), bases his discussion of Hoh and Quileute basketry in chapter 6 on his forty years of research among the two tribes. Powell has documented an extensive and valuable lexicon over the years, and his research has provided invaluable knowledge on many different topics and on Quileute school curricula. The large number of terms he presents for basketry, materials, weave, and motif is extraordinary. No other in-depth knowledge of so many terms for basketry exists on the peninsula, or likely elsewhere. Powell also shares with the reader his wealth of respect for and knowledge of the spiritual and ritual aspects of basketry, demonstrating how intertwined basketry is with Hoh and Quileute ancient culture and lan-

guage. Powell's chapter highlights what a powerful tool language is in understanding the importance of cultural traditions; the large number of descriptive Quileute terms for the techniques, materials, and styles of basketry reveal its significance.

Both Nile Thompson and Carolyn Marr, the authors of chapter 7, have extensive knowledge of Makah basketry. Marr has worked on several projects with the Makah Cultural and Research Center, including developing the exhibit centered on the book *Portrait in Time: Photographs of the Makah by Samuel G. Morse, 1896–1903*, for which she wrote the text. She has also interviewed Makah basket makers and researched Makah baskets as a visiting scholar at the Smithsonian. Although the Makah traditionally made a wide array of baskets, they are best recognized for the popular wrapped-twined covered basket, which became a tourist trade item as early as the 1860s. It is not known when the technique of closing the wrapped twining originated, but we do know that no examples have been found at the Ozette archaeological site, which dates to as recent as two hundred years ago (Marr 1988:57). Wrapped twining was used among the peninsula tribes to varying degrees, but the tremendous amount of wrapped-twined baskets produced by the Makah from the mid-1800s to the mid-1900s is what made them so well known for this style.

In chapter 8, "Ancient Basketry of the Olympic Peninsula," Dale Croes conveys his extensive research on the first dated basketry in this region, based on his archaeological fieldwork at the Hoko River and Ozette sites. Croes describes the types and characteristics of ancient basketry he has found at water-saturated sites and compares them with findings from other "wet sites" in the region, presenting theories about the relationship between ancient basketry and contemporary people.

Chapter 9, "Weaving Cultural and Ecological Diversity," derives from the extensive PhD research of Daniela Shebitz and Caren Crandell. The basketry material beargrass is being threatened by illegal harvesting for the floral industry, and sweetgrass has been diminished by shoreline development. Restricted access to gathering grounds has affected weavers' supplies of both species. Shebitz's and Crandell's groundbreaking research provides a new perspective on ways by which these plants might be perpetuated and their natural habitats restored.

In the last chapter, "Basketry Today," are contributions from tribal weavers and artisans, as well as two chapter authors. The basket weaver continues to follow cultural rules and conventions, while adding dimensions of uniqueness and spontaneity to processes that transform native materials into elegant objects of art that continue to flourish today. This chapter presents the personal experience of those who are skilled in this art form and some of the issues affecting the future of basketry. The creators of Olympic Peninsula basketry live with the elements of the sea, sky, and forest, possessing knowledge of the environment from which they draw sustenance, inspiration, and art that enriches their existence (Jones 2006).

In appendix A, "Basket Construction Techniques," Joan Megan Jones imparts a keen understanding of technique. The appendix is based on her years of research and her extensive 1976 University of Washington dissertation, "Northwest Coast Indian Basketry: A Stylistic Analysis," which is the defining source on Northwest Coast basketry styles. The reader will gain a clearer appreciation for the complexity of basket weaving from her precise explanations of techniques and styles of peninsula basketry and her new paradigm for recognizing basketry's intricate artistic value.

Appendix B, "Pre-1960s Basket Weavers," contains a list of traditional basket weavers, along with other information if known: birth and death dates, close relatives, tribal membership, and the place where they lived most of their lives. In addition to assisting collectors with understanding where baskets may have originated, this chart provides extensive documentation for future research into the weavers' genealogies.

Notes

1. OPICAC previously published *Native Peoples of the Olympic Peninsula: Who We Are*, edited by Jacilee Wray (2002).

2. For information on Quileute-language orthography, see chapter 6, note 1.

3. Proto-Salishan, a language that existed long ago, developed regional dialects that eventually became different Salishan languages. The first dialects became languages, and those daughter languages may in turn split over time.

The Weaver as Artist

JACILEE WRAY

In the late nineteenth and early twentieth centuries, museums, often funded by philanthropists, and individual collectors acquired thousands of Northwest Coast baskets as representative examples from an era that was quickly disappearing. The Jessup North Pacific Expedition in 1897, for example, was sent out specifically to collect "vanishing" ethnological objects and investigate the ethnology of the Northwest Coast for the American Museum of Natural History in New York. Anthropologist Franz Boas, of Columbia University, directed the fieldwork and was accompanied by anthropologists Harlan I. Smith, Livingston Farrand, and others. A manuscript by Farrand on Salish basketry, based on his collection of Quinault baskets, was later included in a museum memoir (Farrand 1900).

Boas was instrumental in reexamining the anthropological focus on basketry of that time period, from its "origin and history" to the design created by the "artist himself" or, more accurately, herself. In fieldwork among the Thompson Indians of British Columbia, Boas directed James Teit to document the individuality of the basketry artist's style. In a 1909 letter, Boas wrote: "In noting down the details of the method of weaving used by different women, will you not be as specific as possible? . . . I wish you could get from as many women as possible, quite accurately, just what designs they make, and also the critique of other women of their work. . . . It seems to my mind that . . . designs have been treated too formally and too little from the point of view as they appear to the makers" (Jacknis 1992:144).

Under the direction of Boas, Teit and later Hermann Haeberlin and Helen Roberts focused their research on the individual artist (Haeberlin, Teit, and Roberts 1928). Teit carefully recorded the names of the weavers he worked with. Ira Jacknis (1992), who wrote an article on Teit's basket weaver research, states that "at the turn of the century there was a common belief that tribal societies were extremely conservative and left no room for individual variation." Boas sought to supplant that idea, however, and to emphasize the weaver's virtuosity (Jacknis 2007).

With the exception of Teit's documentation of basketry artists, very few baskets within museum collections retain the name of the weaver. This state of affairs became frustrating as attempts were made to match baskets in the Olympic National Park collection with similar baskets in other collections that might have information about a particular weaver. The question arises, why would the name of the weaver not be included with the other data, as is done for other works of art? Why was providing the name of the basket weaver different? Even an anthropologist working as late as the 1940s omitted women's names in his field notes. For instance, he listed the names of entire families, but the spouses were listed as "wife." This is not surprising, considering that in our society at that time married women were known by "Mrs." and their husband's first and last name—for example, "Mrs. John Brown." Most of

the collectors and anthropologists of the time were male and probably had a bias favoring men's art over women's sometimes functional (household) works of art.

With the scarcity of weavers' names associated with peninsula basketry, subsequent authors were left to identify the shape, color, or motif of the baskets they documented in other collections and hope that this might somehow lead to a weaver's name. Anthropologist Lila Morris O'Neale (1995 [1932]), who worked with Klamath basket weavers in 1929, was unable to identify older basketry artists. The weavers could tell her how the configuration of the basket motif signaled a local design, but not who the weaver was. O'Neale did document the contemporary weavers' names during the time she was working with them, however (Berlo 1992:11).

At Neah Bay many weavers incorporated the whale as a design. In fact the whale motif was presumably first used there. Sarah Ward Woodruff Hines, a Quileute basket weaver born in 1910, also used motifs of whales and whaling canoes in her work. These designs had been handed down through generations of basket weavers to her grandmother, who then taught her (*Seattle Post-Intelligencer* 1983). Other peninsula weavers used the whale motif, as well as wolf, duck, coot, and raven designs, in their basketry, so it is often difficult to identify a basket as originating from one tribe or another. For example, Quileute tribal member Chris Morganroth III owns two century-old baskets made of the same material (beargrass) and bearing the same wolf designs: one is a Makah basket and the other a Quileute.

In order to distinguish one weaver's basket from another, there must be something unique and individualized in the design. In the evaluation of Olympic National Park's extensive basket collection, attempts to match as many baskets to a weaver by motif, weave, or design led to only one match within the entire collection. This match was discovered by Makah basket weaver Melissa Peterson. She located a nearly identical basket at the Makah Cultural and Research Center, and the weaver's name, Alice Kalappa, was documented in the museum's records. A third, similar basket was also found in the Smithsonian collection of Leo Frachtenberg.

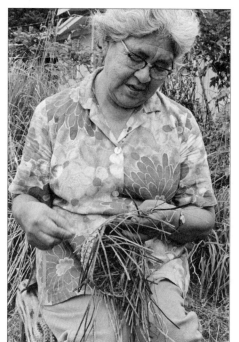

Figure 1.1. Sarah Ward.
PHOTO BY VICKIE JENSEN,
CIRCA 1970.

Basketry's popularity in the early twentieth century is evident by the publication of two extensive books on the subject. *Aboriginal American Basketry*, by U.S. National Museum curator Otis Mason (1904), is a substantial descriptive work that addresses all aspects of basketry manufacture in an academic manner. Mason labels the images in the book by tribe, but he includes only one image from an Olympic Peninsula tribe and does not indicate the names of the weavers pictured. He describes them only as "Makah Indian basketmakers," but we know from a handwritten caption on an uncropped version of the Samuel Morse photo he uses that the two women are Makah weavers

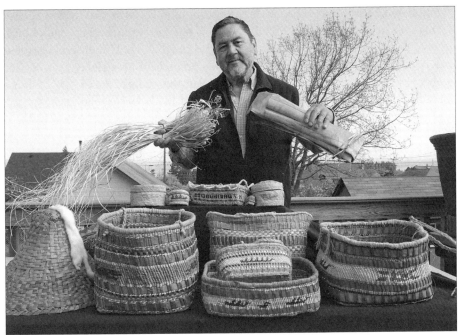

Figure 1.2. Chris Morganroth III, holding beargrass and cedar bark materials.
Baskets from left to right, top row: wolf mask on Makah basket made by unknown weaver; other baskets by Helen Harrison, Eleanor Wheeler, Jackie Smith, and wolf mask on basket made by Suzie Morganroth. *Bottom row*: baskets by Elaine Grinnell (*far left*), Pam Morganroth (*second from left, and center top*), Sarah Hines (*center middle*), Leila Fisher (*center bottom*), and Eleanor Wheeler (*far right*). PHOTO BY JACILEE WRAY. COURTESY OLYMPIC NATIONAL PARK.

Figures 1.3 (*left*) and 1.4 (*right*). Baskets probably made by Alice Kalappa. Figure 1.3: Courtesy Olympic National Park (72/948).
Figure 1.4: Frachtenberg Collection, courtesy National Museum of the American Indian, Smithsonian Institution (060056). PHOTO BY NMAI PHOTO SERVICES STAFF.

"Weisub and Neisub" (see chapter 7). The second book, George Wharton James's *Indian Basketry*, originally published in 1909, is filled with illustrations and photos. In his appendix James states that he "always endeavor[s] to obtain the name, Indian and American, of the weaver, and her photograph where possible," yet among his numerous images of weavers, only two are from the peninsula area and both are identified merely as "a Washington Weaver" (G. W. James 1972 [1909]:264).

One reason a weaver's name may not have been included with the basket documentation is that baskets are not easily signed,[1] so if a weaver's name happened to be written on a piece of paper and placed in the basket, the note might be lost over time. A tag could have been inserted through the weave, but where we do see baskets with old tags, they usually do not include the name of the weaver but mention only the place purchased or the tribe of origin. Linen tags were attempted on Navajo blankets from 1914 until 1917. Even though the tags were required to list the name of the agency, the date, the words "Navajo Made," and the agency superintendent, the weaver's name was not required, if used at all (Schrader 1983:8–10). Contemporary Navajo rugs bear the weaver's name on a Polaroid image of the weaver taken by the trader.

Another possibility for the omission of names is that skilled basket weavers were highly sought, so dealers often protected the identity of their source. On the Olympic Peninsula, traders or art buyers were known to keep names secret in order to dominate the market of a particular weavers' work. In 1963 there were a few Quinault women who did very fine work, but their names were a mystery, according to arts and crafts specialist Ed Malin. On one of his acquisition trips to the peninsula, Malin found that the Quinault weavers were not easy to contact, because secrecy about weavers' identities gave dealers a monopoly on their work (NASP RG435 1963e).

It is quite possible that only the one weaver, Alice Kalappa, will be identified among the creators of all of the baskets in the Olympic National Park collection, unless a collection is found that retained weavers' names. Locating such a collection is not a simple task, as evidenced by the experience of the Smithsonian Institution. Its extensive collections date back to 1846, and in many cases its experts must conduct additional research just to verify that the identity of the affiliated cultural group is correct. When biographical information about donors and collectors is available, it is used to help verify the tribal group (Smythe and Helweg 1995:2).

The only collections examined for this book that contained the weavers' names were the Burke Museum's small Beatrice Black collection and a Washington State University collection known as the Peck collection. Olympic National Park's many baskets were originally donated to other parks such as Mount Rainier, Lassen, Mesa Verde, and Sequoia and Kings Canyon and then transferred to Olympic National Park in the 1940s and 1950s; the information associated with these transfers shed little light on provenance. For example, eleven baskets transferred from Mesa Verde noted the pieces only as "Indian" or "Canadian." At some point the identification of Makah and a few other peninsula tribes was added to many of the inventory cards. This additional documentation may have been made by Erna Gunther, who assisted the park with basketry identification in 1958 (NPS 1958). Gunther spent a lot of time conducting fieldwork with the Makah and was devoted to highlighting Native American basketry as art. "So often things that Indians make are looked upon as souvenirs and nothing else," she once said (Gunther 1965).

The designation of Indian baskets as "tourist basket," "trinket basket," "souvenir basket," or "curio" devalues their true quality as art pieces or utilitarian objects made with great skill. The term "tourist," however, does characterize an era of the late nineteenth and early twentieth centuries when women of independent means traveled throughout the West and purchased extraordinary souvenirs. If the traveler bought a basket directly from its weaver, the buyer probably saw herself as more cultured. But no matter how much such tourists may have prized their purchases, they seldom used the term "art" to describe a basket or obtained its weaver's name.

Early author Septima Collis went on a voyage to Alaska in 1890. She describes a picturesque group of "Siwash"[2] on the porch of the government building in Sitka, "offering for sale their stock of baskets, spoons, bracelets, rings, miniature totem poles, and all kinds of knick-knacks" (Collis 1890:97). And Canadian artist Emily Carr, who traveled to Sitka in 1907 with her sister, wrote, "As the day of our departure . . . drew near . . . [we went to the village] and found a curio or two as mementoes of our happy trip. . . . [T]ourists came back from their twenty minute stopover . . . having seen a few old Indian [women] who spread shawls on the end . . . of the wharf and sold curios . . . [and] baskets, . . . and the tourist carried off the cheapest and poorest articles, and exhibited them as specimens of Indian craftsmanship" (Thom and Hill 2006:27–28). The terms "knick-knacks" and "curios" are used by these prominent women to describe their souvenirs. In addition Emily Carr looks upon her purchases as of a higher standard than those selected by the "tourist." Given the language used and the clear elitism of the experience, it is not too surprising that the weavers' names were not sought or have been lost to time.

As mentioned earlier, Lila O'Neale's early basketry research focused on specific weavers. A Franz Boas student, O'Neale was the first female anthropologist to conduct her own fieldwork on basketry. Her work included interviews with fifty weavers among the Yurok and Karuk of California during the summer of 1929, with documentation of their personal tastes and idiosyncrasies (Schevill 1992:162, 189). In O'Neale's book *Yurok-Karok Basket Weavers* (1932), the weavers are identified by tribal affiliation and with a number assigned to each to protect their identities, a standard practice of the time. Luckily, the names were archived and are now listed in the 1995 reprint of the book.

O'Neale documented a transition in basketry type from techniques that created utilitarian objects, such as cooking bowls and storage baskets, to those that became "tourist art." This change occurred during a period when the Klamath River basket weavers, like those of other tribes, were becoming less dependent on subsistence practices and more so on economic needs, making their basketry take on a new role as a source of income. The weavers explained that they were bored with replicating older "traditional" designs that buyers considered "authentic," so the weavers invented new design elements (Schevill 1992:171). O'Neale's research during this transition period was unique, as it documented changes among the Klamath that were rapidly occurring all over the region. As basketry became important economically, weavers reacted by inventing new and unique designs that were sought by collectors.

Such artistic changes arise from the creative process as well as external factors. A basketry artist creates a basket from a set of types but might experiment and come up with an innovative form. Boas and his students described the skills of different

weavers based on Boas's interest in the "virtuosic origin" of design and found that certain forms and specific techniques were carried out by only a few experienced and skillful weavers. James Teit noted that the weaver who created new basketry patterns was one of the exceptional ones who accomplished the greatest variety of forms (Jacknis 1992:141, 149). O'Neale similarly concluded that most new forms were created by weavers who were masters of both form and technique (Schevill 1992:168, 176, 178).

On the Olympic Peninsula there were many weavers who were creating "virtuosic" new forms, and they are known as master weavers. One Olympic Peninsula woman who was considered a master weaver was Julia Lee. A BIA report documents that during Franklin Roosevelt's trip across the Olympic Peninsula in 1937, Mr. and Mrs. Robert Lee of Queets gave the president a miniature canoe carved by Robert and a basket of cedar bark and mountain grass (beargrass) made by his wife, Julia Bennett Lee (NASP RG75 1937h). The FDR presidential librarian discovered that Julia Lee's basket was not in the FDR collection, but the canoe carving was (Frauenberger 2005). Let's hope that Eleanor Roosevelt enjoyed the basket.[3]

Anthropologist Leo J. Frachtenberg made a large contribution to our knowledge about basketry among the peninsula's coastal tribes. In 1916, as part of an effort

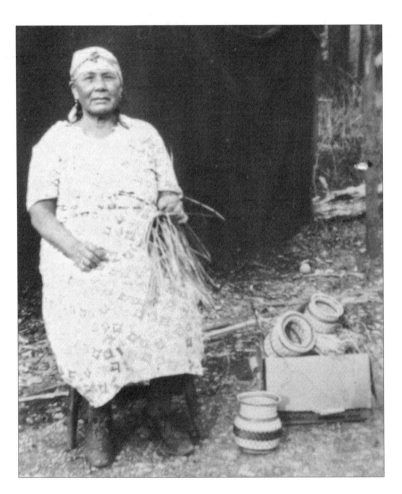

Figure 1.5. Julia Lee, with her unique form of basketry. Courtesy National Archives and Records Administration (NAOC RG435 n.d.).

to establish a museum of Native American artifacts, collector George Heye hired Frachtenberg to acquire ethnologic items from among the Quileute, the Quinault, and the Makah over a two-year period, ancillary to Frachtenberg's linguistic work for Franz Boas (Cole 1985:218). In a letter to Heye, Frachtenberg (1917a) commented that he was glad to do this collecting, for "in so doing, I gather, in a practical way, a great deal of valuable ethnological information, and get away from the nerve-racking work of linguistics." The Heye collection is now part of the Smithsonian's National Museum of the American Indian.

From his hotel room at Mora, Frachtenberg (1916a) wrote to Boas on the Smithsonian's Bureau of Ethnology letterhead, discussing how tribes on the Olympic Peninsula shared basketry techniques and designs:

August 12, 1916

My Dear Prof. Boas:

Since my last letter to you I have been busy on the study of basketry and matting. My informant wanted to put in his hay, before giving me his time, so I studied basketry in the meantime.

The baskets made by the Quileute are twofold: those of native origin and baskets introduced by the Salish and Makah. The native baskets were made of cedar-bark, vine-maple splints, cedar twigs and spruce-roots. The work is rather crude, primitive and is not ornamented with any designs woven by means of colored grasses. The weaves employed are: the checker weave for cedar-bark baskets, the twilled weave for vine-maple baskets, the open wrapped-twined weave for baskets made of cedar-limbs and spruce roots, and the twined weave for spruce-root baskets. All baskets were used for carrying and storing. The baskets made of spruce-roots were used for cooking purposes. The only form of ornamenting native baskets was to insert (in cedar baskets) colored cedar splits. The only colors employed for that purpose were yellow and black. Yellow was obtained by boiling a certain grass [possibly wild onions, which were used for a pale yellow dye] . . . and by dipping the cedar split in the water; black was obtained by smearing the cedar splits with the mud taken from the tide-lands or (later on) by the use of the soot from the iron kettles.

About seventy years ago [1850s][4] specimens of Quinault basketry were introduced and copied by the Quileute. These baskets are made of grasses [probably sweetgrass] . . . and are twined or cross warp twined. They are ornamented with geometrical designs or with figures, obtained by weaving colored strands of grass.

About fifty years ago [1870s] the Quileute began to learn the technique and designs of Makah basketry. Today most of the baskets made by the Quileute are of Makah origin. . . . All coloring is done by means of diamond-dyes [Diamond brand dyes], and the material used for these baskets consists of cedar-bark and grasses which are obtained either here or from the Quinault Indians. Geometrical designs and figures have been observed in most cases: zigzag, double knot and curve; stars, harpoon, lizard, sea-gull, crow, raven, whale, canoe, wedge, mountains, wings, etc. . . .

. . . P.S. In very recent years the water-tight baskets of the Clallam Indians have been copied. (Frachtenberg 1916a)[5]

Fannie Taylor, the hotel proprietor, postmistress, and store owner at Mora,[6] donated more than two hundred Quileute baskets to the Smithsonian National Museum in

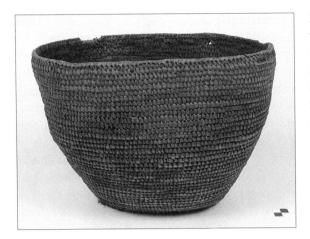

Figure 1.6. Quileute coiled watertight basket. Frachtenberg Collection, courtesy National Museum of the American Indian, Smithsonian Institution (57845). PHOTO BY NMAI PHOTO SERVICES STAFF.

1916 at Frachtenberg's suggestion (Frachtenberg 1917b:113); Frachtenberg (1916b) notified the museum assistant secretary, Richard Rathbun, that he was sending "two specimens of each type of basketry made by the Quileute women." The accession records for this collection contain detailed descriptions of the baskets, written by Frachtenberg upon his return to D.C., which are very similar to the descriptions in his letter.

No weavers' names appear in the Fannie Taylor accession records. Frachtenberg (1916c) observed, "It was impossible for me to place tag-numbers on each specimen, since I had only a few hours in which to assert and pack up the [Taylor] collection." The relationship between Fannie Taylor and her Quileute neighbors was very friendly, and it is more than likely that she would have documented the weavers' names for the Smithsonian if she had been given the opportunity, but Frachtenberg was in a rush to mail them. The Smithsonian accepted only 88 of the Taylor specimens (Rathbun 1917) and sent the remaining 126 baskets to Frachtenberg at the Bureau of American Ethnology (Hough 1917). The location of the latter baskets has not been ascertained.

Fannie Taylor's journal reveals her keen appreciation of the weaver as artist. Taylor writes of one specific Quileute weaver in an entry dated February 25, 1915:

> Mrs. She-Ste-cop [Jennie Hudson, wife of Jack] came up this morning with some baskets to sell; saying Hal [George, Jennie's nephew] did not have any money. Today I refused the baskets. In a little while she came back with a dollar and a half which she wanted me to send to Hal [at the Chemawa Indian boarding school]. I made out a money order and also put in $2.00 myself. She was so thankful because I fixed the letter up for her that she went down to the canoe and brought the baskets to me, *cultus potlatch* [Chinook Jargon for "gift"]. She did not know that I sent the $2.00 either. Some people are thankful for small favors. I do not think that the Indian women know how I appreciate the baskets they give me. I know that many of the gifts they potlatch to me are the best work they do. (Wray and Taylor 2006:67–68)

As early as 1908, soon after Fannie Taylor and her two children moved to Mora, the Quileute newspaper reported that Julia Lee, Mrs. A. (Eva) Howeattle, and Grant and Clara (Hobucket) Eastman went to Mora to sell baskets to Mrs. Taylor (*Quileute Inde-*

pendent 1908). In 1914 Julia Lee gave Fannie Taylor "a very nice basket," as did Mrs. Ella (David) Hudson (Wray and Taylor 2006:9, 32).

The weavers the newspaper mentioned are likely some of the those who made baskets that are in the collections donated by Taylor to both Olympic National Park and the Smithsonian. Another collector of basketry from the same period was Clara Young, who taught school for the Orrett family at Teahwhit Head, an isolated promontory overlooking the coast just south of the Quileute Reservation. Young collected approximately forty-four baskets between 1914 and 1915 from her Quileute neighbors through trade, purchase, or gift. About twenty-seven of these Quileute baskets are at the Museum of History and Industry in Seattle, along with Young's diary. Except for Ella Hudson, most of the weavers Young traded with were not the same individuals Fannie Taylor had acquired her baskets from a few years earlier. Besides Ella Hudson, the other weavers Young traded with were Susie (perhaps Suzie Morganroth), Mrs. Tommy Payne (Elsie Hudson), Mrs. Wilson Payne (Susanna Ross),

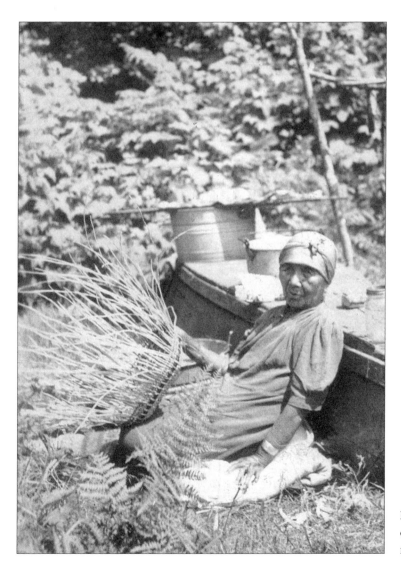

Figure 1.7. Mrs. David (Ella) Hudson.
COURTESY OLYMPIC NATIONAL PARK, POLLY POLHAMUS COLLECTION (POL.015.015).

Mrs. Conrad (Nancy) Williams, Mrs. Bill Hudson (Mary Johnson), Mrs. (Beatrice) Black, Bessie Gray, Mrs. T. Black, Myra Hobucket, Grace Hobucket Jackson, and Jerry Jones, whose wife, Ada, was a weaver. Even though these women's names appear in her journal, they are not associated with any particular baskets in the collection (Museum of History and Industry 1985).

Hermann Haeberlin followed up on Teit's basketry fieldwork among the Thompson in British Columbia with a related project involving Puget Sound basket weavers. He collected baskets and presented photographs of basketry made by the Puget Sound Salish at Puyallup and Tulalip in the summer and fall of 1916 and the summer of 1917.[7] He also collected a few baskets from the Skokomish and the Quinault. These baskets and his field notes are preserved at the American Museum of Natural History, but he listed no weavers' names in his field notebooks for peninsula baskets. Haeberlin's goals were to see if the weavers could identify—from designs, spatial composition, and combinations of figures—who had woven particular baskets and to see how the women critiqued the work of other weavers. Unfortunately, he did not live to finish this project; he died in the spring of 1918 as a result of diabetes (Jacknis 1992:145, 147, 150).

Each weaver's design might be similar to another's, yet a unique personal expression is often found in a weaver's work. Viola Riebe (2006), a contemporary Hoh weaver, says, "I learned the various kinds of weaves from my elders and incorporated the motifs as my own creative expression. My work of art is in there!" In their monograph on Thompson coiled basketry, Haeberlin, Teit, and Roberts (1928) find that the individual weaver invents variations on old basketry designs and adds new patterns. A weaver's designs and variations may be considered to belong to her because she invented them, but their origin is often lost after the designs have been copied or changed by other weavers a generation or two later (Jacknis 1992:150–51).

An unidentified basket weaver might never be known unless a motif can be exactly matched to a known example of her work. We might not be able to appreciate who the weaver was, but we can appreciate her unique expression that was so deeply rooted in her art.

Notes

1. Isabell Ides began signing the bottom of her baskets in the 1980s (see chapter 8).

2. Chinook Jargon for "Indian."

3. After this was written, it was brought to the author's attention by Charlotte Kalama that she, not her grandmother Julia Lee, had actually made this basket. Charlotte remembers the basket quite well. She recalls that it was small and oblong, with a lid and designs of a canoe and perhaps a bird. She said that she was too shy to go down to Lake Quinault Lodge when Roosevelt came through, so someone took it down for her (Kalama 2009). Charlotte was born in 1924, so she would have been about thirteen if she made the basket in 1937.

4. The date for sharing patterns and techniques is probably much earlier.

5. Permission to reprint letter courtesy American Philosophical Society, Philadelphia.

6. See Wray and Taylor 2006.

7. Leo Frachtenberg left his fieldwork at La Push for two weeks to assist Haeberlin with his research at Tulalip on October 12, 1916, at the request of Franz Boas (Frachtenberg 1917b).

Marketing Olympic Peninsula Basketry and the Indian Arts and Crafts Act

JACILEE WRAY

The Development of Collecting

In 1774 the first contact and trade between Native peoples and Europeans on the Northwest Coast occurred when members of the Spanish vessel *Santiago* met the Haida off the northernmost island of the Queen Charlottes. In their transactions the Spanish received cedar bark mats and basketry hats among other items. Curiosities continued to be traded during encounters with explorers and fur traders, but only secondarily to the ship's main mission. The Tlingit of Yakutat in southeast Alaska began producing articles for sale very early. In about 1791 "the women were observed much occupied making [baskets] and the men in making dolls, spoons and other articles of wood." Masks seemed to be the most prized purchase (Cole 1985:1, 5–6).

After the beginning of settlement in Puget Sound, especially during the gold rush period of the 1850s and 1860s, more and more people came to the coast to barter or purchase artifacts. This period of collecting may have been influenced by the establishment of the Smithsonian in 1846, which was created to conduct ethnological research, among many other scientific investigations. By 1855, when the Smithsonian "castle" was constructed, the museum was encouraging government collectors to bring back "a mass of matter" from their travels. In 1857, appropriations were provided to the Wilkes Expedition (Wilkes 1845). The result was an increase of 13,084 objects by 1873, which were mostly curios of the collectors' experience, leaving the museum to reconstruct the objects' meaning through analogy (Cole 1985:10, 12). George Gibbs of the forty-ninth parallel boundary survey obtained small collections for the Smithsonian in 1862–63 and 1871. James Swan, a teacher at Neah Bay in 1863, collected for the Smithsonian off and on until 1887 (ibid.: 46).

At this time the U.S. Indian Office began to emphasize the development of Indian crafts as a manufacturing industry, in order to assimilate Indians more quickly into the mainstream economy. By 1890 there was a growing concern for Indian welfare, the ideal being to help the Indians help themselves. In 1900, Indian field matrons were instructed to do what they could to stimulate the "old" arts and crafts, and in the larger cities Indian art was exhibited in museums and sold in shops that had Indian art departments (Schrader 1983:3, 5–6, 41).

Indian art in America allowed both artists and patrons to contribute to the culture of their own continent and to show that the United States had original decorative arts, just as Europe did (S. Goodman and Dawson 2008:229). In 1919 Mary Austin of the School of American Research in Santa Fe wrote to Secretary of the Interior Franklin Lane about the "great treasures of Indian art which, after all, were developed out of living on American soil."[1] She noted that the government must

establish ways for the art to travel from the producer to the consumer (Schrader 1983:12).

In 1922 concerned private citizens formed the American Indian Defense Association to address diminishing Pueblo lands and to affirm support for the preservation and continued production of Indian art (Schrader 1983:15). John Collier, who would become the commissioner of Indian Affairs, was one of the original directors of the association. Secretary of the Interior Hubert Work organized what he called the Advisory Council on Indian Affairs in 1924, with John Collier as an appointee. In response to the ideas of John Collier and others, Secretary Work requested a report in 1927 to be written by Lewis Meriam along with specialists in Indian arts and crafts. Completed in 1928, the Meriam Report provided a framework on which to base Indian policy, with attention to Indian arts (ibid.: 21).

Indian Arts

Interest in Indian arts contributed greatly to a Native American basketry trade, which flourished between the 1880s and the 1930s. Steamship trips to Alaska provided visitors with the opportunity to purchase Alaska Native baskets as early as 1884. Those who did not travel could find baskets at local curiosity shops, like Seattle's Ye Olde Curiosity Shop, which opened in 1899. The shop featured valuable Aleut baskets, which were made as early as 1860. It also offered baskets made by Makah, Quileute, Skokomish, Attu (Aleut), Klamath, Taku (Tlingit), Haida, Yakutat, and Shasta Indians (Duncan 2000:204). Native women's arts such as pottery, weaving, beadwork, and basketry were highly coveted by homemakers striving to decorate their homes in the popular arts and crafts style at the turn of the twentieth century (Cohodas 1992:89–90). Indian basketry in particular fit the interior design of the arts and crafts home; "as the Indian basket maker had twined or stitched her hopes and dreams into the baskets used by her family, the modern woman could express her creativity in the objects" she displayed (Herzog 1996:86). The collection and display of basketry gave the housewife an "experience that separated" her from women who "shopped at department stores for decorative accessories," making her hobby of collecting for "home decoration a transcendent adventure" (Bsumek 2003:120).

Native basketry was thought to "represent the first stage of women's art brought to a level of sophistication before the invention of pottery and textile weaving," when people lived in "closest harmony with nature" (Cohodas 1992:90). That sounds as if basketry was a stage to get to a higher level of art, but basketry was art in and of itself. A romantic quotation, attributed to George Wharton James, states that baskets are "an Indian Woman's poems; the shaping of them her sculpture" (Herzog 1996:86). James was a champion of Indian basketry and in 1903 published a quarterly entitled *The Basket: Or, The Journal of the Basket Fraternity or Lovers of Indian Baskets and Other Good Things.*

Collectors and museums acquired huge quantities of Native American art and artifacts, mostly through the fieldwork of ethnologists and anthropologists. Collecting what remained of the Indians' past became paramount for appreciating the art of basketry (Jacknis 1992:142), but the number of fine old baskets in Indian households available to sell was finite. In fact, in 1907 the Navajo sold so many of their old wedding baskets that they had to borrow them back from the traders and missionar-

ies in order to use them in ceremonies (Bsumek 2003:136). Basketry changed when its purpose shifted from the creation of utilitarian, household, and sacred objects to an economic pursuit in which baskets were made mostly for sale to consumers. Basketry's artistic splendor was considered enhanced with this shift, depending on personal preference.

Creating Anew

Among the Olympic Peninsula tribes it is not known precisely when the more marketable type of basket began to be sold. We know that baskets were made much smaller, with tightly twined designs, and sometimes with a lid. The Makah consider Queen Annie to be the weaver who first made and sold small twined baskets utilizing beargrass, which until then had been used only in weaving cattail mats. In 1859 Queen Annie is known to have combined beargrass with split cedar bark for the warps on these small baskets, since beargrass was pliable and easy to use. Cedar bark was already being used for the checkerboard weave warps in soft baskets and wallets.

By 1900 weavers from the Neah Bay agency[2] must have been making a lot of the small twined baskets because Indian agent Samuel Morse said the tribes made their living from fishing and from the basketry and curios the women sold (ARCIA 1900:395). Kate Duncan, author of *1001 Curious Things*, wrote that in 1901 Indians from the Olympic Peninsula brought baskets to Ye Olde Curiosity Shop, "coming up to the back door" of Seattle's Colman Dock in their canoes (Duncan 2003:17).

It is likely that basketry made purely for economical purposes began to take hold by the late 1870s and was flourishing on the Olympic Peninsula by the early 1900s. Certainly the marketing of basketry on the peninsula increased with the influence of basketry as decor, much of it driven by the world's fairs of the early twentieth century. For example, the 1904 St. Louis Fair was organized around arts and crafts home decoration that emphasized Indian arts (Trennert 1993) and the 1905 Lewis and Clark Centennial Exposition highlighted Northwest Coast Indian art (Kreisman and Mason 2007:30–31). The 1909 Alaska-Yukon-Pacific Exposition in Seattle featured a building that showcased women's art and achievements, such as the display and sale of Indian baskets organized by the Washington State Federation of Women's Clubs (ibid.: 82–83). This federation, begun in 1896, was part of the international General Federation of Women's Clubs, which spearheaded projects of concern to women.

Basket weavers created new techniques or experimented with new designs to cater to this tourist market, as Erna Gunther observed: "Where the openwork burden basket presented practically no opportunity for variety of shape or design new techniques gave the basket maker a real field for creative endeavor" (1935:38). Thus a new form of twined basketry was created, the fancy basket. The largest of the twined fancy baskets, the shopping bag, looked like a woman's purse and was "obviously designed to appeal to the white housewife" (ibid.).

In a 1900 photo taken by Samuel Morse, almost all of the baskets pictured appear to have geometric designs (Duncan 2000:201). The predominance of the geometric motif is also photo-documented by Livingston Farrand in a collection of Quinault basketry, although some of the figures depicted are animals made of angular lines. Farrand notes that the "materials in basket-weaving practically forbid the use of curved lines, and confine the artist to right lines and angles" (1900:395–96). There

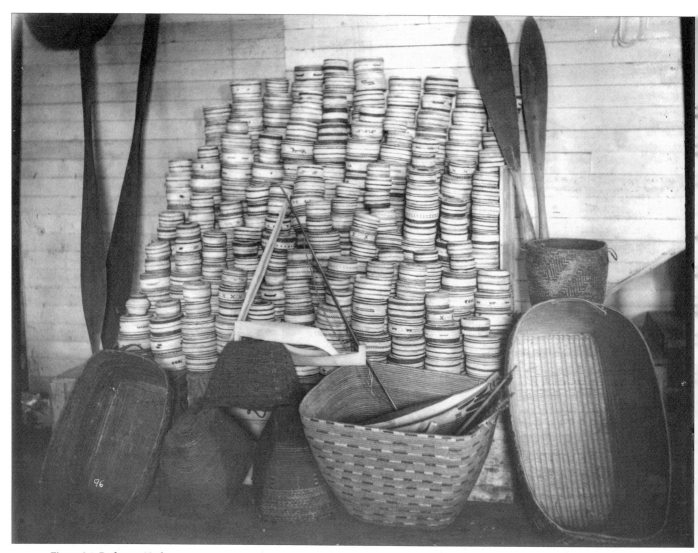

Figure 2.1. Baskets at Neah Bay, July 1902. PHOTO BY SAMUEL MORSE. COURTESY WASHINGTON STATE HISTORICAL SOCIETY (NO. 96).

seems to have been a transitional period when more elaborate and representative designs were added after the turn of the century. In 1902 Samuel Morse took a photo of basketry at Neah Bay in which several examples with animals and canoes can be seen among the geometric patterns. Curved designs had to be made with each tiny stitch or twist of the material (Herzog 1996:79). The proprietor of Ye Olde Curiosity Shop, Joseph Standley, took "some credit for the innovation," stating that "tourists wanted something fancy" so he asked the local Indians to incorporate designs in their work (Duncan 2000:201–202). The progression from geometric motifs to more realistic portrayals of animals probably ties directly to a marketing strategy by the weaver.

Basketry materials as well as baskets were prized as trade items among tribal members. In 1906 correspondence between the Indian agency superintendent at Neah Bay and Albert Reagan, the schoolteacher for the Quileute Tribe, Reagan reports that Jack Ward of La Push gave a potlatch for his wedding and Mrs. Ward received "a few bunches of basket straw and some dishes." Then the Quileute gave away "money and basket straw"[3] to the honored guests from Neah Bay (Reagan 1906). Basketry

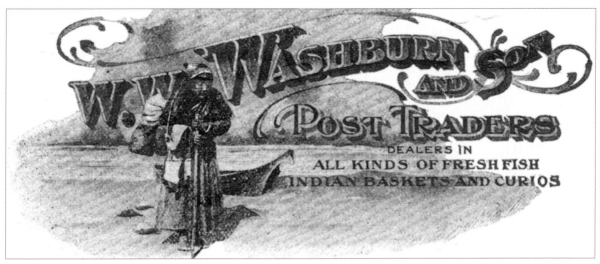

Figure 2.2. Washburn letterhead (NADC RG75 1911).

was a very prestigious gift, such as at the potlatch. The art of basketry may have been viewed as a cultural responsibility by the women at such giveaways, as well as a way to enhance the family's income and prestige.

Creating an Industry

In 1902 and 1903 agent Samuel Morse commented that at Neah Bay "our women make hundreds of fine baskets, which they have a ready market for" (ARCIA 1902, 1903). The beautiful baskets and mats[4] brought in revenue of $3,000 in 1904. The basket weavers took advantage of the long rainy season to make their baskets. At Neah Bay "all the female population are basket makers, even to small girls," Morse observed. "But few men[5] work at basketry" (ARCIA 1905, 1906).

In a 1909 report the Neah Bay Indian agent says that women sell their baskets (sometimes on the street) in Seattle and other nearby cities, earning 25 to 75 cents per day during the winter from this "very important industry" (NADC RG75 1909; AR 1911:9). Basket weavers paid their store bills at Neah Bay solely with earnings from basket making (AR 1913:13). In 1915 W. W. Washburn and Son was the only licensed trader at Neah Bay and purchased all the baskets brought to the store. In 1916 the Washburns paid $6,000, much in trade, for baskets that were made by sixty-five Makah women. At first glance this may seem like a lot more money than the 20 cents an hour the women could earn from cannery work, but the number of baskets the $6,000 represents is unknown (NADC RG75 1916).

The Neah Bay agent noted that basket making was an "industry" in which mostly older women engaged (NADC RG75 1919), contrary to the 1905 report that all females, even small girls, made baskets (ARCIA 1905). Perhaps this was because the younger girls were required to leave the reservations and attend boarding school at Neah Bay, Chemawa, or Cushman during this period. We know that many women were making baskets in 1920, as only two industries were listed in an annual report for Neah Bay: fishing and basket making (AR 1920).

Several peninsula weavers were marketing their baskets in Seattle in 1920. Records from Ye Olde Curiosity Shop list the following women who came to sell their

baskets at the shop: Agnes (Hudson) Ward, Mrs. William (Sally) Tyler, Rosa Yokum, and Mrs. Charlie Swan, all from Neah Bay; Florence Greene of Port Angeles; Mary Chips of Alderton near Puyallup, identified as Quileute; Mrs. Tom Brown, Mrs. R. M. (Rosie) Black, Mrs. Frances Cleveland, Mary Tate, and Ida (White) Taylor Penn, all from La Push; and Johanie (Johnie or Joan) Sailto of Hoh (Duncan 2000:202, 253n16).

In 1927 assistant Indian commissioner Edgar B. Merritt reported to the House Appropriations Subcommittee the need to find markets for Indian art through local traders and outside sources. Then, in the 1928 Meriam Report, it was recommended that the federal government begin to foster the development of Native arts and crafts (Schrader 1983:17, 19). By 1929 the basketry trade was being well documented for the Washington Office of Indian Affairs by the local Indian agency.

In 1929 the Taholah Indian agent, Superintendent William Sams, recorded that ten weavers in his jurisdiction had made 250 baskets and earned a total of $500[6] from their sale (AR 1929). In that same year, the Washburns' store at Neah Bay was overstocked with baskets. In a letter to the commissioner of Indian Affairs, the agent at Neah Bay wrote that if the baskets were not sold, the Makah would not be able to pay for their groceries during the winter (NASP RG75 1930a). The store was also marketing baskets to other dealers, including the Lake Quinault Hotel (NASP RG75

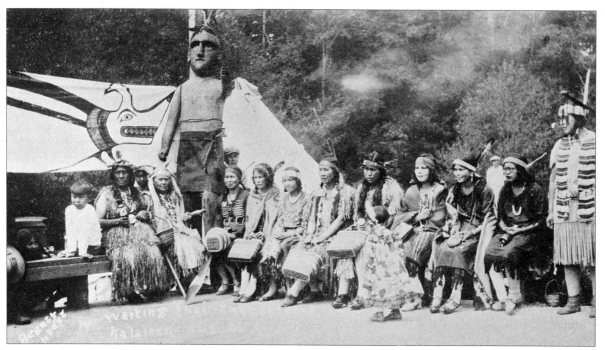

Figure 2.3. Opening ceremony of Highway 101 at Kalaloch, 1931. *Left to right*: Manuel Fisher (son of Scott Fisher, Hoh River), Mary Howeattle (Quileute), Rebecca Coe (Quileute; won honorable mention in the beauty contest), Violet Black (Quileute), Catherine Obi Eastman (Queets), Helma Swan (Makah; won second place), Nellie Sam (Queets), Nellie Williams (Quileute), Pearl Cultee (Quinault/Quileute, Tacoma; won first place), Adele Martin (Quileute), May Black (Quileute), and Ida White (Quileute). The little girl in front is Caroline Woodruff (daughter of Fred and Sarah Woodruff, Quileute).
COURTESY NORTH OLYMPIC LIBRARY SYSTEM, KELLOGG COLLECTION, INDN PORT 14.

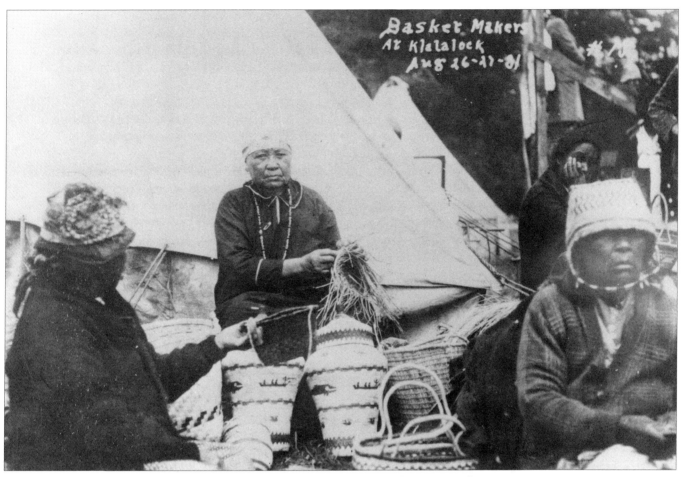

Figure 2.4. Basket makers demonstrating their work at the 1931 ceremony of the opening of Highway 101. Nina Bright is in the center. COURTESY NORTH OLYMPIC LIBRARY SYSTEM, KELLOGG COLLECTION, INDN PORT 37.

1931b, 1931c).That same year, the Department of the Interior asked agencies to send Indian artwork to be displayed in the lobby of its building in Washington, D.C. Two baskets were sent from the Neah Bay agency and were purchased while on display in D.C. The agent sent more, stating that basket sales represented $3,000 a year to the Indians at Neah Bay and were "in some cases their sole means of support" (NASP RG75 1929, 1931e). Indian commissioner Charles J. Rhoads responded that his staff would "give [the baskets] prominence in a new case which has been placed in the central section of the main corridor of the Department of Interior building" and would sell any baskets "for which we have calls" (NASP RG75 1931a).

On August 26, 1931, the opening of Highway 101, the final stretch of the Olympic Peninsula's Pacific coastal highway, was a celebrated event at Kalaloch. The highway's opening was seen as a way to draw attention to opportunities for purchasing tribal arts on the reservations. The main dedication celebration included traditional events, Indian dances, seal harpooning, and an "Indian Queen" beauty pageant at Kalaloch. Washington State governor Roland Hartley was given a beautiful Indian basket during the ceremony (PAEN 1931).

FINDING A MARKET

The Depression hit soon after Highway 101 opened, and by 1932 the Washburns stopped purchasing baskets because of the large stock they had on hand. Even though the agency had tried to find a market for his stock, "practically all of the tourist agencies and national parks . . . refused to take any of the baskets." To make the situation worse, the price of fresh fish had fallen to between 2 and 4 cents a pound, the lowest price in thirty years except for 1914, jeopardizing tribal people's welfare (NASP RG75 1932a).

In hopes of strengthening the art of basketry, Cleora Helbing of Chemawa Indian School wrote in March 1933 to Edna Groves, the home economics supervisor for the Office of Indian Affairs, stating that when the school was built at Neah Bay, a room was provided for teaching basketry, but the teaching position became vacant because of a new requirement that instructors have a teaching certificate. The Indians at Neah Bay made a superior basket, Helbing said, but during the previous few years their basketry was becoming inferior and they were rapidly losing their love and appreciation for the art, "which is their inheritance." Helbing was trying to get the Office of Indian Affairs to pay $200 a year toward the salary of an Indian basket weaver to teach the Makah so that the school could "establish a department second to none . . . in the country," thus strengthening the Makah's economic prominence in basketry again. Weavers were making baskets in a hurry in order to trade them for food at the Washburns' store, and Helbing thought it would help the trader market the baskets if a class was offered to help weavers create a better product. Helbing assured Groves that "the $200 would be well spent, and this new department . . . [would be] essential to the success of the school" (NADC RG75 1933). It appears that Helbing succeeded; this teaching position apparently existed at the school in 1935, as it is referenced in a 1936 memo (NASP RG75 1936b).

The Office of Indian Affairs continued to be very involved in marketing basketry. Taholah Indian agent Nels O. Nicholson received a request for an Indian basket in 1933 from the Indian Affairs office in Salt Lake City, so he sent one made by Mattie Wheeler Howeattle, or *Ha-thla-kooth*. Mattie Wheeler was born on the Hoh River in 1861, and in 1933 she was living at Taholah. The workmanship of her baskets was not typical Quinault, according to Nicholson. The grasses were native, but the dye was artificial and the designs were of an Indian canoe and a whale. That year the price of her basket was $1.50 (NASP RG75 1932b). In all, eight Quinault weavers are noted in Nicholson's correspondence, and they made forty baskets that year, earning them a total of $80 (AR 1933).

Included in a Taholah agency file for 1933 is a narrative bearing no title, date, or author, but the writer—who asserts that his father, Joseph N. Locke, was the first settler in the Quinault Valley—recalls visiting the Quinault Reservation in February 1890 before the basketry "tourist trade" began: "The women have always been very capable basket makers, and until they began to use Diamond Dyes and made baskets for the tourist trade their baskets were superior. There could be a very considerable business built up with direction along this line, and there are old weavers enough left to train the younger ones [in traditional basket-making skills]" (NASP RG75 1933). It was a noble idea, but an unrealistic one, given the amount of time needed

to collect and process the materials to make such a basket and the poor market at that time. The process of collecting native plants and producing natural dyes was extremely labor intensive. When aniline dyes became available from the Hudson's Bay Company, most of the weavers began to use them by the late 1800s (NASP RG75 1937f). However, some basket collectors purchased only baskets made with natural dyes, so the weavers who preferred to make baskets the traditional way were highly sought (NASP RG75 1937a).

As an emergency relief effort, an art survey for Public Works Administration projects was begun in December 1933 in order to find markets for artists. The names of Indian artists eligible for work under this program were submitted to regional art directors who recognized the importance of developing "handicrafts" in the Indian Bureau to assist Indian artists in becoming self-reliant and independent (NASP RG75 1934g).

In 1933 Mrs. Charles Collier[7] began "preparing a survey of the Indian art and craft situation for a report to a commission which ha[d] recently been appointed by Secretary [of the Interior Harold L.] Ickes." Mrs. Collier requested that Superintendent Ryan of Chemawa Indian School "furnish a list of Indian painters, basket makers, potters, and other craftsmen whose work is of a high standard" for the survey (NASP RG75 1934a). Ryan sent a negative response to Collier, stating that Chemawa Indian School's role was to assimilate Indian children:

> Indian arts and crafts have about passed away in our district with the exception of a few old Indians who still occasionally make baskets. The younger generation is leaving the reservation searching for a place where they can earn a satisfactory living. This has all led to a decrease in interest in Indian art and I believe it is safe to say that basket making will shortly pass away here. Prices for such work have been so low that an Indian could earn but a few cents for a day's work at best. This has resulted generally in the making of inferior products. (NASP RG75 1934b)

Ryan's assessment came only three years after Chemawa Indian School began an applied fine arts program in the fall of 1931 that included weaving, pottery, basketry, wood carving, and metalworking. The program made "use of Indian art and design with special reference to that found in examples of the culture of the children's own tribe" (NASP RG75 1931d).

Superintendent Nicholson of the Taholah Indian Agency[8] had a more positive perspective and provided Mrs. Collier with the names of the basket weavers in his agency, noting that the best assortment of baskets could be purchased around April and May, soon after they were made during the winter. By fall the baskets were all picked over by the tourists, who coveted the best. Nicholson praised Quileute weaver Ida White Taylor as the maker of the finest baskets of all (NASP RG75 1934c). The list of weavers that Nicholson compiled is incorporated in appendix B.

In a second letter, Superintendent Nicholson provided Collier with additional basket weavers' names, stating he would forward others as soon as he received them (NASP RG75 1934d). He did soon forward a list from W. W. Washburn at Neah Bay (NASP RG75 1934e), as well as the names of two Queets weavers sent to him by William Penn, a Quileute (NASP RG75 1934f). Despite the extensive number of weavers Nicholson provided to Collier, the Taholah statistical report for 1934 lists basket

weaving only among the Chehalis, the Skokomish, and the Makah. The Chehalis are listed as having five weavers, the Skokomish six, and the Makah one. No data for basket weaving appear on the statistic sheets for weavers from Nisqually, Squaxin Island, Ozette, Quinault, Hoh, Shoalwater Bay, or even Queets and Quileute, although Nicholson had provided names for weavers at both places[9] (AR 1934).

Indian Arts and Crafts Act

The Senate bill for the Indian Arts and Crafts Act (SB 2203) was introduced by Senator Elmer Thomas of Oklahoma "to promote the development of Indian arts and crafts and to create a board to assist therein, and for other purposes." The Indian Arts and Crafts Act passed on August 27, 1935 (Public Law 74-355), and established the Indian Arts and Crafts Board as a separate agency of the Department of Interior to promote the economic welfare of American Indians and Alaska Natives through the development of Indian-produced arts and crafts. Even with this act and the emphasis on Indian art, no mention of Indian art or basketry was made in the 1935 annual report for the Taholah agency (AR 1935).

John Collier, the commissioner of Indian Affairs under FDR, was in charge of promoting tribal economic welfare through the development and marketing of Indian arts and crafts. Collier believed that Indian art was more than ethnographic objects sitting in a museum and hoped that it would be removed from "the dusty shelves of museums of anthropology" and promoted, so that people would understand that American Indians were quite different from the portrayals by James Fenimore Cooper and others. It was time to help people see Native Americans as creative contemporary artists and to change the view that their art was a relic of the past (Rushing 1992:198–99; Schrader 1983). The Indian Arts and Crafts Act stimulated interest in genuine Indian art and created an increased market for the artist. In the process it curtailed the illegal practice of selling fake Indian art and rejuvenated Indian basketry in popular tastes (Rushing 1992:204–205; Gunther 1965).

When Erna Gunther was asked to bring something to display at the "woman's building" for a local Washington fair "because [they] hadn't gotten enough doilies," she brought them Indian baskets. After having to argue for the baskets—"that or nothing at all"—Gunther said she noticed that every time she went back to the building, people were looking at the basket case. Gunther speculated that after people went home from the fair, they probably brought out their baskets from the attic, realizing they owned a piece of art. Gunther thought people's interest in Indian art could be channeled with big projects "and sometimes with smaller ones within communities," but she knew that "a national movement," such as the Indian Arts and Crafts Act, would spark interest in the artist (Gunther 1965:6). In addition to its importance as art, basketry provided the weavers' families with much-needed income for buying food and clothing, just as in former days when baskets were taken to the Hudson's Bay Company in Victoria to trade for shawls, beads, and staples like flour and sugar (ibid.: 40).

Taholah superintendent Nicholson diligently tried to find sales markets for basketry. In 1937 he wrote to Louis West, general manager of the Indian Arts and Crafts Board:

In the aggregate the Indians of the Makah, Quileute and Quinault make a large number of baskets. The Indian women of the Makah Reservation are now concentrating on the smaller, lower-priced basket for which the local trader has developed a market, and he is now accepting these at the rate of about five hundred per month. He will accept only baskets of native grasses and carrying typical Indian design. The baskets generally turned in are small and not of exceptionally good weave, and the Indians receive for these small baskets only 25 cents in trade. He actually sells them to his outside markets for 25 cents in cash. It is sincerely hoped that as a result of your efforts markets for these products at higher prices can be developed. (NASP RG75 1937d)

Around this time, Indian agents were receiving many requests to purchase Indian art. For example, in 1937 the Taholah agent received a letter from Paul Standar, who wanted more Indian baskets to sell at his photo and souvenir shop at Sun Valley Lodge, Idaho, as well as a letter from arts and crafts dealer Dan Hightower of San Francisco, who was "making contacts with Indian agencies . . . in an effort to learn what hand-made Indian articles may be obtained . . . during the coming year" (NASP RG75 1937g, 1937i).

Indian commissioner Collier wrote to Tulalip agent Oscar Upchurch, asking if there was an opportunity for spending $1,000 or $2,000 from the hoped-for rehabilitation fund on an arts and crafts project. Collier wanted Upchurch to discuss this with Erna Gunther when she returned to the University of Washington (NASP RG75 1936a). Upchurch responded:

Spending of a small amount of money in the discovery or rediscovery of methods in arts and crafts, I may say that such a contribution would be of unquestionable value. Last year on one of our reservations [Makah], we had a basketry instructor, an Indian woman employed under a relief project, who developed quite an interest among some of the younger people in native baskets. This interest is difficult to maintain because the manufacture of good baskets is not commercially profitable. Our Indian women artisans find more practical profit in wool work, manufacture of sox and sweaters for which they spin their own yarn and for which the revival of the popularity of skiing in the Northwest has furnished a splendid market. Some form of subsidy therefore, is necessary as well as the development of the love of art in order to enable our women to be artists rather than artisans. (NASP RG75 1936b)

Gunther and Upchurch discussed popularizing Indian art and decided that they would show an exhibit of "tight baskets" (close-wrapped-twined), from the University of Washington collections, in Indian communities and high-class stores in Seattle (NASP RG75 1936b). In addition to this exhibit, Paul Fickinger, the assistant director of Indian education for the Office of Indian Affairs, wrote to Nicholson at Taholah in March 1936, asking for baskets worthy of becoming museum pieces to be shown in a traveling exhibit. He asked that Nicholson select "only beautiful, perfect baskets which are authentic in material, weave and design." The first showing was to be an exhibition at the Texas Centennial, for which they specifically requested "a fine Neah Bay basket," limited in cost to $15, along with information on the materials used, the weaver's name, and a photograph of the weaver at work so that it would provide greater interest in the basket. Nicholson sent a basket of beargrass and cedar bark woven by Katie Hunter with a "voucher for 4.00 and two photographs,"

Figure 2.5. Katie Hunter (Ozette), weaving Neah Bay baskets from cedar bark and mountain grass (beargrass) (NASP RG75 1936f).

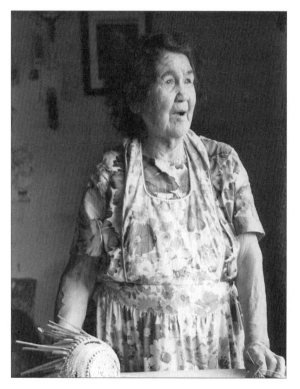

saying that the "basket in front of Mrs. Hunter is the one sent for exhibit" (NASP RG75 1936c, 1936d, 1936e). No photo was with the archived memo, but the photo of Katie Hunter from Helen Carlson's annual Home Economic Report of 1936 is likely one of the images sent (fig. 2.5). Carlson had accepted the job of Makah home economics teacher in 1936, and in this position she was seeking a market for fine basketry (NASP RG75 1936f).

Where to Shop

In 1936 Taholah agent Nels Nicholson identified some of the peninsula's markets for basket sales. Stores at Neah Bay, Taholah, and Queets sold baskets, as did individual weavers like Maggie Kelly, a Queets basket maker who sold on a small scale from her home (NASP RG75 1936g). Soon after, Indian Arts and Crafts Board general manager Louis West asked Nicholson for names of Indian art dealers and buyers. Nicholson sent him the names of W. W. Washburn at Neah Bay and La Push; Henry Markishtum, a Makah tribal member who had a store at Neah Bay; Mrs. Rogers, a Taholah trader who purchased a few baskets; and N. A. Jones at the Lake Quinault Hotel. Nicholson also gave West the names of the Meier and Frank department store in Portland, Oregon; the Frederick and Nelson department store in Seattle; and several other Seattle stores that "were prevailed upon to make an exhibit of Indian goods some time ago" in hopes that they would provide an outlet for basketry. This was likely a reference to the exhibit that Gunther and Upchurch had worked on the previous year (NASP RG75 1937a). West replied to Nicholson: "We are considering the publication of a directory of currently produced In-

Figure 2.6. Maggie Kelly (Quinault/Quileute) made baskets practically her entire life. Kelly learned how to make baskets when she was seven or eight years old by watching her mother, Sally Freeman, and her grandmother Sally Chepalis (Kelly 1973; J. E. James, Jr., 2009). PHOTOGRAPHER UNKNOWN; PHOTO COURTESY JUSTINE JAMES. JAMES IS THE GREAT-GRANDNEPHEW OF MAGGIE KELLY.

dian goods. . . . It is our desire to show items by materials and by use—for example, a basket may be described as a splint basket and also as a waste-paper basket. Where any well-defined use is indicated by the shape, material, or purpose, this information should be given" (NASP RG75 1937b).

Nicholson received another request for Quileute and Makah baskets soon after his communication with Louis West, and Helen Carlson sent the items off to West. For the Quileute piece, she included a description of a cedar basket woven by Rebecca Bright, "an old Quileute woman." The basket was made of peeled and split cedar roots and was smaller than average, but a "true weave and design of the old type storage basket used formerly by the Quileute." Carlson commented on how this particular weaver seldom incorporated any color or decoration except a simple black design that was no longer commonly made (NASP RG75 1937c, 1937f).

The Makah basket was made by Martha (Mary) Green[10] and had a finer weave than most, according to Carlson, "although some are woven finer here." The weave, color, and design were typical Makah, with a canoe, duck, and whale design of woven beargrass over a foundation of cedar bark. The grass had been gathered and carefully cured, then colored with native dyes from plants and minerals; these were dyes that had been in use until aniline dyes became common. The beargrass was scraped and split to prepare it for weaving around the split cedar bark ribs. The heavier basket materials were slightly dampened, not soaked. Carlson mentioned that weavers liked to work in rainy weather because the baskets came out smooth and firm, but fine baskets could not be woven in cold, frosty weather (NASP RG75 1937f).

In her 1937 Home Economic Report, Carlson told how she and some of the weavers took part in marketing basketry at the Meier and Frank department store in Portland during Rose Show week, with women from each of four reservations in their regalia.[11] They each wove baskets at the fair and sold them for a total of $89, and the sales opened up avenues for marketing many more. In August Carlson held a similar weaving exhibit at the county fair in Port Angeles (NASP RG75 1936f). A local newspaper article, "Glimpse of Past Age in Neah Bay Exhibit," read in part:

> Mrs. Helen Carlson, Government teacher at the reservation, and several of the women with their shell headbands and basket weaving materials, have arranged the booth. . . . Among old curios are water-tight baskets long in use for holding food and water . . . [and] a rush mat. . . . On-lookers noticed that the baskets and mats made by the women, of mountain straw [beargrass] over cedar bark strips, are characterized by a duck design and a canoe, alternating. (NASP RG75 1937e)

Carlson's 1938 report described the exhibit at the Port Angeles fair, stating that the women had woven baskets during the fair and had many of these items for sale (NASP RG75 1938a). Carlson was successful at marketing the area's basketry, as is evident in Dan Hightower's mail order in 1938 for his San Francisco shop. In it he requested "four of the 25¢ [baskets]" and "three of the 50¢ ones and two of the $1.00 ones." He added, "Also you may send me two of what you term the 'open' baskets [pack baskets], provided they are of good material and workmanship, as well as one of the shopping baskets" (NASP RG75 1938b).

An interesting basket request came to Nicholson from the Bo-Kay Perfume Company in New York. The order was for sweetgrass baskets that met the following specifications, presumably to hold Bo-Kay perfume bottles.

> 2" diameter at lid
> Tapering to 1 1/2" at base
> 1 3/4" in height all over. . . .
> And also a round mat 2 1/4" in diameter. (NASP RG75 1938c)

Helen Carlson responded on Nicholson's behalf: "[There] is none of the so called sweet grass [actually there was][12] here. . . . We do have very attractive covered baskets in the two inch diameter of cedar bark and mountain grass with a woven design of canoe or bird that sell for 25¢ each. . . . We could furnish small mats at from 15 to 50¢ depending on size and amount of design woven in" (NASP RG75 1938d).

Another request came from the Oregon Worsted Company of New York for 660 baskets to be Christmas presents. The company wanted two baskets for each box, and each pair of baskets was to be filled with products from the state of Oregon [apparently it did not matter that the baskets were from Washington]. "We would want the baskets to be typically Indian and colored according to typical Indian colorings and designs. We have in mind a basket about 14 inches high, although this dimension is not at all specific" (NASP RG75 1939a).

The agency wrote back that a fourteen-inch-high basket would cost from $5.00 to $10.00 and forwarded some different samples made by the Quileute "who make one of the most reasonable [*sic*] priced baskets in this vicinity" in the 75-cent price range: "These Indian baskets are made of cedar bark, swamp grass [sedge], mountain grass [beargrass] and cat tails" (NASP RG75 1939b). The company opted for one of the sample baskets that had a lid, ordering 336 for their Christmas gift packages. The theme for their gifts was the "Indian Idea" (NASP RG75 1939c). The company wanted to have a "very decided Indian effect" and asked for a small sticker or tag to place on each of the baskets that could provide "a little story full of interest so that customers who receive these products will know the romance which lies behind them" (NASP RG75 1939e).

The proceeds for the 336 baskets went to the individuals who made them. It took about one and a half days to make one basket with a lid, not considering the time required to gather and cure the materials used, which had been previously collected during certain seasons (NASP RG75 1939d). The agency sent a photograph taken at La Push that showed a group of Indian women making baskets along a roadside and offered the photo for 3 cents each to go with the baskets (ibid.). An image that was also used in a postcard image is probably the one that was sent (fig. 2.7).

Production for the basket order was divided between the Chehalis, the Quinault, the Quileute, and the Makah to ensure there would be enough baskets by the deadline. "The workmanship must be of the finest and up to the same standard as the samples," Taholah Indian Agency superintendent Robert Bitney wrote to the Chehalis Works Progress Administration sewing instructor, adding, "We hope that your ladies will 'go to town' on this project" (NASP RG75 1939f).

On November, 22, 1939, Bitney express-mailed the baskets to the Oregon Worsted Company with a letter stating:

> We have tried to give in each of the three boxes the 'Romance' of the particular group. For your convenience we have kept them in separate boxes, although there

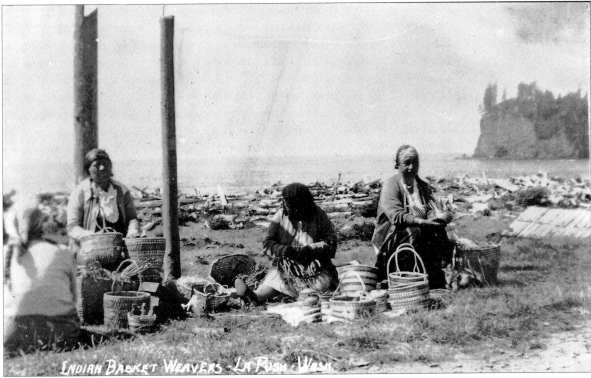

Figure 2.7. Postcard titled "Indian Basket Weavers, LaPush, Wash." *Left to right*: Nina Bright, possibly Nellie Williams, and Rosie Black. COURTESY OF THE FORKS TIMBER MUSEUM.

is no essential difference in those from Taholah and Neah Bay, as both are Coast Indian groups, while the Chehalis is a River group. We are leaving the romancing for individual baskets to you as we do not have the facilities for this and feel at any event that you can use the material furnished, to suit your desires better than we could. (NASP RG75 1939g)

Regardless of the popularity of traditional Indian arts and crafts, in 1940 Secretary of the Interior Ickes received several telegrams and letters supporting "a supposed plan to abandon the Native Indian arts and to substitute art training for the Indians on the European model" (NASP RG75 1940). In response, Collier sent a memo to "field employees and officials":

> We would be as likely to abandon our land conservation program for Indians, or to ask to repeal the Indian Reorganization Act, as we would be to reverse our policy and practice in Indian Arts and Crafts. Rather, we hold that the policy has demonstrated itself brilliantly, especially in the last year. Those who attended the San Francisco Exposition will know what I mean. The Museum of Modern Art in New York for five months in the year ahead will devote itself exclusively to the display of native Indian crafts and paintings. Among the murals recently placed on the walls of the Interior Department at Washington, none have vied with the murals painted by the Indian young people. . . . Comprehensively, I would say that a marvelous efflorescence of Indian decorative genius is taking place. (NASP RG75 1940)

The murals Ickes mentioned continue to be appreciated for their artistry today by federal employees and visitors to the Department of Interior building, as is the Indian Craft Shop inside, which has operated there since 1938.

Ladies' clubs were very popular in the 1940s, and the peninsula tribes all seemed to have them. In 1942 extension worker Helen Carlson and Quileute weaver Rosie Black worked with the La Push Ladies Club to sell baskets to fund the purchase of fabric for making clothing (NASP RG75 1946). In November 1943 the Neah Bay Ladies Club sent sixty-seven baskets to Taholah agency superintendent George LaVatta[13] to sell (NASP RG75 1943). LaVatta wrote back that all but eight of the baskets were sold at the Cushman Hospital for a total of $44 (NASP RG75 1944b). That same year, the Taholah Ladies Homemakers Club was established to make articles for use and sale, such as baskets, socks, and sweaters (NASP RG75 1944a).

In 1945 LaVatta submitted a summary report to the U.S. Senate Committee on Indian Affairs. In it he stated that a few of the older Quinault Indians supplemented their income with baskets, although the return was not large, and that older Makah women spent most of their time at home weaving Indian baskets, which they readily sold (NASP RG75 1945a).

In June 1945 Willard Beatty, the director of Indian education for the Office of Indian Affairs, wrote LaVatta about the possibility of increasing the production of Neah Bay baskets, as Beatty believed there was an increasing market for "this craft[,] provided the Indians can be persuaded to improve the quality of product." Beatty also asked if the Indian Arts and Crafts Board could be of any assistance in improving production or opening up new markets (NASP RG75 1945b). LaVatta informed him that "the Indians have not been making very many baskets during the past two years, principally due to the war" (NASP RG75 1945c). The Pacific Coast was a vital defense point during World War II, and many of the resident Indians, including women, were employed on defense projects (ibid.). For example, Charlotte Kalama of Quinault was a welder on U.S. warships. Her small frame was an asset for welding in confined spaces (J. E. James, Jr., 2009).

Indian Arts and Crafts Board

Funding for the Indian Arts and Crafts Board was drastically cut after the middle of 1942 because of World War II. In 1943 an amendment to eliminate the Indian Arts and Crafts Board altogether was brought forward to the Senate Subcommittee on Appropriations (Schrader 1983:268–69). The board survived, but Collier was finally fed up with the "grinding action of an omnipotent subcommittee that scorned and even hated the program of Indian regeneration," and he resigned on January 19, 1945 (ibid.: 278, 294). Collier had created a firm foundation for the board, which appointed a full-time general manager in 1951. By the 1960s, congressional opposition had shifted, and board staff increased, with an emphasis on technical assistance in production and marketing (ibid.: 298).

In February 1963 the Indian Arts and Crafts Board opened its first area office in the Northwest. Edward Malin served in the position of Indian Arts and Crafts Board specialist from 1963 to 1968. From his office in Lake Oswego, Oregon, Malin was to find creative Native artists who wanted their art promoted and marketed in the states of Washington, Oregon, and Idaho.

On Malin's first trip to the Olympic Peninsula, he was accompanied by George LaVatta, who was the BIA education administrative officer at the time. Malin wrote that Neah Bay offered some possibilities, as he met several "potentially capable peo-

ple who know crafts." The happy note of his trip was the welcoming reception he received at La Push and the potential he saw there with the spectacular increase in tourism. Sadly, Malin noted that many of the customs lived on only in the memories of the old-timers, not among the younger generation. He saw outsiders moving in and taking advantage of the Indian arts market, and the production and sale of craft items made only a negligible contribution to the tribal economies. "In view of the demand for curios and craft products," he wrote, "this could be a substantial and rewarding aspect of Indian reservation enterprises" (NASP RG435 1963d:2).

One reason for the diminishment of basketry during this period may have had to do with the restrictions on tribal allotment lands. In Quinault, for example, the allotments were opened up to large logging companies, thus removing tribal members from many of their important basketry material collection sites.

Malin spent a lot of time traveling throughout his jurisdiction, especially on the Olympic Peninsula. He made eight to ten field trips to Neah Bay to visit the Makah, who were the most receptive to his ideas. He visited the Quileute two times, and he found several families among the Hoh and the Queets who made basketry and sold their products in the small shops on the peninsula. However, Malin discovered that the Quinault weavers were "shrouded in mystery," as the traders and store buyers were very possessive of the weaver's work (Malin 1963). "They wouldn't give me names," he later recalled. "You know, that was one of the things that was important for me to use, because then I could have a little biography about them that would go to the central office. But there was an agreement of silence [among traders]. . . . They didn't give names" (Malin 2007).

Malin received help from LaVatta in reaching out to these communities. LaVatta wrote to Mrs. Cleve Jackson of Taholah, saying that he would appreciate it if she would notify Mrs. Johnson Black, Mrs. Blanche Shale, and the rest of the women in the Ladies Club that Edward Malin, an arts and crafts consultant from Oregon, would be in the area and could be of assistance to them (NASP RG435 1963b). The Indian Arts and Crafts Board had also provided the names of the following Quinault weavers to Malin:

- Beatrice Black—basket weaver who takes special orders only and sells all she makes.

- Irene Shale—makes baskets but she is not very active any more.

- Ancy [Ansy] Hyasman—Hats are her specialty and any shape of basket and dolls of cedar bark. She is not active now.

- Mrs. Beauchamp [Hannah Bowechop]—makes baskets but has no monetary interest. She gives them away as gifts.

- Blanche Mowitch—a fine basket maker. (NASP RG435 1963c)

Malin eventually discovered quite a few of the peninsula weavers, as he submitted over sixty names in his various memoranda about his Olympic Peninsula work. He acquired many of the names from other sources, such as a list of Makah weavers compiled by Nora Barker and Helen Peterson for Evelyn Tinkham[14] (NASP RG435 1963a); names of craftspeople at Hoh, Queets, and Quinault from the Everett BIA office; and others (NASP RG435 1963g, 1963h, 1963i, 1963j). Malin also received a

register of craftspeople at Neah Bay and La Push. All of the basket weavers' names that Malin acquired are incorporated in appendix B (NASP RG435 1963d).

A Makah tribal crafts shop that sold basketry, shell jewelry, and totem poles made of shells with painted expressions opened in 1958 at Neah Bay. In 1963 Malin estimated that the Makah Arts and Crafts Shop sold about $1,000 worth of merchandise annually. That same year, the Washburns' store sold between three and four hundred various-sized baskets. The Makah crafts shop was a consignment store, while Washburn and Son traded groceries for the items. Thus more weavers took their basketry to the Washburns, making it difficult for the Makah shop to compete (Malin 2007).

Malin reported that the Quileute women's cedar bark and beargrass baskets were sold on an individual basis to nearby motels that had sales areas, in stores in Forks, and directly from the weavers' homes. One weaver produced tightly woven conical hats and rather unusual beargrass dolls, but Malin could not recall the artist's name (NASP RG435 1963d:6).

In 1963 the *Seattle Times* reported that the Northwest was emerging as a center of Indian arts and crafts. Erna Gunther, as director of the Northwest art exhibit at the Seattle World's Fair, wanted people to recognize that basketry as an art form was "highly sophisticated" (*Seattle Times* 1963). The following month the *Post-Intelligencer* featured an article titled "Basket Weaving: A Vanishing Indian Art," and in it Beatrice Black spoke of the four remaining basket weavers at Taholah, two of whom were "getting too old" to weave. Beatrice mourned, "After we are gone, no one here will know how." She said that contemporary girls didn't want to learn to weave baskets because it was hard on their fingers and made their hands rough. Beatrice continued to weave as a matter of pride in a declining traditional art. "I couldn't make a living doing this," she said, given that she made only about $100 a year selling baskets. Beatrice made baskets to order and always had a market for them (*Seattle Post-Intelligencer* 1963).

A Quileute, Beatrice had been born in La Push to Harry and Anna Pullen in 1890. She was six years old when her mother taught her to weave baskets. Beatrice married Johnson Black and moved with him to Taholah in the early 1930s, seeking work. At age eighty-eight she stopped making baskets because of her failing eyesight, but she was proud to recall that in 1964 her basketry had been displayed at the National Mall between the Lincoln Memorial and the Washington Monument as part of an arts and crafts fair

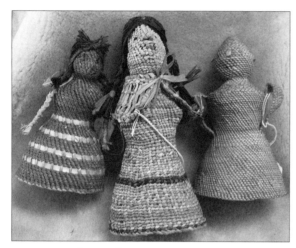

Figure 2.8. Basketry dolls made by Mattie Howeattle. OLYM #14132, 14133, 14131.

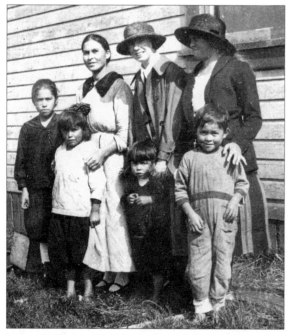

Figure 2.9. Beatrice Black (*third from left*) with children and friends of Theodore Rixon, circa 1910. COURTESY OLYMPIC NATIONAL PARK, POLLY POLHAMUS COLLECTION (POL.016.017).

there (*Seattle Times* 1979). She later estimated that she had made more than a thousand baskets that she gave away to friends or sold to tourists visiting the reservation (*Oregonian* 1986). Known as Grandma Black in her later years, this beloved elder and basketry teacher was one of the last of a generation of renowned basket weavers.

Although the older weavers were dwindling, basketry did not seem to be vanishing in 1963. Rather, tribal members probably started to sell their fine older baskets from home. That year Malin reported that the shopkeeper of the Lake Quinault museum and craft store, Bernice Morgan, was doing a "brisk" business in basketry; one basket sold for $35. People from around the world came to Lake Quinault looking for Northwest Coast art (NASP RG435 1963e). In the same report, Malin found that the Washburns had "practically stopped selling baskets" in their store, and they were happy to do so in order to stimulate sales at the Makah Arts and Crafts Shop at Neah Bay (ibid.).

A couple of ideas for developing greater sales opportunities for Indian arts on the peninsula had emerged during this time. The Quileute Tribe was considering an arts and crafts enterprise in its development plan (NASP RG435 1963f), and Malin spoke with the Makah Arts and Crafts Shop's business manager, Helen Peterson, about new basketry designs that might have a greater sales appeal. Malin also noted that there were many Baskets For Sale signs displayed in front of homes in the villages of Queets and Hoh and that the general stores at Queets and Amanda Park were selling baskets (NASP RG435 1963k).

Malin concluded his 1963 report by saying that he had seen some "positive signs of change" at Neah Bay's arts and crafts shop. The manager there was receptive and made efforts to improve store features, including the design of a product stamp:

‖ Mask Designs

‖ *Makah Indian Baskets*

‖ *of Cedar Bark and Grasses*

‖ *Thunderbird Canoe*

In his summary Malin observed that better marketing was needed, but there was "little more to be done" until the powers that be recognized the changes that were vital to the "perpetuation of crafts" (NASP RG435 1963k).

Malin's supervisor from the Indian Arts and Crafts Board, George Fedoroff, expressed interest in a woven hat made by Makah basket weaver Lena McGee and shipped by Malin to Washington, D.C. Fedoroff said that it had "excellent potential," and he wanted to see it produced in quantities for wearing at resorts and beaches, as it was "quite elegant in form" and "should be sold through the more exclusive outlets" (NASP RG435 1964a). Malin wrote back that the hat was the first one McGee had ever made, and it had taken her three tedious days. The price was $30, which was too much to market it for, and besides, McGee said she "would not like to make too many of these hats" (NASP RG435 1964b).

In a memo to Robert Hart, general manager of the Indian Arts and Crafts Board, Malin wrote of a product that could be marketed more easily—a woven doll made of cattail. The particular sample he was referring to was made by Marj Grenier, a Tulalip Indian from Marysville, but this same type of doll was being made by women at La Push and Taholah (NASP RG435 1964c).

In his 1964 status report, Malin commented that Ye Olde Curiosity Shop in Seattle had degenerated badly, even though it had a new location on the waterfront that was much larger. In general, he said, "the crafts for sale continue to be depressingly poor," a situation that did not appear to be improving (NASP RG435 1964d).

In another report Malin described his visit to the gift shop at Hurricane Ridge, a concession within Olympic National Park, and said it was the best-stocked crafts shop he had seen in the Northwest. Bedford Esters and concession manager Ozzie Atwell purchased the basketry for the shop during annual trips to the Indian villages at Hoh, Queets, La Push, Taholah, Lake Quinault, and Neah Bay and kept about $25,000 worth of Indian crafts in stock at the ridge each year, probably yielding close to $10,000 in sales annually. Malin believed that the concessionaire's purchase of all the basketry was the reason he was having such difficulty acquiring basketry himself. "These crafts are obviously being sold to this buyer, who they call 'that crazy basket man'" (NASP RG435 1964e).

In an interview with Ozzie Atwell (2007) about his former position with the concession, he said the reason he was called the crazy basket man was because he "would buy anything and everything." He recalled, "We would always take a roll of money," which was used to try to buy a one-year supply. Atwell began working for National Park Concessions in 1956 as the manager of Hurricane Ridge visitor center and Lake Crescent Lodge.[15] In 1963 he was promoted to vice president out of the home office in Kentucky, but continued to make trips to the peninsula to help new lodge managers with the buying. Atwell believes most of the baskets at the gift shops were sold to collectors from California who would come to look for museum pieces. By 1965, soon after a short boom in sales, Atwell found that the supply of baskets had diminished. The reason, he reflected, was probably that once the Indians' existing collections of older baskets were sold, weavers found it no longer economically feasible to make new baskets. The materials were more and more difficult to gather and were time-consuming to prepare. "Mrs. [Beatrice] Black always complained that she could not get the younger generation interested in crafts. They would try for a while, but they would not be very good at it," Atwell said. Black was one of the best basket weavers Atwell knew, and she was organizing Quileute arts and crafts at the time. At her home in La Push she would dry fish in one room and soak grass and bark in the other, using natural dyes, including berries, for reds.

Some of the other weavers Atwell purchased from were Leila Fisher, Lillian Penn (Pullen), and Blanche Mowitch. Blanche was from Quinault and made coiled baskets, and Atwell recalled that all of her coiled baskets featured canoe and whale designs (Atwell 2007).

In a 1964 letter to Robert Hart of the Indian Arts and Crafts Board, Malin stated that the best basket weavers were Lena McGee, Ida Cheeka, Nora Barker, Blanche Mowitch, Beatrice Black, and Mattie Howeattle. If Leila Fisher and Lillian Penn from Atwell's list are added, then this group likely comprises the main weavers of the 1960s (NASP RG435 1964f). Atwell said that for each basket he sold, he made a tag that included the weavers' name, how much he paid for the basket, and the retail price (Atwell 2007).

By 1965 weavers were no longer putting their baskets on consignment at the Makah crafts shop, and the last remaining baskets in its stock were sold (NASP RG435 1965). Malin's close-out evaluation of his Northwest field activities for 1967 related the goals he had for the program, which were to emphasize continuity with the past and to institute a crafts program that offered monetary and psychological

rewards for the artists (Malin 1967). When Malin returned to Neah Bay later that year, he was pleasantly surprised to find that Nora Barker was teaching basketry once a week to several students and that the Washburns' store had a stock of more than sixty baskets of various sizes (NASP RG435 1967a). Weavers on other peninsula reservations, such as Rosie Black and Lillian Pullen at La Push, were teaching basketry classes as well.

Malin suggested that the large number of baskets he saw at stores around the peninsula might indicate that people were beginning to produce more baskets again. Neah Bay had made some positive changes from year to year, and he thought this progress might lead to more development in the arts (NASP RG435 1967a).

In 1967 a Seattle newspaper article, "Keeping Alive the Ancient Art of Indian Basket Making," featured Hoh River weavers Pansy Hudson,

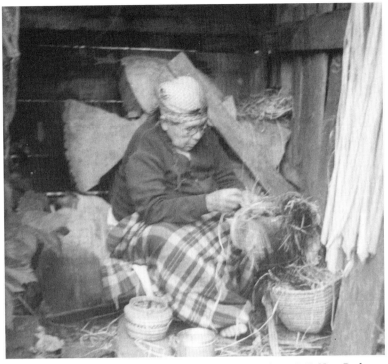

Figure 2.10. Nora Barker, in a photo labeled "Indian Basket Maker." COURTESY OF JEFFERSON COUNTY HISTORICAL SOCIETY, 2005.78.52.

Leila Fisher, Lilly Bell Williams, and Nellie (Williams) Richards (*Seattle Times* 1967). Malin lamented to his supervisor that he had tried innumerable times to make contact with these particular weavers, asking them to hold meetings to discuss their arts. He had also visited the Hoh on more than one occasion to try to develop "open communications" with the weavers, without much success (NASP RG435 1967b).

Malin's focus on behalf of the basketry artist may have been different from that of the basket weaver herself. Malin's goal was to assist in the production and marketing of basketry, whereas, for many of the weavers, basketry was first and foremost art for art's sake. It provided a small income, yet many weavers preferred to gift their baskets; in this way the basket weaver was recognized for her skill. Perhaps the psychological benefits were always more important than the monetary ones. Being an excellent basket weaver was a matter of prestige and status.

Looking back on his position, Malin believed that to have been more successful in his endeavor would have required much more travel to the reservations, consistent enough to keep his contacts interested—an important aspect of his work that would have helped solidify relationships. He felt that five years was really not long enough to get anything off the ground; ten years perhaps, as people were slowly beginning to recognize Northwest Coast art (Malin 2007). A few years later Malin's efforts might have fared better, but as Atwell (2007) pointed out, basket making had substantially diminished by 1965. With the disparity between forced assimilation and the Indian Arts and Crafts Act to produce traditional art, it must have been difficult for the weavers to mentor the younger generation to maintain the art.

Malin's attempt to revive Indian arts in the 1960s undoubtedly yielded some positive outcomes. The most important thing to realize today is that basketry—whether

destined for sale to individuals or for admiration in a museum—has come to be recognized for its true value as an art form, an accomplishment that very well would have happened regardless of a federal act.

Notes

1. Austin was a famous western author; see, for example, *The Land of Little Rain* (1903).

2. Neah Bay was the agency headquarters for the Quileute, Hoh, and Makah tribes between 1876 and 1933.

3. "Basket straw" was a general term often used by elders to refer to dried basket materials. In this case the materials are probably beargrass.

4. Probably the small round mats that served as hot plate pads or trivets.

5. We know the following men from the peninsula tribes made baskets in historical times: Walter Ward (Hoh) and Charlie, Fred, and Elliott Anderson (Ozette).

6. Taking into account that it probably took several days to collect and process the basketry materials, plus days to make the basket, the $2 per basket is a pittance.

7. Nina Perera Collier (b. 1907), daughter-in-law of Indian commissioner John Collier, was the liaison officer between the Indian Office and the Public Works of Art Project, a proposed program to produce artwork, such as large murals, for buildings constructed by the Indian Office (Schrader 1983:80).

8. Between 1933, when the Neah Bay Agency was abolished, and 1950, when Taholah was combined with Tulalip, the Taholah agency had jurisdiction over ten reservations: Makah, Ozette, Hoh, Quileute, Quinault, Shoalwater Bay, Chehalis, Nisqually, Squaxin Island, and Skokomish.

9. This discrepancy points to the importance of multiple sources of research material to ensure that unreliable information is recognized.

10. Mistakenly noted as Martha.

11. Probably the Makah, Quileute, Hoh, and Quinault reservations.

12. The Indians of the Olympic Peninsula do use sweetgrass, *Schoenoplectus pungens*, obtained from the Grays Harbor area. This is a different species from the sweetgrass of the East Coast (*Hierochloe odorata*, now *Anthoxanthum nitens*).

13. LaVatta was superintendent of the Taholah Indian Agency from April 1944 to January 1946. After that, he appears in 1948 correspondence as "Supervisor of Tribal Relations." Throughout his career LaVatta assisted Indian commissioner John Collier in numerous ways. Prior to 1944 he was a field agent for the Indian Commission, and in 1944 he helped Collier set up the National Congress of the American Indian.

14. Evelyn Tinkham opened an establishment called the Longhouse on First and Race streets in Port Angeles, where Native arts were sold in 1954 (*Seattle Times* 1954).

15. Around 1915 Fannie Taylor sent baskets from Mora to Singer's Tavern to sell. Singer's became Lake Crescent Lodge in the late 1920s. Some of these old baskets were probably still for sale in the lodge's lobby in the 1980s, along with Atwell's baskets. Displayed on a shelf high up near the ceiling, the baskets probably had seldom been moved and likely still had their original price tags. When a new concession president told the manager to "clean up the lobby," that was somehow interpreted as "get rid of all those old baskets," and—unbelievably—the baskets were burned (Atwell 2007).

CHAPTER THREE

Klallam Basketry

JAMIE VALADEZ, KATHY DUNCAN, MARIE HEBERT, and
KAREN JAMES, with contributions by ELAINE GRINNELL

Introduction
Karen James

There are three federally recognized Klallam tribes—the Elwha Klallam Tribe, the Jamestown S'Klallam Tribe, and the Port Gamble S'Klallam Tribe.[1] All three tribes recognize each other as the Klallam Nation, descendants of Klallam families who lived in villages along the Strait of Juan de Fuca before the Treaty of Point No Point with the United States in 1855.

This chapter on Klallam weaving reflects the views and experience of the authors, who are cultural specialists, educators, and weavers, and each from a Klallam tribe. The art of weaving is an important part of traditional and contemporary Klallam culture that is featured today by Klallam educators in tribal communities, in public and private schools, and at public events.

Jamie Valadez of the Elwha Klallam Tribe began teaching Klallam language and culture in 1999 in the Port Angeles School District as an accredited heritage language teacher appointed by the Elwha Klallam Tribe in partnership with the school district. In 2003 a pilot program between Washington State and the tribes established that the tribes could certify their own language teachers. Jamie and Elaine Grinnell were the first tribally certified Klallam language teachers, and later became the first Klallam language teachers certified by the state. Jamie was named as one of four "Teachers Who Make a Difference" in western Washington in 2009. She is one of the founding members of the Olympic Peninsula Intertribal Cultural Advisory Committee (OPICAC).

Kathy Duncan is cultural resource officer for the Jamestown S'Klallam Tribe. She is also one of the founding members of OPICAC and a highly respected Jamestown S'Klallam master weaver of basketry and textiles. Kathy takes part in weaving workshops and demonstrations as an educator and instructor.

Marie Hebert of the Port Gamble S'Klallam Tribe is certified by her tribe as a Klallam language teacher. She is the cultural resource director for the Port Gamble S'Klallam Tribe and has served on the tribal council. Marie is the founder and chair of OPICAC, which she began in 1992.

Elaine Grinnell of the Jamestown S'Klallam Tribe has contributed her thoughts and support to this chapter. She is a storyteller, cultural specialist, master basket weaver, and educator in Klallam language and basketry. Elaine was a recipient of the Washington State Governor's Heritage Award in 2007. Elaine and her granddaughter, Khia Grinnell, who learned weaving from Elaine, demonstrated their weaving at the 2006 Smithsonian Folklife Festival in Washington, D.C.

Elaine recalls when she first learned to weave:

> I can remember sitting on the beach with the beach grass that grows down here [and] . . . my grandmother Elizabeth Prince teaching me, just sitting there, just so easy. It seems like if you're growing up with something, it's kind of like matter-of-fact. There's nothing really special about something that you see all the time. . . . You don't even know how you do it because somebody just works it into your life, and then [it's] . . . part of your life. (Grinnell 2009)

Elaine also credits her aunt Fran James and cousin Bill James, both master weavers from Lummi, with influencing her weaving.

Elaine uses weaving and basketry in her classes in the public schools and at the Olympic Park Institute, an education and conference center at Lake Crescent in Olympic National Park:

> It is so natural to include the weaving because it was so natural in the lives of people long ago. You learned a lot of vocabulary, you learned your colors, you learned how to count, and if you're going to weave a doll, you learned names for your head, names for your toes, and you learned how to associate different things in your work, such as the deer, canoes, fish, and birds. . . . The baskets that I take with me when I go to class are just tools that would be used every day. They are not something that you would stick up on the wall. . . . When they can see it and then I can tell them how we harvested, well, then it makes plain sense to them. . . . I would never be able to tell them what it looks like and feels like specifically so that they would remember it. But when they touch it and feel it, I can give them the noises . . . when that tree gives up that bark. I can tell them, "Sshhpp, sshhpp," like that. And then you can hear kids throughout the room making that noise, like it's actually breaking the suction in the pitch—in that fluid that runs between the tree itself and the bark. (Grinnell 2009)

THE THREE KLALLAM TRIBES

At the time of the Point No Point Treaty, Klallam home territory extended along the south shore of the Strait of Juan de Fuca deep into the foothills and mountain passes of the Olympic Peninsula. On the strait, Klallam communities were situated along major rivers and streams, and near the shorelines of bays sheltered by sand spits such as Ediz Hook and Dungeness Spit, and headlands like those at Clallam Bay, Sequim Bay, and Port Discovery Bay. Before treaty times, Klallam who had intermarried with the Songhees and the T'Sou-ke (Sooke) of south Vancouver Island founded a village at Rocky Point on Becher Bay, an area that had been vacated by the T'Sou-ke who once lived there (Gunther 1927:179–80; Suttles 1990:456). Two settlements in Victoria Harbor in Songhees territory have been referred to as "Clallam." Many Klallam who were intermarried with or related to the Songhees people moved to Victoria Harbor after the establishment of Fort Victoria by the Hudson's Bay Company in 1843 (Keddie 2003:27–28, 53–54).

Within their homelands on the south side of the Strait of Juan de Fuca, the Klallam lived in villages that were politically independent but connected by kinship and shared language,[2] culture, and territory. Their closest neighbors on the Strait of Juan de Fuca were the Makah to the west, the Chemakum to the east, the Quileute to the southwest, and to the south the Twana of Hood Canal. As indicated above, the

Klallam, particularly the Elwha Klallam, were closely connected to their neighbors directly north across the strait on southern Vancouver Island (Lane 1975:2).

The Klallam, Chemakum, and Twana were all parties with the United States to the Treaty of Point No Point. Under the terms of the treaty, the United States anticipated that the Klallam would move to a reservation at the Skokomish River on Hood Canal, but as a group the Klallam refused to leave their home territory and resources. Klallam communities were in locations well suited to their needs. As Euro-American settlers began to move into Klallam country, in some cases before the treaty, they found these same locations good places to live that corresponded to their own ideas of commerce, agriculture, and trade. With the growth of Euro-American settlement, the Klallam were forced out of their villages and had to find ways to stay in their homeland by whatever means they could.

By the 1850s or earlier, some Klallam were moving into former Chemakum territory. The Chemakum numbered around ninety individuals in 1854, reduced largely as a result of epidemics and warfare with other groups, including their neighbors. A Klallam village was established at Port Townsend during these early years (Gibbs 1877 [1855]:177).

Before the treaty some Klallam families began settlement of *nəxʷqíyt*[3] at Port Gamble near the entrance to Hood Canal, where one of the first sawmills in Puget Sound began operations in 1853. The village became known in English as Little Boston. Klallam who originally settled Little Boston were used to fishing in Hood Canal during the summer and fall with their Twana friends and relations. They were accustomed to using the Port Gamble area as a campground, and the mill provided work (Gunther 1927:180; Elmendorf 1960:55; Lane 1977b:2–3). Klallam families began purchasing land for themselves near Little Boston, and one Klallam family claimed an Indian homestead there. In 1938 a reservation was formally established by the United States for the Port Gamble S'Klallam on the east side of Port Gamble Bay (Beckwith, Hebert, and Woodward 2002:55–56).

Klallam families in the Elwha River valley, the Pysht area, Deep Creek, and Clallam Bay also began claiming Indian homesteads as soon as the law allowed in 1875. Following passage of the Indian Reorganization Act in 1934, the U.S. government purchased lands at the mouth of the Elwha River. These lands, once the site of a Klallam village, were formally established as a reservation in 1968. The reservation was settled mainly by Klallam families from the Hoko River east to the Port Angeles area (Valadez 2002:26; Lane 1975:1).

In the Dungeness-Sequim–Port Discovery area, Klallam families under the leadership of James Balch purchased acreage in 1874 along the shoreline between Dungeness Spit and Discovery Bay, where a Klallam village had been located in aboriginal times. The lands were subdivided among families according to the amount each had contributed to the purchase price (Gunther 1927:180; Lane 1977a:22–23, 25). The settlement became known as Jamestown. The U.S. government continued to recognize the Jamestown community until after passage of the Indian Reorganization Act in 1934, when the Jamestown S'Klallam were given the option of moving to other reservations or losing their treaty rights. The Jamestown S'Klallam chose to stay in their homes and on their land. Federal recognition of the Jamestown S'Klallam Tribe was restored in 1981 after many years of arduous effort. A reservation was eventually established in 1986 for the Jamestown S'Klallam at the head of Sequim Bay (Bridges and Duncan 2002:41–43).

Klallam Weaving

Klallam weaving has received very little attention from writers. There is some discussion of Klallam weaving in writings by Otis Mason (1904) and George Wharton James (1904). Mason sketched three baskets that have been identified as Klallam, two of which were donated by James Swan to the National Museum of Natural History in 1876. Mason identified a fourth basket as a Klallam basket collected by the U.S. Exploring Expedition in 1841 (Mason 1904:436, plate 165). The basket has since been identified as a Quinault basket (Marr 1984:48; Smythe and Helweg 1996:46).

Other than the brief discussions by Mason (1904) and James (1904), only two other authors address Klallam weaving in any detail. Myron Eells, a missionary at the Skokomish Reservation from 1874 to 1907, discusses Klallam weaving in various reports and articles dating from the late 1870s and in his manuscript completed in 1894 (and published in 1985). Anthropologist Erna Gunther addresses Klallam basketry and weaving in her "Klallam Ethnography." According to Gunther's field notebooks (n.d.) from the mid-1920s and 1930, Mary Wood, from Jamestown, and Henry Charles and possibly Martha Davis, both from the Klallam village at Becher Bay, provided Gunther with much of her information about weaving and weaving materials. Mary Wood and Robert Collier were originally from the Klallam village at Washington Harbor (Sequim Bay).

In the 1870s Myron Eells described fiber-working tools used by the Klallam and the Twana as knives for preparing materials, grass-trimming tools, and awls made of bone or wood that were used for pressing the weave firmly together (Eells 1985:169, see p. 176 for photos of a sewing awl and grass-trimming tools). Gunther describes an awl made of a duck's wing bone and used as a coiling aid (1927:223). All of these tools, sometimes made from different materials, are used by weavers today.

Many types of plants within traditional Klallam lands bordering the strait and in the mountains were harvested and processed into weaving materials for making basket containers, mats, and cordage. Myron Eells and Gunther both recorded plant species used in weaving by the Klallam and their western Washington neighbors: western red cedar (*Thuja plicata*), cattail (*Typha latifolia*), nettle (*Urtica lyallii*), and beargrass (*Xerophyllum tenax*) had universal value throughout the region as weaving materials. Alder (*Alnus oregona*) and Oregon grape (*Mahonia* sp., formerly *Berberis* sp., as in Gunther 1945 and 1975) had similar widespread use in making dyes (Eells 1889:617–18; Gunther 1927:219–26; 1974 [1945]:20, 21, 23, 27, 28, 30). Swatches of beargrass are valued now, as they were in the past, as gifts and in trade (ibid.: 23). If resources were scarce nearby, weavers traveled considerable distances to harvest, trade, or purchase the materials they needed (ibid.: 21; K. James and Martino 1986:71, 75–76). Yellow cedar (*Chamaecyparis nootkatensis*) and sweetgrass (*Schoenoplectus pungens*) are other species that continue to provide highly valued weaving materials.

Lists of weaving materials do not include all resources that were once used by weavers, or all the ways they were put to use. Gunther (1974 [1945]) does not indicate Klallam use of wild cherry (*Prunus emarginata*) and spruce (*Picea sitchensis*) in weaving, but it is clear from Klallam baskets in collections, and from contemporary weavers, that both species were important for Klallam weavers. Spruce and wild cherry are abundant on the west end of Klallam territory. Cherry bark was used for

making the design in imbrication on coiled baskets, for making cordage, and for wrapping fish spears and other implements (ibid.: 37). The limbs and roots of spruce are used like those of cedar in weaving (ibid.: 17, 19–20).

Gunther's field notes on Klallam weaving describe the use of "fine cedar root" for coiling on baskets. The outside part of the root was coarser and was used for the bottom of coiled baskets and under imbrication. Weaving in black was done with cattail roots. Cherry bark was used in place of cattail root on imbricated baskets. Gunther (n.d.) was told that the bottom end of a "grass"[4] from the Cascade Mountains was used for the "white on imbrication," indicating that the plant was beargrass. Beargrass is not specifically mentioned in "Klallam Ethnography," but Gunther writes that a "grass" was sometimes used in making designs (Gunther 1927:223). This "grass" also is most likely beargrass (*Xerophyllum tenax*). Gunther writes that beargrass was used by all Indian groups in western Washington in her *Ethnobotany of Western Washington* (1974 [1945]:23).

Weavers from neighboring groups, particularly where there was intermarriage and exchange, likely used resources in similar ways and shared information about harvest and weaving characteristics of different materials. Gunther writes that willow bark was used by the Klallam for string and cordage and by the Quileute in basketry (1974 [1945]:18). An open-weave Klallam carrying basket in the National Museum of Natural History collections is described as being made of willow (Smythe and Helweg 1996:6), indicating that the Klallam also used willow in basketry. Gunther notes that the Klallam and other groups boiled hemlock bark for a red-brown dye (1974 [1945]:18). The Klallam may have sealed their watertight coiled baskets, as the Quileute did (see Pettitt 1950:10), by infusing the basket with an extract of finely chopped and boiled hemlock bark.

Weavers also exchanged information about how to construct different styles of baskets. In 1916 anthropologist Leo Frachtenberg worked among the Quileute at La Push and was told they had learned a style of coiled basket from the Klallam. Frachtenberg noted trade between the Quileute and the Klallam from Pysht (1916d:Q1:54).

Exchange of knowledge and materials has become even more important in the weaving community as the effects of population growth, private land ownership, landfill, industrial development, and pollution have changed the landscape and severely affected weaving resources. Private land ownership and local, state, and national preserves have made it difficult to gain access to those areas where useful plants can still be found.

As noted by Shebitz and Crandell (2008), western red cedar throughout its range is highly valued by Native people for its use in material culture, but the amount of cedar that can be used today by regional and Olympic Peninsula tribes is a fraction of what was once available. The decrease in abundance because of the demand for cedar is coupled with poaching of the tree, since it is so valuable. The creation of parks and protected areas provides a sanctuary for the last of the old-growth cedar but also limits accessibility by tribal members. Protection of cedar, sweetgrass, beargrass, and other resources used as weaving material has been and will continue to be at the forefront of discussions concerning the needs and cultural survival of Olympic Peninsula tribes (Pavel, Miller, and Pavel 1993:54). Other materials are beginning to be used to replace cedar, such as cane or raffia for basketry; and rather

than hewing canoes from large cedar logs, some tribes are making them with cedar strips (Shebitz and Crandell 2008).

This transition in basketry materials makes the Klallam baskets and other woven objects collected in the early years even more revered, such as the ones held in private collections and in local, state, and national museums. Of 206 objects in the National Museum of Natural History collections, 62—the largest number of objects identified with a specific Salish group—have been identified as Klallam. Many of these objects are baskets, tumplines, and rugs (Smythe and Helweg 1996:6).

The Burke Museum at the University of Washington has several Klallam baskets that were donated by Mrs. Thomas Burke. Klallam baskets were purchased in 1900 and in 1952 by the Washington State Museum (predecessor to the Burke Museum) from the Alaska Fur Company. Eleven of them are identified as clam baskets, one of which is made from spruce roots. A wooden needle used in making mats was collected from the Klallam community of Jamestown and donated to the Burke Museum by anthropologist Erna Gunther and her husband, anthropologist Leslie Spier.

Two baskets at the Burke Museum are identified as having been woven in 1893 by a Klallam woman, Mary Waterman, for the Washington World's Fair Commission. Mary Waterman (McKissick) was born before 1850 at Dungeness. This is one of the few instances where a collector has associated the name of a weaver with a basket. As noted elsewhere, very few woven objects are identified by the name of the artist in museum or private collections. Elaine Grinnell observes that it is the responsibility of the collector to "run home and record the maker's name." Recording the weaver's name, information about the materials used, and when the object was made and acquired shows respect for the work that has gone into weaving and ensures that the weaver's name will be known (Grinnell 2009).

A number of intricately woven Klallam tumplines and rag rugs were collected by James G. Swan[5] for the Smithsonian Institution in the 1870s. These fine examples of Klallam rag rugs are described as woven using twined weaving techniques "in native frames and with native apparatus." According to a catalog card with one of the rugs, perhaps written by Swan, the rugs are "an excellent example of the survival of ancient aboriginal stitch and technique on materials used by the white man."[6]

In his 1894 manuscript on the Indians of Puget Sound, Myron Eells described three types of rugs, most of which were made by Indian women in the region. All of the rug styles were introduced after white contact and were made mainly of rags. Rags were cut into strips and braided and sewn into circular or oblong shapes, or the rags were torn into strips and woven with a warp and weft. A third, more ornate rug was made by using a piece of burlap as backing on a frame and pulling rags through the burlap using an iron tool with a wood handle, similar to a large crochet hook. Patterns were made by drawing rags of similar color into a desired shape (Eells 1985:75–76, 169).

Eells describes a loom used in making blankets and robes that he had once seen in use by a Klallam woman weaving a rug. The loom consisted of two posts about four feet long, six inches wide, and three inches thick. The posts were sharpened on one end and driven into the ground. Two bars that held the weaving were inserted into holes in the posts (Eells 1985:172). Gunther describes a similar loom and refers to this type as a "roller loom" (1927:221). Adeline Smith from Elwha Klallam recalls that her grandmother, Emily Sampson, wove rugs on a loom that was hung indoors on the wall or from a tree limb outdoors on warm summer days (A. Smith 2009).

Weavers used the same looms and rags from old cotton and wool clothing to make rugs for their own use and to sell to white settlers. The adaptation of the early treadle sewing machine to turn wool into yarn, instead of the work involved using the hand-operated spindle whorl, shows the ingenuity of the artist in modifying traditional techniques (Lane 1951). Incorporating remnants of introduced clothing as weaving materials, and using traditional weaving techniques to create useful and beautiful items, are examples of an evolving and utilitarian art form.

Weaving is an integral part of Klallam culture. Klallam weavers once gathered and prepared materials for creating baskets, cordage, mats, robes, and coverings of many kinds that were essential to daily life. Immense changes affecting Indian communities of the peninsula over the last 150 years have had an impact on the gathering and processing of materials for weaving, but the fundamentals of protocol, techniques of gathering, preparation, and weaving, while evolving and adapting, have remained basically the same from the earliest times to the present. For the Klallam and other Olympic Peninsula tribes, weaving is a steady, relatively unchanging part of the past, a foundation for the present, and a reminder of the importance of the future.

Figure 3.1. Rounds of cedar bark and split spruce root. The large round on the left is red cedar (*Thuja plicata*), the smaller round is yellow cedar (*Chamaecyparis nootkatensis*), split spruce root (*Picea sitchensis*) is on the right, and a mixture of split cedar and spruce root is at the top center. PHOTO BY BETTY OPPENHEIMER, PUBLISHING EDITOR, JAMESTOWN S'KLALLAM TRIBE.

The Elwha Klallam
Jamie Valadez

The origin story for the very first Klallam people is associated with a basket.[7] Many of our ancestors who lived on the Elwha spoke about a place on the river where there is a big flat rock with two holes in it containing water. These holes are shaped like a coiled basket called *spčúʔ*. This is where the Creator bathed the people and blessed them. This is the place on the river where people would go to get information about their future. If you put your hand in the hole and pulled out something like a shell, it would mean wealth. If you pulled out deer hair, you would become a good hunter. Before you could go to the Creation Site, you would first go to the hot springs to bathe and physically cleanse yourself in preparation. You would go alone, fasting, meditating, and then bathing in the cold river (Valadez 2008).

The Klallam word for the tightly coiled watertight basket used for cooking (stone boiling) and as a container for carrying water or berries is *spčúʔ*. This type of basket was made by Klallam weavers out of split cedar or spruce roots. A clam basket or burden basket that is carried on a woman's back is called *qaʔáwəc*. The burden basket was usually made of split roots or limbs from cedar or spruce. The Klallam word for any kind of basket is *məhúy̓*.

Figure 3.2. Drawing of the Creation Site, by Roger Fernandes, *Kawasa*, Elwha Klallam Tribe.

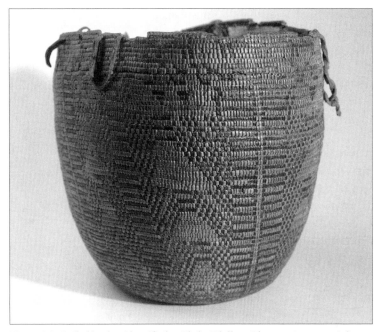

Figure 3.3. Coiled basket identified as Elwha Klallam. The weaving materials are described as "plant fiber and hide." The "plant fiber" is probably cedar or spruce root; the "hide" likely refers to the handles attached to the corners of the basket for fastening the tumpline. Courtesy of the Division of Anthropology, American Museum of Natural History, catalog no. 50.2 (1935).

A woven tumpline or headband called a *cə'ŋaʔtən* was secured to the basket and placed across the forehead or across the chest to free the hands and transfer weight to the back. Tumplines were woven for strength. The ropes on either side of the headband were woven from braided alder bark, three-eighths to five-eighths of an inch thick (Eells 1889:636, 637). The core material was made from braided nettle fibers or alder bark and woven with wool.

Weavers from different tribes shared weaving styles and materials, and as a result many made their baskets in similar ways. Twine was made from nettle fibers, willow bark, cedar bark, and sometimes from Indian hemp acquired in trade from east of the Cascade Mountains. Men made the heavy ropes used in fishing nets and harpoon lines from twisted cedar withes or kelp or from animal gut, sinew, or hide.

Women were often the ones who wove mats of cattail, cedar, rush, or tule. Mats made of cattail or cedar were called *qáẏʔŋən*. Large house mats were made for lining the walls of winter houses. The cattail mats were waterproof and used as rain tarps or fastened over pole frames to make the roof and walls of the summer mat house. Smaller mats were used as mattresses, temporary rain covers, seat and table covers, bedding, and coverings and for sitting or kneeling in canoes while traveling (Eells 1889:626, 627; Gunther 1927:220). In the Central Coast Salish region, cattail was also woven into flexible bags with drawstrings for storing dried fish (Suttles 1990:461). A similar bag made by Klallam weavers was described by Gunther as a sacklike carrying basket made of grass (1927:222–23).

Klallam women traditionally wove several types of baskets. A large soft basket made out of materials like cattail and sweetgrass with an overlay of beargrass was used primarily as a storage container. Openwork wrapped lattice burden baskets used when gathering roots, shellfish, and firewood were made of split cedar or spruce limbs. Dale Croes writes in chapter 8 that Klallam ancestors may have had a distinct style of weaving these burden baskets, called cross-stitch wrapping. This type of weave was used in an ancient basket fragment found under the edge of a snowfield in the Olympic Mountains dating to about 2,900 years. The fragment was determined to be part of a burden basket, similar to the carrying basket described above, and made of cedar roots and branches woven with a distinctive Salish-style cross-stitch–wrapped weave.

A Klallam village on the western Port Angeles waterfront, *čix̌ʷícən*, was unearthed during a construction project in 2003. Archaeologists investigated the site and

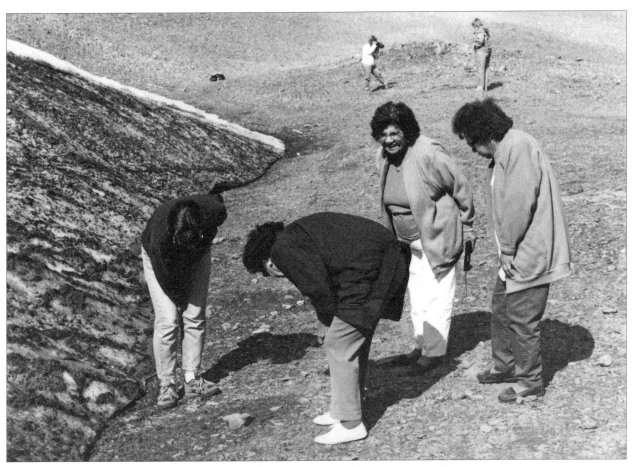

Figure 3.4. Elwha Klallam tribal members (*left to right*) Jamie Valadez, Adeline Smith, Beatrice Charles, and Bernice Anderson look for basketry pieces where a visitor to Olympic National Park found a large fragment of a burden basket in 1993. Photo by Jacilee Wray. Courtesy Olympic National Park.

found it to be the largest Indian village ever discovered in Washington State. The remains of the village date back at least 2,700 years and include several longhouses and many artifacts of a fishing community. Among the artifacts were bones of whale and seal, an obsidian projectile point, a harpoon handle, basket fragments, and a spindle whorl made of a whale vertebra. Other items that could be associated with the hundreds of burials found there include a hair comb, a blanket pin, trade beads, and hundreds of unique etched stones, some with the representation of a face. A few fragments of weaving, remnants of twined or coiled baskets, were also found in the areas that were excavated and analyzed at čixʷícən.

A spindle whorl is featured in a painting by Canadian artist Paul Kane, who visited the Klallam village of ʔiʔínəs, Ennis Creek, about a mile east of čixʷícən. Here, in 1847, Kane sketched scenes of the village and described the Klallam people living there in his journal (Kane 1968 [1859]). One of Kane's later paintings shows the inside of a longhouse and a woman weaving on a loom. A white dog is also featured in the picture. The fur of such specially bred white dogs was used to weave beautiful blankets. In the background can be seen a spindle whorl used to spin yarn from the wool of the

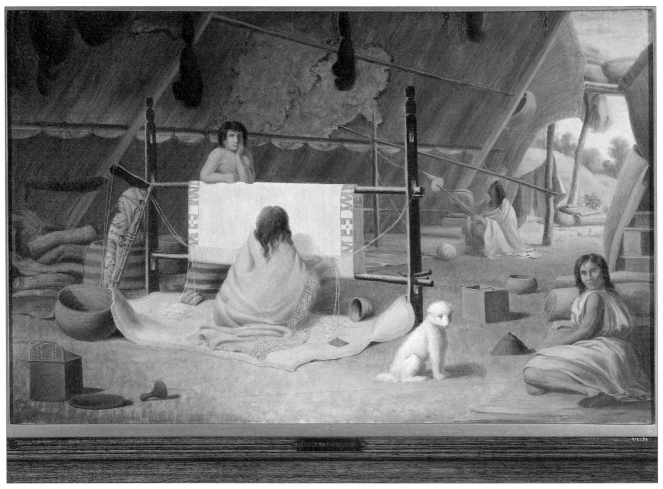

Figure 3.5. Painting by Canadian artist Paul Kane, based on sketches he made in 1847 of a Klallam woman weaving on a loom. WITH PERMISSION OF THE ROYAL ONTARIO MUSEUM © ROM.

dog mixed with the wool of the mountain goat and the fluff of the fireweed plant. The spindle whorl was rotated on the leg like a flywheel, twisting the fibers into yarn or twine.

An 1880 Klallam census conducted by Myron Eells enumerated Klallam people living between Clallam Bay and Port Gamble. The census lists their names in Klallam and English and gives their age and occupation. Out of a total population of 485 persons, 172 were women; 36 of the women were designated as basket weavers or mat makers.[8] Most of the Klallam weavers in 1880 were born before the treaty of 1855 and were living in Klallam settlements at Clallam Bay, Pysht, Port Angeles, Dungeness, Jamestown, Sequim, and Port Gamble (U.S. Census 1880). This important source of data has been incorporated into appendix B.

Elwha Klallam elder Adeline Smith recalls being told that in the late 1800s and early 1900s, Klallam women from Indian homestead families continued gathering cattail, beargrass, cedar bark, and other materials that they wove into mats and baskets for their own use and for sale in Port Angeles. The women raised sheep, spun wool, and knit clothing articles for their families and for sale to stores in Port Angeles or traders' stores in outlying communities like La Push (Charles and Smith 1994).

Bea Charles (1921–2009) learned to make baskets when she lived at Deep Creek and Pysht. As she recalled, "there was always a corner [in the house] where the women did their baskets." Charles was also taught by her grandmother Susie Sampson how to use a spindle whorl by turning it on her thigh to spin wool into yarn. When Singer sewing machines became available, the men altered the whorl so it could be operated using the foot treadle of the sewing machine (see Lane 1951).

Beds were once made out of cattail mats. Adeline Smith recalled that as a young girl she slept on cattail mats. When feather mattresses replaced them, the thick cattail mats were placed under the mattress. Cattail mats were also hung on walls as insulation in Adeline Smith's grandmother's time (Charles and Smith 1994).

Cattail was gathered near the mouth of the Elwha River. Adeline Smith and Bea Charles both remembered that there used to be plenty of places to get cattail until the land was sold and the landowners said no trespassing. Now there is no place to get cattail except in the ditches along the roads, where the cattail is not of the best quality and is likely to be contaminated by pesticides.

There was beargrass high in the Elwha Valley within Olympic National Park. Adeline Smith went into the mountains as a young girl with her grandmother Emily Sampson to gather beargrass. Smith recalled that she was probably more trouble than help, but her memories of her grandmother pulling the long grass and shaking out the short strands are still vivid. The Klallam word for beargrass is *x̣ə́x̣*. Trips to the mountains were made by families to get what they needed, such as beargrass, berries, medicinal plants, and elk. It was a vacation time. Adeline's sister Elsie Sampson and her aunt Louisa Mike gathered grass and berries at what the Klallam refer to as the Meadows in the upper Elwha on the west side of Hurricane Hill. They traveled to the Meadows with wagons loaded with blankets and berry buckets, accompanied by Adeline's father, Charlie Sampson, and her brothers Ernest and Bill Sampson.

Women adapted their basket weaving abilities to weave rag rugs from strips of old denim pants and other worn clothing. Some of these rugs were used in their own homes, and others were sold. Adeline Smith said her grandmother Emily Sampson had someone take her to Port Angeles to sell her rugs and baskets to non-Indians— "Wherever she could make money, she pursued it" (Charles and Smith 1994).

Basket Weaving Class

Today, during summer educational programs, Elwha Klallam elementary, middle, and high school students learn how to make baskets. They begin by gathering cedar bark, but first they learn the proper protocol of asking the tree's permission and leaving a gift for the cedar. They are taught to take only a hand's width of bark from each tree so that they don't girdle and kill the tree. After demonstrating that they know how to pull the cedar bark from the tree, the students learn to separate the inner bark from the outer bark and bundle it up. The inner cedar bark that is so important to the weaver is called *syə́wiʔ*. The outer bark is not used, so it is left on the ground to decompose back into the earth. Students are taught to keep their minds happy and not to work on their baskets when they are upset or mad, because their feelings will be woven into the basket that they create.

Bonnie Peters is among the young students who have shown an especially strong interest in making baskets. She has been encouraged to keep improving her skills

with each basket she completes, and has been taught the proper protocol of giving her first basket away to a family member or friend.

During the 1960s and 1970s there were still many elders who could pass on the traditional knowledge of gathering basketry materials to the younger generation, such as when to gather cedar, cattail, beargrass, and sweetgrass. The elders taught the younger generations where to gather, what time of year, and the proper way to take from the plants. These elders spent much of their time teaching the youth how to make baskets and cattail mats. That was a generation ago. When the first of the intertribal canoe journeys began in 1989, many people did not remember the skills of weaving, so masters from other tribes taught them the fine art of weaving cedar into vests, headbands, and hats.

During the 1990s, classes were taught through the Northwest Indian College in Bellingham on how to gather and prepare cedar for making cedar bark hats. These classes were taught by Linda Wiechman, from Elwha.

In 1996 the Northwest Native American Basketweavers Association began meeting, in an intertribal effort to revive and learn from each other the traditional knowledge of basket weaving. Many Elwha tribal members participate in this effort. Today there is one master basket weaver from Elwha Klallam, Vicki Charles-Trudeau. She lives at Quinault and has learned the art from tribes in that area as well as from her Klallam relatives.

Jamestown S'Klallam
Kathy Duncan

This story is a gift from my ancestors. This is a story of the cedar, a tree of life for Northwest Coast peoples. The cedar tree provided for the people's houses and their transportation. Clothing made from cedar bark shed water and kept the people warm and dry. For thousands of years our ancestors have honored the cedar tree. There is a feeling of awe for the life this tree gives, an abundance of life.

When I am in the woods to gather bark and I pause to place my hand on a tree, I think about an ancestor who pulled the bark from the same tree many years before me. In that moment I can feel the closeness of my ancestors. We are connected from one generation to the next, like a chain from the distant past to the generations to come. This chain connects me to the ones who have gone before, to those who have not yet heard what the ancestors have to say.

All things are living. In recognition of this life, nothing is taken from the environment without leaving an offering in return. The offering shows respect for what has been given. If you take too much of the cedar bark, the edge will not heal over, and you may cause the death of the tree that your ancestors touched.

Women used to know exactly how much food and materials were needed for their families to live healthy lives throughout the year. Those who could not plan ahead would starve. Necessary food and materials were collected, processed, and stored in baskets that kept them dry in this moist climate. The types of baskets were an important part of planning, and women had to make enough baskets to keep the family goods stored throughout the winter. It was essential that the food be kept dry and well ventilated so that mold would not ruin the winter supply. The right type of basket had to be used for the right storage.

To gather materials and weave a basket is to engage the whole body. The weaver's breath and the oil from the weaver's hands become part of each piece of material that is bent and handled during the process of pulling, cleaning, stripping, and splitting. Her materials become part of the weaver, and the weaver becomes part of each basket.

It can take an entire day just to pull cedar bark. In the spring you travel into the woods, searching for a stand of proper-sized cedar. If searching for Alaskan yellow cedar, you must travel to a higher elevation. This is a good time to spend with family and friends, all working together. It may be cold and rainy, with water dripping down your neck, or it could be a day that turns out sunny. Pulling bark and separating the outer bark from the inner bark is laborious work. When you take a break, after a few minutes' rest the smell of the fresh and earthy forest turns your attention to the plants springing forth to reach the sun or turning up their faces to catch the rain. You can hear the birds in the brush and the scurry of small animals, and if you are in tune, you can even see where bears and cougars sharpened their claws and you can see their sleeping hollows. Appreciate these gifts; watch as a breeze touches the branches to remind you of life's giving.

It is important to find a straight tree to obtain long strips of cedar. When a straight tree is found, you make a horizontal cut into the bark, being careful not to damage the wood. As you start to pull from the bottom up, the bark comes loose and the cedar splits up the tree with a sloppy ripping sound that has been heard in these forests for thousands of years. The silky, smooth inner bark is bendable and is coiled into rounds for carrying home.

The use of cedar and spruce roots in making strong baskets is due to the strength and flexibility of the root. Spruce root may be rather thick when used or it can be split down to a heavy thread. While gathering cedar and spruce roots, you look for nurse logs where the straightest roots grow and are easier to pull from the log. The most important thing is to be gentle with the forest and disturb as little as possible. Before the bark and roots are stored, they must be dried and split if too thick. The outer bark of the roots is removed as soon as they are gathered. The roots are then heated before pulling them. When the roots are heated, the sap is released, making a lubricant that keeps the bark from adhering to the root wood. The roots are pulled through a pair of stakes so that the outer bark slips off. If you let the root dry, or if it does not get warm enough, then the bark will not slip off. Of course if you heat the roots too much, you can start a fire. Sometimes an oven and two sticks held in a vise works rather well; just don't burn down the house. The bark and roots are stored in a dry place so they won't mold, and they must be kept away from wood that may be infested with bugs. Once dried and stored, the bark and roots should keep for a few years.

In preparing material for making a basket, the bark must be soaked and split into narrow strips until they are all the same length and width. When splitting, use a blade to start (about a half-inch blade), then pull the bark apart with equal pressure on both sides. Splitting this way will make the two sides even. If you put too much pressure on one side, then the bark will be thicker on one side, or it will not split all the way to the end. When gathering limbs for burden baskets, choose limbs that are reaching out to the sunlight; they grow straighter. Once the outer bark is removed, the limbs are split and stored in a dry place.

Baskets are made in all shapes and sizes, each to fit a need. The materials used are often the same, but each basket is unique. Small fancy baskets were an important

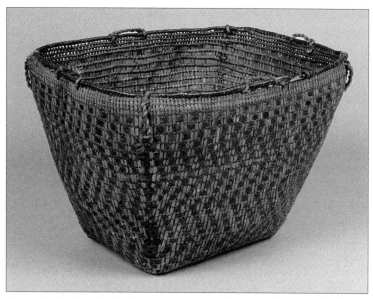

Figure 3.6. Klallam clam basket with sides woven like those of a burden basket, from spruce or cedar roots and limbs in a wrapped-twined weave. The bottom is woven in an open weave that allows water to drain out. COURTESY OF THE BURKE MUSEUM OF NATURAL HISTORY AND CULTURE, CATALOG NO. 1-1217.

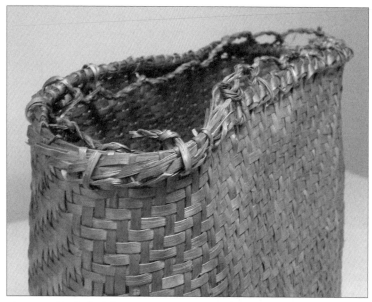

Figure 3.7. Twilled Klallam basket donated to the Smithsonian by James G. Swan in 1876. Catalogue no. E 23509, Department of Anthropology, Smithsonian Institution. PHOTO BY KAREN JAMES.

source of income for women in supporting their families. The colored patterning and fine weave added beauty to Klallam homes and to many early settlers' homes. The fancy baskets with lids and the materials tightly woven around bottles are made with a wrapped-twined weave. Wrapped twining is done by having a strip of grass on the inside of the basket uprights that is woven on the outside wraps and around the inside grass. In this weave the outside weaver is always the same, as is the inside runner. In two-ply weaving the weavers are exchanged, the front going to the inside and the inside coming to the front. When the wrapped-twined technique is used, the sides are a solid weave with a slight slant and with colors woven into it to create designs and figures.

The baskets woven in a twill weave pattern are the least time-consuming to make. The bottom of the basket is woven in a twill weave that merges with the sides to continue the twill pattern that forms the basket. These baskets were often made from willow. The twill weave pattern is also the most common weave used to make a Salish blanket.

Burden baskets have been made for thousands of years in the same pattern still used today. The burden basket was used for carrying heavy loads and was strengthened with supports placed on the inside. Once you have all of the limbs or roots prepared to make the vertical sides of the basket, the corners are made of roots that have *not* been split—two nice round roots that are straight and long are bent in half to make a U for each side of the basket. The weave and the shape of the basket are kept straight by changing the direction of the weave. If the weave is slanted to the right for a row, then the next row alternates and slants to the left. If the weave is all slanted in one direction the basket will start to sag in that direction. At the top of the four corners a loop is made from the roots to hold a strap or tumpline. The tumpline is woven from nettle fiber and wool. When the tumpline is placed on

the forehead or across the chest, the weight is carried on your back. This leaves your hands free to pick up items to place in the basket or to carry a walking stick. On trips inland for hunting or berry picking, the burden basket was filled with dried venison, bear meat, or berries for the return trip home.

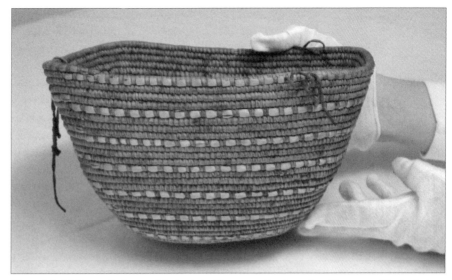

Figure 3.8. Klallam coiled watertight basket with an occasional overlay of beargrass. The basket was donated to the Smithsonian by James G. Swan in 1876. Materials used in the basket are spruce root, possibly cedar root, and beargrass. Catalogue no. E 23512, Department of Anthropology, Smithsonian Institution. PHOTO BY KAREN JAMES.

Watertight baskets are made from spruce or cedar roots. This is the most time-consuming basket to make. The root coils are sewn so tight that when water is poured into the basket, the root material swells. When the basket is used for cooking, you place hot rocks from the fire into the water for boiling. Not only are these baskets tough for their purpose, but they sometimes are also decorated with imbrications of beargrass. This type of basket is also used for storage.

When a coiled watertight basket is being constructed, an awl is used to make holes for sewing the roots. The roots are stripped down, and the outer round is used for sewing the coils together; inside of the coil are thin strips from the inner core of the root. A coiled watertight basket may keep the wild trailing blackberries fresh for months. The basket is placed into the ground next to a spring or creek where the water can flow around the basket and keep the berries cool but dry—a form of refrigeration.

Sweetgrass from estuary tide flats and cattails are sometimes woven into baskets of cedar bark, or the baskets may be made of just sweetgrass and other swamp grasses. After you gather the grass, you clean, split, and store it in a dry place. Beargrass has very sharp edges and a strong spine on the underside. The spine on the grass is removed, and then the grass is trimmed to the correct size for the basket. Beargrass is used for imbrication on coiled baskets and for wrapped twine on other baskets. For small baskets the grass is very slim. The grass is often left natural, since beargrass is shiny and smooth on the top side and gives the basket a glossy look. Wild cherry bark is sometimes used for the design and trim. Wild cherry is a very tough bark, so you must peel off the outer layer into thin strips. When cherry bark is rubbed, it turns reddish brown with a warm shine.

Weavers have often placed their own hidden signature or insignia within the basket weave. This may have been in the woven pattern, at the bottom, middle, or top of the baskets so other weavers would know who made it. It may be the way a basket is started on the bottom, or the turning from the bottom to the sides may have a unique pattern. This unique insignia may also be in the main design or in the way the top part is finished off—with a braid, sewn, or wrapped. After seeing many

baskets made by the same weaver, even if someone copies the weave, a person with a keen knowledge of basketry can tell the difference. When visiting different collections, they might be able to pick out a weaver's style and recognize the same style at other places and then be able to match and obtain information from both places. It is like other forms of art; when you see a piece you recognize, even when copies are made, there are unique qualities that others cannot reproduce. Every hand is unique in how the basket is woven, in the tension of the weave and in keeping the weave straight or slanted. There are those who have been privileged to have seen and touched their ancestors' woven works from many generations of the past.

Port Gamble S'Klallam
Marie Hebert

Basket weaving has always played an important role for the Port Gamble S'Klallam people. In interviews,[9] our elders have shared names of women who were basket weavers; including Jenny Jones (b. ca. 1856), Susie Solomon (b. ca. 1860), Emily Webster (b. 1883), Ellen Sigo George (b. 1884), Martha John (b. 1891), and Clara George Jones (b. 1903). These were important women in our tribe.

One basket that was very common and practical was the clam basket. It worked like a colander—the gaps were wide enough to drain the water, but small enough that the clams couldn't fall out. When people went digging clams, they filled the basket and rinsed the clams in the salt water. The sand would rinse off and out of the basket, leaving behind clean clams. Ivan George told how his mother, Ellen Sigo George, made her clam baskets out of cedar limbs:

Figure 3.9. Klallam clam basket. COURTESY OF THE DIVISION OF ANTHROPOLOGY, AMERICAN MUSEUM OF NATURAL HISTORY, CATALOGUE NO. 16/8876.

> She'd take skinny limbs and spread them and make baskets and fill the baskets up with cockles. Just walk out in the water and dunk 'em a couple of times and the sand would run right through them. . . . They braided a lot of rope right in with their baskets around the edge of the top of the basket. And they'd sew the top of the basket clean around it with the big limb around the top. And then they'd put their clams in. The baskets come in handy for everything when you were fishing. (I. George 2005)

Other kinds of baskets were very useful too, such as berry baskets, which people used for picking different types of berries. These baskets have a tight weave to them. William Jones told how his grandmother, Jenny Jones, used her berry baskets:

> Our Grandma'd take dishpans and all her baskets when we'd go look for berries and she would not leave that place until everything was full. . . . She said, "We have

to fill all these up before we go home." . . . We went all the way down to Ludlow, the whole family, and we stayed there until everything was full—all the baskets and dishpans. Then she canned all the berries when we got home. We ate a lot of jam! (W. Jones and G. Jones 2005)

Another grandchild of Jenny Jones, Virginia Jones Ives, remembered how Jenny stored her berries in her baskets:

I think the neatest thing was how they kept berries in the old days, when I was about eight years old. I was so amazed. In June Grandma would take a half-bucket basket that was waterproof and line it with maple leaves. She'd put a layer of leaves, then a layer of berries, then a layer of leaves, then more berries and more leaves. She'd put the basket in a hole in the mud and then come Thanksgiving, when there were no fresh berries, she'd dig them out and they were just like fresh, from June til November! I said, "My Grandma's a magician!" (Ives, in Port Gamble S'Klallam Tribe 1994:7)

Clara George Jones used her berry baskets when she picked *squossum*, "Indian ice cream" berries, a favorite of Port Gamble S'Klallam elders:

Mom used to talk about pickin' that *squossum*. She said in the old days they used salal leaves. They'd take them and they'd whup it like that in the basket until it folded up and it'd start getting real stiff and then they'd add their sugar and their berries. She was real thankful that they come up with electric mixers . . . it really saved your arm! (W. Jones and G. Jones 2005:25)

Martha John used cattails to weave baskets and mats. When Gene Jones was young, Aunt Martha sent him down to Eglon Slough in the spring to gather cattails for her:

And you had to walk through the muck, you know, and the mud is about this deep. It'd kinda stink. And you walk out there and there's cattail—what they call cattail. And you go and you get a great big bunch like this and you take a knife or a machete and you just—whap!—cut it down by the base, by the water. And when you hit, the snakes are in the bushes and they all take off. (W. Jones and G. Jones 2005:27)

Martha John said that beargrass and cattails were gathered in May or June, the same time as stripping cedar bark in the mountains (John 1975[?]:4).

In the past, some Port Gamble weavers made textiles, and there are some textile weavers today. Textiles for regalia or other items are created of wool or other materials using a loom. Geneva Jones Ives, a granddaughter of Jenny Jones, recalled that her grandmother not only wove baskets but also made rugs on a loom, and she spun and carded her own wool.

My grandma Jenny Jones used to make all kinds of rugs on her own loom that Grandpa made for her. She sold them for only six dollars to all the people in Port Gamble. She made baskets too and I wish we could learn how to make all those pretty baskets. . . . She made the rugs from all different colors of torn-up material. She'd just work in her design. She got her own wool and carded it. She had little spinning things and we'd just pull the wool back and forth and stretch it. It would make big, long, soft things and she'd spin it." (Ives, in Port Gamble S'Klallam Tribe 1994:21)

Figure 3.10. Portion of a Klallam rug donated to the Smithsonian by James G. Swan in 1876, showing the use of clothing rags in the weave. Catalogue no. E 23427, Department of Anthropology, Smithsonian Institution. PHOTO BY KAREN JAMES.

Some of the current textile weavers at Port Gamble include Darlene Peters, Melissa Struen, Juanita Holtyn, Kari DeCoteau, Sue Hanna, Karron McGrady, Trisha Price, and Tleena Ives.[10]

Today weavers continue to make baskets and other woven materials, although these items are cherished more as art than they are as tools or resources. Baskets are no longer used as they were traditionally, yet weavers continue to make many usable products such as cedar bark hats, visors, and vests. A few of the Port Gamble basketry weavers today include Mary Jones, Melissa Struen, Gary Wellman, James Struen, Natashe Reynolds, Connie Wellman, and Darlene Peters.[11]

Our ancestor weavers have passed on, but the Port Gamble S'Klallam continue to keep the weaving tradition alive. Even though some of the uses have changed for woven products, the tradition carries on.

Notes

1. "S'Klallam" has had different spellings in English, including S'Klallam, Klallam, and Clallam. The Elwha Tribe has preferred to use "Klallam"; Jamestown and Port Gamble use "S'Klallam."

2. The Klallam language has been studied for many years by linguist Tim Montler. As described by Montler, the Klallam language was spoken along the north shore of the Olympic Peninsula and in nearby areas, including Becher Bay on south Vancouver Island. People from the westernmost Klallam villages, including the village at Becher Bay, to villages to the east toward Port Discovery and Port Townsend spoke several dialects, but according to Montler, the dialects varied only slightly from each other in pronunciation and in the use of some words.

3. All Klallam words in the chapter are from the Klallam Language website at www.lingtechcomm .unt.edu/~montler/klallam/. A dictionary of the Klallam language is in preparation by Tim Montler.

4. In her field notes, Gunther (n.d.) recorded *tcatólbixu*, a Lushootseed word for beargrass, glossed "mountain grass."

5. James G. Swan (1818–1900) lived at Neah Bay and Port Townsend and had extensive contact with the Makah, the Klallam, and other Indian people along the Pacific Coast and the Strait of Juan de Fuca. Swan added many fine Klallam and Makah items to the Smithsonian collections.

6. Quotation courtesy National Museum of Natural History, Smithsonian Institution (E023429).

7. The Elwha River origin story has been recorded in the unpublished field notes of three anthropologists, T. T. Waterman in 1919, Erna Gunther in 1925, and Wayne Suttles in 1952. Waterman's field notes are at the National Anthropological Archives, Smithsonian, and those of Gunther and Suttles are at the University of Washington Archives.

8. Eells (1972 [1886]:141) writes that 40 Klallam women were basket or mat makers. The 1880 census enumeration sheets for Klallam families begin with sheet 21, indicating that twenty

enumeration sheets may be missing. This could account for the discrepancy in the number of weavers.

9. Quotes from interviews are included courtesy of the Port Gamble S'Klallam Tribe.

10. Not all Port Gamble S'Klallam textile weavers are listed.

11. Not all Port Gamble S'Klallam basket weavers are listed.

The Heritage of Twana Basket Making

NILE R. THOMPSON and CAROLYN J. MARR

Figure 4.1. The title page of each of Edward Curtis's twenty volumes of The *North American Indian* incorporates a design representative of the cultural area the book describes. For volume 9, which describes the Coast Salish and other tribes, the icon is a Twana basketry design motif. COURTESY MUSEUM OF HISTORY AND INDUSTRY, SEATTLE.

Art historians, collectors, and ethnographers have long singled out the Twana soft-twined basket for its artistic qualities. It is the "variety and brilliance of design motifs" that make this type of basket exceptional (Nordquist and Nordquist 1983:1). The best examples are praised as "having almost the fineness and flexibility of cloth" (Curtis 1913:62).[1] The Twana are "justly famous" for this specialty basket that "perfectly exemplifies the beauty and complexity of Northwest Coast basketry," which includes "some of the finest baskets in the world" (Holm 1987:44).

Less well known, however, is the breadth of basketry types made by the Twana. Rev. Myron Eells, a resident of the Skokomish Reservation from 1874 to 1907, is credited as the first to record this great diversity (Mason 1904:433). In this chapter we not only discuss the history of the "Skokomish-type basket" but also provide a picture of the totality of works that constituted Twana basket making.[2]

The Twana People

The Twana (*tuwaduq*) lived in twenty or so winter villages situated along and near the coastline of their homeland, the Hood Canal basin. The largest of these communities were the Skokomish (*sqWuqWu7b3sH*, "big-river people"), who resided in six settlements along the Skokomish River. Other communities were at Coyle, Dabob, Dosewallips (near Brinnon), Duckabush, Hoodsport (on Finch Creek), Quilcene, Tahuya, Union, and Vance Creek. One village moved from the Skokomish River area and established a new home on Mission Creek near Belfair around 1780, becoming the Duhlelap Twana.

The Twana people shared a common language (*tuwaduqutSid*, "Twana language") and ethnic identity. Because they practiced exogamy (marriage to people of other villages), the Twana communities included within their memberships men and women who married into and lived in the Hood Canal drainage. While usually maintaining a connection to the village of their birth, they learned to speak the Twana language and participated in the economic, social, cultural, and religious activities of their new home.[3]

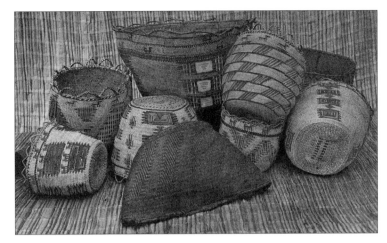

Figure 4.2. The hallmark of the so-called Skokomish-type basket, a band around the rim usually containing one or more animal designs, makes it one of the most recognizable types in western North America. Curtis, *The North American Indian*, vol. 9 illustration, Skokomish Baskets, facing page 62. COURTESY MUSEUM OF HISTORY AND INDUSTRY, SEATTLE.

Basketry Types, Techniques, and Uses

The Twana people made and used at least eleven different types of baskets. These can be divided into four broad categories in terms of their construction (table 1).

Only the first five basket types in table 1 might be decorated by adding design elements. The *Tqayas* is the so-called Skokomish basket, which rose in importance above the coiled basket among the Twana. Fine twined baskets had a higher value and importance for the Twana than among the southern Puget Sound Salish tribes (M. W. Smith 1940:304), who reasoned that this basket type "took longer to make and wasn't as useful" as a coiled basket.

Many of the open-weave baskets were utilitarian, made for everyday uses such as carrying and storing shellfish and steaming foods. There were many more women who could fabricate the utilitarian baskets than there were specialists who made the finer baskets (*sp3cHu* or *Tqayas*). However, some women were known as experts in making a specific type of utilitarian basket. For example, Kitty Charley (*tS3baq3l-w3d*), a Skokomish Twana (b. ca. 1830) who was married to a Doctor Charley, a Duhlelap Twana, used spruce roots to make a large storage basket (*duxWd3ha7d3d*, "where you put your possessions"). She was "considered [to be] a good weaver" (Nordquist and Nordquist 1983:3).[4]

Environment and Basic Materials

Twana territory ranged in elevation from sea level at Hood Canal (a saltwater inlet) to alpine at the crest of the Olympic Mountains. Within that area a wide array of vegetal and other materials was available for basket making. Even so, the basic materials of Twana baskets, those forming the construction rather than the design, were few in number: the limbs, roots, and bark of the cedar tree; cattail leaves; sweetgrass strands; and spruce roots.

The western red cedar (*QWili*) supplied both roots and bark for basketry. Cedar roots, which were used in both coiled and open-weave utilitarian baskets, were collected along the banks of streams or dug from under the ground. To protect the tree, only a few pieces of root would be taken. The roots were peeled and split to prepare them for basket making. The cedar bark was stripped from the tree when the sap was running.

TABLE 4.1

Types of Twana baskets

Construction	Twana name	Description	Main uses/subtypes
Coiled	*sp3cHu* (Burke 1-1176)[a]	Hard watertight basket of cedar or spruce roots	Cooking; berry picking; bed pot (*duxWsXWayad*); food and water transport and storage (see Eells 1985:82a, 83a)
Twined	*Tqayas*	Soft-twined overlay basket	Storage of clothes and valued personal items; as potlatch gifts (see Eells 1985:81a–b, 81c, 82b, 86a)
	qaqal3cH	Plain-twined sweetgrass basket with some overlay	Storage of small personal items
	Q3lcHi (Burke 1-1066)	Soft open-weave twined basket	Storage of dry goods and clothing
	y3b3T3l3cH	Wrapped-twined basket	Storage of valuables
	QxulicHad	Close-twined cedar bark basket	Picking low-bush berries
Plaited	*QWilul3cH* (Burke 120)	Cedar bark basket	Storage of lightweight household articles, clothes, tools; storage bag for gambling pieces; carrying bag (*sHaya7ap*); large food storage basket (*duxWsihLadb3d*)
Other open-weave	*X3lap3l3cH*	Crossed-warp basket	Shellfish gathering; food steaming
	sxW3l3kWcHi	Vertical-warp basket	Shellfish gathering and washing; fish transport; dry-food storage and transport; rinsing dog salmon eggs
	sHidicHi (Burke 163, 166)	Open-weave cattail basket	Lunch transport; temporary clothing storage
	ka7awatS	Split-cedar-bough basket	Storage basket (*duxWd3ha7d3d*); later used as hops basket (*XaTLulacH*)

[a] For examples of the basket types designated by "Burke" in this column, visit the Burke Museum website (www.washington.edu/burkemuseum/); click on Research & Collections, then Ethnology, then Explore; and type in the basket number.

Gatherers made a horizontal cut about two to three feet above the ground and then pulled straight up to achieve a long, even strip. Batches of bark were folded and taken home to be peeled. Only the inner bark was used for basketry, and it had to be separated from the shaggy outer layer while moist. Various widths and thicknesses of bark became both the foundation (warp) and the weaving strand (weft) for many types of baskets.

Leaves of the cattail (*sw3hLahLqut*), and only those without the brown catkins, were gathered from swampy areas between early July and August. Those growing in the shade could be collected later in the season. Some weavers preferred gathering cattails where there was a saltwater influence because they felt those plants were stronger. After gathering and the soft inner core was removed, the cattails were dried and the outer edge separated to form the weaving strands.

Associated more with traditions of peoples living along the Pacific Coast, both sweetgrass and spruce root were used less frequently by the Twana, who made more use of cattail and cedar root. Sweetgrass (*kaqsxW*), a sedge that grows in tidal areas, formerly grew on a low-tide island near the mouth of the Skokomish River. After the sweetgrass strands were cut, they were set out to dry for a few days until bleached a light cream color. Then they were cleaned and the outer jackets removed; further drying could take place either indoors or out. The Sitka spruce (*sqabay*) is scarce in Twana territory,

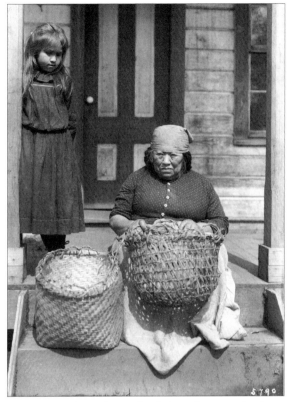

Figure 4.3. **Basket maker on the Skokomish Reservation in 1905, holding a *X3lap3l3cH* basket and with a *QWilul3cH* basket beside her. Photo by Asahel Curtis.** COURTESY WASHINGTON STATE HISTORICAL SOCIETY (1943.42.5790).

but a few basket makers were known to make use of spruce roots in their weaving. The roots were considered by some to be softer than cedar roots and thus easier to work.

Decorative Materials and Dyes

Beargrass (*X3lalsH3d*) was preferred as a decorative material because of its durability and attractive shiny surface. It was used in its natural bleached-white state or was colored with dyes. The Twana had easy access to beargrass, which grows in open areas near Lake Cushman and on hillsides above the Skokomish River. Gathering time is early July to August, with higher-elevation plants cut later in the season; by September, beargrass gets too tough and hard to pull. Gatherers sought long strands that were wide enough for weaving. Drying and bleaching might take several days, and then the strands were bundled and stored in a dry place. Final preparation involved removal of the backbone and trimming the strands to an even width.

Other decorative materials in Twana baskets are cherry bark and horsetail root. The outer bark of the wild cherry tree (*y3li7ahLpi*, "turns around the trunk") was peeled off the tree in a spiral, then scraped and rubbed to reveal its glossy red color. Cherry bark appears in the designs of coiled baskets. The roots of certain species of horsetail (*X3bXabay*, "giant horsetail," and *sbaqbaq*, "scouring rush") were peeled,

and the bark was used in the designs on coiled baskets. The bark of the horsetail root is a dull black color.

To give decorated baskets a wider array of colors, Twana weavers applied dyes to cedar bark, beargrass, and other materials. A bright yellow color was extracted from the bark around the root of the Oregon grape bush (*CHuyuxWaysi*). The bark was boiled in water, and the beargrass left in the bath until it reached the desired shade. The bark of the red alder tree (*l3w3qay*) was applied to cedar bark to create a reddish color. A paste was made by chewing or pounding the alder bark, and then it was placed directly on the cedar bark when it was fresh. The color was rubbed in and left to dry on the bark in the sun. One of the most unusual sources of basketry dye was a blue-gray clay (*tSa7alsH3d*, "stays on the foot"). This clay was formerly found at wet locations in Twana territory and was used to blacken cedar bark and beargrass leaves. The bark and leaves were each rubbed with mud and then buried until they became the desired color. If left too long, the material would rot; sweetgrass could not be dyed with mud because it would disintegrate.

Designs

Decorative techniques were applied to certain types of baskets during their construction to add to their artistic quality. The major decorative techniques used by Twana basket makers were imbrication and beading on coiled baskets, and overlay and wrapped twining on twined baskets. In coiling, the maker would sew strands of root around the bundle that makes up the foundation of the basket. To make the imbricated design, a piece of contrasting color and texture was inserted. It was laid down on the foundation, caught in a stitch, and folded back, with the next stitch catching the fold. Then the inserted piece was drawn over the second stitch, neatly concealing the sewing on the outside of the basket. Complex designs were created by arranging decorative strands in various patterns. Occasionally an entire basket was imbricated with light-colored beargrass, with dark-colored materials such as cherry bark or blackened cedar bark forming the design. Beading is a simpler decorative technique in which a contrasting strand is placed on the coils while they are being stitched, passing over one or two stitches at a time. Beading and imbrication sometimes occur on the same basket.

The defining technique for the *Tqayas*, the soft-twined overlay basket (and to a lesser extent *Q3lcHi*, the soft open-weave twined basket), is the overlay, in which extra strands are laid on top of structural wefts. As the weft is being covered with the decorative piece, it is given a half twist around each warp. By changing colors of the overlay strands, the weaver creates complex designs. Occasionally weavers make a full twist with the structural weft and overlay, so that the design appears on the inside as well as the outside of the basket. Designs derived from this special technique appear only on rim designs, where they are most visible.

Wrapped twining is a decorative technique common among the coastal groups and is found to a limited extent on Twana baskets. In wrapped twining, one weft is wrapped around both the warp and a single weft held on the inside of the basket. Designs are formed by varying the colors of the wrapping weft.

The surface of a Twana basket is commonly divided into two independent design fields: a narrow band at the rim and a broad area for the main design. Rim designs are typically zoomorphic (dog, wolf, and helldiver) and occasionally geometric (spider

web, icicle, and mountain), usually separated from the main design by one or more horizontal lines. Main designs can be arranged in horizontal bands, vertical columns, diagonal stripes, or an allover pattern. A vertical arrangement with four columns of rectangular elements spaced around the basket is perhaps the most common.

Some Twana overlay-twined designs have to face a certain direction because the weave slants up to the right and the design must conform to it. Thus a wolf or a horse design must face to the right to have a downward-slanted tail, a dog to the left to get bent legs, a mountain goat to the left for horns and an upward-slanted tail, a deer to the right to have drooped ears and a short-slanting tail, and a helldiver or puppy to the left for downward-slanting legs.

Designs can be related in their composition, with elements being added to simple designs to form more complex ones. For example, starting with the rectangle for a house, a weaver can form a blanket by adding fringe. To the blanket, a weaver can add a couple of concentric rectangles within it and a couple of other motifs to form a seal roost (described below). However, background designs into which some designs are added to alter their meaning have no symbolic meaning of their own within that design. For example, the diamond background behind a puppy is not interpreted as a flounder.

The following is a listing of Twana designs for which a name is known ("OT" signifies that a design is restricted to overlay-twined baskets, and "CO" signifies that it appears only on coiled work):[5]

Blanket (*qWatSaptS3d*)—The same as the boxes design, except for the addition of a series of small dark rectangles on the edges of the outside rectangles, interpreted as the blanket's fringe. (OT)

Boxes (*Q3w3Q3b*)—A series of concentric rectangles. (OT)

Butterfly (*X3l3LX3l3l*)—Two triangles (the wings) joined at an apex (the body). (CO)

Canes (*Q3WQawacHi*)—Alternate sections of diagonal and vertical lines in rows around the basket. (OT)

Crow's feet (*cH3lcHalasH*) **and Crow's dishes** (*KaKas sw3Layad*)—Stacked trapezoids representing Crow's dishes or Crow's shells (keyhole limpets), with hand designs representing Crow's feet superimposed on the trapezoids. (OT)

Deer (*sXWisHsH3d*)—Like the wolf but with ears and a short tail slanting downward. The use of the slant necessitates that the animal can face only to the right. (OT)

Dog (*sqW3Bay*)—Like the wolf but with an upturned tail. The dog faces leftward on a soft-twined basket, a characteristic carried over from an older version of the design (found on baskets collected in 1841) that shows the bottom of the legs bent above the paws, with the angle of the bend necessitating that the dog face leftward. The design represents a generic dog rather than a specific breed.

Fish backbones—Differing designs represent halibut, herring, salmon, and sturgeon backbones. Each of them appears in horizontal bands around the main design field. Some have short vertical lines spaced along a central band, or "backbone." The sturgeon backbone differs in that it is a series of sideways Z shapes within a rectangular band. (OT)

Fishnet—A crisscross pattern over the entire main design field of a basket, leaving large diamond-shaped spaces in the background.

Fish weir (*t3qust3d*)—Vertical lines placed in a rectangular shape.

Flounder (*PuWay*)—A diamond shape. (OT)

Flounder bed—A flounder is placed within concentric rectangles (the bed). A triangular break in the rectangles at the top indicates a rock. Crow's shells appear on the sides of the rectangles. (OT)

Flounder in a box—A flounder inside concentric rectangles, with fringe on the sides of the outer rectangle, representing seaweed. (OT)

Flying geese—A zigzag design that circles the basket and is made up of dark and light stripes often five strands wide. (OT)

Hail (*TLbuY3X*)—Bands of alternating dark and light stripes placed horizontally around the basket. (OT)

Hand (*cHalasH*)—Short vertical lines (representing fingers) with outward-facing bars at the top, with the tallest in the center and shortest at the sides. The center finger can either be singular with a T at the top or double.

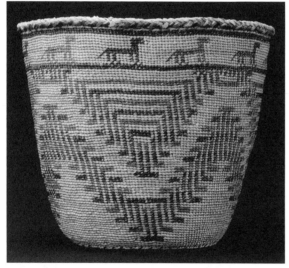

Figure 4.4. *Tqayas* with horse design. By a Twana weaver (Skokomish), circa 1910. Cattail leaves, beargrass, and red cedar bark. 8 × 10 1/4 in. (20.32 × 26 cm). COURTESY SEATTLE ART MUSEUM, GIFT OF JOHN H. HAUBERG, PHOTO BY PAUL MACAPIA (86.91).

Helldiver (*sn3n3Kiya*)—The helldiver, or horned grebe, is a small left-facing figure with two slanted legs.

Horse (*stiqiw*)—In postcontact times, after wolves were exterminated on the Olympic Peninsula, some Skokomish Reservation residents interpreted the wolf design as that of a horse. The actual horse design is like the wolf but with four articulated hooves angled to the front rather than straight legs. (OT)

House (*siya*)—A blanket with a triangle (as a window) pointing upward in middle of the base. (OT)

Icicles (*sQaxW*)—Downward-facing solid triangles in a horizontal row.

Lightning (*swaQWs3b*)—A zigzag design placed in vertical rows around the basket.

Little Earth (*t3btabaxW*)—This figure is much smaller than the man design and lacks both arms and feet. Little Earths were an earlier race of humans who were transformed into short people. A carved figure of this shape helped locate lost objects. (OT)

Man (*stiBat*)—A standing figure with downward-turned arms, no hands, and outward-turned feet. Some have hats.

Mountains (*sb3dbadid*)—Upward-facing solid triangles in a horizontal row. (OT)

Mountain goat (*sXWiTLay*)—Like the dog but with its horns and tail slanting up to the right. The slant of the weave necessitates that the animal can only face to the left. (OT)

Power board—A vertical rectangle that represents a cedar power board. On each side a hole used for holding onto the board is depicted. The board, which represents a sunfish (*y3lbIxW*), was used in a winter dance to bring in herring and other types of fish. (OT)

Puppy (*sqW37iqW3bi*)—When the figure used for the helldiver is superimposed on top of a diamond, it is interpreted as a puppy.

Rainbow (*kWibatSsH3d*)—Alternating light and dark zigzags running horizontally over the entire main design field.

Salmon gills (*sTSayAt3licH*)—A series of S shapes in a diagonal arrangement. They can be placed in a V pattern or in diagonal stripes.

Seal roost (*iw3l*)—The most elaborate of all Twana twined basket designs, the seal roost is formed from two adjacent sets of concentric squares that represent rocks. Two vertical lines in each of the inner squares add the perspective of height. The fringe on all four sides indicates seaweed. The six triangles pointing into the center from the midline of each square plus a diamond in the center represent seals resting on the rocks. Two pairs of dark vertical lines beneath each box with a hook facing outward from each pair represent the harpoons of the unseen hunters. (OT)

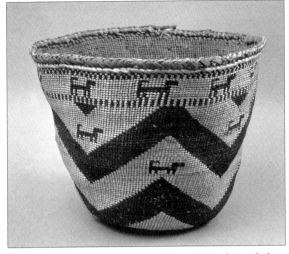

Figure 4.5. Basket with dogs on the rim design and a rainbow in the main design field, augmented by a few more dogs. COURTESY OF THE BURKE MUSEUM OF NATURAL HISTORY AND CULTURE, CATALOG NO. 1-488.

Spider web—Like the icicles design but with outlined rather than solid triangles.

Star (*hLi7hLiCHayas*)—Like a small plus sign. This may be used as either a rim design or a main design.

Starfish (*KW3lacHi*)—A starfish is represented by a rectangle with a band extending upward and downward from its horizontal axis. These bands flow into other starfish stacked above and below.

Wolf (*dusHuyay*)—Like the dog but with a downward-slanted tail. The slant of the weave necessitates that the animal can only face rightward.

Woman (*shLaday*)—Like the man design but with a skirt and no feet.

At the core of Twana designs were a number of common Coast Salish patterns, often interpreted somewhat differently from those of neighboring tribes (see Thompson, Marr, and Volkmer 1980:14). A similar design to the Twana hand is called marsh plant by the Quinault. The Twana helldiver is the Quinault seagull but the Upper Chehalis flying squirrel. The Twana star is the same as the Upper Chehalis and Puget Sound Salish fly. The Twana rainbow is a Quinault mountain range. And the Twana starfish is seen as a box by the Puget Sound Salish. The Twana and the Quinault did share common interpretations of the flounder and fishnet designs. The Twana also had a number of designs in common with non-Salish tribes. For example, the Twana butterfly is similar to the Yakima flying bird. A scene of whalers pursuing a whale on one Twana *Tqayas* might have been inspired by Makah baskets.

Individual basket makers created new designs in an attempt to distinguish their work. The ideas for the designs could come about through artistic experimentation or by receiving the image in a dream.

Professional Basket Makers

As part of their training in various skills needed to keep a household, most girls, and some boys as well, learned basic basketry techniques. First by observing and then doing, children learned how to make the start of a basket. Those who showed an interest

in learning the finer points of basketry could become an apprentice to an older relative or respected weaver in the community. All children assisted in the gathering of basketry materials such as cedar bark, cattails, and cedar roots.

By the age of puberty most girls were reasonably skilled at the making of baskets. When a girl had her first menstruation (*TaQWicHad*), she was taken to stay in a menstrual hut built by her family away from the village. Each girl had her own shelter where she stayed for a period of seclusion ranging from one to eight months. During this time she practiced making baskets, sometimes weaving a basket and then unraveling it and reusing the materials to make another one. An older woman assisted the girl in bathing, brought her food and water, and gave advice and instruction. If the girl performed all of her tasks well without needing to stop and rest frequently, she was considered someone who would make a good wife and become a hard worker. The baskets made at this time were presented as gifts to older relatives.

Many women constructed utilitarian baskets that were needed for the everyday chores of gathering and storing food, but only a talented individual could be a specialist, or *QuLalcHi*. These women were regarded as trained professionals. As such, they were excused from other chores in order to devote most of their time to making baskets. These women specialized in making the highly decorated *Tqayas*. When an individual weaver gained recognition for her skill and well-executed designs, the extended family gained prestige. Her baskets would be presented as valued gifts at potlatches.

The larger of the Twana communities were divided into three social classes: the upper class, the lower class, and slaves. The basketry specialists came from the upper class, who practiced band exogamy. An upper-class man could marry a woman either from a different Twana community or from outside of the Hood Canal basin. This resulted in three types of Twana basket makers: (1) those who had been trained in Twana basket making from an early age and remained within Twana society, (2) those likewise trained but who continued to make Twana baskets within another society, and (3) those from outside who married in at a young age and adopted Twana basket making. Women of this latter category, who became members of Twana society through marriage, brought in ideas from other basket-making traditions that contributed to the variation in technique and design seen in Twana basketry.

Other women who married into Twana society continued to make baskets in the style of the group where they were born and raised. Often these women were specialists who created coiled baskets, although some coiled baskets were made by Twana. Coiled baskets were not as identifiably Twana as were the *Tqayas* and were not considered to be as special as the *Tqayas* by neighboring Puget Sound Salish groups who also made coiled baskets.

The most renowned basket weaver of the late nineteenth century on the Skokomish Reservation was Betsy Old Sam—also known as Betsy Adams or *kayasiTSa*—who created the seal roost design. A Skokomish Twana (Elmendorf 1993:287) who was half Klallam, she was born about 1825 (U.S. Census 1880). Much of her fame was gained at an 1878 potlatch (*s7iwad*) given at Enatai by her husband, Sam Adams (the Duhlelap Twana half brother of Billy Adams), who was also known as Old Sam or *CHabat* (see Eells 1985:323–25 and Elmendorf 1993:29–37 for descriptions of the potlatch). Betsy's baskets were among the most valued items distributed during the giveaway.

Old Sam's half brother was Billy Adams (*sPa'Xil*), a Hoodsport Twana born circa 1846 (U.S. Census 1880; Elmendorf n.d.a; Thompson n.d.). His two sisters were *si7a'hLt3blu* (b. ca. 1840) and *di'day* (b. ca. 1842). *Di'day* was known for her basket making. About 1858 they and their mutual husband, Mowitch Man (*da'tXuqWad*), a Steilacoom Indian born around 1825, moved to Skokomish when the Steilacoom were not provided with their own reservation (U.S. Census 1880; Thompson 1989; Elmendorf 1993:4). "The trio lived for many years [on the north shore of Hood Canal] between Brown's Spit and Tahuya" until Mowitch Man's death (prior to 1915), at which time the "wives were removed to the Skokomish reservation" (Dalby 2000:104). A basket made by *di'day*, collected by Myron Eells in 1892, is located at the Burke Museum (17B5). It is a plaited work used for holding gambling materials.

Another admired basket weaver was Lucy Jones, who in the mid-1880s resided on the Skokomish Reservation at the cedar plank house of Old Shell (Elmendorf 1960:37), a half brother of Old Sam's.[6] She was a Chemainus from Penelakuts on Kuper Island (off southern Vancouver Island) but received training from a Klallam-Makah woman in the years before her marriage to a Skagit man. Lucy was one of a number of non-Twana residents of the Skokomish Reservation at that time who made decorated coiled baskets.

Lucy's daughter, Louisa Jones Charley Pulsifer, was born in Old Shell's longhouse at Skokomish in 1886. Louisa learned how to weave cattail baskets when she was six years old. She credits Mary Peter (*gaY*), the wife of her uncle Clallam Peter, as being the first to teach her basketry through observational instruction, saying of Mary: "Boy, she sure had good eyesight . . . for an old woman" (Thompson n.d.).[7] After Louisa's family had moved out of the communal house, Mary would come over to the Jones house for company while she sat weaving soft-twined baskets. "When I was young," Louisa said, "I used to go up to the old peoples that makes baskets and I memorized all these materials and the designs they have. I was a weaver from nine years old" (ibid.).

When she was about twelve years old, Louisa sought out Betsy Old Sam as a tutor: "I stayed with [her] for a month, copying her work" (Thompson n.d.). Louisa helped the elderly couple around the house in exchange for lessons in weaving. The first design Louisa learned from Betsy was the puppy. She went on to learn Mrs. Sam's hallmark design, the seal roost. By the time she was fourteen, Louisa was able to skillfully weave baskets with designs. Although she specialized in soft-twined baskets, she continued to make utilitarian baskets in her twenties, such as a clam basket. Louisa was one of the last traditionally trained Twana basket makers and was one of the most highly regarded basket makers of the last half of the twentieth century.

One weaver of Twana baskets who was well known for her work after she had moved away from the Hood Canal basin to marry and live among the Satsop people was Big Ann, or Satsop Ann. By 1906, after a second

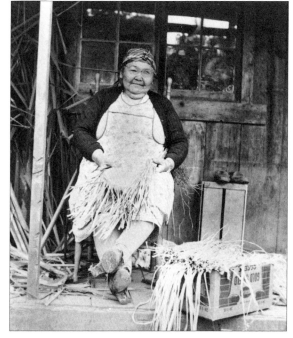

Figure 4.6. Louisa Pulsifer on her porch with weaving materials.
PHOTOGRAPH BY THE NORDQUIST FAMILY, COURTESY OF THE BURKE MUSEUM OF NATURAL HISTORY AND CULTURE.

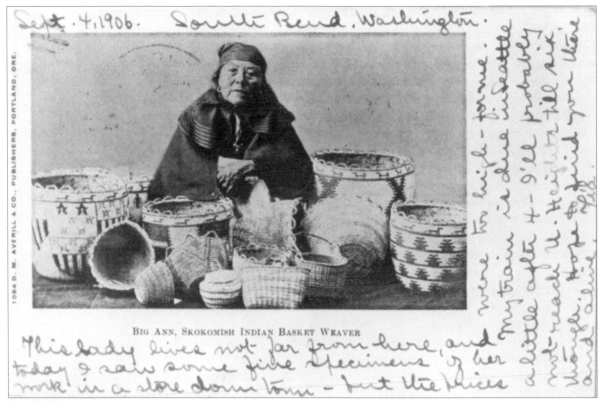

Sept. 4, 1906. South Bend, Washington.

1064 D. M. AVERILL & CO., PUBLISHERS, PORTLAND, ORE.

BIG ANN, SKOKOMISH INDIAN BASKET WEAVER

This lady lives not far from here, and today I saw some fine specimens of her work in a store down town — but the prices were to high for me. Besides — my train is due in Seattle a little after 4 — I'll probably not reach U. Heights till six o'clock. Hope to find you there and alive, Ed.

Figure 4.7. Postcard featuring Big Ann with some of her baskets.

COURTESY UNIVERSITY OF WASHINGTON LIBRARIES, SPECIAL COLLECTIONS, NA1949.

marriage, she was living on the coast "not far" from South Bend on the Willapa River, where her baskets were sold in a store. In a postcard from that period, in which she is identified as a "Skokomish Indian," she is shown with a number of non-Twana-looking baskets, indicating that she also made works in the styles of the communities in which she resided.

Sarah Curly is said to have been the most highly esteemed of the weavers on the Skokomish Reservation in 1909: "Of the few good Skokomish weavers left, Sarah Curly is said to be the best, and she will work only when the weather is damp and rainy, as she says otherwise her grasses crack and split" (G. W. James 1972 [1909]:263).[8]

Phoebe Watson Charley (*wadsH3b*) began her life in 1847 in a Satsop village at what is now Elma. She came to Hood Canal as a young girl after an arranged marriage to a Duhlelap Twana doctor (the brother of Louisa Pulsifer's first husband). The following is part of her story as she related it in 1926.

> My mother's father [Old Watson] belong[s] to Satsop. My father's father belongs to [Wynoochee]. . . . [When I was a y]oung woman [thirteen years old, he] want to buy me[,] Skokomish old man[.] In the old Injun way [of the] old-timers[. We]ll, I was [sold when he] put up money, horses, everything [that] come to [$]1,000. Grandmother let me go. That was Indian way. After that, I stay [at] Skokomish, never see [my] people [for] two year[s]. I got to know how to [dry elk and deer meat on hunts] way up [the Satsop River] early in spring.[9] (Adamson n.d.)

Phoebe learned to make Twana baskets, but the broad, bowl-like shape of some of her work had its roots in her Satsop heritage. In 1915 she regularly traveled by bug-

gy from the Skokomish Reservation to the nearby town of Union City to do the Dalby family's washing and sell her baskets at the McReavy General Store and Post Office (Marr 2008:220).

The styles of various weavers' soft-twined baskets can be seen in something as simple as their depiction of the dog. Some weavers, like Satsop Ann, continued in the traditional style and always made the dog with elbowed legs and facing to the left. Other weavers continued to face the dog to the left but gave it straight legs. Still others, like Phoebe Charley, faced their straight-legged dog to the right, the same direction as the wolf. Louisa Pulsifer, in order to give her dog a curved tail, also faced it to the right.

Even the dog on the Twana coiled basket can vary from maker to maker. Although it might face either direction if it has straight legs, one maker might prefer to face it to the right, while another prefers facing it to the left. Another distinction between makers is the length of the dog's legs. Some makers give each leg two stitches, but others prefer to use just one.

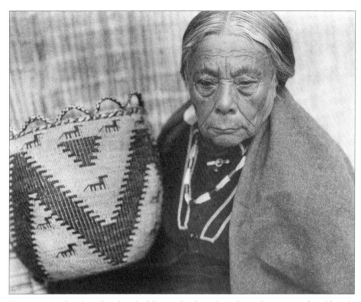

Figure 4.8. Phoebe Charley, holding a basket that shows her uses of wolf and salmon gill designs, 1913. PHOTO BY EDWARD CURTIS, COURTESY MUSEUM OF HISTORY AND INDUSTRY, SEATTLE.

Influences of Collecting and the Commercial Market

In 1892 Myron Eells purchased basketry examples as part of the "old-fashioned Indian articles, some finished and some unfinished, showing their method of work," that were sent from the Skokomish Reservation to the Chicago Exposition (*Seattle Post-Intelligencer* 1892).[10]

By the early twentieth century, collectors were buying up baskets on the Skokomish Reservation in quantity. One such collector was Mrs. J. Frohman of Portland, Oregon, "an intelligent collector, especially of the baskets of the Northwest" (G. W. James 1972 [1909]:259). The Frohman Trading Company published a catalog

Figure 4.9. Baby rattle made by *di'day*; this was the family nickname for *i'p3l3w3t*, who was one of Mowitch Man's wives. The rattle is made of cattail, cedar bark, and beargrass and is filled with pebbles that clatter when it is shaken. It was part of the Washington State exhibit at the Chicago Exposition. COURTESY OF THE BURKE MUSEUM OF NATURAL HISTORY AND CULTURE, CATALOG NO. 89.[13]

offering "Alaska, California, and Northern Indian Baskets and Curios" for sale to both a wholesale and retail market. Another collector was W. B. Blackwell, who was married to Harry Blackwell—the superintendent of the new Skokomish fish hatchery from 1899 to 1902 (*Mason County Journal* 1900, 1902b). Some of her Twana baskets are now part of the collection of the Washington State History Museum. Another frequent collector on the Skokomish Reservation was Captain Tozier, whose acquisitions later became part of the Washington State Historical Society collections when the society merged with the Ferry Museum in 1931.

Hood Canal, May 13, 1902

> Captain Tozier of the revenue cutter, Grant, spent yesterday on the reservation, with a party of his men, having left the cutter in Union City. The Captain came for a fishing trip, and to obtain Indian baskets. He said that he has a collection of four thousand Indian baskets, and five thousand other curios, which have cost him thirty thousand dollars. All are now deposited at the Ferry museum at Tacoma. (*Mason County Journal* 1902a)

An effect from the basketry market was that weavers hurried their work so they could produce more baskets in a shorter time. Thus the signature Twana twined basket was reduced in size. The traditional size was up to twenty-four inches in height (Marr 1990:273), but "since the importance of this basket style to white buyers was as a souvenir, it was no longer necessary that the basket be large" (Nordquist and Nordquist 1983:2). Newer baskets, created solely for sale and not for use, were made much faster and required less material; they averaged only five to ten inches in height. Many were decorated with the simpler designs, and the complex designs that were used, such as Crow's shells, were simplified. Some stacked designs even stopped midway through a design element. These smaller baskets were very rapidly produced and by about 1909 "thousands of tiny specimens [had been] made for commercial purposes" (Curtis 1913:62).

By 1909 the number of active weavers on the Skokomish Reservation had declined. Twana soft-twined baskets were "growing rarer as the years go by," and there were only a "few good Skokomish weavers left" (G. W. James 1972 [1909]:263).

The increase in basketry production placed a strain on native materials, which forced basket makers to travel farther to find and gather them. Sweetgrass formerly grew on the Skokomish Reservation on low-tide islands, but this environment had been destroyed by diking (Thompson 1994:601). Some weavers traveled to Grays Harbor or Willapa Bay on the Pacific Coast to collect their sweetgrass. Because it was available there in greater quantity than it had been at Skokomish, its use became more popular in the 1920s. Other weavers turned to commercially available materials such as raffia.

Larger economic factors also contributed to the end of the heyday of traditional Twana basketry. Basket collecting fever reached its height around the turn of the

Figure 4.10. Basket with a rim design of helldivers and a truncated version of the Crow's shells design in the upper row of its main design. COURTESY OF THE BURKE MUSEUM OF NATURAL HISTORY AND CULTURE, CATALOG NO. I-490.

century and nearly disappeared during the Great Depression. Without economic incentive, few weavers carried on with the tradition. When University of Washington anthropology student Delmar Nordquist came to the Skokomish Reservation in 1952, he found only two women actively weaving. "Of the six women living on the Skokomish Reservation who had done basketry, only Mrs. Pulsifer and Mrs. Miller were still practicing it and were willing to share their wealth of knowledge . . . about the Twana basketmaking tradition" (Nordquist and Nordquist 1983:vi). These two active weavers, Louisa Pulsifer and Emily Purdy Miller, were born in 1886 and 1894, respectively (Drachman 1969: 15–16).

When anthropologist William Elmendorf was a student, he made "a number of short field visits" to the Skokomish Reservation between 1934 and 1938 and then worked there more extensively in the summer of 1939 and largely on weekends in the summer of 1940 (Elmendorf 1993:xxix). Unlike Nordquist, who was documenting the existing culture, Elmendorf sought "to obtain a correct and detailed picture of the native culture as it was when significant acculturation change had just begun" (1958:3). Elmendorf admitted to the "limitations" of his data. He worked with only three individuals and they "were all male" (1960:7–8). Still, he claimed he did not see that the members of the Skokomish Tribe were that different from their white neigh-

CROW'S SHELLS
Artistic Basketry of Puget Sound

An exhibition sponsored by the Skokomish Indian Tribe and the Folk Arts Program of the National Endowment for the Arts

Figure 4.11. Cover of a flyer designed by artist Margaret Davidson for the exhibit "Crow's Shells: Artistic Basketry of Puget Sound." COURTESY NILE THOMPSON, DUSHUYAY RESEARCH.

bors, and he predicted an end to *Tqayas* production: "The Skokomish have undergone a century of intensive acculturation, and have largely replaced their native culture with a version of our own. . . . Two or three elderly women, still living, know something of how to make the beautiful and intricate Skokomish baskets, but their technical knowledge will die with them, for they have not succeeded in passing it on to the younger women" (Elmendorf 1958:3). Elmendorf's estimation of culture loss and his prediction of the end of the *Tqayas* were both too pessimistic.

When linguist Nile Thompson came to the Skokomish Reservation in 1975, both Louisa Pulsifer and Emily Miller were still weaving, and each had passed on basketmaking knowledge to members of their families. Additionally, a renaissance in basket making—stimulated in part by an early-1980s project funded by the Folk Arts

Program of the National Endowment for the Arts, and a subsequent exhibit—generated a cadre of fourteen Twana basket makers a decade later (Thompson 1994:601).[11] Many of those who attended postexhibit classes at the Skokomish Tribal Center, taught by the late Gerald Bruce Miller (*subiyay*, a great-grandnephew of *di'day*'s), today form part of the larger community of basket makers on and near the reservation. One younger weaver, Lynn Wilbur Foster (a daughter of carver Andy Wilbur-Peterson), had a basket she created in 1999 with the seal roost main design and dogs around the rim included in a Salish exhibit at the Seattle Art Museum (Marr 2008:221). The Skokomish Culture and Art Committee declared, "The Skokomish are determined to carry their traditional practices and wisdom into the future" (2002:72). The *Tqayas* has indeed survived into the twenty-first century.

Notes

1. The finest weave we have recorded for a Twana basket is twelve warps and twelve wefts per inch.

2. The use of the term "Skokomish basket" is misleading as that particular type of basket was produced by other Twana communities as well, not just the Skokomish living in villages on and near the Skokomish River. The confusion arises from all of the Twana people being generally referred to as "Skokomish" after the establishment of the Skokomish Reservation at the mouth of the Skokomish River in 1859.

 The practical alphabet used here was adopted by the Skokomish Indian Tribe in 1975. It uses a southern European vowel system (like that of Italian and Spanish) along with capitalization not only to capture the underlying sounds of the language but also to allow typing on a keyboard without special fonts now readily available on computers. For example, the English words "body" and "shoe" are written as *badi* and *sHu*. The symbol *3* represents a schwa (ə); this usage is also seen in the name of the recent television series *Numb3rs*. Some capitalized letters—P, T, CH, and TL—represent glottalized sounds, which in technical linguist orthography are depicted with a raised comma ('). The only change made here to the original alphabet is the employment of *7* rather than the question mark (?) for a glottal stop, the sound heard in the middle of English "huh uh."

3. Frank and Henry Allen's mother, Mary Allen, was an example of such a woman who married in from outside the Hood Canal basin. She was a Dungeness Klallam (b. ca. 1840) who married into the Skokomish Twana. After a marriage, the "boy's family take girl with them—she's Skokomish woman now." Frank Allen further stated: "My mother stayed at Skokomish for years till my father died, then went back to her people—she talked Skokomish just as good as anybody" (Elmendorf n.d.b).

4. Kitty Charley (*tS3baq3lw3d*) and her brother, Old Peter, were Skokomish Twana from the village of *basQ3laXad*, "it has a stockade" (Elmendorf 1960:33). She was the first wife of Doctor Charley of Duhlelap. As an older co-wife, she was instrumental in the education of Louisa Pulsifer after the latter married Doctor Charley. More on Kitty Charley can be found in Elmendorf (1993:50, 74, 164, 184, 214, 227).

5. A number of the designs in the list are found in photographs and sketches in Thompson and Marr (1983).

6. Lucy's husband was Charley Jones, who was one-half Skagit, one-fourth Klallam, and one-fourth Sahewamish (closely related to the Squaxin Island Tribe). According to Louisa, Char-

ley's cousin (her Aunt Jenny) raised Lucy at Little Boston "until she was a woman." Other non-Twana residents of the Skokomish Reservation included Ellen Young, a Steilacoom who lived there with her Steilacoom husband.

7. Mary Peter (b. ca. 1839) is listed as being half Twana and half Nisqually (U.S. Census 1880). She was formerly married to a white man named Smith, with whom she had two daughters, Alice (b. ca. 1865) and Kate (b. ca. 1873). Kate Smith Pulsifer gained renown as a blind basket weaver: "[She] learned basketmaking before her blindness, continued to weave occasionally thereafter. Selected the proper materials and colors according to their position before her. Her children aided her by counting stitches for a given design while [she was] weaving" (Nordquist and Nordquist 1983:3).

8. James may have gotten his information from Mrs. J. Frohman, who was at that time amassing a collection in Portland, Oregon, for a trading post. If so, it is likely that some of Sarah Curly's works were in Frohman's collection. On the 1880 Skokomish census, Curly's wife is listed as *m3na'hL*, a twenty-one-year-old who was three-fourths Twana and one-fourth Klallam (U.S. Census 1880).

9. Phoebe was married to Tenas Charley. Her mother (*wi7ila*) came to the Skokomish Reservation in 1858, the same year her daughter and her husband moved there. The following chart represents Phoebe's family tree as described to Thelma Adamson, with the addition of information from the 1880 census.

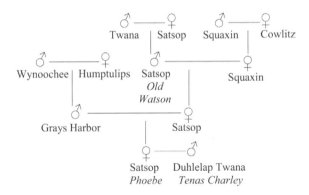

10. Most of these objects are in the collections of the Field Museum in Chicago today. The Chicago Exposition, more accurately called the World's Columbian Exposition or the Chicago World's Fair, was held in 1893 to celebrate the four hundredth anniversary of Columbus's landing in the New World.

11. A two-year grant was obtained to document the basketry traditions of the Suquamish and Skokomish tribes and resulted in an exhibit shown at museums in Seattle, Tacoma, and Bellingham, Washington, as well as Portland, Oregon. Nile Thompson and Carolyn Marr (1983) prepared the exhibit catalog. The late Gregg Pavel, a nephew of G. Bruce Miller's, assisted them in cataloguing Twana baskets.

CHAPTER FIVE

Quinault Basketry

JOAN MEGAN JONES

The Quinault people have lived on the Pacific Coast and along the Quinault River up to the lake of the same name for hundreds, if not thousands, of years. They were first visited by the early explorers to the Northwest Coast and later by trading ships, settlers, and missionaries. By the late 1800s great changes had been taking place in the way of life of the Quinault. One important part of their traditional culture, basket making, has managed to survive and continue to the present day. The traditions and skills of the creative and productive Quinault basket makers have been passed down through succeeding generations, as well as displaying innovation and change.

During 1976 and 1977 the Quinault people engaged in a community-wide project to document their past and present culture. As part of this activity the women who made baskets shared their knowledge and experience. This work was published as a book, *Basketry of the Quinault* (J. M. Jones 1977). Much of this chapter is based on the interviews and informal discussions with basket makers during this project.

The descriptions of the styles of Quinault baskets are also drawn from some of the early ethnographic work of Ronald L. Olson and from viewing and studying many baskets in museum collections. Some of these important collections were assembled by anthropologists such as Franz Boas of Columbia University and some of his students—Leo J. Frachtenberg, Livingston Farrand, Hermann Haeberlin, Erna Gunther, and Melville Jacobs. Each visited the Quinault at some time during the late 1800s through the 1930s. They came to record culture and language and also collected traditional artifacts for the Smithsonian Institution's National Museum of Natural History, the Museum of the American Indian (now part of the Smithsonian), the Field Museum in Chicago, and the Burke Museum at the University of Washington. These historically important collections offer a view of the range of Quinault basketry through time.

Quinault weavers made a wide variety of styles of baskets prior to European contact. For hundreds of years they used roots, sedges, reeds, rushes, grasses, and barks to make baskets that served utilitarian purposes. The most common shapes were rounded cylinders and bowls or box-shaped utility baskets. Weavers used twined, plaited, and coiled techniques, with various applications for the decorative surface.

A great rise in production of baskets took place from the 1890s up to the 1920s as Native weavers responded to a rapidly increasing market for their work. This period of intense productivity was also a time of great stylistic experimentation and diversity. Over the past century, close-wrapped-twined weaving had been well established, and with the developing market for basketry, industrious weavers quickly adapted the close-wrapped-twined technique to cover seashells, glass fishing floats, and other miscellany.

By the 1920s the traditional twined basket with overlay decoration had disappeared from the weavers' repertoire, having undergone some change in the process.

Organization of surface design became simpler in the later baskets, and new motifs were added, or even replaced the geometric forms, such as the design by a Quinault weaver that was based on the U.S. flag. Small bowl shapes came to supersede the curved cylindrical form. Around the early 1900s a few Quinault weavers experimented with raffia, developing a new technique of double-wrapped raffia around wide cedar bark strips that gave the appearance of a cross-stitch. Quinault weavers abandoned the use of some native materials when they substituted raffia in their coiled baskets.

After the 1930s the declining market for basketry resulted in fewer girls becoming basket weavers, and some traditions were lost as the older women passed away. This trend has shifted, and during the last twenty-plus years there has been renewed interest in native basketry. As a result of tribal intermarriage and tribal allotment on the Quinault Reservation, women from other areas who came to Quinault introduced their various basketry traditions, so that basketry of the present-day Quinault is a diverse blend of older Quinault styles and other older styles, showing some adaptation and change, and fresh, new expressions that have revitalized coastal weavers.

The Quinault Basket

Every basket is a blend of artistry, technique, and tradition. Women shared their basket-making activities by collecting and preparing materials together and by teaching the techniques to young girls. Girls became involved at a young age as observers, tagging along with their mothers, grandmothers, and aunts while they gathered grasses or dug roots and then processed these materials during the busy spring and summer season.

Actual basket construction was most often a winter activity. Girls could begin learning the construction techniques from around seven to ten years of age as they worked alongside their older female relatives, who might start them off making the bottom of a basket that would then be given to a more experienced weaver to complete. A young apprentice might continue making basket bottoms for a year until she acquired enough skill and control of techniques to be able to progress further. She would be taught the rules and conventions of the traditions and the special designs she might use. Throughout her childhood a young girl continued working with her teachers, learning and developing her skills until she acquired full control of techniques and designs. In the past most women made baskets for their own household. Designs from the older traditional style of twined spruce root baskets usually consist of intricate, mazelike lines that can appear in horizontal bands or cover the entire body surface below the rim, with the rim having a separate small horizontal design band. Although these designs are made up of geometric shapes, some of them have descriptive names such as "ripple of the sea."

In the early 1900s and the years following, some women made up new designs to decorate their baskets. One such new motif was inspired by the design on a

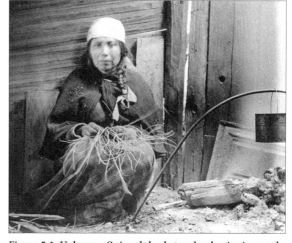

Figure 5.1. Unknown Quinault basket maker beginning work on a twined basket. Emma Damon Collection, COURTESY OF RAE MUNGER.

soap wrapper. Another basket maker based her design on an illustration she saw in a magazine.

Before construction of a basket can begin, weavers must have the necessary material ready. Fibers would have already been prepared from bark and roots, thin twigs, grasses, reeds, rushes, and sedges. The preparation of these materials is almost always done by the weaver (with the help of family and friends), who knows how to recognize the right species of trees and plants and also the best time to dig roots and pick grass. One weaver, Sarah Sotomish, remembered that "in the old days . . . there were songs and dances performed after a long day of gathering, as a way of thanking the Creator, . . . for giving them the grasses so they could make their baskets" (J. M. Jones 1977:8).

Figure 5.2. Sarah and Gilbert Sotomish at Lake Quinault. COURTESY OF JESSIE CURLEY AND LEILANI CHUBBY, QUINAULT INDIAN NATION MUSEUM.

Grass, reeds, and sedges may be used in construction or decoration and are often bleached or dyed. A basket maker, helped by her family, will collect what she needs and may share the harvest with others who can no longer get out to collect (J. M. Jones 1977:8). Western red cedar is prized as an excellent basketry material, with the inner layers of the bark used for soft, flexible storage containers. A sheet of bark is stripped off a young cedar tree, and the rough outer portion is removed, revealing the smooth, flexible inner layer. This is later split into narrow strips and, along with reeds or grass, is used to weave a variety of baskets. Olson reported that cedar bark was best gathered in spring and summer when "the sap was running and the bark was loose" (1967 [1927, 1936]:83).

Strips of roots of Sitka spruce were used by Quinault weavers in their fine twined baskets. During the winter, women located and dug up the trailing roots with a sharp-pointed stick. The slender roots, up to three inches in diameter, were cut into lengths about four feet long, and the outer bark was peeled off. Holding these root pieces over a fire for a few minutes made the outer bark easier to remove (Olson 1967 [1927, 1936]:82). The root pieces were then split lengthwise into thin strips.

Twigs of vine maple, split lengthwise into sections two to three inches thick, were used in the sturdy gathering baskets. According to Olson (ibid.: 83), this material had to be fresh and green and kept wet during processing.

A great variety of plant fibers are used to make up the decoration on the basket surface. Beargrass or sweetgrass is bleached to obtain a light cream color, and the bleached material may be dyed to obtain other colors. In past times, surfgrass (*Phyllospadix torreyi*) was used occasionally by the Quinault for black patterns in their flexible beargrass baskets (Mason 1904:33). Weavers in the old days made use of many natural dyes obtained from plants, roots, seaweeds, and berries found in the area to create designs on their baskets. Beatrice Black and Sarah Sotomish recalled some of the old traditional ways to dye basket materials: brown was obtained by boiling hemlock bark, peeled from trees in May, June, and July; orange could be achieved from boiling alder bark strips; roots of Oregon grape (*Mahonia aquifolium*)

produced a yellow dye;[1] wild onions would yield a pale yellow; and materials were dyed black by burying them "for a long time" in mud clay (J. M. Jones 1977:7).

Later, many women adopted the commercial dyes brought in by traders (J. M. Jones 1977:7). These new dyes produced a wider range of brighter, more intense colors, and weavers were quick to see advantages in their use. In 1976 Sarah Sotomish and Beatrice Black remembered the strong commercial Diamond Dyes that they purchased. Materials to be dyed were put in a large kettle of water with a little salt, and the dye was boiled "for a while" (ibid.: 8). When the desired depth of color was achieved, the dyed materials were removed from the dye bath and hung to dry.

After the materials are collected and prepared, they are tied in bundles and put aside for later use. When a basket maker is ready to begin weaving, all she needs to do is soak the prepared materials in water for a short time to make them pliable enough to weave. Even back in 1977, however, weavers were expressing the increasing difficulties they were having gathering and preparing sufficient materials because of lands being cleared, swamps and wetlands being filled in, and chemicals for weed control destroying valued plants (J. M. Jones 1977:9).

The construction techniques used by Quinault basket makers are plain twining, wrapped twining, checker or plaited, and variations or combinations of these. The split cedar roots that were made into coiled baskets in the old days were eventually replaced by raffia.

The basket maker's major tools are a sharp knife and a pointed awl or a steel needle. Before metal knives were obtained in trade, women cut and trimmed materials by using a shell that had been ground to a fine edge on a stone. An awl, usually a deer leg bone shaped to a tapering point, was used in making coiled baskets. Some weavers changed over to metal awls when these became available around the 1880s, but Frank Cushing believed that the bone awl was far better for basketwork than any implement of steel (Mason 1904:87), because the metal awl may break or fray the cedar root fibers instead of gently separating them as the bone awl does. A long steel needle is now used in making coiled raffia baskets. Some basket makers use a tool called a splitter, made of a thin metal blade set in a block of wood, to cut cedar bark into even widths. A container to hold water for soaking materials completes the list of needed supplies. Apart from these relatively simple tools, the weaver's deft fingers control the weaving process.

Figure 5.3. Bone awl used in making coiled cedar root baskets. Collected by Leo Frachtenberg at Taholah, 1917. Courtesy National Museum of the American Indian, Smithsonian Institution (059505). PHOTO BY NMAI PHOTO SERVICES STAFF.

Basket shapes produced by Quinault weavers are based on circular or rectangular forms. In modern times some weavers departed from the traditional shapes and experimented in creating unusual forms they copied from items introduced through trade.

The construction techniques used in basket making affect the form and design of the finished product. Weaving and coiling are additive: the form is built up stitch by stitch, using the same basic units repeated over and over. Because of the additive and modular nature of basketry, the designs that are woven into the surface as the form is created are limited by the confines of the technique. Designs must be made up of the

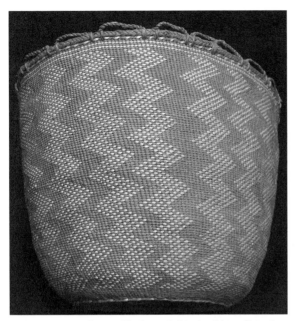

Figure 5.4. Quinault twined basket with "ripple of the sea" overlay decoration of beargrass, spruce root warps and wefts, and loops added at rim. 14 in. top diameter, 11 in. depth, 8 in. base. This basket was collected by Mrs. J. B. Montgomery of Portland around the early twentieth century and donated to Mount Rainier National Park; it was transferred to Olympic National Park in 1941. COURTESY OLYMPIC NATIONAL PARK (39/386).

repetition of the same basic unit of the stitch and have a linear rather than curved appearance. The point, the line, and geometric shapes such as triangles and rectangles are used to make up the design motifs. Naturalistic or realistic designs that rely on curved lines are more difficult to achieve successfully on a basket surface. A curve must be simulated from a series of angular stepped lines. Within these structural confines, weavers have created designs remarkable for their organization, complexity, and symmetry.

Traditional baskets were created as functional utensils, but on another level, museum patrons and art collectors may view them as works of fine art. Some features that may portray the artistic qualities of a basket are surface decoration and refinement of technique and shape. Quinault basket makers in the 1970s talked about the qualities that define a "good" basket—well-prepared material, even stitches, proportions of the decoration, and smoothly shaped sides.

Surface decoration, either worked in as an integral part of the structure or added as a supplemental element, may be achieved through color contrast, manipulation of structural elements for decorative effect, or both. Color-contrast decoration is usually woven into the basket as it is constructed. Quinault weavers have used two main techniques for applying this type of decoration. In the older traditional twined spruce root baskets, a third contrasting strand was carried along with the two weaving pieces and turned so that it showed only on the outside surface. The resulting pattern is commonly referred to as overlay decoration. The simplest method to create a surface design is to substitute a strand of a contrasting color in twining, wrapped-twining, and coiling techniques.

Structural elements of the basket may be manipulated by the weaver for decorative textural effects. Quinault weavers use this mode by itself and also in combination with color contrast to create a visually interesting and complex surface. Within the surface design, great artistry is seen in composition and in achievement of unity and balance. Design motifs are commonly made up of geometric shapes arranged in larger units to compose the total pattern. The arrangement and composition of design units may be organized on the surface in horizontal, vertical, or diagonal bands on the basket walls. Pleasing proportions, perfect spacing of units, and the balance and unity of the total composition are qualities that are exemplified in the traditional Quinault twined spruce root basket, with its intricate geometric design.

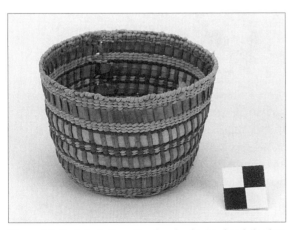

Figure 5.5. Basket of alternating bands of twined and checker weave, cedar bark warps, and dyed wefts. Collected by Leo Frachtenberg in Taholah, 1917. Courtesy National Museum of the American Indian, Smithsonian Institution (059489). PHOTO BY NMAI PHOTO SERVICES STAFF.

Basket makers attain control of technique to the degree that a basket is perceived as a harmonious whole. Such harmony can be achieved only by careful preparation of materials and technical perfection in construction. The pieces of root or the grasses must be cut and trimmed in exact, even widths so that no flaw appears. The weaving must be so expert that the entire surface of the basket recedes, becoming a background for the design, ensuring that no coarse, uneven stitches compete with the primary focus. Well-made baskets display an elegance of line and proportion, with the sides extending in a smooth, unbroken line.

Basket Styles

Style is simply a way of doing something. The items people make, may they be canoes, houses, masks, or baskets, display regularities and similarities that suggest the makers have followed some set of rules, pattern, and order in their creation.

Although a basket is the unique creative product of an individual, its maker followed a set of traditions and cultural conventions that influenced choices throughout the manufacturing process. Quinault basket makers have created their baskets within these conventions, and similarities are evident in features of construction techniques, decoration application, motifs, rim finishes, and shape. Throughout the past two hundred years these styles have changed through processes of invention, adaptation of new materials, and response to meeting the demand for baskets to sell or trade.

Baskets were collected in great numbers during the latter decades of the 1800s for museums. While some collectors may have shown preference for the "fancier" decorated baskets, many other examples of more utilitarian types were acquired to demonstrate the earlier range of manufacture in the area. Museum collections of Quinault baskets contain both items in the decorated twined spruce root style as well as the plainer utilitarian types that were also produced at the time.

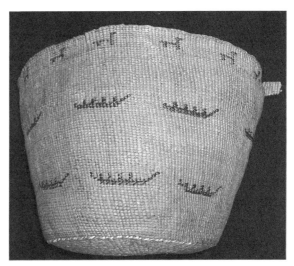

Figure 5.6. Quinault plain-twined basket with stylized realistic designs of canoes and animal figures woven into the surface with the overlay technique. 12 in. top diameter, 10 in. depth, 8 in. base. COURTESY OLYMPIC NATIONAL PARK (39/418).

Twined Basket with Overlay Decoration

The most distinctive traditional Quinault basket is of a two-strand twined weave. These baskets have split spruce roots for the warps and the wefts. Bleached grasses were used to apply the overlay decoration. The basket sides have a gradual curve outward from the slightly rounded base. The overlay stitches have the same directional slant as the body stitches and do not show on the inside of the basket. Rims are usually a false braid and are sometimes finished off with evenly spaced loops around the top edge. Some later baskets have a rim of wrapped raffia. The basket body decoration may have two clearly delineated zones consisting of a narrow space below the rim and the remainder of the body extending to the base. Each zone is treated differently. The rim design may consist of thin horizontal stripes or one narrow band of simple stylized animal or bird

figures. The body zone has a predominant vertical or diagonal organization of design motifs commonly made up of densely packed chevron or mazelike compositions.

Weavers probably stopped making the twined spruce root baskets in the early 1900s as other materials took the place of spruce root. The overlay technique of weaving intricate geometric designs into the basket body also gradually was abandoned during the same period. Although many of the baskets in museum collections identified as Quinault are twined spruce root with overlay geometric decoration, this was not the only type made during the 1800s.

Twined Basket with Substitution of Different-Colored Strands

Contrasting decoration of baskets woven in two-strand twining was created simply by substituting a weaving piece of a different color. These soft-twined baskets have narrow bands or stripes of a contrasting color, usually not covering the entire surface but confined to the central area of the body. The grasses and reeds used in their construction give them a matte appearance. Weavers from neighboring Coast Salish tribes in southwest Washington also made baskets of this type. Because of these shared but indistinctive characteristics, these baskets are difficult to identify as to tribal origin.

Twined Basket with Overlaid Warp Decoration

Quinault weavers made baskets with a supplementary upright strand laid over the warps and held in place with rows of widely spaced plain twining. Some baskets also used a supplementary strand laid horizontally across the surface and held in place with the widely spaced twined rows. These baskets have a firmer and sturdier body because of this double thickness of materials. Strips of bleached or dyed grasses are used for the supplementary pieces.

Plain-Twined Basket without Color-Contrast Decoration

Weavers in western Washington made undecorated, plain-twined baskets for a variety of uses in the past. These soft, flexible baskets, either cylindrical or rectangular in shape, were twined of grass and cedar bark by most coast tribes, including the Quinault. Rectangular boxlike shapes are found most frequently. There may be local or tribal differences in shape, proportion, or material, but since these baskets are so widespread and lacking in decoration, precise identification of origin can be difficult.

Other Twined-Weave Basketry

In earlier times, before the traditional ways were changed, fine twined hats with smoothly flared walls were a common part of people's attire. These practical hats offered protection from the weather. Although the production of woven hats waned for several decades, present-day weavers are bringing them back. Weaving techniques and hat shapes used by Quinault basket makers were similar to those of their neighbors. Plain-twined as well as wrapped-twined weaves were used in the construction.

Some hats had decoration woven in, while others were undecorated (Olson 1967 [1927, 1936]:55). These hats were never painted, as the Tlingit and Kwakwaka'wakw (Kwakiutl) hats were.

According to Olson (ibid.: 138), dolls were made in the distant past. These were simple constructions of bundles of cedar bark, a stick, and some wrapping to hold them together. During the past century, some weavers created a more elaborate doll of plain twining. The body of the female doll is usually in the form of a flared skirt with some decorative pattern woven in. Arms extend out from the body, and the head is complete with eyes, nose, and mouth woven in. Shredded bark is added for hair. Some dolls even have small beads added for earrings. Doll figures also depict males dressed in traditional clothing. Mattie Howeattle, a prolific weaver, was well known for her woven dolls.

OPEN-WRAPPED-TWINED BASKETS

A type of functional container that was made by most tribes throughout western Washington is the open-wrapped-twined gathering basket. Quinault weavers and their neighbors made heavy open-weave baskets of split twigs in boxy shapes. With the addition of a strong woven strap (tumpline) laced through the rim, these baskets were used to carry heavy loads. They made excellent containers to hold a load of clams, and the open weave allowed the water and sand to drain off. Smaller baskets in the same weave construction were also made. Twigs of vine maple or red cedar were the main materials used.

Figure 5.7. Quinault basket weaver with unfinished twined hat by her side. Courtesy National Archives, Pacific AK Region (Seattle) (RG75 BIA, PAO, Tribal Operations Branch—General Subject Files, Taholah Schools 1940, Box 1151).

The weave structure, consisting of upright strips, was held together with a strand wrapped around the upright or warp strand and a third strand held in back at right angles to the warps. Usually the pitch of the stitch was reversed every few rows so that the sides of the basket were not pulled out of line.

A variation of this technique is seen in the treatment of the warp strips. These are arranged in opposing diagonal lines with the wrapped weaving leaving evenly spaced gaps between the rows. Occasionally a supplementary strand may be laid over the warps as a contrasting element. The basket is usually finished off with a strong, sturdy rim and loops to attach a tumpline.

CLOSE-WRAPPED-TWINED BASKETS

Although the close-wrapped-twined technique was used for many years in the past to make functional baskets, Quinault weavers, along with their neighbors, adapted this

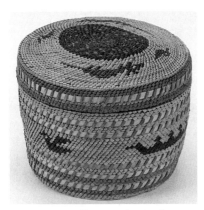

Figure 5.8. Small wrapped-twined covered fancy basket. Collected by Leo Frachtenberg at Taholah, 1917. Courtesy National Museum of the American Indian, Smithsonian Institution (059492). PHOTO BY NMAI PHOTO SERVICES STAFF.

basic weave structure to create fancy baskets for sale. These novelties, usually associated with Makah weavers, were made by Quileute and Hoh basket makers, in addition to the Quinault. Using bleached and dyed grasses and cedar bark strips, weavers made many small baskets using this close-wrapped-twined technique. Decoration was added to the basket surface by substituting a strand of a contrasting color. Small-scale representations of birds, whales, and canoes were popular.

These baskets, with their brightly colored designs, appealed to tourists and collectors and became an important source of income for Quinault and other weavers of the peninsula. Weavers experimented with the novel technique of twining over the surface of objects, such as bottles, jars, and shells. The skill and control of the weaver's technique is evidenced in these cleverly executed basketry items. It is not surprising that these novelties and the decorative hot plates and table mats became popular items to sell to tourists and collectors.

During the early 1900s some Quinault weavers who made baskets to sell traveled to Seattle and other cities and towns nearby and sold directly to people on the street. Large displays of baskets were sometimes set up in Moclips to sell to people visiting the ocean beaches. Two large department stores, Frederick and Nelson in Seattle and Meier and Frank in Portland, ordered baskets from Quinault makers to display in the 1930s (J. M. Jones 1977).

OTHER WRAPPED WEAVES

A variation of the wrapped technique is seen in basketry shopping bags. The warps are usually split pieces of cedar bark, and the wefts are a combination of rows of close-wrapped twining separated by wide cedar bark strips in a checker weave. A firm rim and handle are the finishing touches added to this useful type of basket. Quinault weavers and their neighbors continue to make shopping baskets today.

A different way of working the wrapped stitch was used by inventive Quinault basket makers. On a basket with warps and wefts of cedar bark strips, a thinner strand, sometimes of raffia, was used to wrap across the row in one direction. The same weft strand was then wrapped in the opposite pitch back across this row, crossing each of the stitches of that previous row. This technique gave the appearance of a cross-stitch. A row of this stitching was sometimes alternated with a checker weave, making the entire surface texture visually interesting.

PLAITED OR CHECKER-WEAVE BASKETS

Baskets woven in plaited or checker weave were made by many Northwest tribes. These baskets lacked complex decoration, showed a minimal use of color contrast, and appeared in a limited range of shapes. Many of these baskets were made of thin strips of cedar bark, although there is some use of other materials, such as cattails or reeds. The basic form is a box shape in varying proportions. Decoration may consist of a few stripes. These light, flexible containers were easily portable and were frequently used to hold food and gear during trips by canoe. When not in use, these baskets could be readily folded flat and stored out of the way.

In addition, Quinault weavers along with their Quileute, Hoh, and Makah neighbors along the Pacific Coast made a variety of plaited baskets and bags that were used to hold whaling, sealing, and fishing gear.

COILED BASKETS

In contrast to the wider distribution and greater diversity of woven basketry throughout the Northwest, the practice of sewn or coiled basketry with imbricated decoration appears only among the Coast and Interior Salish tribes. Little diversity is seen in technique or materials. The same basic methods of split root construction, stitching, and application of decoration are common to the baskets made by weavers in this area, although there are local variations in shape, proportion, rim finishes, and design motifs. In the past some Quinault weavers produced the hard, coiled cedar root baskets, but they gradually abandoned the use of split cedar root because of the difficult and time-consuming task of gathering and preparing the roots for the foundation coil and the stitching. Weavers adapted and changed their traditional coiled styles when prepared raffia was introduced. In addition to the materials used in the basket, the methods of applying decoration and sewing the coils were changed.

Figure 5.9. Basket of checker and twined weave. Collected by Leo Frachtenberg at Taholah, 1917. Courtesy National Museum of the American Indian, Smithsonian Institution (059448). PHOTO BY NMAI PHOTO SERVICES STAFF.

The old-style coiled baskets have a stiff, corrugated appearance imparted by the split-root bundle foundation. These baskets were sewn in a continuous spiral, built up and shaped into the desired form. The foundation coil, consisting of a bundle of split root pieces, was sewn together with even, closely spaced stitches using the smooth outer sections of the root. Each stitch was threaded through a hole pierced in the center of the stitch covering the coil of the preceding row. A bone awl was used to make an opening in the foundation coil so that the stitching strand could be threaded through. Bleached and dyed grasses and wild cherry bark were used as supplementary strands applied to decorate the basket surface, using a method known as imbrication. Coiled baskets were strong and were used as gathering containers and cooking pots. Coiled watertight baskets were filled with water and stones heated in a fire, and food was cooked in this simmering basket "pot."

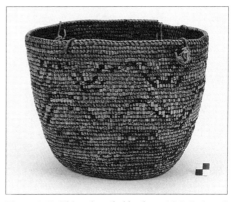

Figure 5.10. Old-style coiled basket with imbricated decoration. Collected by Leo Frachtenberg at Taholah, 1917. Courtesy National Museum of the American Indian, Smithsonian Institution (059423). PHOTO BY NMAI PHOTO SERVICES STAFF.

Shapes of old-style coiled baskets made at Quinault were most likely to be rounded or oval, with gradually flaring sides, but some coiled items made for sale were flat trays and mats. Quinault weavers in 1976 remembered older relatives who used to make these baskets, and some women even recalled learning this technique when they were very young (J. M. Jones 1977:21).

As difficulties in getting good-quality native materials increased, raffia offered a convenient alternative. No arduous gathering trips or time-consuming preparation were required. The fiber, processed from a tropical palm, was imported to Europe and England and then traded throughout the United States. By the early 1900s the

Quinault replaced the split roots in coiled baskets with raffia, both for the foundation coils and for the sewing strand. Decoration applied by substituting a dyed contrasting strand became an integral part of the basket structure. The design was also visible on the inside of the basket.

Figure 5.11. Beatrice Black. COURTESY LEILANI CHUBBY, QUINAULT INDIAN NATION MUSEUM.

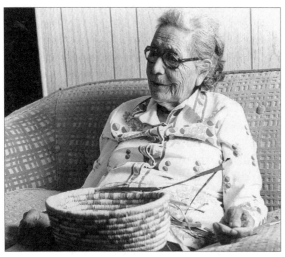

Figure 5.12. Elizabeth Capoeman. COURTESY LEILANI CHUBBY, QUINAULT INDIAN NATION MUSEUM.

Quinault Basket Makers

Quinault basket makers shared their experiences and knowledge for a 1970s community project supported by a grant from the American Revolution Bicentennial Administration's Native American Program. These memories, along with historical information and photographs of early collections of Quinault basketry, were assembled by myself and published as *Basketry of the Quinault* in 1977. The weavers who contributed their stories were Beatrice Black, Elizabeth Capoeman, Emma Capoeman, Maggie Kelly, Nellie Ramirez, Sarah Sotomish, and Hazel Underwood. Their different backgrounds are reflected in the variety of basketry styles and traditions they learned. Also demonstrated are their artistry, skill, and lively creative and innovative energy.

Sarah Sotomish, born in the Queets village around 1886, lived all her life on the Quinault Reservation. The styles she made included both woven and coiled techniques.

Beatrice Black came to Taholah in the early 1930s from La Push. She brought the Quileute basketry styles with her and continued specializing in wrapped-twined weaves. She also taught basket making on the reservation. Beatrice had a unique style of twined weaving called "going up the stairway," in which she carried her running weft up the inside wall of her baskets like a set of steps, rather than cutting the weft when the color would not be used for a while. This clever method of handling wefts when working with several colors could be used in plain-twined, wrapped-twined, and plaited weaving. Beatrice taught other weavers to weave this same way (Andrews 2010; J. M. Jones 2010). As the *Oregonian* (1986) reported, "A little bit of history is woven into every one of the baskets Beatrice crafted during her lifetime. . . . Although there was no way to sign her work, Black often used whale, duck and canoe designs that became her insignia."[2]

Elizabeth Capoeman, born in Queets, came to Taholah in 1909. She made the sewn, or coiled, type of basket.

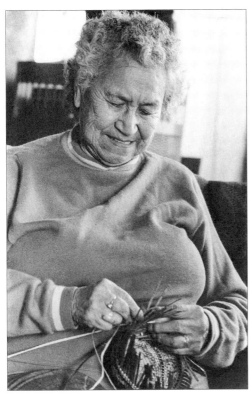

Figure 5.13. Emma Capoeman. COURTESY LEILANI CHUBBY, QUINAULT INDIAN NATION MUSEUM.

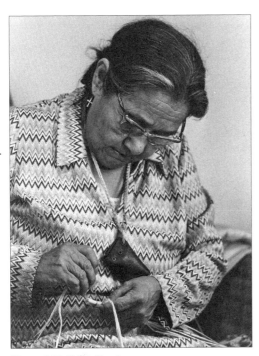

Figure 5.15. Nellie Ramirez. COURTESY LEILANI CHUBBY, QUINAULT INDIAN NATION MUSEUM.

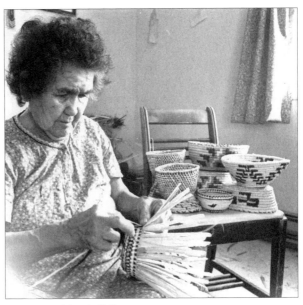

Figure 5.14. Maggie Kelly. COURTESY LEILANI CHUBBY, QUINAULT INDIAN NATION MUSEUM.

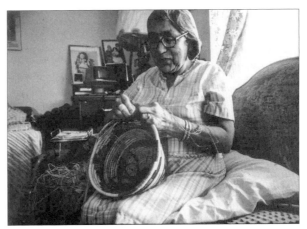

Figure 5.16. Hazel Underwood. COURTESY LEILANI CHUBBY, QUINAULT INDIAN NATION MUSEUM.

Makah weaver Emma Capoeman, born in Bremerton, came to Taholah after she was married. She wove her baskets using several different techniques.

Maggie Kelly was born in Taholah in 1886. She lived in Queets and made both woven and sewn basket types.

Nellie Ramirez came from Squaxin Island to live in Taholah. Her specialty was sewn baskets.

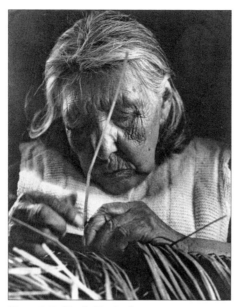

Figure 5.17. Mattie Howeattle. PHOTOGRAPH COURTESY JOSEF SCAYLEA PHOTOGRAPHY.

Hazel Underwood, born on the Skokomish Reservation, came to live in Taholah. She made both woven and sewn styles of baskets (J. M. Jones 1977).

Mattie Wheeler Howeattle, who was no longer living when the basketry project was done in 1976, was well known for her creativity and innovation. A prolific weaver, she was an influential force in the Quinault community for many years. Born in 1861 on the lower Hoh River, Mattie was the daughter of Quinault chief Bachalowsuk Wheeler. She married Quileute tribal member Washington Howeattle.

Nothing alive stays the same, and the dynamic blend of basket styles among the Quinault has changed over time and continues to evolve as a living art. Weavers keep experimenting with new materials, techniques, and the challenge of achieving a new shape. Quinault weavers today are keeping the respect for the old traditions alive and giving them a vital and exuberant new interpretation. The creative energies of the present generation will

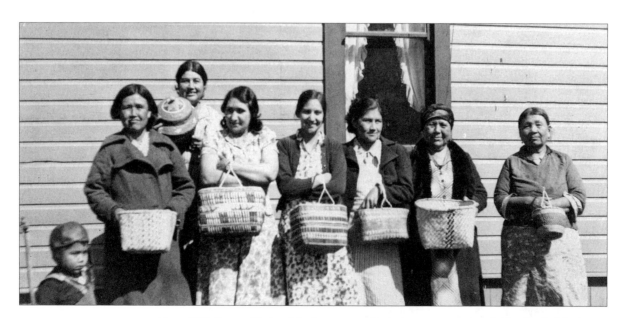

Figure 5.18. Group of Quinault basket weavers displaying an assortment of twined and plaited baskets. COURTESY NATIONAL ARCHIVES AND RECORDS ADMINISTRATION, PACIFIC AK REGION (SEATTLE) (RG75 BIA, PAO, TRIBAL OPERATIONS BRANCH—GENERAL SUBJECT FILES, TAHOLAH SCHOOLS 1940).

preserve the skills and carry on the traditions that encompass both convention and invention.

Notes

1. Mason (1904:23) states that the Quinault dyed beargrass with Oregon grape twigs and bark.

2. The Burke Museum of Natural History and Culture has a collection of Beatrice Black's baskets, purchased with funds provided by John Putnam. They can be seen on the museum's website (www.washington.edu/burkemuseum/).

Quileute and Hoh Basketry

JAY V. POWELL

Through the years there have been general descriptions of the traditional lifeways of the Quileute and Hoh River reservation communities. There have also been reports and studies that focused on their language, territory, hunting and fishing, plant use, myths and legends, music, spiritual beliefs, ceremonial life, traditional values, leadership, intertribal relations, community history, and archaeology. But this is the first comprehensive look at Quileute and Hoh weaving and basketry. As such, it is a chance to compile quotes, observations, generalizations, and tentative opinions about traditional and current Quileute and Hoh basketry and weaving. This chapter is based on my own inquiries and observations (made between 1968 to the present) and on published and archival materials of those who observed and recorded Quileute life: Albert Reagan (1905–1907), Leo Frachtenberg (1916), George Pettitt (1944 and 1950), Erna Gunther (1930s), and specific museum collections.

In 1968 the *po'oqwot'isq'wa*,[1] or old people, spoke "Indian" to each other over the phone, in the store, and on the street. According to their customs, they followed many of the old ways. The older generation still went out to hunt their elk when the devil's club berries were red, just as their folk knowledge said they should. Some bathed at the mouths of creeks when they needed to draw on their *t'axilit* (guardian spirit power). And they burned the effects of the dead in solitary ceremonials on the beach. In their homes, the parlor chairs of old women were surrounded by heaps of basketry materials in the process of being dried, split, dyed, soaked, and woven. In her past-prime Hudson automobile, Sarah Hines and her passenger, Nellie Williams, stopped to hand me a just-completed shopping basket of cedar bark and beargrass that Nellie had finished weaving as they drove through the village. Those *tałaykila 'wi'wisat'sopat* (old-time women) just wove baskets while sitting or riding, as if their fingers were on autopilot. Motel offices in La Push and the drugstore in Forks had a counter with woven basketry souvenirs for sale from $12 to $20 in the 1960s.

Baskets are a feature of life. Throughout the past forty years among the Quileute and the Hoh, I recall families stopping to fill up the trunk of their cars with *sit'say* (cattails) and *lok̲'way* (swamp grass) or sending their husbands and grandkids out to dig spruce roots. In May, groups would go down the logging roads to pull cedar bark, and on nice mornings later in the summer a carful of women of every age would leave the reservation for a run down to Quinault to gather *iba'* (beargrass).

The talented basket makers received regular calls from local people and Seattle collectors with orders for baskets. Some afternoons Pansy Hudson and I collected *x̲ak'* (beach ryegrass), and on other days I worked with Leila Fisher at Lower Hoh, recording Quileute basketry terminology. At La Push there were always baskets being made, and I listened to the old stories Lillian Pullen, Rosie Black, Bernice Jones, Hazel Bright, and the other talented basket weavers told. Many of those older

women knew how to make openwork and coiled basketry but stuck to producing the easier, quicker *ɬichc'hisa* (twined) basketry forms that had by then become the "traditional" Quileute and Hoh weaving style. For the most part, Native weaving focused on articles for sale, ceremonial use, and home decoration: large and small baskets, place mats, covered bottles and clamshells, match holders, V-shaped letter holders, and even conical rain hats.

And then one by one those basket makers started to pass away. Many of the women of that older generation had taught their daughters basketry. Their daughters and granddaughters continued to weave their first baskets, either in culture classes at the tribal school or "basket classes" in the community center.

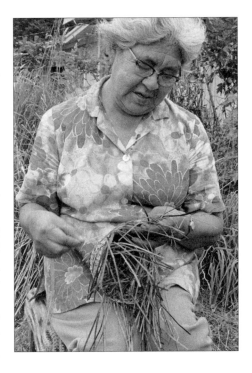

Figure 6.1. Sarah Woodruff Hines, weaving a basket.
PHOTO BY VICKIE JENSEN.

Figure 6.2. Design originally made to hold harpoon points; it came to be used as a marketable letter holder. Made by Carrie Gray. In the care of Olympic National Park, Pansy Howeattle Hudson Collection, no. 14174.

Some became technically good, even if not as quick as their elders were. A few of the weavers purchased their *sik'woya'* (cedar bark), and others enjoyed going out to pull the strips of bark off standing cedars or to harvest bark off logs in the mill sorting yards. Making baskets became a symbol of Native identity, a link with the ancestors. In 2005 Lela Mae Morganroth counted the number of Quileute and Hoh women who knew how to weave baskets and came up with 160, or approximately one-half of the adult female tribal membership. Clearly this is a traditional custom that is carrying on.

Figure 6.3. Lela Mae Morganroth. PHOTO BY JACILEE WRAY, COURTESY OLYMPIC NATIONAL PARK.

This chapter attempts to reconstruct and describe aboriginal basketry traditions among the Quileute and the Hoh, who share a common heritage. Two separate reservations were established for the Quileute and the Hoh in the late 1800s, but they share the same language, hereditary leadership, and cultural practices. Members of both groups recognize interrelatedness through an extensive genealogy, and residents of the two reservations have had a tradition of free movement back and forth for economic activities. This interrelatedness and movement between the two villages has resulted in basketry technology of the Quileute and the Hoh that is indistinguishable.[2]

The definition of basketry used here is consistent with the traditional Quileute and Hoh concept of weaving. This aboriginal conceptual category is based on the Quileute root *hokw-* (meaning "to weave," as in basketry, mat making, cedar bark clothing production, and blanket weaving). Such a definition expands the category of woven things beyond baskets but is responsive to the traditional Quileute-language cognitive category of woven things. This is consistent with the traditional semantic category of "woven things" recognized by Quileute speakers. All types of weaving could be discussed in this chapter, although the emphasis will be on baskets and basket making.

The assumptions and understandings about Quileute and Hoh basketry in this chapter come from the ethnographers listed above and from three main museum sources. There are a number of museum collections containing Quileute and Hoh basketry. The most extensive collections are at the Smithsonian Institution and include both the National Museum of Natural History's rich corpus of baskets collected by Fannie Taylor, donated in 1917, and collections at the National Museum of the American Indian, formerly the Heye Foundation. The Burke Museum at the University of Washington and the National Park Service at Olympic National Park in Port Angeles also have impressive collections. These collections vary in the amount of documentation their catalog records contain.

The first cultural observer of the Quileute was the notable Albert Reagan (schoolmaster, Indian agent, amateur biologist, sociologist, and ethnographer). Reagan

came to La Push in 1905 and stayed four years as the schoolmaster. Traditional life had already accommodated to new foods and trade goods. Reagan said he missed by ten years the baked Native "bread," *t'sok'wot'sit*, made by grinding fern roots and camas into a paste and baking it on a rock beside the fire. The arrival of potatoes, carrots, turnips, and flour had made it easier to cultivate a garden than to get up before dawn to hike to the prairies, dig roots all day, and then pack the roots home. But the Quileute and Hoh people still made traditional basketry.

Fannie Taylor, who lived at Mora, across the Quillayute River from La Push, donated more than two hundred Quileute baskets to the Smithsonian at the urging of Leo Frachtenberg in 1916. Although the weavers' names are not identified on the catalog cards, we know from Fannie's diaries and the Quileute tribal newspaper that she purchased baskets from weavers Julia Lee, Clara Eastman, Eva Howeattle, and Jennie Payne, the wife of Jack Hudson and the sister of Isabel Payne, and also from Suzie Morganroth, according to Suzie's grandson Chris.

Leo J. Frachtenberg taught at Chemawa Indian School in Oregon during 1916. Here he met Hal George (Quileute-Makah) from La Push, who served as Frachtenberg's guide and informant during a summer of fieldwork at La Push. Frachtenberg described the Quileute village as follows:

> The old people still walk around barefoot, even in winter time. Tattooing of arms has been forbidden by the Indian Office, so that the younger people are no longer tattooed. Older people do not speak English. They use Quileute and seldom Chinook Jargon. Even the children prefer to use Quileute outside of school hours. In their frail canoes,[3] they go out sealing 20–30 miles into the ocean attacking whales with their primitive weapons and sealing. (Frachtenberg 1916d:1:1)

At the time of Frachtenberg's research there were still elders alive who remembered pre-treaty times and aboriginal manufacturing customs and techniques. Frachtenberg's primary consultants regarding traditional Quileute and Hoh weaving were Mrs. Jim (Jennie) Black (the mother of Old Man Roy Black), Mrs. Carl (Sally) Black, and Arthur Howeattle.

During World War II, George Pettitt was stationed at the La Push Coast Guard base. Interested in cultural change, he made notes and later returned to do interviews and archival research that he used in producing a community history, *The Quileute of La Push, 1775–1945*. His notes include a real sense of culture change within the lifetime of Quileute still living when he was conducting his research. For instance, Morton Penn told him that twined rain hats were still being made when he was a boy: "His mother made them of split spruce roots, twined like a basket. The band of the hat was made separately and fastened inside the hat later. These hats, and the rain capes also, were made water-repellent . . . by soaking them in an infusion of boiled hemlock bark" (Pettitt 1950:10). Pettitt's description of basketry types reveals that basket manufacture had become more commercial within the thirty years since Frachtenberg's visit. Only five types of basket were being made in the mid-1940s (ibid.).

Baskets

I have drawn extensively from my own field notes based on interviews and interactions with Quileute speakers at La Push and Lower Hoh between 1968 and the

present. We have identified the types of basketry made by the Quileute and the Hoh. Reconstructing with reasonable certainty the taxonomy of distinct types of basketry that Quileute-speaking basket makers of this period distinguished, the following types of baskets were found in the descriptions of Frachtenberg (1916d) and Pettitt (1950). I checked these against the memories of basket weavers Ethel "Rosie" Black, Hazel Bright, Leila Fisher, and others during the late 1960s. The traditional types of Quileute and Hoh baskets that are identified within the Quileute language include these:

a'awił—A small basket for filling a larger basket while picking berries.

baxuy'—A twilled vine maple basket. Often used for dry storage, these baskets were made in sizes from tiny to very large, but the most common had a "square bottom and round top" and "stood about 18″ high" (Pettitt 1950:10; Frachtenberg 1916d:1:49).

itbay (pl. *i'itbay*)—Small and medium-sized burden baskets that were twilled of split vine maple withes in a truncated cone shape (i.e., roughly the shape of an ice cream cone with the bottom 60 percent cut off). They were used for carrying small burdens with a tumpline, *hak'wakstił* (strap for carrying something on one's shoulders) or a *p'axat'sidaxayit* (braided strap for packing). The burden basket straps were woven of cedar bark, dune wild ryegrass, or beargrass and, later, recycled fabric or clothing. The strap was about 1 1/2 inches wide and worn across either the forehead or the front of the shoulders.

ita'abay—Baskets made of cedar bark and beargrass, with thick cedar bark strips between rows of beargrass and the design.

ḵa'wats—Large openwork burden baskets woven of cedar withes and twined over and under with split spruce roots. Sometimes vine maple splints were substituted for cedar withes. According to Frachtenberg (1916d:1:156–58), "the weave was wrapped twined . . . and was open and coarse." The weaving was two-strand, wound in either a conical or an oblong shape. They were used for carrying heavy loads (like wood) and always had a tumpline attached. A single-strand, lighter version of this utility pack basket was called *ho'osolabay* or *ho'ołbay* (Pettitt 1950:10).

k'wayic'hisa'—"Checkerboard" baskets of interwoven cedar bark strips. These baskets are sometimes also called *k'woxwo'id* (wallet). They were always oblong-shaped and were woven in such a way that they could be laid flat and folded like gunnysacks, so that they took up as little space as possible when traveling. Usually made of interwoven strips of cedar bark approximately one inch wide, the baskets were two to three feet in diameter and eighteen inches high. They were used for storing dried fish, roots, and other edibles (Pettitt 1950:10; Frachtenberg 1916d:1:159–61).

łichc'hisa—A category that includes two types of baskets: the small twined round or oblong basket (the latter generally with a lid) and the "shopping bag" basket, both of which usually had beargrass or raffia designs.

pikwo'—A spruce root watertight basket. Spruce splints were scraped and very closely twined, and the baskets were usually about twelve inches high but varied in diameter. When each section (base, side, lip) was completed, protruding tiny splints were cut off and the material was beaten with a smooth stone. To make the basket watertight, an infusion of boiled hemlock bark was poured over it (Pettitt 1950:10). However, if the basket was intended for cooking (hot stones were used to heat the water in the basket to a boil), it was simply made from thin spruce splints twined extremely tightly and then treated with hemlock juice (Gunther 1974 [1945]:18).

Figures 6.4 (*left*) and 6.5 (*right*). Figure 6.4: Twined basket donated by Fannie Taylor, Smithsonian no. 299151. Figure 6.5: Shopping basket in the care of Olympic National Park, Pansy Howeattle Hudson Collection, no. 14177.

po'okw—A basket made of hemlock or alder bark for storing elderberries that could be enjoyed during the winter. After being harvested, the bark was immediately cut into large strips (2 feet by 4 feet), and incisions were made to indicate the folds that would give the basket its shape. The bark was then heated over an open fire, which made it pliable. The basket was bent into the shape of a container (bottom and sides) and stitched with spruce roots. The basket or box was filled with elderberries and covered with soft maple leaves (*la'axałchiyił*) or wild currant leaves (*t'łolo'ołchiyił*). A piece of fitted bent bark would be set on the top and bound in place with cedar bark twined rope. Then the basket was buried in a stream or in a hole dug in a creek bed, weighed down with a flat stone, and covered with gravel and mud. Such baskets were also used for boiling meat on hunting expeditions with a hot rock added to heat the water.

t'at'adebay—According to Mrs. Carl (Sally) Black, a type of basket more recently made by the Quileute and the Hoh that was woven with beargrass inserts.

t'łopitbay—A basket made of cow parsnip stems.

t'salasbay ("lace basket")—A fine grass basket made of *lok̲'way* (swamp grass) using the crossed-warp twined weave. This basket was traditional among the *Kwidayiłt'* (Quinault) and introduced to the Quileute by the Hoh.

t'sikbay—According to Frachtenberg, a type of basket the Quileute speakers learned how to make from the *Kłalabt'* (Klallam). It is uncertain what type of basket this was, but Frachtenberg (n.d.) states that it was a coiled basket that was introduced to the Quileute by the Klallam.

MATS

Mats of various types were made, most often using the checker "over-under" weave (Frachtenberg 1916d:1:162–65).

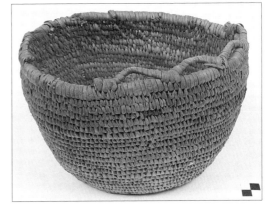

Figure 6.6. Quileute coiled basket. Frachtenberg Collection, courtesy National Museum of the American Indian, Smithsonian Institution (57847). PHOTO BY NMAI PHOTO SERVICES STAFF.

When the Quileute and the Hoh camped on the prairies, they made *hokwtit-ti* shacks, or "mat houses," consisting of a pole frame with a plank roof and mat walls. Women made mats for sleeping, laying out food spreads, padding canoe floors, and other purposes. They used a long wooden or elk bone mat needle (*t'sikkił*) to shape the reeds into rows, and a mat smoother to flatten out the fibers. Mats were sometimes ornamented with simple designs.

Figure 6.7. Quileute mat smoother. Frachtenberg Collection, courtesy National Museum of the American Indian, Smithsonian Institution (057567). PHOTO BY NMAI PHOTO SERVICES STAFF.

pała'a—A general term for a mat, meaning "flat."

hokwtit or *sit'saytit*—The most common type of mat, made of cattail. (The suffix -*tit* means "woven mat," and *hokwtitt'sis* means "to weave a mat." The suffix -*t'sis* means "to make something.")

xapo'tit or *chida'axtit*—A mat of tule or bulrush (*xapo'* or *chida'ax*).

x̱*its'itit*—A mat of dune wild ryegrass.

lok̲'waytit—A mat of slough sedge or basket sedge (swamp grass).

wilo'otit—A mat of cedar bark (checkerboard interweaving) for lining the floor of a canoe. The name means "long mat." This type of mat was also used as a sail on oceangoing canoes.

t'apiłit—A mat for sleeping on the floor. The name means "layered mat"; a pile of these mats was often used for sleeping.

Quileute and Hoh Basketry Techniques and Customs

There has been some query regarding the Makah origin of some types of Quileute and Hoh basketry. Several references in the early ethnographic notes on Quileute and Hoh lifeways suggest that some types of basket making were learned from the Makah during the contact period (1855–1920) or precontact times.

In his discussion of Quileute (including Hoh) basketry, Frachtenberg wrote:

> According to Mrs. [Carl] Black, Makah basketry was introduced among the Quileute some 40 years ago [ca. 1876], after the wars between those two tribes had stopped. Quileute women used to accompany their husbands and fathers to Neah Bay on fishing trips. While there they learned the Neah Bay basketry and introduced it among the Quileute. Mrs. Tommy Bower, still living [in 1916], is one of those who learned this type of basketry [*łichc'hisa*] while sealing with her father at Ozette and taught it upon her return to the Quileute women. (1916d:1:32)

Pettitt reported:

> Many of the weavers will insist that such baskets and the designs on them have always been made that way and that they learned how to make them from their mothers or grandmothers. It was not until Joe Pullen happened to be present while weaving was under discussion that the subject got down to brass tacks. He simply remarked, "What has been said may be true, but what I remember is different. I don't think baskets were made like this fifty years ago. I think we learned to

make them from the Makah." Thus brought down to earth, the women agreed that maybe he was right. (1950:53)

There are other references to the Quileute's having learned cedar bark basketry, and mat making in particular, from the Makah (Gunther 1974 [1945]:20), but these comments are assertions, not arguments. There was a common northern bias in the early 1900s, which continues among even some well-informed anthropologists up to the present, that presumes that the further north one goes up the Northwest Coast, the more developed the art becomes. This view results in comments such as the following by Frachtenberg, which reflects this bias: "The really nice and artistic baskets are those introduced by Neah Bay Indians. The old Quileute work was coarse, crude and primitive and lacking in any artistic designs" (1916d:1:34).

The twined and twilled baskets made by the Quileute and the Hoh during the contact period are so complex that it would seem unlikely that these tribes did not practice all of the usual basketry types of the Olympic Peninsula area in precontact times. This includes the basketry types mentioned above, except for the *łichc'hisa* and the *t'sikbay*. In precontact times, basket makers didn't create the various types of baskets simply for artistic variety. For the most part, each basket type had its own critically important features. The *pikwo'* was waterproof. The k̲a'wats was tough openwork that allowed water to drip through the open warp and weft. The k̲'wayic'hisa could be laid flat and folded for easy storing or carrying while traveling. The *po'okw* could be stored underwater for months at a time. And the *itbay* and k̲a'wats were the burden baskets, often with a tumpline attached. As the technology and materials of mainstream North American life arrived at La Push and the Lower Hoh River area, necessities that had previously been produced by weaving traditional baskets stopped being made, their function now being provided by modern bags, boxes, pots, and cloth objects.

Baskets soon became highly sought tourist trade items. The sale of baskets was a source of income available to Native women, and the Quileute and Hoh women turned exclusively to weaving the *łichc'hisa* baskets favored by the tourists. It was this type of basket that the Quileute and the Hoh had learned to make from the Makah by early contact times. Thus it is correct to say that the type of baskets that the Quileute and the Hoh primarily make nowadays (i.e., *łichc'hisa*) is thought by the Quileute themselves to have been learned from the Makah. But it is definitely incorrect to suggest that the Quileute and the Hoh did not have a basketry tradition of their own in precontact times or that they learned all of their traditional basketry from the Makah.

The Quileute and the Hoh also remember that they learned the use of design patterns in *łichc'hisa* basketry and a number of specific design patterns first from the Makah. They learned the style of *pałc'hisa* bag weaving from the Makah and the *t'sikbay* style of weaving from the Klallam.

The designs that were and still are woven into the twined cedar bark, beargrass, and raffia *łichc'hisa* basketry include these:

kwat'ła—Whale.

abiyat hixat ta'awaxw—Whaling canoe and harpooner.

kwalil—Seagull.

ka'ayo' (chasa) bayak—Crow or raven.

a'axit—Mountain.

xa'alax—Red lizard.

t'łot'oło'ot—Star(s).

kaxa'—Twins (stars or knots).

The Quileute women were "inventing" their own designs—for instance "twin knots" (probably *kaxa'*), according to Frachtenberg (1916d:1:32).

According to Frachtenberg, the Quileute and the Hoh originally used only various types of geometric designs and did not use motifs. The terms *kadok'wal* and *kalishsk'wayo* were used for zigzag patterns (possibly distinguishing straight zigzag lines from rounded ones). *Ayaxitska*, a design known to be "like little mountains," was a string of triangles used on the sides and tops of baskets. *Tik'wa*, "a rope," was a running design resembling a twisted rope. Another common type of design was strips of horizontal colored rows near the top and bottom of the basket (Frachtenberg 1916d:1:32). "Weaving the various designs, some women attain such a skill that they do not have to have a model or template before their eyes when actually weaving," Frachtenberg observed. "Their skill is great and their fingers nimble" (ibid.: 1:36).

Weaving Materials

Baskets were made of the following materials:

sik'woya'—Cedar bark.

lok'way—Swamp grass, slough sedge, or basket sedge.

iba'—Beargrass.

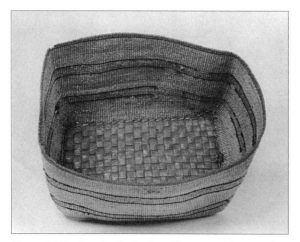

Figure 6.8. Basket of cedar bark and beargrass. Museum of the American Indian. PHOTO BY VICKIE JENSEN.

xitsi'—Dune wild ryegrass, which occurs on beach sand.

k'ak'ipat—Ryegrass, which occurs in open forest areas and clearings.

xapo' or bayakłał—Tule or bulrush. Both the hard-stemmed and soft-stemmed bulrushes were used. (The suffix -*łał* means "grass," and attached to *bayak* (raven), it forms a term meaning "raven grass.")

sit'say—Cattail.

chida'ax or chishobix—Probably the woodrush, obtained in trade from the Puget Sound area and cherished by Quileute basket makers.

k'ałba—Yellow cedar. The bark was used as red cedar bark was, but was even finer.

t'iłiyat—Split spruce roots.

lalakwtsił **or** *t'apsiyokwpat*—Split vine maple withes, which were commonly used.

t'lopit—Cow parsnips. Baskets were made from the stringy stems.

t'łoxwałał **or** *lapiya*—Raffia, which originated in Africa and Madagascar and is imported largely from the Pacific Islands today. In traditional times the Quileute and the Hoh made a similar material from the interior tendon of cattail stems; it had the same tape-like features that raffia has.

xak'—What Quileute weavers occasionally refer to as surfgrass. It is almost certainly eelgrass and turns black when dried or white when bleached.

Root baskets were round. All other baskets were square, rectangular, or oval. No birch bark was used in basketry, although two-inch-wide strips of hemlock bark were used to make pans for drying berries into berry cakes (Frachtenberg 1916d:1:32).

Many parts of a basket have Quileute names:

oc'hodokwat—The bottom.

k'aptit—The cover.

łibec'hix—The body, main part of the basket.

olilas—The walls.

tsa'axwa—The section with a beargrass design.

p'ilax'a—The bottom rows of the lid, where it bends down.

kadast'al—Handles on a basket. They were made of vine maple or spruce roots that were twisted and braided, then wrapped in raffia.

Each area of the basket requires a different type of weaving, as follows:

tikwo'wa—To weave with two strands (e.g., for basket handles).

p'axa'—To weave with three strands (e.g., for basket handles).

t'łapa—To interweave cedar bark strips as in the checker pattern on the bottom.

p'ilax'ats—To weave the edge of the top of baskets.

t'sipela'—To put the braiding on the top of a wide cedar bark row.

t'salasa'—To make the twined weave in openwork baskets.

The profusion of vocabulary for basketry is an indication of the value and importance associated with Quileute weaving in traditional times.

Dyes and Coloring

In Frachtenberg's time, weaving materials were dyed using modern aniline Diamond Dyes. Water was boiled and the dye added. After the grass had soaked in the boiling water for about two hours, the grass was taken out and hung in swatches until dry. The favorite colors were black, yellow, red, green, purple, violet, and brown (Frachtenberg 1916d:1:19).

Traditional dyes included a greenish black from the wolf moss,[4] while cedar bark was dyed black by dipping the strips of the bark into the black mud of tidal areas.

Mrs. (Sally) Carl Black used *la'wat'sakilipat* (literally, wolves' roots), described as a plant that grows in the mountains, has long green leaves with "a needle on the end," and stays green all year. It is probably wolf lichen, *Letharia vulpina*, which creates a brilliant yellow dye (Turner 1979:50–51).

HARVESTING AND PREPARING MATERIALS

Around May the cedar bark was pulled off the tree. The inner bark was separated from the outer bark by pulling the shaggy dark outer bark from the smooth orange inner bark. The outer bark was discarded, and the inner bark was rolled up and taken home to dry. When the material was needed, it would be soaked to make it pliable and then would be laid out flat, cut to the appropriate length, dyed, and, finally, split to the desired thinness. A technique for producing very thin strips of cedar bark was described (somewhat ambiguously) by Frachtenberg:

> To make very thin strips, the bark is cut with safety pins. It is soaked first to make it pliable. The bark is held in the left hand between thumb and index finger, safety pin in right hand. An incision is made with a pin and the thumb of the left hand is used as the marker of the desired width. After the required number of incisions has been made, the strips are loosened by means of the fingernail of the fourth finger of the right hand. (1916d:1:59)

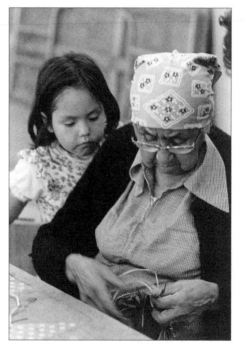

Figure 6.9. Rosie Black, cleaning cedar bark.
PHOTO BY VICKIE JENSEN.

Straw was split with a splitter (*wachałkwoł*), a three-inch-long wooden tool. The splitter was often carved with an animal design, and on the stomach of the animal two strips from razor blades were driven into the wood, the distance apart being the same as the width of the desired strip of beargrass, or "straw" (a general term often used by the old people to refer to dried basket materials). A good weaver sometimes had two or three splitters so she could split strips of different widths.

A vine maple withe (branch) was split into multiple strands as follows. An incision was made down the length of the branch with a sharp instrument, usually resulting in several long splints (strands). One side of the incised part was then held between the teeth while the other side was pulled down with the right hand, causing the two sides of the branch to split all the way into two halves. The thumb and forefinger of the left hand guided the split so that it would tear evenly. After the desired number of even splints had been obtained, the weaver used her teeth and fingernails to even up the split strands.

Spruce roots were dug with a digging stick called either a *k'woyo'* (mostly for edible roots and camas) or an *a'akwsiyat* (digger for basketry materials). Roots were also gathered when a spruce beside a creek or river had its roots exposed by bank erosion; these roots were usually dug by men and boys and pulled out from the base of the tree. The roots were harvested any time of the year and were split immediately and then hung in bundles to dry.

Figure 6.10. Double-headed splitter, from Pansy Howeattle Hudson Collection. Courtesy of Olympic National Park, catalog no. OLYM 14121. PHOTO BY GAY HUNTER.

Basketry during a Period of Cultural Change

There are a number of recorded descriptions of the experience of Quileute and Hoh basket weavers during the contact period (1855–1920), when traditional lifeways were abandoned as a result of the availability of new materials, trade items, and technologies; and the transition period (1920–75) when, with a few exceptions, the last of the traditional Quileute and Hoh weavers had died or were very old.

THE CONTACT PERIOD (1855–1920)

The Quileute and the Hoh certainly had opportunities to encounter Russian, European, and American explorers and traders before the treaty negotiations of 1855. Northwest Coast tribes already had copper, obtained by trade from the north, and iron from flotsam that was carried to Olympic beaches from the Orient by the Japan Current. The Spanish and the British at Nootka Sound traded items that certainly made their way down the coast to the Olympic Peninsula. The forts at Astoria and Nisqually were sources for trade goods that worked their way north. However, for the Quileute and the Hoh, regular contact and access to trade items was not established until treaty times in 1855.

Aboriginal technologies were extremely labor-intensive, both to make items and to use them. More access to new materials and manufactured items resulted in reliance on trade goods from the outside rather than putting in all the hard work to produce them at home. Knowing that such items as a gunnysack existed did not mean that the old people could stop making storage baskets; but when a regular supply of gunnysacks was available, it made gathering materials and weaving baskets for carrying and storing unnecessary. Gradually, during the second half of the 1800s, trade items replaced traditional utilitarian items, including baskets, in Quileute and Hoh life.

It is possible that a truly informed basketry expert could examine baskets from this period attributed to the Quileute and the Hoh and detect differences in technique and style, differences that would allow us to determine with confidence the baskets of particular skilled weavers. We could then reconstruct lines of development and point to innovators and high points of expertise. However, accomplishing this is highly improbable because the weavers' names are almost never identified in collections of Quileute and Hoh basketry, although the provenance is recorded.

We do know the names of several respected Quileute and Hoh basket makers during this period, if not their distinct technique and style. In 1914 Fannie Taylor, postmistress of Mora near the Quileute Reservation, mentioned Ella (Mrs. David) Hudson, Julia Lee, and Susanna (Susie) Payne Ross.

Frachtenberg (1916d) consulted with weavers: Mrs. Carl (Sally) Black, Mattie (Mrs. Washington) Howeattle and her oldest daughter, and Jennie Hudson. Pettitt (1950) regarded the oldest and most facile basket makers of his day (pre-1920) to be Elsie Payne, Annie Hopkins, and Mrs. Charles Sailto. Hal George, quoting his grandmother Susie Payne, spoke of *didisatskal hikłti* ("the expertness one boasts about"), implying that the quality of a woman's baskets and mats was the criterion by which a woman was evaluated in traditional times. It is likely that most women along the Quillayute and Hoh rivers were accomplished and versatile weavers in the early 1900s.

Ceremony and Ritual as an Aspect of Traditional Basket Making

It is impossible to understand the lives of traditional Quileute and Hoh basket makers without a sense of their belief system. Ceremony and ritual were important to basket weavers in the old days. The Quileute and Hoh *tałaykila pot'sokw*, "old-time people," believed that spiritual beings and powers were totally natural—not supernatural. You just couldn't see them. There were two types of spiritual powers that controlled different outcomes: the nature spirit, *T'sik̲'ati*, who controlled whether the other living things of the world (fish, birds, animals, sea mammals, great trees, berry bushes, root plants, and basketry reeds) submitted themselves for the people's subsistence and use; and each person's guardian spirit power, or *t'axilit*, which, if gratified by the character and actions of its human ward, empowered that individual to succeed or excel in everyday activities. Success as a basket maker required the help of both the nature spirit (in gathering basketry materials) and her guardian spirit (in terms of skilled, successful outcomes of her efforts). Different rituals were necessary for a good relationship with both of them.

T'SIK̲'ATI—THE NATURE SPIRIT

The old people prayed regularly to the great nature spirit, *T'sik̲'ati* (which means "earth, world, and nature," as well as being the name of Nature's Power). Albert Reagan, the schoolteacher at La Push from 1905 to 1907, wrote that the Quileute thought of *T'sik̲'ati* as creator, but that is not correct. Quileute cultural narratives (mythic stories) indicate that the traditional Quileute believed that the world had always existed, even though physical features were changed during the time of beginnings by *K̲'wati* (the shape-changing transformer who turned wolves into the ancestors of the Quileute people and taught the ancestors of the Hoh to walk on their feet rather than their hands).

T'sik̲'ati responds positively to being appreciated. Thus those basketry material harvesters who prayed to the nature spirit thankfully were thought to be more successful than those who simply took what the great Nature provided without prayerful recognition. Hal George (b. 1894) was taught that a person should pray both before and after harvesting, fishing, sealing, whaling, or hunting. *T'sik̲'ati* was in

charge of the outcome of these activities. Without *T'si̱k'ati*, anyone setting out to gather the food and other resources of the world could be unlucky, foiled, jinxed, or skunked. The nature spirit and the appropriate rituals were known to be necessary in the important enterprise of basket making.

T'axilit—Guardian Spirit Powers

Frachtenberg found that Quileute basket makers had rituals and cultivated a lifestyle that involved staying in a right relationship with an empowering guardian spirit, *t'axilit*, who could make them skilled and successful weavers. For instance, basket makers who wanted great basketry skill (and skill in other aspects of their life) bathed regularly and vigorously, since guardian spirits were offended by individuals who were not clean. Basket makers engaged in ceremonials with the goal of staying in a right relationship with their *t'axilit*, for the old people felt that humans could not succeed in even the most mundane activity without their spirit power's aid. In order to have success in designing and weaving fine baskets, the basket makers honored their individual guardian spirits and did things that they knew would please the spirits. One of the guardian spirits of weavers was believed to take the form of cedars with extremely high lower branches (so bark pullers could take off long lengths of bark). Other basket weavers' guardian spirits were redwing blackbirds (which frequent cattail marshes) and especially birds such as wrens and orioles that weave elaborate nests. Sarah Woodruff Hines told me that when she was a young girl, her mother sent her out in the spring with small tangles of cedar bark threads (about the size of a golf ball) to leave in conspicuous locations to help birds weave their nests. Sarah said that parents set basket traps to catch birds and then, before releasing them unharmed, rubbed the fingers of infant daughters with the feet and beaks of the birds because that was how the birds wove nests, with only their feet and beaks. William "Big Bill" Penn was told that young women even marked their bodies as a form of contagious magic by tattooing overlapping lines on their fingertips (like tic-tac-toe designs, but symbolizing interwoven threads). These indelible marks were made by rubbing a needle-thin bone in soot and then passing it under the skin. Big Bill smiled as he told me, "*Tsixa'li k'itasxaɬ*" (It worked every time).

 Quileute folklore included other ways for women to become expert weavers. For example, the area around the mouth of the Quillayute River was inhabited by giants, monsters, and mysterious beings such as *Bask'alit'iɬxw*, a woman who lived in heavy brush upriver from the village of La Push. Any woman who caught sight of her would be taught to be an expert basket maker. And Leo Frachtenberg recorded *Ba̱k'wots* as a spirit who causes the owner to never tire of making baskets or mats (Frachtenberg 1916d:7:21).

The Transition Period (1920–75)

The last monolingual Quileute speaker was Hazel Bright, who was born in 1885 and died in 1971. She told me that she was the last of the people able to make the four most demanding types of basketry: *baxuy'*, *itbay*, *ḵa'wats*, and *pikwo'*. Hazel made all of these types of baskets in her life, and her home contained a collection of various types of baskets that she could make but had not actively produced for decades. She

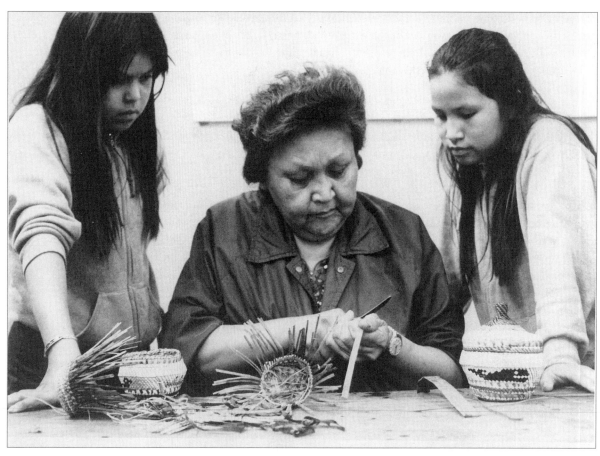

Figure 6.11. Bernice Jones and students. PHOTO BY VICKIE JENSEN.

explained that she felt basket-making skills were known by all of the *taɬaykila pot'soḵw*, "old-time people," and when those vestiges of the old ways had been forgotten, the old ways would truly be dead. A few contemporaries claim to be able to weave one or more of these types of basketry, but no one can make all of them. Hazel Bright was right. That aspect of traditional weaving seems to have passed on with her.

Still, weavers continued to use their fine baskets for utility. One morning in 1968 Bernice Jones was hanging up her laundry with clothespins stored in a small *ḵ'wayic'hisa'*, a cedar-bark-strip bag. When asked to trade her clothespin holder for a new commercial one so the original could be put in the eventual Quileute museum, she said, "Oh, that was made by my auntie. Maybe I'll keep it." The bag, which was tied to the clothesline, deteriorated over the years. Bernice's generation still thought of baskets as useful objects rather than objets d'art.

Quileute Basket Making according to Pettitt

While George Pettitt was living in La Push in the mid-1940s, he made the following observations, which give us some insight into community basket-making activities and insider perceptions.

A few of the oldest weavers, among them Mrs. Elsie Payne, Mrs. Annie Hopkins, and Mrs. Charles Sailto, still know how to make these baskets, notably the carry-

ing basket with a tump strap that goes around the forehead. But these weavers and others recognized as successful basket-makers devote most of their time to what may be called "tourist baskets."

. . . The designs used are certainly traditional in motif, for they consist largely of canoes with paddlers, whales, ducks, Tlokwali masks, and geometrics. A few, however, are confessedly modern: roses and other flowers, elk or deer heads with antlers, and whorls or pinwheels. But these are often accounted for in a traditional manner: they were dreamed about or came in a flash, and were then worked out secretly on trial baskets which are kept hidden and used as weaving guides. . . .

. . . Most of the baskets made at La Push are traded for groceries or cash at Charles Howeattle's or Tuttel's Trading Store. A few are sent away on consignment to stores in distant cities. The prices obtained bear little relation to the labor expended in making them. The miniature baskets which may take several hours to complete sell for 35 to 50 cents. Shopping and sewing baskets which consume several days of labor sell for only $4.75. The largest and most elaborate of the baskets, many of them beautifully worked and well designed, seldom sell for more than $8.00 to $10. All the weavers state that baskets are worth making only if one has nothing else to do. However, there is an element of self-satisfaction in the production of fine baskets and in gaining a reputation for such work, which compensates to a considerable extent for the limited financial return.

Not all Quileute women were basket-makers. . . . Among those usually listed by the tribe as good basket-makers [in 1944], in addition to the three already mentioned, were: Mrs. Roy Black, Mrs. Leven P. Coe, Mrs. Grace Jackson, Mrs. Stanley Gray, Mrs. Agnes Penn, Nellie Williams, Mrs. Beatrice Scott Hobucket Ward, Mrs. Tyler Hobucket, and Mrs. Charles Howeattle. It is doubtful, however, whether the best of them made more than $100 a year by weaving. Nellie Williams estimated that she did not make more than $50 in 1944, and Mrs. Coe computed her sales for that year at less than $75.

The money derived from baskets, moreover, is not clear profit. Most of the women gather their own mud grass [lokʼway, slough sedge], a brownish material, found locally, which is used for strength; but the cedar bark and the elk grass [ibaʼ, beargrass] are commonly purchased from people at Queets or Neah Bay at from 50 cents to $1.00 a bundle. The elk grass gives color to the baskets, either white when bleached and used natural or any color of the rainbow when dipped in dye. The bleaching is done in the sun, usually, though a few weavers speak of the efficacy of a little moonlight as well.

Certain totally foreign industries give indication of developing at La Push among the basket-weavers. A considerable market in lapel ornaments [such as] . . . tiny straw hats with pins on the back . . . are looked on as strictly commercial products. The makers are proud of such work, but in rating the handiwork of the village, proficiency in this field is seldom mentioned. The criterion is always baskets, and ability to make the old utilitarian carrying basket rates higher than ability to make the modern decorated basket. Among the modern baskets, furthermore, the simplest and least colorful, constructed

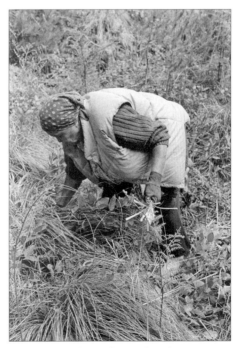

Figure 6.12. Lillian Pullen, picking beargrass.
PHOTO BY VICKIE JENSEN.

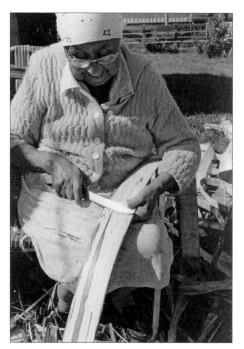

Figure 6.13. Rosie Black, beginning a basket.
PHOTO BY VICKIE JENSEN.

entirely of cedar bark[,] are often praised most highly and handled with more deference. (Pettitt 1950:54)

Contemporary basketry was a symbol of Native identity. There were hundreds of Quileute and Hoh basket makers during the transition period. These women wove baskets the way other women of the period knitted—constantly, in all situations, and, for the most part, without seeming to think about it. Women kept their hands busy on a basket while they chatted, rode in cars, taught classes, waited, read the paper, and even walked on the beach. Lillian Pullen and Rosie Black had a good-natured contest to see who could complete a shopping basket first while they concentrated on producing and recording the words and phrases for the book project *Quileute for Kids: Book 5*. Rosie won. That generation wove baskets with a skill based on decades of practice, and they wove basketry because it was a value-laden activity that gave them identity.

The difference between the early weavers and contemporary basket makers is skill, speed, and, to some extent, purpose. These days there are basket makers on both the Hoh and Quileute reservations that make basketry for spending money, for gifts, for creative enjoyment, and for the pleasant repetitive activity involved in hobbies. Also, and possibly primarily, contemporary Quileute and Hoh weavers make baskets because doing so is a symbol of Native identity, just as using words and phrases in Quileute serves as a symbol of Quileute and Hoh tribal identity. Pearl Woodruff Conlow once said: "Sure, I can make baskets. Mum made baskets all the time, so I wanted to know how to do it. I learned, but I never really enjoyed it and I make really poor baskets. But you can't say you're a Quileute [woman] if you don't make baskets."

It's a rare week at La Push and Lower Hoh River when there isn't a class or group of women getting together to work on baskets in one of the villages. Late spring, summer, and fall continue to be harvest time to strip *sik'woya'* (cedar bark), gather *iba'* (beargrass) and *lok̲'way* (swamp grass), and try to collect a couple of bundles of *sit'say* (cattail leaves or fronds) without getting one's shoes soaked. What seems to have changed is that there are few living rooms anymore that have chest-high piles of basketry materials alongside and behind the basket weaver's favorite chair. Nobody keeps their clothespins in an old basket anymore. The basketry is displayed on shelves behind glass cabinet doors. Baskets are showpieces, and each has a story. There is no end of Quileute and Hoh basketry in sight. It is not an endangered cultural trait. What has changed over the generations is the meaning of baskets, the values associated with the craft, and the objects themselves.

Notes

1. The orthography regularly used for writing Quileute has been slightly altered for transcribing Quileute words and phrases in this chapter's nonlinguistic treatment of basketry. Please note the following phonetic conventions.

 Quileute has a four-vowel phonetic inventory: *i*, *o*, *a*, and *a̱*. Each of these vowels has several different phonetic actualizations, depending on the sound around it:

i	The *ee* sound in "seed," the *i* sound in "bit," the *eh* sound in "Pepsi," and the *ei* sound in "weigh"
o	The *oh* sound in "rope" and the two different *oo* sounds in "boot" and "look"
a	The *ah* sound in British "father" and the *uh* sound in "but"
a̱	The *a* sound in "bat"

 Some details about Quileute consonants and their pronunciation may also be helpful:

 1. Quileute distinguishes a set of "back" *k*-type sounds, which are pronounced at the back of the mouth. These back *k* sounds written with an underline. So you will notice both *k* and *ḵ* and both *x* and *x̱*.

 2. Quileute also distinguishes plain sounds from "glottalized" versions that are pronounced with an audible click or snap. The explosive versions have been written here with an apostrophe. So you should distinguish *p* from *p'*, *t* from *t'*, *k* from *k'*, and *ḵ* from *ḵ'*. The language also distinguishes *ts* from *t's*, and *ch* from *c'h*.

 3. Quileute has rounded versions of some consonants, pronounced like a sequence of *k* and *w*, as in English "queen." These consonants include *kw*, *k'w*, *ḵw*, *ḵ'w*, *xw*, and *x̱w*.

 4. Quileute has whispered sounds that do not occur in English. So you will notice the barred *l* (*ł*). To pronounce a word beginning with *ł* (e.g., "leap"), just blow out at the beginning of the word. You will also notice *x* and *x̱*, which are pronounced like the German *ch* sound in *ich* or the Scottish *ch* sound in *loch*. To pronounce them, set your mouth as if to pronounce a word that starts with *k* (e.g., "keep") and then simply blow.

 5. Quileute words also have glottal stops, written with an apostrophe. Such "stop sounds" can occur between vowels such as *-o'o*, which is pronounced like the expression of worry that English speakers write as "oh-oh." Glottal stops also occur before consonants in Quileute words.

 Those interested in a more detailed primer on Quileute pronunciation should consult Powell and Woodruff's *Quileute Language: Book 1* (La Push, Wash.: Quileute Tribe, 1974) or *Quileute Dictionary* (La Push, Wash.: Quileute Tribe, 1980).

2. It is clear from the archival and folk-historical record that the people of Hoh River originally spoke Quinault. The Hoh River people of the late eighteenth and early nineteenth centuries intermarried with Quileute speakers of the greater Quillayute River watershed to the north. As they intermarried, their children grew up bilingual, speaking both their father's and their mother's languages. When this bilingualism was generalized in the Hoh community, the Hoh chose to identify themselves as Quileute speakers rather than Quinault speakers. In the course of time, the Hoh identified themselves totally as descendants of Quileute speakers rather than the Quinault.

3. Canoes were definitely not frail.

4. Wolf moss is listed by Mason (1905:28) as *Everina vulpina*, which would be *Letharia vulpina* today. Mason notes the color as canary yellow. Perhaps the greenish color comes from *Usnea filipendula* (beard lichen). Nancy Turner states that some Coast Salish people used a species of *Usnea* to make a dark green dye (1998:49).

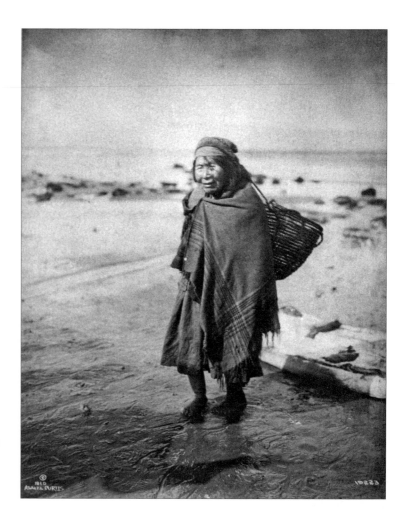

Figure 7.1. A Makah woman on a beach with an open-weave burden basket supported by a tumpline. PHOTO BY ASAHEL CURTIS, 1910. COURTESY UNIVERSITY OF WASHINGTON LIBRARIES, SPECIAL COLLECTIONS, NA584.

The Evolution of Makah Basketry

NILE R. THOMPSON and CAROLYN J. MARR

Baskets have been integrated into all stages of Makah life, from infancy to death.[1] Traditionally, just after birth an infant was placed in a cradle, woven either from cedar bark or made of wood, and there the child spent almost all of its first year of life (Swan 1964 [1870]:18). At a young age Makah girls received instruction from the elder basket makers on how to construct small baskets, which they would carry on berry-picking excursions into the woods, or to the shore at low tide in search of shellfish (ibid.: 15).[2]

As adults, women made a variety of baskets, each of which was constructed to serve a fairly specific purpose. Some were used for gathering berries, others for gathering shellfish. Larger baskets were designed for transporting or storing particular items. Individuals were not equally skilled in making baskets, nor did everyone make every type.

A large twined open-weave basket proved to be the most useful container for food-gathering tasks because it was lighter-weight than a box and allowed for drainage of excess water (Gunther 1935:37). According to one observer of Makah culture, the burden basket with its long carrying strap (or tumpline) symbolized women's work in the traditional division of labor (ibid.). Makah men were known to gather shellfish with handled baskets at low tide (McCurdy 1961:107). Food was stored in baskets above sleeping areas that lined the walls of the traditional home (Swan 1964 [1870]:5–6). Baskets were given away at potlatches, both as presents and as containers for guests taking food home. The Makah traded for types of baskets they did not make. For example, they traded with the Quileute for vine maple storage baskets because that tree "does not grow [near] Neah Bay" (Ada Markishtum, in Gunther n.d.).

During a woman's pregnancy she tended to stay in the house and keep still. This was the time to devote one's efforts to basket making, a sedentary activity (L. J. Goodman and Swan 2003:69). Women were warned, however, that the wrapped-twining technique was not to be used at this time, because to do so would cause the umbilical cord to twist. After her child was born, a mother could continue to work on making baskets while rocking her child to sleep in a cradle. The rocking was accomplished by using strings attached to the top of a pliant pole (Swan 1964 [1870]:7). One end of the string could be manipulated by the mother's foot, while the other held fast to the cradle, so that by moving her foot she could produce the rocking motion. In 1902 Samuel Morse, then superintendent of the Indian Training School at Neah Bay (Marr 1987:7), took a series of photographs of Mary Butler rocking her baby girl, Lyda Butler (Colfax), in a wood cradle while weaving; see Kirk (1986:109) for an example.

Presumably, all Makah women spent some time weaving. Those families who held slaves had extra help; just as male slaves assisted their owners in fishing, female

slaves contributed to the manufacture of baskets and mats (Swan 1964 [1870]:10–11). Older Makah women, once free of tending young children, created a quiet space for basket making:

> My great-grandmother was always busy, either making baskets or cutting fish or drying fish. Sometimes when she'd be tired of staying inside, she'd go out back where we had a shed, and she'd build a fire there. She would pack the cedar mat and spread it out and sit by the fire and make her baskets. All the old people seemed to have that habit. They'd build a little fire, sit around there, and make their baskets. (Helma Swan, in L. J. Goodman and Swan 2003:68)[3]

Makah burial practices included placing a portion of the deceased person's property on top of the coffin. Baskets continued to be part of these objects even after European contact. A woman was buried with "beads and bracelets of brass, iron, calico, baskets, and her apparel" (Swan 1964 [1870]:83).

Makah basketry and its role within Makah culture have always been in a state of evolution due to environmental and economic influences. To understand how changes have come about, one must look at both the prehistory and the history of the Makah.

Background on the Makah

The Makah are residents of Cape Flattery, the northwesternmost point in the contiguous forty-eight states. A relationship between people and place is expressed in the Makah name for themselves, *qʷidiččaʔa·tx̌* (*qWeedeecHcHahʔahtX*), or "Cape People." The Makah (a name given them by the Klallam) moved to their present territory from a prehistoric homeland on Vancouver Island. Their closest affiliations in language and culture are with the Ditidaht (earlier called Nitinaht). They were more distantly related to the other Nootkan-speaking groups on the west coast of Vancouver Island, formerly called Nootka but now referred to as Nuuchahnulth.

The Makah actively engaged in trade and enjoyed a central position in the transfer of resources along the Pacific Coast between the mouth of the Columbia River and Vancouver Island. Swan (1964 [1870]:17–42) provides the following description of the flow of goods, although it is certainly not exhaustive. From the south, the Makah got vermilion, or cinnabar, from the Chinook, sea otter skins from the Quinault, and a "yellowish clay or ochre" that the Quileute baked in the shape of a ball, which was used for painting faces, canoe interiors, and hair seal buoys used for whaling. From Vancouver Island, the Makah got dried cedar bark, dried salmon, and, from the Clayoquot, bentwood cedar boxes and yew paddles. The Makah also served as middlemen in the flow from Vancouver Island of large canoes (from the Ditidaht and the Clayoquot) and dentalium shells and slaves to the tribes to the south. Whale oil and dried halibut were traded both to the north and to the south by the Makah, while whale blubber just went northward. The Makah imported camas from both the south and the north.

The first recorded contact between the Makah and Europeans was in 1788, when a ship captained by English navigator John Meares anchored off Tatoosh Island (Gunther 1972:56–57). The Spaniards came to Neah Bay in 1792 and established

a short-lived outpost. We do not have Makah population figures for this time, but by 1840 the Hudson's Bay Company at Victoria recorded a Makah population of about 1,000. In 1853 a smallpox epidemic greatly reduced the population. In 1855 the Makah signed the Treaty of Neah Bay, which established the Makah Reservation. A census taken in October 1861 recorded 654 Makah in five winter villages: Baada, Neeah, Waatch, Tsoo–yess, and Hosett (Ozette) (Swan 1964 [1870]:2). Ozette was nearly abandoned in 1917 as families moved to Neah Bay so their children could attend school as ordered by the government.

Basketry Heritage and Research

Archaeological excavation conducted at the Ozette village between 1966 and 1981 provides evidence for the antiquity of Makah basket making. Examples of the open twining technique, in which the direction of the wrapping alternates from one row to the next, were found and dated to about five hundred years ago (Croes 1977; also see chapter 8).

Knowledge of the more recent history of Makah basketry relies on the research of four firsthand observers who were assisted by members of the Makah Tribe (many of whom were unnamed), along with current research on historic photographs and baskets in museum collections. The earliest resident observer was James G. Swan, who was in Neah Bay from 1859 to 1866.[4] During that period he witnessed various types of basketry being made and utilized, and collected examples that are now in the Smithsonian Institution. In 1864 he wrote the first ethnography of the Makah, *The Indians of Cape Flattery, at the Entrance to the Strait of Fuca, Washington Territory*, which was published in 1870.

Myron Eells, a Congregational minister who lived on the Skokomish Reservation, made ethnographic observations from the eastern and northern areas of the Olympic Peninsula between 1874 and 1894. He recorded information on Makah basketry types and collected a number of examples. A 1985 publication of his manuscript, entitled *The Indians of Puget Sound: The Notebooks of Myron Eells*, contains a number of photographs.[5]

James McCurdy came to Neah Bay as a boy in 1877 and spent two years there while his father constructed a lifesaving station. He later recorded his experiences as a youth in his memoir *Indian Days at Neah Bay*, which was published in 1961. McCurdy was introduced to Makah basketry and other aspects of Makah culture by Mrs. Quedessa, a basket weaver, and her husband, Lighthouse Jack.

Erna Gunther, a University of Washington anthropologist, as part of her ethnographic research of the region interviewed Makah basket weaver Ada Markishtum in the late 1920s. Gunther considered Ada and her husband, Luke, to be "real naturalists with an intelligent and observant interest in their surroundings" (1974 [1945]:11). Ada showed Gunther "which plants were used for each basket, and how they were harvested and prepared" (Colasurdo 2003:73, 82). Gunther continued her fieldwork with Ada in 1934–35, and they worked on projects together off and on into the 1950s.[6]

More recently, Makah tribal member Helma Swan, who was born in 1918, worked for almost twenty years with Linda Goodman to create her memoir, *Singing the Songs*

of My Ancestors, which was published in 2003. Included are discussions of aspects of basket making within the Makah culture and specific basket makers in her family.[7]

Traditional Basket Types

"basket" (generic), *bo-whie* (Swan 1964 [1870]:93)—see description of large packing basket below (under "Storage Baskets"); compare with Klallam *məhúy'*, "any basket" (Montler n.d.)[8]

The Makah classed their baskets "according to the material of which they are formed, and the uses to which they are put" (Swan 1964 [1870]:46). The broad categories are storage baskets, burden baskets, carrying baskets, basketry hats, and basketry cradles.[9] When the Makah and Ditidaht languages have the same name for a particular type of basket, it suggests that the Makah brought the tradition with them when they moved south to the Olympic Peninsula. In the names used by both tribes, the frequently found suffix *-ats* (pronounced like the final three letters in "huts") means "container."

STORAGE BASKETS

The Makah made five types of storage baskets, each related to its function through construction technique and size. The three general types of storage baskets (the first, second, and fourth types described below in this section) were often constructed "of cedar bark, split into strips, a third or half an inch wide, and woven together in much the same way as the cedar bark mats" (Eells 1985:97). The bottoms of these were flat to facilitate storage. While they frequently were made to hold a bushel or more, they were also woven in smaller sizes (ibid.). These plaited baskets were "not strong, and [did] not bear much rough usage," so although the Klallam traded for them, the Twana and the Puget Sound Salish seldom did so (ibid.). The other two types (the third and fifth types described below) had more specialized constructions.

Large (for Fish)

ƛapa·t (MCRC)[10]; *klap-páirk* (Swan 1964 [1870]:46); compare with Ditidaht *ƛ'apa·t*, large storage basket (Turner et al. 1983:24) and Clayoquot cedar bark basket, *tla'-pat* (Curtis 1916:200)

This is the largest type of Makah basket (Swan 1964 [1870]:46) and was used to store fish. According to Swan, "The heads [of the halibut] are taken off [, then the] skin is . . . carefully removed, and the flesh then sliced as thin as possible to facilitate the drying; and when perfectly cured, the pieces are wrapped in the skin, carefully packed in baskets, and placed in a dry place" (ibid.: 23).

The closely related Ditidaht people are said to have changed their word for "one hundred" to a word that means "just fits in inside," in reference to old storage baskets that could hold one hundred dried salmon (Hess 1990). An example of a Makah plaited cedar bark basket used for storing fish was collected by Swan prior to 1874 and is at the Smithsonian (collection no. E013113; see http://anthropology.si.edu/conservation/whatsnew_acl_2004-03.htm).

Medium (for Harpoon Lines)

ɫaʔa·š (MCRC); compare with Ditidaht ɫaʔa·š, baglike whaling-line
holder (Turner et al. 1983:24)

This type of storage basket was often made by twilling, perhaps to give it added
strength over the checker-weave form. The cedar bark strands were twilled on both
the base and the sidewalls. Large examples of this type (32 × 32 × 17 in.) were used
in Makah whaling canoes to hold the long, coiled harpoon line that was attached
to the harpoon head (Wright 1991:139 contains a photo of a 1988 example woven
by Norma Pendleton). Swan (1964 [1870]:19–21) described the harpoon line: "The
rope or lanyard [(*klūks-ko*) is] always of the same length, about five fathoms or thirty
feet. This lanyard is made of whale's sinews twisted into rope about an inch and a half
in circumference, and covered with twine wound around it very tightly. . . . The rope
is exceedingly strong and very pliable."

Medium (for Harpoon Heads)

Whaling harpoon blades were made "from sharpened mussel shell" (McCurdy
1961:105). They were stored in pouches to prevent their blades from being broken.
The pouches were rectangular, with a tapered top to close the sheath, and the bark
was simply folded to protect the blade. The pouches were made by twining cedar
bark (see sketch in Johannesson 1984a:16). The pouches were stored in cedar bark
baskets of an unusual shape. The lower third was rectangular, with a plaited checker
weave. The middle third was constructed with roughly the same dimensions and using
the same technique, but the checker weave had narrower strips. The top third was
a continuation of the middle but flared out at the ends, so that on some baskets the
mouth was roughly twice the width of the base. The top was finished with open weave
and a braided rim. Many baskets of this type were excavated from the Ozette site (e.g.,
MCRC Collection 71/iv/32, which mea-
sured almost three feet tall).[11]

These baskets were kept loaded in
the canoe along with the baskets hold-
ing the harpoon lines, so hunters could
enter the water quickly when a whale was
spotted. "Each canoe . . . was equipped
with harpoons, lances, ropes and seal-
skin floats" (McCurdy 1961:104).

Small (for Clothing, Etc.)

See Ditidaht ƛ̓ituqʷsc
(Turner et al. 1983:24)

This small size of the plaited basket was
used to store everything from light-
weight household goods, such as blan-
kets and clothing, to food (Swan 1964
[1870]:46; Eells 1985:97).

**Figure 7.2. Whaling gear bag made in 1890 for the World's Columbian
Exposition in Chicago. 18 × 12 in.** COURTESY OF THE BURKE MUSEUM OF
NATURAL HISTORY AND CULTURE, CATALOG NO. 143.

Smallest (for Cosmetics)

piku' or *piku·ʔu* (MCRC); compare with Ditidaht *pukuʔ* or *pukwʔu·*
(Turner et al. 1983:26), Nuuchahnulth *puk-oo* (Dyler 1981:13),
and Klallam *spčúʔ*, waterproof berry basket (Montler n.d.)

The Makah and the Ditidaht used this small basket in precontact times to hold cosmetics. These included deer tallow, used as a face cream to prevent sunburn, and mussel-shell filings, used like talc to lubricate the thigh while spinning fiber to make rope or to make twine for a fishnet (Turner et al. 1983:26; Johannesson 1984b:6, 11). The Makah wove these baskets with the same materials used on southwestern Vancouver Island: cedar bark, basket sedge, and eelgrass. It is unknown to what extent, if any, these early examples had designs.

Burden Baskets

qaʔawac (MCRC); *ka-á-wats*, burden basket (Curtis 1916:200)

Burden baskets, also called pack baskets, were supported by a tumpline. They were constructed with spruce roots or cedar twigs (Swan 1964 [1870]:46) as the horizontal element in the open-wrapped twining. The bottom was soaked to make the elements flexible during the weaving process, which Ada Markishtum described to Gunther (n.d.): "Burden baskets were made only by certain women. The rod for the twining is cedar limb, the warps are spruce root and so is the twining. Made bottom and soaked it in a canoe left at eave drop [i.e., downspout] where it could catch rain water. Bottom [is] twilled." Burden baskets had a wedge shape, with the keel-shaped bottom allowing them to be leaned on one side for loading. They were made in three sizes (Gunther 1935:37), and there were two subtypes of the large size.

Large (for Fish)

qaʔawac (MCRC); *Kaʔáʔwats* (Ada Markishtum, in Gunther n.d.);
compare with Ditidaht *qaʔawc*, larger carrying basket (Turner et
al. 1983:24), and Klallam *qaʔáwəc*, clam basket (Montler n.d.)

This, the largest of the pack baskets, was referred to by the generic name for a burden basket. It was approximately three feet by two feet and, supported by a braided cedar bark tumpline, was used for transporting three or four halibut or whale meat (Ada Markishtum, in Gunther n.d.). The halibut were taken in this basket "from the beach to the place where they were prepared for drying" (Gunther 1935:37). This type of basket was traditionally traded (Ada Markishtum, in Gunther n.d.).

Large (for Wood)

buxʷi· (MCRC); *bo-hé-vi*, wedged-shaped packing basket (Swan
1964 [1870]:46); *buh·-wí*, storage basket (Curtis 1916:200);
compare with Klallam *məhúy'*, cedar bark basket (Montler n.d.)

The open-weave burden basket has a wedge shape, with a large mouth and tapered sides. This type of basket was worn on the back, with a tumpline over the forehead.

Figure 7.3. Wedge-shaped fish packing basket, tipped on a beach as halibut are being processed.
COURTESY NORTH OLYMPIC LIBRARY, KELLOGG COLLECTION, INDN FISH 9, 5-5.

The shape of the basket allowed people to transport loads with greater ease, since the weight was kept well up on the shoulders.

Medium (for Transporting Berries)

tiai yŭx sats (Ada Markishtum, in Gunther n.d.)

The Makah took advantage of a cycle of berry crops that began with the salmonberry in June, followed by other summer berries until autumn, when the salal berry and the cranberry appeared and continued until November (Swan 1964 [1870]:25). Once an individual berry-picking basket was filled, the berries were emptied into this medium-sized burden basket, in which they were transported home (Gunther 1935:37).

Small (for Picking Berries)

dīsxōb (Ada Markishtum, in Gunther n.d.)

Each berry picker had a small picking basket hanging around the neck that rested on the chest while collecting berries (Ada Markishtum, in Gunther n.d.). The holes in the open weave of this basket were necessarily small, so that the berries would not drop out.

Carrying Baskets

See Ditidaht *buxu·y'*, oblong, handled utility basket, clam basket (Turner et al. 1983:24)

The Makah gathered a vast amount of food items from the intertidal area. These items included crabs, a variety of clams, limpets, sea urchins (or sea eggs), sea anemones, mussels (a particular favorite), barnacles, sea slugs (or sea cucumbers), periwinkles, sea snails, chitons, and an occasional octopus (McCurdy 1961:104; Swan 1964 [1870]:24; L. J. Goodman and Swan 2003:27; Peterson 2002:154).

Figure 7.4. Intertidal basket used for gathering clams and other shellfish. 12.7 × 21.5 × 19 in. wide. COURTESY OF THE BURKE MUSEUM OF NATURAL HISTORY AND CULTURE, CATALOG NO. 1997-92/13.

The type of basket used in gathering along the shoreline was specially designed for that purpose and was made in different sizes, as Ada Markishtum related: "Burden basket with handles and square bottom for devil fish [or octopus] and bait and sea eggs [was] made in three sizes" (Gunther n.d.). The largest size of the intertidal basket was used to hold octopi and crabs.

Intertidal baskets were not wedge-shaped as burden baskets were, because the intertidal baskets had to stand unsupported on the beach while shellfish were being collected. They had larger spaces between the warps and the wefts than berry baskets did, to allow the salt water to drain after the shellfish were rinsed off. The handles were integrated into the rim so the gatherer could move the basket along the beach.

Hats

se-ke-áh-poks (Swan 1964 [1870]:97); see *tsitsiapuxsktL*, "resembles a hat" (Waterman 1920)

Both spruce root and cedar bark hats were found at the Ozette archaeological site, constructed with flat, knobbed, or rounded tops (MCRC). The Makah traded hats to the Klallam, who wore them rather than the "tight fitting brimless variety" made by the Puget Sound Salish (Gunther 1927:226).

Spruce Root Hat

See *k³i'tlsk*, "like a basket hat" (Waterman 1920); and *klopitcapx*, "covered with spruce root" (Gunther n.d.)

The Makah conical-shaped hat was described by both Swan (Costello 1895:119) and McCurdy (1961:50) as resembling something worn by the Chinese. The body of the

hat was made of spruce roots "so compact as to exclude water" (Swan 1964 [1870]:16). It was an essential element of Makah clothing until the late 1800s and was worn by both sexes for protection from the rain or sun (McCurdy 1961:50; Gunther n.d.). "They are very ingeniously manufactured," Swan observed, "and it requires some skill and experience to make one nicely" (1964 [1870]:45). Art historian Robin Wright claims, "All well-documented hats of this type come either from the Nuu-chah-nulth . . . or from the Makah" (Wright 1991:84).

Most examples of the Makah hat were woven in diagonal twining, with the tops woven with the three-strand technique. Split cedar bark was used for the lining and the headband of the rain hat (Gunther 1974 [1945]:20), which helped keep the hat securely on the wearer's head (Devine 1980:29). An extra waterproofing was sometimes applied to the hat, using pitch that had been blackened with oil, charcoal, and coal (Ada Markishtum, in Gunther n.d.).

Some spruce root hats had a wide black band painted along the lower portion, or brim; the band varied in width but usually filled about two-thirds of the hat surface (Devine 1980:26). The black paint was produced by grinding a piece of bituminous coal with salmon eggs chewed and spit on a stone. Sometimes red designs were painted on the remaining, crown portion of the hat. The red pigment was made from a mixture of vermilion and chewed eggs. These paints were applied using fine brushes made from sticks or human hair (Swan 1964 [1870]:45).

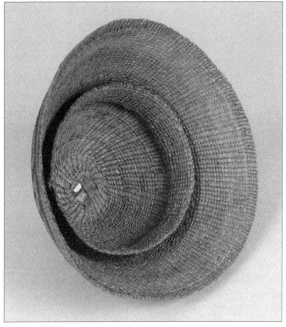

Figure 7.5. The underside of a conical spruce root hat showing the inner liner, which was designed to keep the hat secure on the wearer's head. COURTESY OF THE BURKE MUSEUM OF NATURAL HISTORY AND CULTURE, CATALOG NO. 1-530.

Cedar Bark Hat

On the Northwest Coast there was "a bowl shaped cedar bark hat, typical of the Nootka and southern tribes . . . woven in variations of the twined technique, and the compact texture of the weave rendered [hats of this type] watertight and adequate protectors against the wet coastal environment" (Devine 1980:26). The outer layer of the Makah bowl or dome-shaped hat might be decorated with beargrass that had been wrapped-twined. It was joined to an inner layer at the rim.

Knobbed Hat

The knobbed hat has a distinctive onion-shaped top and always contains woven designs showing the whale

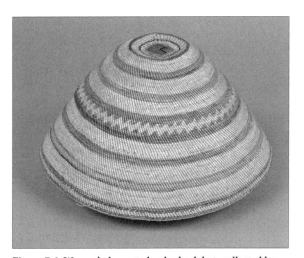

Figure 7.6. Woman's decorated cedar bark hat, collected by James G. Swan for the Washington World's Fair Commission, which was gathering objects for the 1893 World's Columbian Exposition in Chicago. COURTESY OF THE BURKE MUSEUM OF NATURAL HISTORY AND CULTURE, CATALOG NO. 110.

hunting motif. These hats were woven from cedar bark, split spruce root, and surf-grass (Devine 1980:28; Wright 1991:84; Peabody Museum n.d.). The warp was formed of split roots, and the wefts were of light-colored grass and darkened cedar bark. The main body of the hat was constructed with two-strand twining, and designs were applied with the overlay technique. An inner section of more coarsely twined cedar bark was joined at the rim to the outer hat. These hats were described and artistically rendered by Europeans who visited Nootka Sound on Vancouver Island. A portrait of Chief Tatacus (Tatoosh) painted by Spanish artist José Cardero, who visited Neah Bay in 1792, shows high-ranking Makah wearing this type of hat. The designs on these hats depicted whale hunters in canoes holding harpoons in pursuit of the giant mammals. A few examples of whalers' hats were collected as far south as the Columbia River, indicating that they were regarded as a valued trade item among the Chinook. Several questions persist regarding the Makah and this type of hat and show the need for further research.[12]

CRADLES

yadaqsp'ati· (MCRC); *ya-duk-spa-tie* (Swan 1964 [1870]:95); see *yá-duk*, "child" (ibid.: 95); compare with Clayoquot *na-yu'k-pa-to*, cradle (Curtis 1916:200)

The Makah made basketry cradles "of bark, woven [in] basket fashion." in addition to ones out of wood (Swan 1964 [1870]:18). The basketry cradle was constructed entirely out of cedar. The base had wooden slats checker-woven with bark. The sides were checker-woven, and the rim was finished with hitched loops. A dowel-shaped piece of limb was attached to each outer side of the cradle. A braided cedar cord was secured to the outer sticks and run through the sides of the cradle in an evenly spaced fashion. The cord formed the laces by which another. softer line was placed to secure the baby in its cradle. A cradle, 31.5 inches long, 11.5 inches wide, and 4 inches high, made in 1988 by Norma Hottowe Goodwin Pendleton as a replica of one excavated at the Ozette village site, is pictured in Wright (1991:138).

New Basket Types

In 1864 the Makah were already making a highly decorated fancy basket, based on the traditional basket that held cosmetics, and two new types of basketry: decorated bottles and vials, and Euro-American–style hats (Swan 1964 [1870]:45–46). Somewhat later, they also created a version of the shopping basket, table mats, hot pads, and various novelty items.

MODERN FANCY BASKET

pikú or piku·ʔu (MCRC); *pé-ko* (Swan 1964 [1870]:46); *pe-koe* (ibid.: 93); *pīk!õʔ* (Ada Markishtum, in Gunther n.d.); *pikuʔu* (Marr 1990:274)

Although the Makah made numerous distinct types of baskets prior to European contact, there was one form after contact that came to symbolize their basketry.

From the mid-1860s on, the Makah have been known for "the fancy, trinket or tourist basket [that] was made primarily for a non-Indian audience" (Marr 1988:55). This small wrapped-twined basket, produced in great numbers, was of the same construction as the smallest storage basket, which it descended from; the same name was used in Makah for the modern type. The modern fancy basket represents an alteration of the original by the substitution of a new material and most probably the addition of realistic design motifs, such as animals, in an effort to appeal to a commercial market.

In 1864 Swan reported finding both the traditional and the modern forms of the closely woven wrapped-twined basket at Neah Bay. The former was made of cedar bark and "a species of eel grass," or "beach grass," while the latter was constructed with cedar bark and beargrass, which he referred to simply as "grass" (Swan 1964 [1870]:46).

Makah weaver Queen Annie is credited with having invented the use of beargrass on baskets in the late 1850s:[13] "Queen Annie originated the *pīk!ōʔ*, the commercial basket[,] and she used to hide them when women visited so that they would not copy them. Formerly they used squaw grass [beargrass] only to finish off the edges of cattail mats. She thought of using this for weaving. . . . This type of basketry was invented about 75 years ago" (Ada Markishtum, in Gunther n.d.).

We can say with confidence that Queen Annie started to make the Makah fancy basket around 1859, based on Markishtum's 1934 estimate that this type was about 75 years old. Additionally, by 1864 the fancy basket, often "woven with designs intended to represent birds or animals," was being made with regularity (Swan 1964 [1870]:4, 46). Therefore the fancy basket was developed around 1859, and by 1864 it had been adopted by numerous other Makah weavers. The innovation of using beargrass also spread north to other Nootkan groups, and soon beargrass became a trade commodity, passing from Washington to British Columbia.

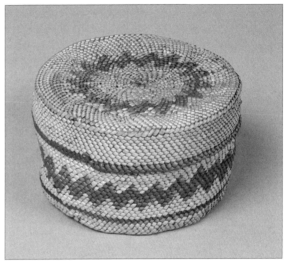

Figure 7.7. Makah basket made by Queen Annie or her mother, according to Ada Markishtum. Gift of Caroline McGilvra, 1944. COURTESY OF THE BURKE MUSEUM OF NATURAL HISTORY AND CULTURE, CATALOG NO. 1-453.

This form of basket always has a lid and can be round, oval, or even square. The sides are built of cedar bark warps, with a close wrapping of beargrass wefts. The beargrass "straws" are dyed a variety of colors, and the design is applied by adding different-colored strands onto a creamy white background. Swan described the wrapped-twined basket he saw being constructed in 1864: "Small baskets are made of bark and grass, dyed of various colors. Some are woven with designs intended to represent birds or animals; others in simple checks of various patterns. Other small ones are of bark, and a species of eel grass that bleaches of a beautiful white" (1964 [1870]:46).

The twenty or so examples of decorated wrapped-twined baskets that Swan collected at Neah Bay for the Smithsonian Institution are of interest: "The baskets he collected show a wide range of shapes and sizes—experimentation with which might be indicative that the basketry form was relatively new" (Marr 1988:58). The basket

shapes include tall cylinders, round baskets on stems, and square ones with lids; the designs decorating them are simple in comparison with those found on later examples.

Swan noted the eagerness with which Makah artisans adopted new and different designs, not only in basketwork but also in carving and painting. Perhaps this explains the rapid increase in the different designs on the wrapped-twined baskets. There were also many innovations in the construction of this basketry type, particularly how the basket bottom was started, how it was finished along the rim, and how new materials were incorporated.

The Makah and related Nootkan tribes did not invent the wrapped-twining technique, but they did become famous for it. It has even been described as the "Makah style" because of the erroneous observation that the "Makah . . . employ this technique almost exclusively" (Mason 1904:454, 456). Similarly, some refer to the fancy basket as "the Makah basket" (also "the Makah-style basket" or "the Makah type"), as if this were the only type of basket the Makah made.

There is variation in the bottom starts of Makah fancy baskets from the 1860s to the 1930s. The bottom starts range from all-twined, to a simple two-by-two checker-weave, to plaiting covering most of the area. In the latter two start types, a checker-woven base of split cedar bark is bordered by a row of three-strand twining, which separates the checker weave from the two-strand plain twining that completes the bottom.[14]

Decorated Objects

Among the baskets Swan collected at Neah Bay for the Smithsonian is a covered glass bottle. He made this comment on this innovation among the Makah: "Within a few years past they have taken a fancy to cover with basket-work any bottles or vials they can obtain, and, as they do this sort of work very well, they find a ready sale for it among the seekers of Indian curiosities" (1964 [1870]:46). In addition to bottles, Makah basket weavers covered other objects with wrapped twining such as seashells, canes, deer horns, fishnet floats, "and anything else that might show the weaver's virtuosity" (Gogol 1980:6).

Table Mats and Trivets

Another new form described and collected by Swan was wrapped-twined table mats and trivets, which he referred to as being "very handsome and durable" (Costello 1895:119). They were constructed of the same materials as the modern fancy basket: cedar bark and beargrass. The mats were oval or round, with designs similar to those on the wrapped-twined baskets. One example (Burke Museum no. 204) was collected at Neah Bay by the Washington World's Fair Commission in 1892.

Euro-American–Style Hats

A novel form of spruce root hat was also made in the nineteenth century for the commercial marketplace and sold as far away as San Francisco and Victoria. This style mimicked that of a common straw hat. The weaver produced a strong and

durable hat by using finely twined spruce roots, as she would in a traditional conical hat. Some of these Euro-American–style hats had designs woven into them, while others were plain but dyed a single color. Perhaps because of their heavy weight, the hats were "more generally purchased as curiosities than as articles for wear" (Swan 1964 [1870]:46–47).

Shopping Basket

Makah basket makers developed their own version of the shopping bag: "The largest basket in the new [modern] group is the shopping bag, obviously designed to appeal to the white housewife. . . . Mrs. Young Doctor is said to have [invented] the commercial shopping bag" (Gunther 1935:38–39).[15] The base of the shopping bag was rectangular, and the warps were generally of split cedar bark. Construction of the sides could vary greatly. Some baskets exhibited five different weaving techniques in alternating bands. Main designs were done in wrapped twining. Wide cedar bark strips were commonly found in a checker weave. A handle was attached to a reinforced rim.

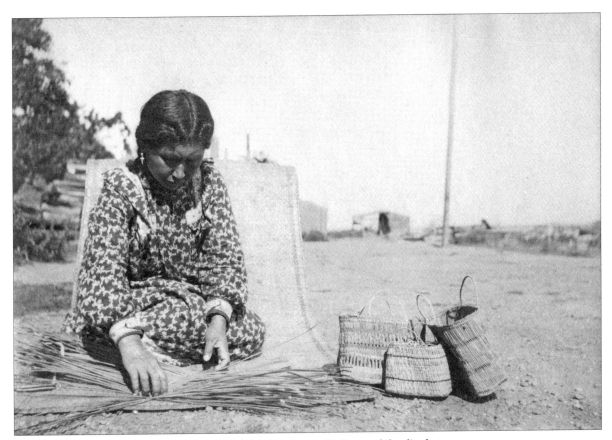

Figure 7.8. Mary Jackson, from Tsoo-yess, married Frank Jackson, a Klallam, and they lived at Jamestown. Here she is seen sorting cattail stalks. Her completed shopping baskets on the right appear to be made with cattails. They might reflect a different Makah style or show that she altered her construction and materials after moving to a neighboring tribe. PHOTO BY EDMUND S. MEANY, 1905. COURTESY UNIVERSITY OF WASHINGTON LIBRARIES, SPECIAL COLLECTIONS, NA1173F.

NOVELTY ITEMS

The Makah made a number of novelty items to sell to tourists. These included decorated cup-and-saucer sets, cedar bark and beargrass match holders, and miniature harpoon-point holders marketed as wall-mounted letter holders. In the cup-and-saucer sets, the saucer is merely a bottom start that is decorated like a lid. The cup is just a small, round basket to which loops might be added around the top. The miniature harpoon-point holder has a V shape. It consists of a diamond-shaped bottom of plaited cedar bark with a wrapped-twined basket attached to each of the openings at the top, and a braid attached between their rims (see fig. 6.2).

Materials

A substantial amount of time invested in basket making was taken up by the collection and processing of materials. Part of the knowledge acquired in becoming a basket maker was where and when to gather materials. In general, Makah basket materials came from the local environment. This means that there was some variation between what the Makah used and what was used by the Nootkan groups of Vancouver Island or the other tribes around the Washington Coast. In many of the Makah names in this section, the suffix -*bŭpt* means "plant" (Gunther 1974 [1945]:13) and rhymes with the English word "erupt."

WESTERN RED CEDAR (*THUJA PLICATA*)

Cedar tree: *łéʔišuk* (MCRC); *klá-e-shook* (Swan 1964 [1870]:101)

Cedar bark: *pīcup* (MCRC); *pī'ts·ōp* (Gunther 1974 [1945]:19); *péet-sup* (Swan 1964 [1870]:95); compare with Nuuchahnulth *pitsup* (Dyler 1981:13)

The Makah made use of the roots, limbs, and inner bark of the cedar tree in their basketry. For example, cedar limbs were used for the warps in open-weave carrying baskets (Ada Markishtum, in Gunther n.d.). Because cedar was not comparatively plentiful in their territory, the Makah used spruce roots for certain types of baskets where others in the region used cedar roots (Gunther 1935:37; Gunther 1974 [1945]:20), such as in the making of rain hats.

Cedar materials were harvested "a short distance up the Strait or on the Tsuess River" (Swan 1964 [1870]:35). The Makah took special care when harvesting the bark: "Cedar bark is stripped only at certain times of the year (late spring). The outer bark must be peeled from the inner bark, which is used for making baskets. . . . A cedar tree was never stripped of all its bark. Only one-third [of the circumference] of the bark was taken from any one tree. The people were careful not to kill the tree for the bark" (L. J. Goodman and Swan 2003:283). Split cedar bark was used for the lining and the headband of rain hats (Gunther 1974 [1945]:20). It also formed the warps and wefts of the fancy basket. Storage baskets were made from cedar bark that had been split into strips one-third to one-half inch wide. Tumplines for packing baskets were made of braided cedar bark.

Sitka Spruce (*Picea sitchensis*)

Spruce tree: *wiƛ'a·qbap* (MCRC); *k!lō´pate* (Gunther 1974 [1945]: 17); *do-hó-bupt* (Swan 1964 [1870]:101); compare with Ditidaht *tu·xupt*, "scaring [or startling] plant" (Turner et al. 1983:71)

Spruce roots: *ƛ'úpač* (MCRC); *k!ɬopatc* (Ada Markishtum, in Gunther n.d.)

Spruce roots were used in making certain types of baskets and rain hats. Spruce roots were obtained only from certain trees because not every tree has straight roots (Ada Markishtum, in Gunther n.d.):

> [You use only the] roots . . . of [a] young spruce tree. Cut about one yard long and about one inch circumference. Straight and even [are the desired characteristics of these lengths]. Soaked in creek for 3 to 4 days. Taken [back] to [your] house. Steamed on coals and turned [from time to time] until bark [is] peeled off. Split cross two dimensions [i.e. into quarters]. Split each quarter into several pieces while [it is] still warm. Split by pulling with teeth. Root then laid on inside of foot and run along under [the] knife [to scrape off the inner bark]. (Gunther n.d.)

Beargrass (*Xerophyllum tenax*)

The grasslike leaves of beargrass (also called pine lily, squaw grass, or mountain grass) were used as the decorative element on fancy baskets:

> The Makah attribute the development of the commercial basket to Queen Annie who first thought of using bear grass . . . for basket making. Up to this time bear grass had only been used in finishing the cattail mats. Since the grass does not grow at Neah Bay, it is bought [or traded] from Queets and Quinault. A handful, as much as could be enclosed by the thumb and forefinger, sells for twenty-five cents, or in barter for one yard of calico. (Gunther 1935:38)

When readied for trade, the leaves were trimmed and tied in small bundles (Gunther 1974 [1945]:23). A government report describes the preparation process: "The grass is scraped and split in preparation for weaving around the split cedar bark ribs. The materials are slightly damp while weaving but they [the Makah] do not soak it as is necessary with heavier types of basket materials. They rather weave baskets in rainy weather. They say it will be smoother and firmer. They can not weave fine baskets in real cold frosty weather" (NASP RG75 1937f).

The use of beargrass does not extend back in time to when the ancestors of the Makah were on Vancouver Island. Turner et al. (1983:26) make only passing reference to beargrass and the Ditidaht. The use of beargrass is said to distinguish some baskets as having been made by the Makah rather than their neighbors to the north.

Slough Sedge (*Carex obnupta*)

čibap (MCRC); *chi-bup* or *č'i·bup*, "swamp grass," "blade grass" (Erikson 2004:361); compare to Ditidaht *č'ibpat*, "basket grass" (Turner et al. 1983:79); Nuuchahnulth *chi-tupt*, "swamp grass" (Dyler 1981:13)

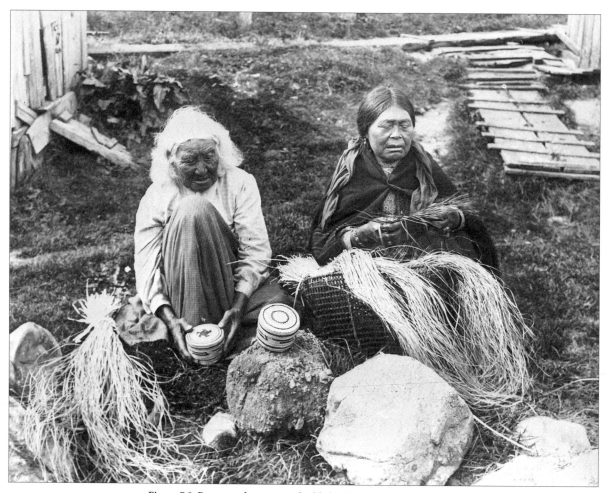

Figure 7.9. Beargrass became a valuable basket-making material with the growing popularity of wrapped-twined fancy baskets. These women, Ooati and Susy Ides, were photographed about 1900 by James G. McCurdy. MCCURDY COLLECTION. COURTESY MUSEUM OF HISTORY & INDUSTRY, CATALOG NO. 1955.970.470.25.

Slough sedge is also referred to in English as basket sedge, marsh grass, swamp grass, or blade grass.[16] It was gathered at Lake Ozette (McCurdy 1961:55). After the grass was gathered in June or early July, each blade was split in half and then run through a closed thumb and forefinger to make it flat and flexible before being tied into bundles and hung to dry and bleach in the sunshine (Dyler 1981:13). It was used as a weft material (Turner 1979:125, 127) and "finely woven into various shapes" of baskets (McCurdy 1961:55). The Makah used it on the bottom of fancy baskets (Gunther 1974 [1945]:22).

SWEETGRASS (*SCHOENOPLECTUS PUNGENS*)

Nuuchahnulth *toh-toh*, three-cornered grass (Dyler 1981:13); Ditidaht *čʼičʼi·tiyuxʷaʔdɬ*, three-cornered grass, or *tuxʷtuxʷ*, "edged along the length" (borrowed from Nuuchahnulth, an onomatopoeic

name after the sound it makes when pulled out), or *t´ut´udxak´k*ʷ, "looks like tule" (Turner et al. 1983:81)

The Makah used sweetgrass shoots for baskets (Gill 1983:332). Sweetgrass grows in tidal areas where salt water reaches up over the shore. The prime locations along the Washington Coast for gathering sweetgrass were at Grays Harbor and Willapa Bay (Thompson and Marr 1983:24). Makah weavers used sweetgrass for the warps on fancy basket lids, the weaving done around bottles and jars, and likely on cups and saucers.

Small-Flowered Bulrush (*Scirpus microcarpus*)

Ditidaht *bi·ʔbik'ʷapt* (Turner et al. 1983:83)

The Makah used the leaves of small-flowered bulrush for the bottom portion of baskets (Gill 1983:332).

Eelgrass (*Zostera marina*)

Ditidaht *taba·* (Turner et al. 1983:89)

Eelgrass, also called sea grass or seaweed, was gathered from quiet, protected waters and bleached white in the sun, before being used as an overlay material on fancy baskets (Swan 1964 [1870]:46). Although eelgrass had been largely superseded by beargrass, Mrs. Young Doctor used unbleached eelgrass for black designs "instead of commercially dyed [bear]grass, retaining in a way a much finer native feeling for the basketry and also giving a more lasting color" (Gunther 1935:39).

Cattail (*Typha latifolia*)

salaxa´xbupt, "mat plant" (Gunther 1974 [1945]:21); compare with Ditidaht *salaxa·ł* (Turner et al. 1983:88)

Because cattails are relatively large and flexible, they were often used for teaching basketry to young girls. Cattail was also used by adults as a material in soft baskets of various types, including some shopping baskets and the fancy basket (e.g., National Museum of the American Indian no. 5/9911 collected by Leo Frachtenberg between 1911 and 1916). A Makah cattail cradle with cedar slats (Frachtenberg Collection 05/9888) may represent an impromptu construction necessitated by childbirth away from home.

The Makah call the fruiting stalk of the cattail "the wife" and use it for mats and baskets, while the male stalk is never used (Gunther 1974 [1945]:21). The "female stalks" have softer cores and less rounded leaves (Thompson and Marr 1983:21). Because cattails were scarce in their territory, the Makah had to travel some distance from their villages in order to gather it (Gunther 1974 [1945]:21). It is then not surprising that cattail mats were used "as coverings for temporary houses and shelters in the summer" everywhere in western Washington "except among the Makah" (ibid.). As with beargrass, the tradition of using cattails in weaving may have come from mat making; this is in fact suggested by the Makah name for the plant. The use of cattails in baskets and indeed in mats is thought to have been a somewhat recent

borrowing by all Wakashan-speaking people: "It is generally maintained that these groups did not make cat-tail mats originally but learned the art from their Salish neighbours in the last century" (Turner 1979:150).

Nettle (*Urtica dioica*)

kalū´p'ki (Gunther 1974 [1945]:28)

The Makah used stinging nettle fibers in weaving baskets (Gill 1983:246). Cordage made from the fibers was used to strengthen the rims of various types of baskets.

Maidenhair Fern (*Adiantum pedatum*)

yuyu'xłcbicał (MCRC); *tlotlotc'sa´dit*, "dry fern" (Gunther 1974 [1945]: 14); *kloko´sasud*, "leaves wither quickly" (Densmore 1939:311)

The Makah used the skinny, dark brown midrib of the maidenhair fern for basket designs (Gunther 1974 [1945]:14).

Coloring

A number of natural dyes were traditionally used on some basketry materials such as beargrass and cedar bark, but others such as spruce root were never dyed (Ada Markishtum, in Gunther n.d.). Each dye had its own manner of preparation. After contact with Europeans, aniline dyes became available from the Hudson's Bay Company traders (NASP RG75 1937f).

Red Alder (*Alnus rubra*)

kw³axsabEp (Waterman 1920); *kwahk-sá-bupt* (Swan 1964 [1870]: 65); *kwárk-sa-bupt* (ibid.: 101); *kwasámbat* (Densmore 1939)

In collecting alder bark for dye, care was taken to use a mature tree of the proper age. The bark of an older tree could be too coarse and pulpy; the ideal tree was about six inches in diameter, according to John Thomas, a Ditidaht (Turner et al. 1983:98). The next step after gathering the bark was to crush it on a rock (ibid.).

Two methods have been described as having been used by the Makah for the next step. In one, the bark was "chewed and spit into a dish" and used to dye cedar bark or "grass" (Swan 1964 [1870]:43, 46). In the other, Mrs. Quedessa said the bark was boiled in water (McCurdy 1961:55). The color obtained ranges from red to brown (Gunther 1974 [1945]:27), according to the method. The saliva mixture produced "a bright red dye pigment," while using boiling water yielded a dark brown (Swan 1964 [1870]:43).

Oregon Grape (*Berberis sp.*)

ƛ'ukšutqbap (MCRC); *kluksitłkobupt*, "raven plant" (Gunther 1974 [1945]:30); *klook-shitl-ko-bupt* (Swan 1964 [1870]:101); see *klook-shood*, "raven" (ibid.:94); compare with Ditidaht *ƛ'uk^wštqapt*, "Raven's-plant" (Turner et al. 1983:98)

The Makah call the Oregon grape bush "raven plant" because they "regard the berries only as raven food" (Gunther 1974 [1945]:30). Its roots were gathered in the fall and used to make a yellow dye. The Makah found the plant just to the east, at the Sail River along the Strait of Juan de Fuca (Gunther n.d.). Swan observed that cedar bark "is not dyed yellow, that color only being imparted to beach grass, which is used in weaving into baskets" (1964 [1870]:46).

Blue-Black Mud

The Makah word *toop-kook* means "black" or "dark blue" (Swan 1964 [1870]:95). This color was achieved on baskets by using "a rare blue clay" as a dye, according to Mrs. Quedessa (McCurdy 1961:55). Swan also described this method:

> [The color] black [is produced] by immersing the material in the salt-water mud, where it remains for several weeks, usually during the summer months; a place being selected where the mud is rich with marine algae, and emits a fetid smell, the sulphuretted hydrogen undoubtedly being the agent that imparts the color to the vegetable fibres of the [cedar] bark or [bear]grass. (1964 [1870]:46)

Sunlight

"[A] pure white [was] obtained from the eel grass, or sea weed, which [was] bleached in the sun," according to Swan (1964 [1870]:46). Beargrass was also bleached in the sun to turn it creamy white.

Western Hemlock (*Tsuga heterophylla*)

ƛ'ačápɫ (MCRC); *kɫak!abupt*, "a wood that snaps" (Gunther n.d.); *klak!ábupt* (Gunther 1974 [1945]:18); *tkakábup* (Densmore 1939: 311); *k'la-ká-būp* (Curtis 1916:203); *kla-ká-bupt* (Swan 1964 [1870]: 65); *klar-kar-bupt* (ibid.: 101)

Hemlock bark was used as a dye for cedar bark, creating a rich red-brown color. To produce the dye, the hemlock bark was cut off the tree, placed in a box to soak for a number of days, and then boiled. One source (Densmore 1939:320) specified that the dye was made from the inner bark, which was pounded before being boiled in salt water (Gunther n.d., 1974 [1945]:18).

Tools and Equipment

Makah weavers used a number of tools, including knives, and some equipment in their basket making.

Black Rock

A special type of small black rock was used in making fancy baskets:

> We had some of those great big, black shiny rocks in the house, and they were clean all the time.... They called those rocks *ƛača'pɫ*. All the old women had them, too. Some of them were shaped like an egg, they'd just fit in their hands, and the

women would use them when they were making baskets. They'd pound on each part of the basket so the weaving would look even. They'd start with the bottom, work the bottom of the basket, then pound on it to make it look even, then they'd rub the rock over it so the basket would get shiny, too. (Helma Swan, in L. J. Goodman and Swan 2003:76)

TOOL AND WORK CONTAINER

Traditionally, basketry tools, material at hand, and work in progress was kept in a basket assigned for that purpose.[17] By the 1920s these were kept in a box. "My mother used to keep hers [a black rock] in her basket-weaving box," Helma Swan recalled. "They always had a box where they put their basket-weaving, and that['s] w[h]ere my grandma did, too" (L. J. Goodman and Swan 2003:76).

TIN POT

hatsac, "container for soaking" (MCRC)

A tin container called a *hatsac* was positioned in front of a weaver as she worked. It held water for wetting the bark and grasses (Marr 1987:61; see fig. 7.12).

Designs

Little decoration was probably applied to traditional Makah baskets. Basketry items found at Ozette show a high degree of functionality but little in the way of design work. By the 1790s the Makah were familiar with depictions of the whale hunt on knobbed hats, and other hats had designs as well. The use of designs in basketry greatly expanded around 1860 when close-weave wrapped twining took hold, and fancy baskets, covered bottles, and table mats were created. A short while later the shopping basket was invented, and it had plenty of space for decoration. In wrapped twining, designs are created by using colored strands as the overlay or outer weft. These contrast against the creamy background of undyed beargrass.

At the time Swan collected for the Smithsonian, he noted that the decoration on fancy baskets could be divided into two types: realistic designs, or those "intended to represent birds or animals," and geometric designs, or those of "simple checks of various patterns" (1964 [1870]:46). There was a proliferation of designs during the heyday of wrapped-twined basketry. Some weavers favored certain designs and became known for them. Many of these designs had precedents in traditional Makah painting and carving. An eight-inch-tall covered bottle from the 1920s, for example, has on one side a carved wolf mask design facing to the left. On the neck, the same basket has an encircling design depicting the start of a row of wrapped twining.

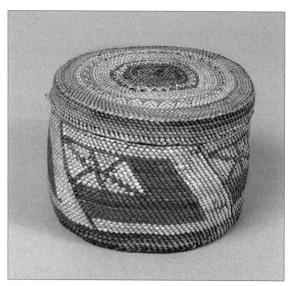

Figure 7.10. Lidded fancy basket with a flag design. 4.5 in. diameter × 3.2 in. high. COURTESY OF THE BURKE MUSEUM OF NATURAL HISTORY AND CULTURE, CATALOG NO. 1-456.

Other designs were inspired by new objects, such as the American flag. Illustrated books and magazines provided additional ideas. When Swan was the reservation teacher, he had encyclopedias and other resources with pictures that were used by Makah painters for new ideas, something that would set an artist's work apart. Additionally, Swan said he was besieged by artists' requests "to paint something the other Indians could not understand" (1964 [1870]:10).

REALISTIC ANIMAL DESIGNS

Many basket makers created a pattern basket to refer to later while applying designs to their work. It served as a record of stitch count and placement. Such a basket might contain the weaver's full repertoire of up to thirty or more realistic designs. These designs generally included seal, serpent, duck, coot, raven, bald eagle (with a white head), thunderbird, deer, and beaver, as well as sea mammal hunting scenes and other land mammals.

Edith Ruth Hottowe described the pattern baskets that her mother, Ada Markishtum, made:

> She did pattern baskets [with d]ifferent designs on them. They're just beautiful designs. . . . But they had [the] typical wolf design . . . like a wolf mask. And they would [have] beaver, seagulls, whale, thunderbird, [and] robin. She had a robin on a limb. The limb was so pretty—probably like a salmonberry limb with pink flowers on it. . . . And [a] laying down elk. (Linzee 2008)

Whale and Whale Hunt

The Makah whale design is found on the main body of the basket and/or on the lid. The black whale has a small dorsal fin, a long mouth, and a black dot in a white circle representing the eye. Gunther wrote, "Since so large a part of Makah life centered about the capture of the whale it was natural that the women should use the whale as a design on their baskets. Mrs. Young Doctor is said to have used the [whale] design first on the commercial shopping bag which she invented. Later it was also applied to the small cylindrical [or fancy] basket" (1935:39). Gunther added, "The whale hunt is even more dramatic than the whale itself and this also is worked into a basket design" (ibid.). Depictions of whale hunt scenes are found in the earlier tradition of chief's hats (hats with an onion-shaped top). In the design as it appears on Makah baskets, whalers in a large canoe pursue a huge whale, its body decorated with stripes or spots. The whale can be connected by a line to the front of the canoe to show they are following it after a successful harpooning, or it can be connected to the rear of the canoe to show that it is being towed to shore. "The whale hunt [is] often quite detailed, including whalers in their canoe, the harpooner thrusting his weapon at a huge whale and even marks representing the barnacles or spots on the whale's back" (Marr 1988:59).

The number of whalers in the canoe seems to vary with the size of the basket. On larger baskets, it reflects the cultural standard: "Each canoe was manned by a crew of eight . . . six paddlers, a helmsman and a harpooner" (McCurdy 1961:104). Medium-sized baskets have six men in the canoe. On smaller baskets the crew is necessarily reduced to two.

Sealing

Makah baskets sometimes had sealing scenes, with the sealing canoe usually having two men instead of the larger number depicted in the whaling canoe (Gunther 1935:39). However, the two-man crew designs we have observed on small modern Makah baskets are pursuing a whale rather than a seal.[18]

Blue Elk

Around 1920 one design "reputed by some to have been made famous by . . . Ada Markistum [*sic*]" was the blue elk, which was applied to large fancy baskets (Gogol 1981:8). The male elk, complete with antlers, is lying down with its head up and alert.

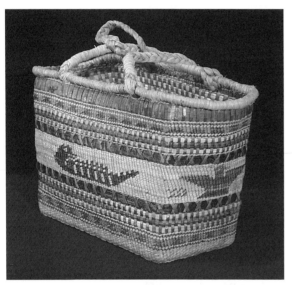

Figure 7.11. Shopping basket with otter design made by Louisa Greene about 1910. 7 in. long × 15 in. wide × 9 in. high. PHOTO COURTESY OF THE LEGACY LTD., SEATTLE.

Otter

Louisa Greene, who was weaving around 1910, used an otter design on a shopping basket (fig. 7.11). The otter is floating on its back with its tail pointed at a forty-five-degree angle. Its black body has a series of white vertical stripes.

GEOMETRIC DESIGNS

In addition to the realistic designs, the Makah incorporated a number of geometric designs into their basketry. "In the field of geometric design there are many simple running figures, most of which have no distinctive names," Gunther noted (1935:39). One geometric design resembled the swastika-like figure used by tribes in the American Southwest.

"To Break Off a Stitch"

Gunther described a common geometric design that was named "to break off a stitch": "It is the familiar meander design: ⎍⎍⎍. In working along any row of this the worker must change color every few stitches, hence the name" (1935:39).

Lightning

Another geometric design was the lightning design. Gunther wrote that it was "like a design found on the baskets of the Tlingit of southeastern Alaska, where it is called the shaman (medicine man's) hat pattern" (1935:39–40).

Basket Makers and Influences of the Marketplace

Several factors contributed to the circa-1860 shift in the types of basketry being created. New trade goods brought about less need to produce utilitarian baskets.

Decorated baskets were deemed to be easier to market to non-Indian buyers. And finally, smaller baskets were quicker to make and required less material than larger ones. This led Makah weavers to concentrate their efforts on fancy baskets and other new novelty baskets, for which there was a ready market "among the seekers after Indian curiosities" (Swan 1964 [1870]:46). The techniques used in this work brought about surfaces that allowed for greater design possibilities than was possible on older Makah baskets. Designs were "made from brightly-colored grasses set against a background of creamy white beargrass" (Marr 1987:41). Thus Makah basketry entered a new era in which baskets became a marketable art form rather than undecorated containers.

Stores at Neah Bay long provided an important outlet for selling baskets. Samuel Hancock established the first post there in 1845, and Swan tried his hand at it in 1859 (Morgan 1955:94). In the late 1870s, the only store there was operated by Captain Zemro Cutler, who was surpassed in importance on the reservation only by the agent.

> Cutler settled down at Neah Bay . . . having been granted a licensed trader's commission by the Indian Department. . . . The store he operated [was] for the accommodation of whites and Indians alike. . . . Groceries were piled helter-skelter at the back of the room. Indian baskets, mats, miniature canoes, totems and other souvenirs for the tourist trade mingled with clothing, blankets and piece goods upon the shelves or under them. (McCurdy 1961:98)

Trading the baskets they made allowed Makah weavers to obtain food or clothing (Gunther 1935:40). Basket makers were able to add "to their larders such trading post supplies as flour, tea, sugar, coffee, molasses, rice and the more common vegetables" (McCurdy 1961:51). The following description is probably from the 1890s:

> Everybody was all the time going places in canoes then. They were big. Some were 60 feet long and eight feet wide and they could carry three families at once. We used to go to Victoria after the last of the halibut was dried—six or seven canoes of us. We children were different then. We knew how to sit still. We could leave about 9:00 in the morning and get to Victoria at 5:00 that same day. Grandmother [*Dah Qua Dih*] and the other ladies took big bags with the baskets they had made and they went to Hudson's Bay and traded for cloth and shawls. (Ada Markishtum in 1962, quoted in Kirk and Alexander 1990:475)

At the same time that the new economics was stimulating certain types of basket making, other institutions had a detrimental effect. The government school at Baada, a residential school where the children were forced to live, disrupted the course of traditional learning:

> The older Indians could see no need for such an institution and regarded it with open hostility. . . . [T]o the older Indians it represented a dangerous encroachment of white civilization into their tribal ways. . . . They would much rather have had their children remain under their own tutelage . . . the boys to be taught to hunt, fish and handle canoes; the girls to become proficient in beadwork, basketry and the curing of fish and berries. (McCurdy 1961:59)

Most girls at the school no longer learned to be basket makers, because they were not home to receive instruction from their female relatives. That training had included

not only techniques but also the passing on of knowledge about when and where to gather materials.

As Makah basket making reached new heights, it was the older weavers who grew in prestige because there were so few younger weavers. These women were recognized as artists and became famous up and down the coast (Marr 1987:61). In addition to Queen Annie and Lizzie Doctor, two other such women who wove from the 1890s into the early 1900s were *He-da-took-ba-yitl* (or Mrs. Weassub) and *Niesub*.[19] Older weavers generally had a set routine for doing their work and wanted to do their best: "They'd get up early in the morning, sometimes before you had breakfast, they'd sit down and weave, so contented, nothing to worry about, it looked like. They wanted to make the baskets nice. They took pride in their work" (Helen Peterson, in Marr 1987:61).

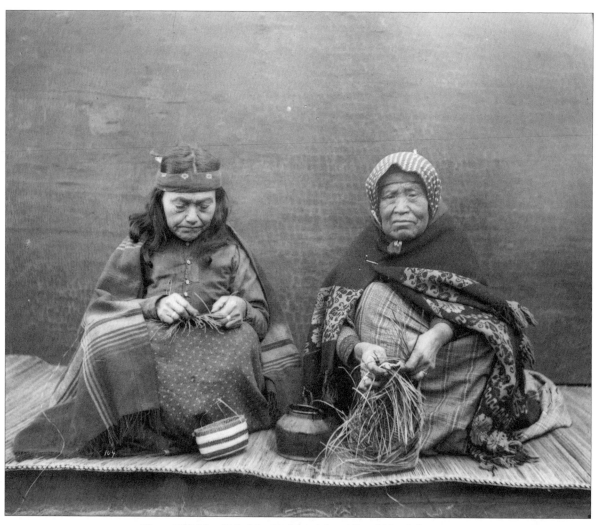

Figure 7.12. Mrs. *Weisub* (or *He-da-took-ba-yitl*) and *Niesub* demonstrate weaving while seated on a cattail mat, with a special tin pot between them that was used for keeping materials damp.

PHOTO BY SAMUEL G. MORSE, CA. 1898, COURTESY WASHINGTON STATE HISTORICAL SOCIETY.

Some older women were still able to pass basket-making skills along to their young relatives. Ada Markishtum, who was born in 1882, "learned to work with tules and cattails from her grandmother, Dah Qua Dih, who was called Quaddy (Mrs. Thomas Ward)" (Burke Museum 2001).

The baskets themselves began to show the effects of growing commercialization. From the 1890s on, there is an increasing amount of plaiting on the bottoms. A basket maker could make a plaited bottom in less time than it took to finish a twined base. The appearance of raffia as a substitute for cedar bark was another time-saver.

In 1902 W. W. Washburn, Sr., became the government trader at Neah Bay, operating a store and serving as postmaster (PAEN 1953). Up until World War I, "about half the baskets were marketed through the trader at Neah Bay," and the "rest were taken to Seattle or Tacoma by the Indians themselves" (Marr 1987:41). In the cities, the baskets were sold to shops or on street corners.

The prices at which weavers sold fancy baskets remained constant from at least 1904 to 1913. Basket makers received 25 cents, 50 cents, 75 cents, or $1 for each piece, depending on its size. However, income from basket making on the Makah Reservation doubled from $3,000 in 1904 to $6,000 by 1915. Weavers were earning 25 to 75 cents per day, suggesting they averaged selling two small baskets a day. In 1915 there were sixty-five women who wove mostly in the winter, when there were fewer other tasks competing for their time. That year W. W. Washburn and Son was still the only licensed trading post at Neah Bay, and it purchased all the baskets the women brought in. Isabell Allabush, who was born in November 1899, "wove lidded baskets by kerosene lamp and sold them for 50 cents apiece at the store for groceries" (Mapes 2001).

Washburn's wife, Martha, who came to Neah Bay in 1903, was a basket collector. In 1917 anthropologist Leo Frachtenberg "was instrumental in inducing" her to give a portion of her collection of Makah baskets to the Smithsonian (Hodge 1919: 53–54). These pieces are now housed at the National Museum of the American Indian (and may possibly be the 1911–16 baskets from Neah Bay in the Frachtenberg Collection).

Basket making provided needed income, particularly during months when there was no fishing. By 1919–20 the local basketry market became saturated, and younger women turned to other pursuits. In 1926 only three individuals were listed as making baskets in Neah Bay: Ada Markishtum (age thirty-eight), who made a considerable number of baskets; Sally Tyler (age fifty-six), who made a few baskets for commercial trade; and Sarah Markishtum (age thirty-eight), who made a few baskets in the winter.

One weaver in the early 1930s was actually able to weave as she worked another job: "We [my husband, Art, and I] worked up [at] the [fire] tower looking for fire for 9 years. Them years were hard times. . . . While we were out [in] the woods to look out for smoke, I used to take my basket material and go up the tower and make the basket, [while I] look[ed] around for smoke" (Ruth Claplanhoo 2001, in Erikson 2004:354).

The Indian agent's report for 1930 indicated that the market for baskets had again become saturated and that the quality of basketry workmanship had declined. In an effort to stimulate sales, the commissioner of Indian Affairs suggested to the Washburns that they start selling baskets in nested sets in their store (NASP RG75 1930b).

A Makah named Henry T. Markishtum (1882–1957) operated a store in Neah Bay in 1931 that carried only a small inventory of baskets for sale. Previously selling about three thousand baskets a year, Washburn's was overstocked with seven thousand baskets. In the first quarter of 1932, W. W. Washburn, Jr., sold only $339 worth of baskets but had sold $1,389 during the same period the year before (NASP RG75 1932a). So he decided in May 1932 that he would not purchase any new baskets until he sold the current inventory.

In the late 1930s Katie Hunter and Martha Green were noted basket weavers at Neah Bay.[20] The favored designs on fancy baskets at the time were canoes, ducks, and whales.

Among the Makah, as with other tribes of the region, basket making was traditionally a woman's occupation. However, males in the Anderson family from Ozette did make baskets, perhaps using skills they honed from net making to produce an income when there was no fishing. Charlie Anderson's granddaughter recalled, "In the wintertime, when it was too rough and stormy to be out at sea, [my maternal grandfather] used to stay home, finish [making] his nets, and then make baskets. . . . He'd be still long enough to make a few dollars on baskets" (Helma Swan, in L. J. Goodman and Swan 2003:69). Charlie Anderson, or *Hedowa*, was an Ozette who lived from 1869 to 1937. He lived at Green Point beyond Tsoo-yess beach. His father was from Ozette and his mother from Wyaatch.

Charlie's brother and his son made baskets too. His brother, Elliott, or *Qui ook tsit*, lived from 1876 to about 1950 and Charlie's son, Fred, lived from 1896 to 1966 (L. J. Goodman and Swan 2003:69, 242–43).

> It was [my grandfather Charlie Anderson] and my uncle Freddie Anderson and my granduncle Elliot Anderson that used to make the real fine baskets. Real fine baskets! . . . I never saw any of the other men do it. But those three used to. . . . My granduncle Elliot Anderson, the last living full-blood Ozette Indian, used to make real fine baskets. That's what he spent the winter doing. He had white friends, trading people, that he used to exchange with—he'd make a bunch of baskets, and he'd send them down to California. They'd either send him Navajo rugs, or they'd send trade beads. (Helma Swan, in L. J. Goodman and Swan 2003:69)

Charlie Anderson instructed his granddaughter Helma Swan in how to make baskets. She remembered, "My grandfather Charlie Anderson was the one that taught me how to make baskets. . . . Sometimes [my dad] would say, 'It's quiet time. It's quiet time. Then we'd have to sit down and if we didn't have anything to do my grandpa would say, 'Oh, sit down and make a basket.' Then he'd start teaching us while my dad was singing" (ibid.: 69, 129).

Few baskets were sold during the Second World War. In the years that followed, sales gradually picked up and weavers started to increase their production. In a 1956 letter the Makah Tribal Council listed twelve women as active basket weavers: Mary Allabush, Nora (Jones) Barker, Mrs. Frances Bowechop, Katie Hunter, Ada Markishtum, Agnes Markishtum, Matilda (Johnson) McCarty, Lena McGee, Meredith Parker, Ida Smith, Ruth (Anderson) Swan, and Ruth Ward (NADC RG435 1956).

In an October 29, 1957, letter, Hildred Williams wrote to Gunther on behalf of the Makah Tribal Council. This message came as Gunther was involved with preparing for the 1962 Seattle World's Fair, so she was probably amassing a stockpile of baskets to be sold there:

I was pleased to receive your letter regarding the basket ladies. By coincidence, Mrs. Meredith Parker dropped in for your address, as she is sending a little package of samples for your approval. They are buying the little baskets from various ladies as they make them. She said to tell you they would prefer to send in lots of one hundred baskets, as two hundred is a little too much to have around. So, I believe, they are working already to fill that order of baskets. (Gunther n.d.)

In the early 1960s the Makah Arts and Crafts Shop, with Helen Peterson serving as business manager, provided a consignment opportunity for artists to sell their basketry and other work. Each basket was labeled with the names of designs, the materials used, and the price, but not the individual weaver's name. The price for a decorated and covered basket, 6 1/2 inches tall and 9 inches in diameter, was $20. To stimulate this weaver cooperative, W. W. Washburn III virtually got out of selling baskets. Although the government tried to encourage the growth of this tribal commercial enterprise, a report from 1965 states that the Makah Arts and Crafts Shop had sold its last five or six baskets. Apparently most weavers preferred to market their work individually so they could get the money upfront, rather than wait for the item to sell.

In the early to mid-1960s, young Makah weavers, like Theresa Parker and Norma Hottowe Pendleton, were beginning their careers as weavers. A museum bio of the latter stated, "Norma has been weaving cedar bark baskets since the early 1960s. She credits her mother, Lyda Butler Hottowe Colfax, for her knowledge of basketry. When Norma was a child, she recalls sitting and watching her mother weave baskets" (Burke Museum 2001).

The excavation of Ozette began in 1970, and a quantity of basketry artifacts was among the vast amount of materials recovered from the five-hundred-year-old village. Isabell Allabush Ides was able to tell the archaeologists "just what they were, how they were made and how they were used" (Mapes 2001). "The Ozette discoveries rippled through . . . the community of Makah basket weavers" (Erikson 2004:341).

The Makah Cultural and Research Center (MCRC) opened in 1979, and its permanent galleries depict life at Ozette. Norma Pendleton "made Ozette archaeological replicas" of baskets for the museum's exhibits (Burke Museum 2001). Six other women were also involved in making replicas of baskets, hats, cradleboards, baby face coverings, mats, and harpoon sheaths (MCRC). Soon basket weaving surged, and contemporary baskets were available to tourists not only at the museum but also at family-run shops, as described in this report from the time: "There are still a dozen or so weavers at Neah Bay, including well known basket makers like Isabell Ides, Irene Ward, and Lena McGee. . . . The museum gift shop sells examples of contemporary Makah baskets. . . . On the Makah Reservation, several basket makers also have little craft shops in which they sell their baskets as well as those of others" (Gogol 1980:6). Younger weavers expanded their repertoire by learning from the Ozette artifacts.

The MCRC produced an exhibit entitled "In Honor of Our Weavers" as part of its twentieth anniversary celebration. Represented in the exhibit were the works of eight contemporary weavers: Ruth Allabush Claplanhoo, Mary Bowechop Green, Isabell Allabush Ides, Leah Smith Parker, Norma Pendleton, Vida Ward Thomas, Irene Hunter Ward, and Helma Swan Ward (Erikson 2004:351).

Today basket making continues to be a living art on the Makah Reservation:

Basket weaving classes are held at the MCRC, mainly during the fall and winter months, and the public school in Neah Bay offers basketry classes for high school students. The high school students are brought into the Ozette collections storage so they can carefully examine the basketry made by the Makah ancestors. The adult weavers are also given the opportunity to examine the Ozette basketry, and the growing collection of ethnographic Makah basketry. (MCRC)

Basketry continues to be a source of pride among the Makah people. According to museum director and tribal member Janine Bowechop: "Other than whaling, we have defined ourselves through baskets for generations" (Erikson 2004:340). The well-known whaling design brings together these two most important traditions. According to another tribal member, Ed Claplanhoo, it is the tribe's signature design (Mapes 2007).

Notes

1. As in many Northwest Coast cultures, basketry played an important role in the day-to-day activities of the Makah. However, the Makah used wooden boxes in ceremonies and for cooking and storing their food while their neighbors used baskets (Gunther 1935:37).

2. "The women . . . used to go out in bunches, eight, nine at a time, and all get their baskets and put 'em on their backs. They made little baskets for us to carry. So we'd go out to the beach and get China slippers or even clams. It was just women—just women and little girls" (Helma Swan, in L. J. Goodman and Swan 2003:68).

3. Here Helma Swan Ward discusses her great-grandaunt *Xedatúk! baix* (also spelled as *He-da-took-ba-yitl*), who was called "grandmother" by Helma's father, Charlie Swan, whom she raised (L. J. Goodman and Swan 2003:302). Known also as Mrs. Weassub (see note 19).

4. There is some uncertainty about when Swan was first in Makah territory. Although Joseph Henry, secretary of the Smithsonian Institution, said in 1869 that Swan in 1855 "accompanied the late Maj. Gen. Stevens, then Governor of Washington Territory, while making treaties with the Makahs and other tribes" (quoted in Swan 1964 [1870]:iii), by Swan's own account (1857:327) it was actually the Chehalis River Treaty Council in February 1855 that he attended with Stevens. We do know that Swan made "an 1859 drawing of Bandak [Baadah] Point, Neah Bay," because a stereoscopic photograph of the sketch is housed in the collection Stereo Views from Alaska to Mexico, ca. 1859–1902 (BANC PIC 1987.011—STER) at the Bancroft Library ([1959]) at the University of California, Berkeley. And it was also reported that "in 1859 Swan became associated with a trading post at Neah Bay" (Morgan 1955:94). He conducted the first census of the Makah in October 1861 (Swan 1964 [1870]:2) and made a survey of the reservation in the summer of 1862 (ibid.: 88). He taught at the reservation school for the Office of Indian Affairs from the opening of the school in 1863 (Renker and Gunther 1990:427) until he resigned his position in 1866 (Cole 1985:14).

5. Baskets collected by Rev. Myron Eells from various tribes are housed at the Field Museum in Chicago, the Burke Museum of Natural History and Culture in Seattle, and Whitman College in Walla Walla, Washington (Castile 1985:vii).

6. Ada Thompson Markishtum (b. 1888) was half Ozette (from the Ward family) and half white (Gunther n.d., Makah Survey Genealogy, folder 1–19).

7. Helma Swan (Ward) (1918–2002) was Ozette and Quileute on her mother's side and Ozette and Nootka on her father's side (L. J. Goodman and Swan 2003:240–43).

8. Words in Makah and neighboring languages have been left in their original transcriptions as found in the sources utilized. Earlier sources, such as Swan and Gunther, used an English-based orthography. Later sources tend to use a technical, linguistic orthography that is influenced by the Czech alphabet. For example, the suffix meaning "basket" appears as *-ats* in early materials but recently has been spelled *-ac*.

9. Another type of basket, the coiled watertight basket, is sometimes attributed to the Makah as a traditional form. Gunther concluded that coiled watertight baskets were not a traditional form for the Makah: "[While] Indians in other parts of the country used baskets in the household, these people [the Makah] made colorful boxes of cedar [instead] to store their goods and even to cook their food" (1935:37). However, in the late 1870s Mrs. Quedessa explained how the "long, pliable roots" of the cedar were sometimes "woven while held under water" when making coiled baskets (McCurdy 1961:54). It is probable that Mrs. Quedessa married into the Makah from a people who did coiling, as McCurdy does state that watertight baskets were not used for cooking in precontact times. The Nootkan groups of Vancouver Island, including the Ditidaht, did not make coiled baskets either (Johannesson 1984b:5; Turner et al. 1983:26). Rather than making them, the Makah traded for watertight baskets (Gunther n.d.).

10. Modern Makah transcriptions and other information on Makah basketry that were supplied by Janine Bowechop, Maria Pascua, and other language program staff at the Makah Cultural and Research Center are attributed to "MCRC."

11. The Makah also had baskets they used for fishing equipment. Two examples, each labeled "Makah fishing basket," were collected by Leo Frachtenberg and are in the National Museum of the American Indian (collection nos. 059027 and 059889). These two cedar bark pouches or wallets are both plaited but are not the same shape or construction.

12. The first issue is whether these hats were made by the Makah or were solely made on Vancouver Island. The Cardero portrait seems to be the only evidence that the Makah made them, an idea that is generally accepted. However, Bill Holm, an art historian who was a student of Gunther's, states that "the hat [was] presumably acquired either as a gift or by trade" (Henry 1984:160), but he does not present any firm reasons for such a claim.

 The next issue concerns one material found in hats located in museum collections. Specifically, the hats are described as containing surfgrass (*Phyllospadix scouleri*). While the Nootkan groups of Vancouver Island used this plant for basket designs (Turner 1979:154), Gunther (1974 [1945]:21) says that the Makah, who called it *xūxwaˊp*, ate the roots in the spring but did not use the plant for basketry. This indicates that these hats were not of Makah origin.

 The third issue deals with the role of the hat in Makah society. There is uncertainty about what it represented, who wore it, and even what it should be called. Holm calls it a "chief's hat" (Henry 1984:160). Wright (1991:84) says that "whalers' hats [were w]orn as a symbol of high social rank and of the prestige associated with the role of the whaler, [and thus] hats such as these were reserved for use by high-ranking people." The Peabody Museum (n.d.) combines the two names and calls them "whaling chiefs' hats," with their role being described in an article accompanying one of the museum's exhibits:

 > Two of the hats in the Harvard collection are of a type that is unique to the Nuu-chah-nulth (Nootka) whale hunters of the Nootka Sound region and their Makah relations across the Strait of Juan de Fuca on the Northwest tip of Washington State. They were

worn by both males and females, and represented the relationship between the role of chief and the role of whaling captain [and as such are] important symbols of rank among the Makah and Nuu-chah-nulth. (Malloy n.d.)

However, women in traditional Makah society were neither chiefs nor whaling captains.

13. Queen Annie was married at least three times. Her first husband was *Kalchute*. She appears on the 1888 Makah census as *Omaks* or Queen Annie, the wife of *Waklah*, her second husband. Either she or this husband are noted as having an Ahousaht or Ucluelet name, *ūai'yuʼqwi'saks* (Gunther n.d.). Her age is given as forty-two, but that is probably an error for sixty-two. On the 1900 Neah Bay census, she is listed as *O-ax* or Queen Anna, a seventy-five-year-old widow. And on the 1903 census she is Anne Green or Queen Annie, and her final husband is John Green or King John. A Register of Indian Families for 1903 lists her and her husband and records her age as seventy-eight.

14. At least one attempt has been made, based principally on bottom starts and materials, to group the changes in Makah fancy baskets into phases and to assign to them hard-and-fast dates:

 Phase I (1860s)—rims and bases twined; warps and wefts of cedar bark

 Phase II (1870s–80s)—rims with lip seat and cedar bark strip; bases with areas of plaiting; materials include sedge or cotton string

 Phase III (1890s–1930s)—bases plaited; materials include raffia as weft (Burke Museum 2001)

 However, the variations found in the combining of different bottoms, rims, designs, and materials do not allow for such a simple categorization. For example, a basket in the Burke Museum Collection (1-453), said by Ada Markishtum to be the work of Queen Annie or Queen Annie's mother, has a twined base, which would associate it with Phase I, but its cedar bark strip at the rim would associate it with Phase II. What this suggests is that a weaver was free at any time to continue with the past, adopt the new, or mix the two. While the phased approach to categorization does not work, the dates (e.g., 1860s, 1870s, and 1890s) can serve as guidelines for estimating when certain innovations were added to the variations from which a Makah weaver could choose.

15. Mrs. Young Doctor appears on the 1888 Makah census as *Haqwatlup*, age thirty-seven. On the 1900 census Young Doctor's wife is listed as Lizzie Doctor or *Hopu-t-sup*, age forty. The 1903 census has her Indian name as *Hopu-sup*. She is said to have been a sister of Jack Ides from Tsoo-yess.

16. The species of sedge used by the Makah was identified as *Carex obnupta* by Turner (1979:124). Gunther (1974 [1945]:22) lists it as "Carex (sitchensis?)."

17. A basket weaver's basket, complete with tools, was found at the Ozette archaeological site (Erikson 2004:341).

18. The Nootkan seal design, which is probably related to the Makah seal, depicts the seal swimming in the water with its head held up (see Dyler 1981:18).

19. The identification of Mrs. Weisub (or Weassub) and *Niesub* comes from a handwritten caption in the Prosch Indian [Photograph] Album at Special Collections, University of Washington Library. Another spelling found, "Mrs. Weasum," reflects an early Makah pronunciation before *m*'s became *b*'s and *n*'s became *d*'s. The 1903 census of the Makah Tribe shows *We-ah-sub* and his wife, *He-da-took-ba-yitl*. This was Helma Swan Ward's great-grandaunt (see

note 3). The latter weaver, *Niesub* (age fifty-eight), and her husband, *Siaha* (age ninety-six)—noted by Gunther (n.d.) as *sai'i'asat*—appear on the 1888 census of the Makah Tribe along with their daughter, Hattie Weic (age nineteen). The daughter may be Mrs. Hattie Hayte on the 1903 census.

20. Katie Hunter (age one) appears on the 1888 Makah census, living in Ozette with her mother, *Qatchkootle*, or Mrs. Hammond (age thirty). *Qatchkootle* has subsequently been identified as Mrs. Charlie Hammond, a sister of Charles Weberhard, or *Satahub*, who also lived at Ozette. Martha Green is likely Mary Bowechop Green.

CHAPTER EIGHT

Ancient Basketry of the Olympic Peninsula

DALE R. CROES

The scientific recovery of archaeological sites can reveal much about ancient cultures. Archaeology provides early dates that can be associated with cultural development in the region, but the archaeological record does not unveil a full portrayal as yet. In fact until 1970 most artifacts that were found in Northwest Coast sites were limited to stone and bone artifact assemblages, which tell us mostly about subsistence and manufacturing practices. The moist coastal climate of the Northwest Coast decays wood and fiber artifacts that could have revealed much more about culture change and the links between ancient and historic Native peoples. The pronounced absence of this material culture became evident while I was working at an archaeological field school on Lopez Island in the San Juan Islands in 1968, where 90 percent of the organic material, such as wood and fiber artifacts, had decomposed.

One of the first professional archaeological excavations that recovered preserved organic material from a Northwest Coast site was conducted on Digby Island near Prince Rupert, British Columbia, in 1969 by the Canadian National Museum of Man (now the Canadian Museum of Civilization). Here archaeologists used hydraulic techniques—pressurized water hoses—to reveal preserved wood and fiber artifacts from this waterlogged site (wet site). Waterlogged sites are produced when springs or aquifers flowing underground create an oxygen-free, or anaerobic, environment where organisms, such as fungus and bacteria, cannot survive to decay wood and fiber. At the Digby Island wet site, the hydraulic excavation technique resulted in the recovery of ancient cedar planks that served as a boardwalk between houses hundreds of years ago.

Ozette Village Wet Site

In 1970 a winter storm eroded parts of the coastal Indian village of Ozette at Cape Alava, Washington, to reveal many of its artifacts. This village was occupied between 2,000 and 300 years ago. Reports of erosion drew people to see the site, and some, unfortunately, began to plunder it. In order to preserve and protect this endangered example of the Makah's rich heritage, the Makah Tribe and Washington State University (WSU) began a full archaeological investigation of the ancient houses that had been encased in a mudslide about 300 years ago.

Archaeologists from WSU, led by Richard Daugherty, discovered basketry and wooden artifacts that had been buried in part of the village by a 1700 mudslide—probably after an earthquake event. Using hydraulic excavation techniques, the wet site's preserved basketry was carefully removed, revealing stylistic evidence that could be used to interpret culture change in the region (fig. 8.1). As more West Coast archaeological sites were discovered and excavated in this same manner, new

examples of basketry and cordage were found that could be compared with the Ozette material to better comprehend the continuity or change in Northwest cultures over thousands of years (Croes 1976, 1977, 1995).

Hundreds of basketry items were found in houses throughout the Ozette village. Fifty-six basket types were recorded, including fourteen decorative flat bag types (fig. 8.2) and one cradle type (Croes 2001); eight mat types, including two tumplines, categorized as flat woven basketry; and seven hat types. Overall there were 697 basketry items and another 406 fragments studied (Croes 1977). Clearly Ozette was producing distinctive art and industrious amounts and kinds of basketry that had yet to be seen in ancient sites.

The Makah Tribe requested that I, as the WSU archaeologist studying the cordage and basketry at Ozette, learn about contemporary weaving from master Makah basket weavers. As joint partners in the project, the tribe believed that I would better understand Ozette basketry if I learned how to make Makah baskets; I was reluctant and thought it unnecessary, but soon came to discover I was quite wrong.

Sisters Isabell (Allabush) Ides and Lena (Allabush) McGee Claplanhoo were the weavers who taught me that individuals and families had distinct styles of basketry. The ancient Ozette basketry, composed of different types of baskets, hats, and mats, might also illustrate cultural distinctions between families or groups. Of course, different individuals had varying skill levels, and this was reflected in their work and distinguished them as individual artists. Basketry styles were handed down from generation to generation and could provide a "signature" for identifying the group and/or individual who made them. I found a possible signature on a basket in the north end of one of the buried Ozette houses; it was the decorative effect that was made by alternating wide and narrow wefts, the horizontal weaving elements, into a cedar bark checker-plaited storage basket (Croes and Davis 1977:161–65; fig. 8.3). Could this represent the unique work of an individual weaver living in the north part of House I, or was this evidence

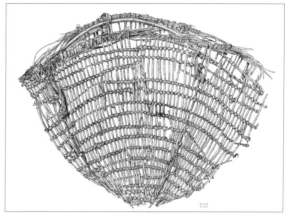

Figure 8.1. Illustration of a traditional open-wrapped-twined pack basket from the Ozette wet site. ILLUSTRATION BY CHRIS WALSH, FROM CROES 1977.

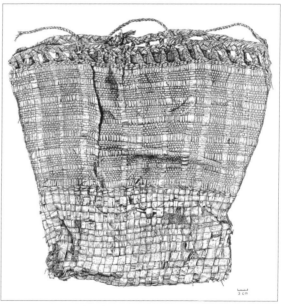

Figure 8.2. Example of a highly decorative and distinct cedar bark whale harpoon flat bag from Ozette (71/IV/32; OB24). Such bags were found at Ozette that contained whale harpoons in folded cedar bark sheaths (OM1), seal skin float plugs, and wooden-handled knives with iron blades, possibly for slitting the dead whale's jaw for tying the mouth shut (Croes 1977: 295–302). ILLUSTRATION BY CHRIS WALSH, FROM CROES 1977.

of a cultural transition taking place toward a more decorative basket? Since this discovery represented one instant in time, comparison with other sites was certainly needed to ascertain how distinctive this example might be.

The Makah basket weavers provided a firsthand understanding of how such a transition in weave style might occur in the ancient Ozette house. Isabell and Lena

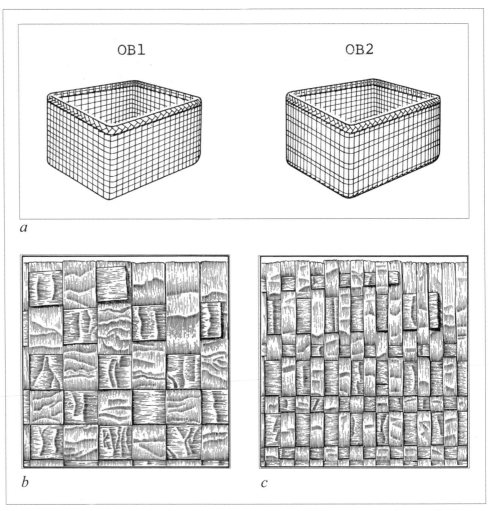

Figure 8.3. *a*, Typical checker weave used to construct the body of a large cedar bark storage basket classified as Ozette Basket Type 1 (OB1, reconstructed, *left*) and a more decorative plaiting on the large cedar bark storage baskets called Checker IIB found in the north end of House I defining Ozette Basket Type 2 (OB2, reconstructed, *right*) (Croes 1977:52, 203). *b*, Checker weave illustrated. *c*, Checker weave IIB. ILLUSTRATIONS BY CHRIS WALSH, FROM CROES 1977.

typically made their cedar bark basket bases with a basic checker weave, but in the late 1970s they, and other weavers, decided to change to a twill weave base. Isabell was having trouble with the twill weave and had her husband, Harold, start the bottom of her large food basket—or *wabit* basket in Neah Bay—that holds utensils, plates, and leftovers. Isabell may have feigned her difficulties with the twill weave to keep her husband involved in the process, because a couple of years later, after Harold passed on ("went home"), Isabell mastered the twill-weave bottoms and carried on the new weaving tradition.

The difference in weave found in House I could have been a weaver's personal signature. As an example, basketry student Vivian "Kibby" Lawrence made a mistake while weaving a design, and her mistake became a new basket design. Kibby

was attempting to put the traditional duck design on her basket and accidently wove the black dyed beargrass before the duck head, rather than after (all designs are built row by row in weaving, or "in the air" as the rounds are woven). In doing this the duck appeared to be looking backward (fig. 8.7). Teachers Isabell and Lena were greatly amused and encouraged Kibby to use this as her particular signature design, which she did. Kibby went on to be the first woman chair of the Makah Nation, and between council duties and raising three sons, she never pursued or passed on her basket weaving. Kibby has gone home now, and her signature tradition has not been carried on.

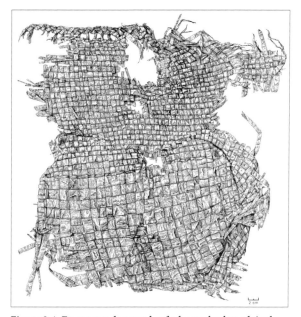

Figure 8.4. Fragmented example of a large checker-plaited cedar bark storage basket (2/V/43; OB1). Most large Ozette baskets of this type were full of contents and were heavily damaged by the ancient mudslide that covered the houses. ILLUSTRATION BY CHRIS WALSH, FROM CROES 1977.

One type of basketry that was rarely found at Ozette was the coiled basket. The few examples that were found were very similar to the early types from the upper Fraser River area; the coiled basket may have originated there and then was introduced to the Ozette people through trade networks (Croes 2003:70–74). Out of the thousand-plus basketry finds at Ozette, only three of these were coiled baskets (fig. 8.8). An interesting discovery were the intentionally cut pieces of coiled basketry in the shape of

a

b

Figure 8.5. Conscious cultural transition of basket base from checker weave (*a*) to twill weave style (*b*), as witnessed at Neah Bay in the late 1970s. Isabell later began signing her basket bottoms (*b*), something not done in the 1970s. NBW means Neah Bay, Washington. PHOTOS COURTESY DALE CROES.

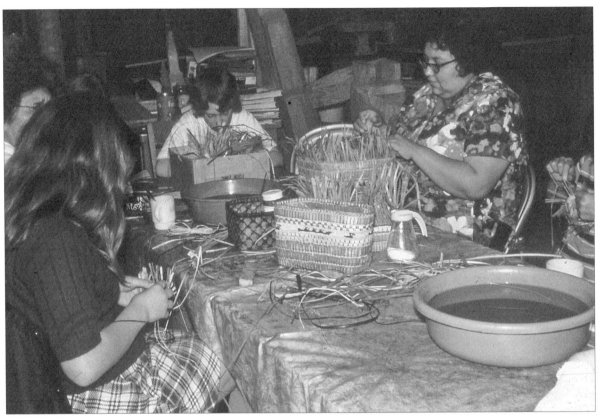

Figure 8.6. Vivian "Kibby" Lawrence (*right*) in Neah Bay School basket-weaving class in 1971. Note the traditional duck design on the basket purse in the foreground. PHOTO COURTESY DALE CROES.

a *b*

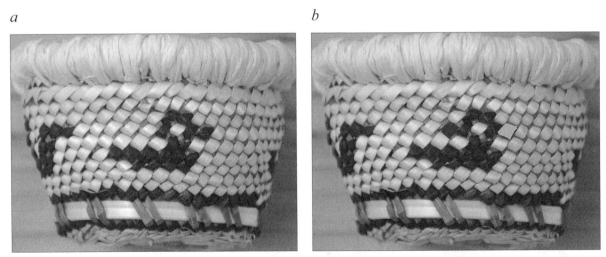

Figure 8.7. *a*, Example of the correct duck design, by Kibby Lawrence. *b*, Example of how Kibby accidently placed the black beargrass element behind the duck's head, creating a duck looking backward. PHOTOS COURTESY DALE CROES.

ribbons, trapezoids, and rectangles (figs. 8.9 and 8.10), which may have been symbolic gifts of value distributed at a potlatch (Croes 1977:362–65). Though rare in other Northwest Coast wet sites, three other sites in the Puget Sound area have examples of ancient or late (last 700 years) coiled basketry fragments (Croes 1991).

Hoko River Wet Site

In 1977, hydraulic excavation was begun at the Hoko River wet site (Croes 1995) and the Hoko Rockshelter shell-midden site on the Strait of Juan de Fuca between Neah and Clallam bays (Croes 2005). A wide array of basketry, cordage, and wooden artifacts were recovered from the Hoko River wet site, which was dated at between 2,600 and 3,000 years old with carbon 14 analysis—equivalent in age to the other oldest-known wet site on the Northwest Coast at the time, the Musqueam Northeast site at the mouth of the Fraser River, Vancouver, British Columbia (Borden 1976; Croes 1976, 1977; Archer and Bernick 1990). Though the typical stone, bone, and shell artifacts found at both sites place them in the same Locarno Beach archaeological phase[1] (Mitchell 1971, 1990), the basketry from each site is very distinctive. The carrying basket, or burden basket, is very common and was found in large quantities at both of these major fishing campsites, constituting more than 50 percent of all baskets at each site (Croes 2005:239; fig. 8.11); however, the weave on the bottom and the body, and the handle and tumpline attachments on these baskets, were distinctly different at each site, with vertical corner tumpline loops commonly found at Hoko (fig. 8.11) and top looped handles at Musqueam Northeast. Statistical analysis of a number of characteristics of Hoko and Musqueam Northeast basketry was performed, using 196 examples of baskets, yet their styles were found to be 100 percent unique to their site of origin (fig. 8.11).

Although the burden basket is quite common at each of these 3,000-year-old wet sites, individual baskets of this type are very different in technology and style—but no doubt equally efficient as carrying or burden baskets. Since the time that these

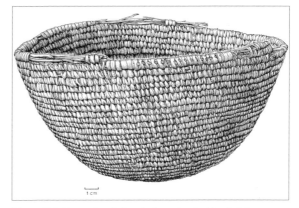

Figure 8.8. Example of a bowl-shaped coiled basket from the Ozette wet site. ILLUSTRATION BY CHRIS WALSH, FROM CROES 1977.

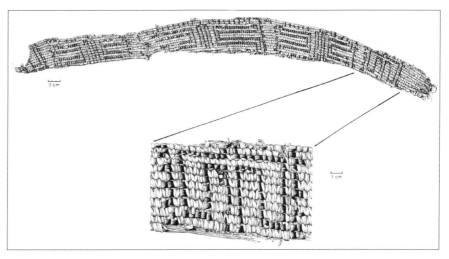

Figure 8.9. Examples of cut pieces of coiled baskets from Ozette. These were probably cut up as symbolic examples of wealth to distribute at potlatches. ILLUSTRATION BY CHRIS WALSH, FROM CROES 1977.

Figure 8.10. Example of a trapezoid-shaped strip cut from a coiled basket. ILLUSTRATION BY CHRIS WALSH, FROM CROES 1977.

Figure 8.11. Definitions of the common pack basket types from the contemporary 3,000-year-old Hoko River and Musqueam Northeast sites (Croes 1977, 1995). Their corresponding and distinctive body weaves are illustrated on the right. Some of these ancient examples are fragmentary, so they may not have the base remaining or extensions. ILLUSTRATION BY CHRIS WALSH, FROM CROES 1977, 1995.

sites were excavated, a third discovery of a nearly 3,000-year-old frozen burden basket was found on Hurricane Ridge above Port Angeles, halfway between the Hoko River and Musqueam Northeast sites. It is also a distinct type of burden basket in style and is discussed further below. Since baskets can be made with very different materials, base and body weave techniques, shapes, selvages, and attachments (such as handles and tump-line loops), they are a sensitive artifact for comparison. Recognizing this, archaeologists compared the array of all distinctive basketry attributes and types present in a large sample at the 3,000-year-old Hoko River and Musqueam Northeast sites with the basketry attributes and types from all other ancient wet sites with large collections, using a number of statistical tests, including a technique called cladistic analysis (fig. 8.12), which shows special, ancestral similarities (Croes 2005; Croes, Kelly, and Collard 2005; Croes, Fagan, and Zehendner 2009).

One consistent result is that all sites tend to link through time with their geographic neighbors, regardless of age, suggesting cultural transmission of styles through time, rather than dispersed transmission of basketry styles over broad regions through time. Basketry styles appear to have been guarded in different geographical regions and not rapidly dispersed, as stone, bone, and shell artifacts styles tended to be (as seen in archaeological phases). For example, the geographically close Hoko River and Ozette village sites consistently link together when their full array of basketry attributes and types is compared with arrays from all other Northwest Coast wet sites, but these two sites are separated by 2,500 years of time. Basketry from the 3,000-year-old Musqueam Northeast wet site, for example, is more closely associated to basketry at the geographically close, 2,000-year-old wet sites of Water Hazard (Vancouver, B.C.) and Puget Sound's Biederbost (Duvall, Washington, near Seattle). These three sites were all linked to basketry at the 1,000-year-old Puget Sound wet sites of Conway and Fishtown (Skagit Delta near La Conner, Washington) (Munsell 1976; Onat 1976; Croes 1989, 1995) and Qwu?gwes (Mud Bay in southern Puget Sound) (Croes et al. 2007).[2]

Archaeologists are seeing other styles of basketry in recent finds, such as the isolated, but first ever, find of a frozen burden basket fragment on the Olympic Peninsula. This basket fragment has been carbon-dated to approximately 3,000 years ago, the same period as Hoko and Musqueam Northeast. This single example is of a distinct

weave not seen at the contemporary sites of Hoko or Musqueam Northeast, so it represents another style of ancient burden basket. The weave is a sturdy cross-stitch wrapping well known today by weavers of the region, especially Salishan basket weavers. What this isolated find demonstrates is the diversity of basketry in ancient times. Unfortunately, this one basket cannot be statistically compared with the relatively large collections of ancient basketry seen from the same periods at Hoko and Musqueam Northeast, so we don't know if this burden basket type is typical of an ancient style found in the central north Olympic Peninsula region; and we won't know until a larger collection of wet-site basketry is found. A portion of the nearby Elwha Klallam Tse-whit-zen (*čx̣ʷícən*) archaeological village site in Port Angeles does date back to about this same period, but the wet-site area was not excavated. Unearthing Tse-whit-zen ceased because of the hundreds of human remains (Klallam ancestors) that were once laid to rest there and needed peace.

Another distinct style of weave was recovered from a single basket at the ancient Hoko River wet site. This basket was woven in a very common historical technique found on the Olympic Peninsula called wrapped twining. This small ancient basket is different, however, in that the technique is done inside out (fig. 8.13).

Native basket weavers are very interested in wet-site archaeology because for thousands of years this ancient art form has changed very little. When Isabell Ides

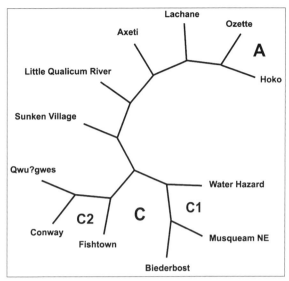

Figure 8.12. Unrooted cladogram derived from Northwest Coast wet-site basketry attributes. From these data, I have proposed that ancient Coast Salish basketry is represented for 3,000 years from lower branches: the right lower branch contains sites from 2,000–3,000 years ago; the left lower branch are sites from 500–1,000 years ago. The top branch of the cladogram represents Wakashan basketry sites for 3,000 years. For details and discussion of all the sites and analysis, see Croes, Kelly, and Collard (2005:137–49). CHART COURTESY DALE CROES.

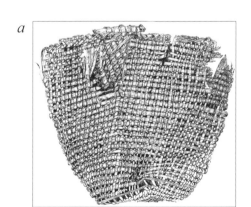
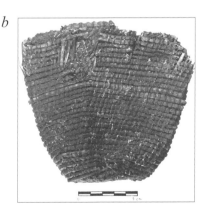
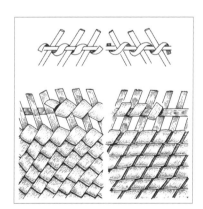

Figure 8.13. *a*, Example of wrapped twining in a 2,600–3,000-year-old basket from Hoko River (illustration by Pat Slade, courtesy Washington State University Hoko River Project). *b*, Although the weaving in this basket is inside out, it can be compared to the common weave used today (from Croes 1977). *c*, Illustration of the wrapped-twined method. ILLUSTRATION BY CHRIS WALSH, FROM CROES 1977.

Figure 8.14. Isabell Ides (eighty-seven), examining a 3,000-year-old basket from the Hoko River wet site in 1987. She was able to explain that it was made of finely split cedar roots with close twining and was probably a berry basket. PHOTO COURTESY DALE CROES.

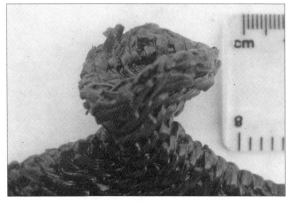

Figure 8.15. Hoko River cedar-bark knob top of conical hat from 2,600–3,000 years ago. FROM CROES 1995.

was shown a Hoko River basket, she explained how she might make a similar basket today, what the basket materials were, and how the basket might have been used 3,000 years ago (fig. 8.14). When basket weavers see similarities between their work and ancient examples, they feel a powerful connection to the basket weaver who was here before.

Hoko River basketry included hats, mats, and shredded-cedar-bark capes and skirts. Hoko's approximately 3,000-year-old hats were of two forms found that date to more than 2,500 years later at Ozette: flat-topped and knob-topped hats. The distinctive knobs woven onto the Hoko River hats were small in comparison with those from Ozette but were definitely knob tops (figs. 8.15–8.18). I concluded from anthropological research and oral history of Ozette's recent past that the knob-topped hats reflect the high status of the wearer, typically of a royal or noble lineage. The owner of a knob-topped hat at Hoko was also likely to have been of high status 3,000 years ago. With considerable continuity with other styles of basketry of the West Coast region and the status reflected in hats and headgear throughout the world's cultures, this seems like a practical assumption.

Ancient mats found at Hoko were made of tule, sewn in close intervals (2 inches separated rows; 26 mats in sample), using an estimated 96 feet (29 meters) of two-strand spruce root string for each one. Since Hoko was mainly a spring halibut fishing station (with more than three hundred wooden-shanked deep-sea fishhooks uncovered there), these mats are believed to have covered the sides of temporary fish camp shelters (Croes 1995:136–43). Reinforced shingles of stick and cedar bark found at the site are believed to have been the roofing

materials used to cover the family shelters (ibid.: 158–93). The sewn tule mats would have served as the shelters' side walls and also were used for mattresses and canoe covers (to protect them from the sun), as represented in a model of the community (ibid.: 229–31).

Shredded-cedar-bark capes and skirts also found at Hoko were made with a spruce root string edging (fig. 8.19), with the shredded bark folded and twined over the string.

Frozen Burden Basket

In 1993 an exceptional discovery was made by tourists visiting an alpine area of Olympic National Park. The only example on the Olympic Peninsula of an ancient basket preserved by freezing (rather than by waterlogging) was found under the edge of a snowfield at over 6,000 feet elevation (fig. 8.20). Though fragmented, it was a sturdily constructed burden basket and, even in its frayed condition, showed that it was originally constructed with a distinctive weave of the type used by Coast Salishan–speaking people on the Strait of Juan de Fuca, Puget Sound, and the Gulf of Georgia, called cross-stitch wrapping (Bernick 2003:232). This burden basket was dated at 2,880 years old, so it is contemporary to the Hoko River and Musqueam Northeast sites, yet no basketry constructed with cross-stitch wrapping was discovered at either of these sites. The only other evidence of a similar ancient cross-stitch–wrapped basket was a lone burden basket fragment found on the Fraser Delta that dates to approximately 1,000 years ago (ibid.: 230–43) (fig. 8.21). Even though the snowfield fragment is 2,000 years older than the Fraser Delta fragment and has wefts spaced farther apart, these two examples are distinctly Salishan, as can be seen in basketry made by contemporary Salishan weavers.

Today similar examples of this cross-stitch–wrapped weave, made with cedar bark warps and wefts and cross-stitched with raffia (fig. 8.22), can be found mostly among the Coast Salish tribes of Puget Sound, the lower mainland of British Columbia, and eastern Vancouver Island and the Klallam on the Strait of Juan de Fuca. When Elwha Klallam elder Ed Sampson visited the site where the snowfield fragment was found, he jokingly remarked, "So this is where I

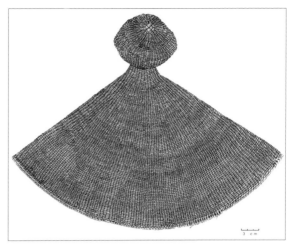

Figure 8.16. Illustration of an Ozette Village cedar bark knob-topped conical hat excavated in 1970. ILLUSTRATION BY MADGE GLEESON, FROM CROES 1977.

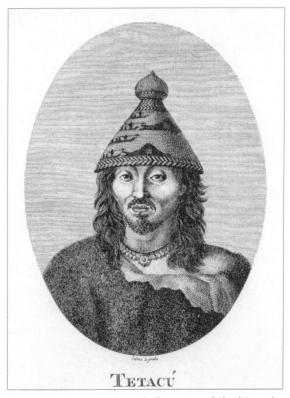

TETACÚ

Figure 8.17. Circa-1792 Spanish illustration of Chief Tatoosh of Neah Bay, wearing a decorated knob-topped conical hat (Espinoza y Tello 1930:30).

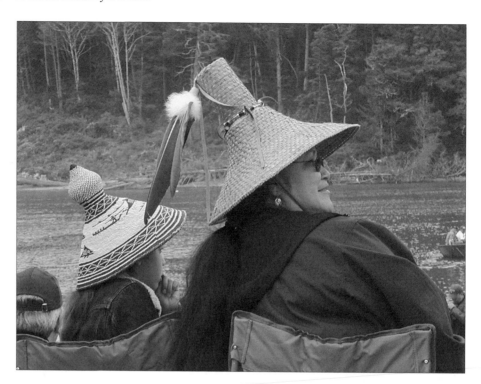

Figure 8.18. Women wearing traditional hats during canoe journey to Quinault, 2002. PHOTO COURTESY DALE CROES.

left that basket." Oral history and archaeological evidence places the Olympic Peninsula tribes in the high country long before the area was explored by newcomers, yet this one basket was especially powerful in conveying to the public the importance of the Olympic high country in peninsula tribal lifeways. For generations the ancestors of today's tribes spent time in the mountains gathering plants, hunting, and visiting with their neighbors, and they traveled across the high mountain divides with their gear in burden baskets as we would use a backpack today. More and more evidence is coming to light showing how ancient Native peoples used the high country in addition to the coast.

The Future

The examination of further waterlogged/wet archaeological sites has great potential for uncovering the complete range of rich and ancient basketry heritage, through both time and space, along the entire Northwest Coast of North America. Such sites have been found from southeast Alaska to southwest Oregon, with dates ranging from more than 9,400 years ago at the Kilgii Gwaay site on the southern end of Queen Charlotte Island, B.C., Canada (1325T) (Fedje et al. 2005) through the contact period. This antiquity and widespread distribution would indicate a high probability of finding sites with good preservation of basketry and other wood and fiber artifacts from all periods of human occupation of the Northwest Coast and along the approximate 10,000 miles (16,000 kilometers) of shoreline. The general environment

of the Northwest Coast of North America is marked by abundant precipitation caused by combined effects of the North Pacific Drift, the prevailing westerly winds, and the steep topography of the mountain barriers along the coastal shoreline. So it seems entirely reasonable that these wet sites on the Northwest Coast should be not only present but also abundant. Every sizable shell-midden site along the Northwest Coast, if explored with the intent to find a waterlogged area, would probably exhibit a wet-site area with preservation of wood and fiber. Unfortunately, wet-site techniques and procedures have not been fully integrated into the traditions of archaeology in the region, so wet sites are rarely sought out by practicing archaeologists. The importance of Northwest Coast wet sites captures the attention of Native Peoples of the region because the wood and fiber (basketry/cordage) artifacts recovered are their own ancient material culture.

From the time of the Ozette village wet-site excavations in the 1970s, Native Peoples typically have been in partnerships with archaeologists working on Northwest wet-site projects, demonstrating the importance to them of finding the wood and fiber components of these archaeological sites. This kind of direct tribal interest in wet-site evaluation and protection may be what's needed to move the discipline to expand its training to include wetland archaeology and make it a mainstream archaeological approach.

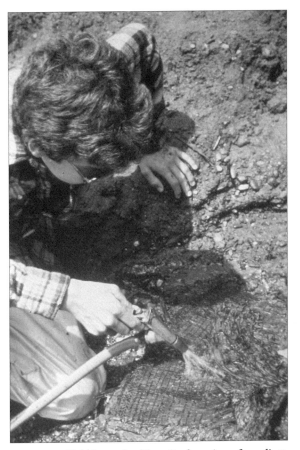

Figure 8.19. Makah member Vince Cooke, using a fine-adjust nozzle to excavate a shredded-cedar-bark cape or skirt lying on top of an open-wrapped-twined pack basket. PHOTO COURTESY DALE CROES.

In large part the importance of basketry for past, present, and future Native communities is demonstrated through joint Native and archaeologist wet-site archaeological work; the forming of and active participation in the regional Northwest Native American Basketweaver Association meetings (where often a thousand Native weavers join together in assuring the cultural transmission of the art); and publications such as this one, actively bringing together anthropologists and Native Peoples to assure that Olympic Peninsula basketry continues to be documented. Ancient finds help reveal the rich basketry heritage and historical links to basketry's active transmission and community/family identities into the future.

a

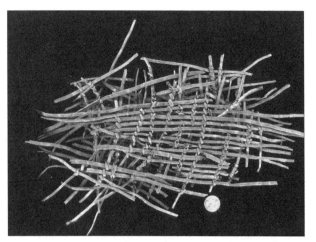

b

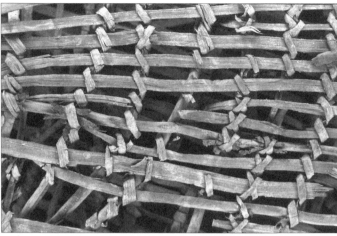

Figure 8.20. *a*, Ancient Olympic high-country pack basket found frozen under a melting snowfield. The entire basket body was woven with a distinctive technique of open cross-stitch wrapping (best preserved in lower right of photo), though other cross-stitches are seen in other parts of this fragment. The main sticks (warps) are of split red cedar boughs, and the wrapping elements (wefts) are of split red cedar roots (Hawes 2009). *b*, Detail of *a*. IMAGES COURTESY OF OLYMPIC NATIONAL PARK.

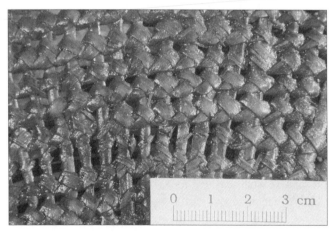

Figure 8.21. Detail of the only other example of ancient cross-stitch wrapping. This fragment from a Fraser Delta wet site dates to 1,000 years ago (DhRq 19). PHOTO BY KITTY BERNICK.

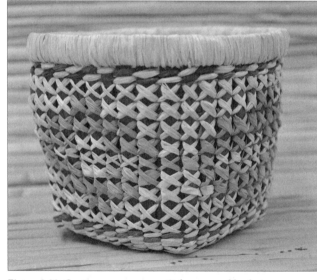

Figure 8.22. Contemporary cross-stitch–wrapped basket made by Ida William, Swinomish, in 1990. PHOTO COURTESY DALE CROES.

Notes

1. Locarno Beach Phase is a Northwest Coast culture phase dating between 3300 to 2400 B.P., a position relative to the development of ethnographic cultures observed on the Northwest Coast.

2. At a recently reported wet site find across from Port Angeles in Esquimalt Lagoon (near Victoria, British Columbia), archaeologists have found several basketry pieces, wooden bentwood fishhooks, wooden wedges, and a large fragmented burden basket dating to 2,980 radiocarbon years. This example is like the main Musqueam Northeast burden baskets, with a distinctive wraparound-plaiting body construction. Again, like the Hurricane Ridge find, this site is halfway between Hoko River and Musqueam Northeast. With only a few dated basketry pieces available for analysis, this basket seems to be closer to the Musqueam Northeast burden baskets in style (B. Clark, Kilburn, and Russell 2008:48–56).

Weaving Cultural and Ecological Diversity

Beargrass and Sweetgrass

DANIELA SHEBITZ and CAREN CRANDELL

Every basket tells a story—a story of the people that made it, the land where it was made, and how the two intertwine. Admired for their beauty, baskets were in fact essential for the survival of Native Americans on the Pacific Northwest Coast. Food was gathered, carried, and stored in baskets, as seasonal rounds to fishing grounds, berry patches, and camas meadows necessitated lightweight containers; pottery was not suitable for the mobile gathering lifestyles of the Pacific Northwest (Hunn 1990:185; Marr 1990:267).

All weaving materials share importance among the eight Olympic Peninsula tribes, but since each tribe uses resources specific to its homeland and local environment, the plants used make its culture unique. Without the traditional full complement of materials historically available for food and fiber, lifeways have been altered. Therefore, preserving plant materials is crucial for preserving culture. Each plant relies on a specific habitat, or local environment with suitable conditions. Variation in the environment creates diversity in the plants. Communities of plants and animals interact with the surrounding environment to make up an ecosystem, and the Native peoples of the Olympic Peninsula interact with that landscape to become part of several ecosystems. The preservation of the various indigenous cultures requires protecting each ecosystem and the biodiversity or variation of the living things within it.

It should come as no surprise, then, that a book about basketry on the Olympic Peninsula is also about cultural diversity and the ecological diversity upon which it depends. Native Americans manufactured functional items by using and manipulating their surroundings. Some types of useful plants were found in unaltered landscapes, and the peninsula tribes gathered them during regular visits to favorite locations. In other cases, tribes modified the environment with traditional management practices, to achieve the biodiversity necessary for subsistence.

In this chapter, two important plants used widely for basketry among the Olympic Peninsula weavers are discussed: beargrass and sweetgrass. Beargrass, and the historic ecological diversity of which it is a part, is dependent upon traditional management within the landscape. This active approach is often referred to as the application of traditional ecological knowledge, or TEK, currently a very widely used term. The second species, sweetgrass, is found in a habitat that has been greatly modified over the course of a century and a half in the Pacific Northwest. The future of this species is dependent both on the preservation of its limited remaining habitat and on the restoration of those systems in which damage can be reversed.

Traditional Ecological Knowledge and Management of Beargrass

TEK is a summation of knowledge, practice, and belief, evolving by adaptive processes and handed down through the generations. It is the relationship of living beings with one another and with their environment. This knowledge includes a keen awareness of the interconnectedness of humans with plants, animals, and soils and the role that each player holds in sustaining the other (Berkes, Colding, and Folke 2000:1252). Ethnoecologist M. Kat Anderson has documented this knowledge by focusing on numerous "environmental management" activities (such as burning or replanting) in which sophisticated techniques conducted by indigenous cultures altered the landscape, the species composition, and individual plants, ensuring that the highest-quality basketry materials were continuously available for use. "Taking care of nature" not only allows for the continued availability of basketry material but also heightens the amount of plant diversity available and enhances the landscape (Anderson 2005:153).

One plant that was historically managed through environmental management and is still a fundamental basketry plant is beargrass. For centuries, beargrass (*Xerophyllum tenax*) has been an important material for baskets made by Olympic Peninsula tribes. To personalize baskets, beargrass blades are often dyed and interwoven with cedar to add ornamentation (J. Storm 1985). Beargrass is not a grass but a member of the lily family. It also goes by other common names, such as pine lily, squawgrass, mountain grass, deergrass, elkgrass, turkeybeard, American grass, basket grass (Thompson and Marr 1983:20), and even fire lily (Anderson 2005:194). Although peninsula tribes have experienced an enormous change in lifestyle over the past century, beargrass continues to be an integral part of their traditions. As Michael Pavel (2004), a prominent teacher of Skokomish (Twana) tradition and history, explains: "We can clearly say that beargrass contributed to the maintenance and preservation of our traditional culture. . . . [Using beargrass in basketry and other ceremonies] is a sacred practice that is important to maintaining the role of certain entities in our lives and recording our history."

On the Olympic Peninsula, beargrass leaves are gathered in the summer, when they are long and soft. According to Thompson and Marr (1983:20), the way to harvest them is to bunch the center strands together, wind them around the hand, and jerk upward. Beargrass gatherers traditionally pull bunches of long blades, gathering

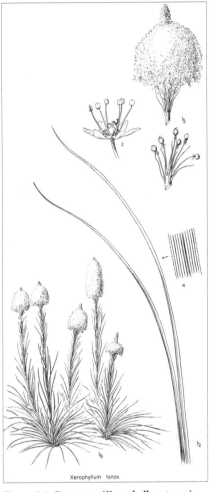

Figure 9.1. Beargrass (*Xerophyllum tenax*). From Leo C. Hitchcock, Arthur Cronquist, Marion Ownbey, and J. W. Thompson, *Vascular Plants of the Pacific Northwest.* ILLUSTRATIONS BY JEANNE R. JANISH (SEATTLE: UNIVERSITY OF WASHINGTON PRESS, 1969), 813.

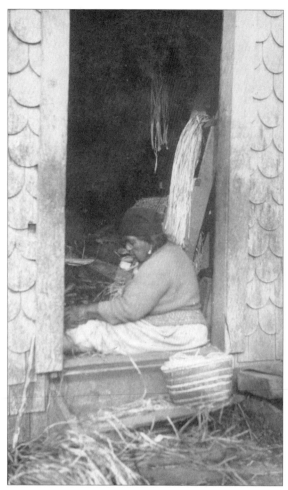

Figure 9.2. Unknown basket weaver at La Push. Notice the beargrass hanging to dry. COURTESY OLYMPIC NATIONAL PARK (POL.015.027).

the tips of a few straws in their "pulling hand" and then pulling until the bunch comes loose from the base. Referring to beargrass as "straw," Charles Peck (1975:8) observes that the gatherers keep pulling until they have all they can hold in their hand. When they have picked a big bunch, they tie a strip of rag around it to hold it together. The bunch is held up by the tip and shaken to make the short straws drop out. Narrow leaves are then separated from the wide blades, and the bunches of grass are braided at one end.

Leta Shale, a Quinault basket maker, recalled that she learned about her family's traditions of beargrass gathering and preparation from her grandparents. She was told to "only pick just certain parts of it": "You found a bunch and you'd go to the middle of the bunch and pulled on it, and when you got it pulled up, then you shook out the little ones left in it." Her grandfather gathered the plant in May and June to have for the rest of the year, and her grandmother would make the baskets: "He would pick the beargrass and then they'd dry it together. They swore by a certain way of drying beargrass, and that's selecting the best of what you pick and braid[ing] it, and then little bunches at a time are hanging [on] . . . racks above the kitchen stove. And they'd hang these. And the fire was always going in the kitchen to dry the grass" (Shale 2003).

Similarly, Charlotte Kalama, a Quinault basket maker (who, sadly, passed away in 2010), discussed how her husband gathered beargrass by taking the leaves individually. Only after beargrass is dried for three to four days in a dry area and has turned white is it ready for use. Charlotte explained that in order for beargrass to be useful in basketry, the leaves must be two to three feet long (Kalama 2003).

The barbed midrib that runs down the middle of the leaf's underside is generally removed with a knife. Special wooden trimmers can be used to even out the strands (Thompson and Marr 1983), but the edges of dried leaves can be razor-sharp and may cut the weaver's fingers if she is not careful. The leaves are soaked for a few hours in water to increase pliability before weaving (Anderson 2005). Beargrass leaves are strong and durable, and this preparation makes the blades flexible for making imbricated designs on the baskets (Slaughter 2006).

Natural dyes were once used to color beargrass leaves (see chapter 4). Commercial dyes introduced the possibility for beargrass to take on brighter hues such as purple, blue, and orange (Thompson and Marr 1983:20). If it is not dyed, beargrass woven into baskets is pale green to sand colored. It is used for ornamentation where it stands out against western red cedar and maidenhair fern (Anderson 2005:193).

Northwest tribes have used prescribed burning to stimulate the new growth of beargrass leaves specifically for their use in basketry. Interviews with Olympic

Peninsula tribal members revealed that more often, however, the burning was conducted not to target beargrass in particular but to clear the habitat where beargrass lived, in order to attract game. Burning land modifies its vegetation to favor early-successional species such as grasses and herbs. In addition, anthropogenic fires may increase mineral elements and available nitrogen (Agee 1993). Since beargrass reproduces asexually, it is capable of quickly sprouting following a fire.

While the primary reason for the burns was likely to attract game, beargrass certainly benefited from the fire. According to interviews with Quinault and Skokomish basket makers, the best basketry-quality beargrass is found under some shade; it is intolerant of deep shade and cannot flower under a canopy (Shebitz 2005). Therefore the use of fire to keep the tree canopy open created ideal habitat for this species. Fire also creates more pliable beargrass blades or leaves, making the postfire growth better suited for basketry than those plants that have not been burned (Rentz 2003). In addition, fire yields greater beargrass abundance, resulting from increases in vegetative reproduction, increased seed germination, and seedling establishment (Shebitz, Reichard, and Woubneh 2008). The use of fire by indigenous people to maintain suitable basketry material was also documented in California by M. Kat Anderson, who found that the Yurok, the Karuk, the Hupa, the Chilula, and other tribes burned beargrass clusters periodically and harvested leaves from these burned clumps one to three years later (2005). After beargrass is burned on the Olympic Peninsula, the leaves typically reach a length suitable for basketry in three to five years.

According to interviews with local tribal members on the Olympic Peninsula from 2002 to 2007, anthropogenic burning was no longer occurring by the late 1800s on the Olympic Peninsula, but information regarding its purpose and extent has been passed on through generations of oral tradition. For example, the late Bruce Miller (*Subiyay*), a Skokomish keeper of plant knowledge and a master basket maker, reported that the Skokomish maintained a network of "prairies" on the southeastern Olympic Peninsula and rotated the burning so that each area burned every two to three years. He explained that burning was conducted in autumn and that the areas burned varied in size from a

Figure 9.3. Leta Shale, 2003. COURTESY LEILANI CHUBBY, QUINAULT INDIAN NATION MUSEUM.

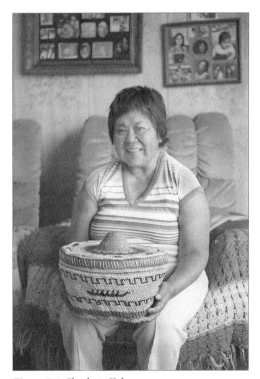

Figure 9.4. Charlotte Kalama. PHOTO BY LARRY WORKMAN.

few square feet to many acres. *Subiyay* described how beargrass occurred in the savanna-like border between prairie and forests and stated that "the periphery of the prairie was equally as important as the prairie itself" (Miller 2004). This preferred habitat for beargrass was also noted by Charles Peck (1975:8) in an unpublished essay on Swan Prairie (at Neah Bay): "The best straw [beargrass] grows around the edges of the flat prairies, in the shade of pine and cedar trees. It grows in big clumps."

Anthropogenic burning also maintained the fundamental Native American food source camas (*Camassia quamash* var. *azurea*) within these open-canopied habitats. In one such dry sphagnum bog on the Quinault Indian Reservation, both camas and beargrass remain today, in part because this area was burned more recently than others. In fact, Quinault tribal elder Justine James, Sr., recalled that in the mid-1900s the land was occasionally burned to maintain it as a hunting ground. He said that the beargrass, which grows on the periphery, was occasionally burned when the fires became larger than expected (J. E. James, Sr., 2007).

The predominant beargrass areas managed through burning were savannas, with grasses and flowering herbs as the main vegetation and scattered trees creating a "parklike" plant assemblage. The trees and shrubs maintained a relatively open canopy, enabling beargrass to receive adequate sun exposure to promote flowering. Due to the absence of indigenous burning over the past century, however, there is no longer an intact example of this beargrass savanna habitat anywhere on the Olympic Peninsula (Peter and Shebitz 2006).

Interviews with basket makers on the Olympic Peninsula reveal a common concern that low-elevation beargrass has declined over the past few decades (Shebitz 2005). Indeed, an ecological research project confirmed significantly lower beargrass abundance on the southeastern Olympic Peninsula, near the Skokomish Territory, in 2003 than there was in 1986 (Shebitz, Reichard, and Woubneh 2008). One cause of the decline is absence of fire. Throughout the past century, fire suppression policies by state and federal agencies have replaced anthropogenic burning and led to the encroachment of what remained of most prairies and savannas in the Pacific Northwest (D. L. Clark and Wilson 2001; Lepofsky et al. 2003). The rapid forest succession of former beargrass-dominated savannas on the southeastern Olympic Peninsula after the mid-1800s demonstrates the essential role that anthropogenic burning played in maintaining open-canopied habitat suitable for beargrass growth (Peter and Shebitz 2006).

Today there are few people who recall burning in the Quinault region, but they do note the dependence of beargrass on habitat with little or no tree cover. For example, Lela Mae Morganroth of La Push stated that beargrass is "where the logging has been cut . . . that's where they get it. It has to be . . . way out in the prairie." According to Morganroth, "It's all in an open area now. In all those old logging roads" (2005).

In interviews, when tribal members were asked if they were in favor of returning fire as a means to restore beargrass habitat, responses ranged from surprise and doubt that fire had ever been used in this area to recognition of its cultural and ecological potential. For example, Keith Dublanica, who was the director of the Skokomish Department of Natural Resources, stated that returning burning to the area "can span generations as well as cultures and . . . affords a unique opportunity

to investigate, monitor, and adaptively manage natural resource landscapes" (U.S. Forest Service 2003). Indeed, both the Skokomish and the Quinault Nations have collaborated with government agencies in reintroducing fire.

A recent project investigated the effects of reintroducing prescribed fire to beargrass habitat in locations that were traditionally managed by the Skokomish and the Quinault prior to European contact. This project was a collaboration between the Quinault Indian Nation, the Skokomish Tribal Nation, Olympic National Forest, and the University of Washington. It was found that prescribed fire led to a significant increase in beargrass quantity after two years and greatly increased the establishment and survival rates of beargrass seedlings. In addition, the work showed that managing the competition from shrubs enables beargrass to quickly increase in quantity. Therefore it is likely that one of the primary benefits that burning had was to maintain the land at a stage without extensive shrub cover, ensuring that beargrass and other culturally important plants were able to acquire the necessary components for growth and reproduction (Shebitz 2006).

Another factor contributing to the decline in beargrass abundance is the unsustainable harvesting practices of commercial gatherers, sometimes operating illegally, who sell the beargrass blades for floral arrangements. Since the 1980s there has been a rise in the gathering of nontimber forest products such as beargrass by the floral industry, for which the U.S. Forest Service and the Washington State Department of Natural Resources issue permits (Hansis 1998). The high demand for beargrass in this international market creates an influx of outside harvesters concerned with bulk collection rather than using careful harvesting techniques to select only the "best" material, as tribal basket makers have done for centuries (Kramer 2001; J. E. James, Jr., and Chubby 2002). In multiple interviews, a common theme among Quinault and Skokomish tribal members was their shared concern that the floral industry is practicing unsustainable harvesting by yanking out the entire beargrass plant. Bruce Miller (2004) expressed his concern about the impact that commercial gatherers are having on beargrass: "They take large parts of the grass whereas we single out individual leaves to pick out."

Similarly, as Lela Mae Morganroth (2005) pointed out, there is great concern that people working for the floral industry do not harvest beargrass with the same care as that of Native American basket makers: "They take a whole handful and they pull it from the root, where we used to just take part of it and we used to twist it back and forth so it comes off of the rooty part. So we didn't take the roots. We just twisted a handful and then took it, and we used to take it and shake it out, and we used to separate the small ones to make small baskets." Morganroth further explained, "The reason why they pick it is they take it home and use some sort of dyes. . . . [T]hey dry it out and they sell it to the florist shops. And so a lot of it has not grown where I used to go" (ibid.).

If beargrass is ripped from the soil instead of carefully cut above ground, the damage inflicted requires a long regeneration period of ten or more years, as opposed to the two to three years needed after selectively harvesting the leaves. Justine James, Jr., has noted that careless harvesting has other effects as well: "The negative harvest technique stresses the quality and integrity of the plant. Insensitive harvest affects the quality of basketry materials by producing a coarser, rougher textured grass that is harder to weave" (2002:2.4). Therefore the illegally harvested beargrass that is

confiscated, although made available to weavers, may not be usable for weaving baskets, and truckloads of beargrass are wasted.

Figure 9.5. Sweetgrass (*Schoenoplectus pungens*, formerly known as *Scirpus americanus*).
From Leo C. Hitchcock, Arthur Cronquist, Marion Ownbey, and J. W. Thompson, *Vascular Plants of the Pacific Northwest.* ILLUSTRATIONS BY JEANNE R. JANISH (SEATTLE: UNIVERSITY OF WASHINGTON PRESS, 1969), 372.

Ecology, Use, and Management of Sweetgrass

Another plant that basket weavers on the Olympic Peninsula are concerned about is sweetgrass, an estuarine bulrush that is a member of the sedge family (Cyperaceae) (K. James and Martino 1986:72; Nordquist and Nordquist 1983:72; T. L. Ryan 2000:40; Turner 1998:110). Since weavers in different regions of North America have given the name "sweetgrass" to several plants in very diverse habitats, we need to be precise about its identity on the Pacific Northwest Coast. Here, "sweetgrass" refers to *Schoenoplectus pungens*, which was formerly known in this region by another scientific name, *Scirpus americanus* (G. S. Smith 1995:97, 100; 2002:51–52). It is a close cousin of tule (*Schoenoplectus acutus*, formerly *Scirpus acutus*), a bulrush that is widely used for mat making. Unlike tule, which is round in cross section, sweetgrass is triangular in cross section and is sometimes called three-square bulrush (Hitchcock et al. 1969:371). Sweetgrass has unjointed, unbranched, three-sided stems with short, narrow leaves attached to the base of the stem. Once the leaves are removed, the elegantly simple stem is an ideal weaving material.

Sweetgrass is used in several Northwest basketry techniques. In twining it is used as the visible, horizontal elements called the weft or as the vertical structural foundation known as the warp (K. James and Martino 1986:73; Nordquist and Nordquist 1983:13; Turner et al. 1983:81). In coiled baskets it is used as the inside, or filler, of the coil and sometimes as the sewer, or the strand wrapped around the coil (K. James and Martino 1986:74, 86; Ramirez 2000). Once the leaf sheaths of sweetgrass are peeled off, the entire stem can be used in weaving. Even the seed heads occasionally appear as decoration when the material is used in twining (K. James and Martino 1986:74). The Twana (including the Skokomish) used sweetgrass to create basketry containers with flexible rather than rigid sides (J. M. Jones 1976:92, 175: Nordquist and Nordquist 1983:15, 16). Sweetgrass is valued as a basketry material because of its multiple uses and its strength, durability, and flexibility. Its flexibility makes it suitable for making dolls and, in the last century, novelty items such as covered bottles and shells (K. James and Martino 1986:74; Nordquist and Nordquist 1983:5). Other documented uses of the plant

among the first peoples of the Northwest Coast include mats, handles for baskets, hats, and a rub for children's hair that was said to promote healthy growth (Turner and Bell 1971:73, 1973:272; Turner and Efrat 1982:54).

Sweetgrass grows in estuaries, where rivers join the sea and freshwater mixes with salt water. Here, in sweetgrass habitat, salt concentrations range from well below that of seawater to nearly fresh (Dethier 1990:33, 35; Ewing 1986:49; Hutchinson n.d.:41–42). On the Olympic Peninsula, sweetgrass is found in semiprotected bays and inlets, such as Grays Harbor and Hood Canal. The species grows at lower intertidal elevations (roughly 6 to 9 feet, or 1.8 to 2.7 meters, above mean lower low tide), where it is covered at least once and often twice a day by tidewater.

The tallest stems are found where salinities are lowest—that is, at regularly inundated lower elevations where salt cannot accumulate or where overland flow or groundwater creates steady freshwater inputs. These tall, preferred stems are harvested by basket makers during low tide, when the tide is fully out, or in shallow water during tidal ebb or flood (K. James and Martino 1986:72; J. M. Jones 1977:3; Nordquist and Nordquist 1983:13; Peck and Peck 1977:3–4). Because these lower areas are often mucky, boards or planks were used to ease maneuvering during harvesting (J. M. Jones 1977:3). Today large pieces of driftwood that settle in the marsh are sometimes used for the same purpose of accessing stems at lower elevations. Before 1900, sweetgrass stands and other estuarine and riverine harvesting sites were probably accessed by canoe

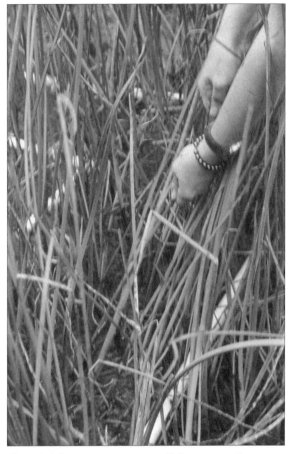

Figure 9.6. Sweetgrass stems are pulled to separate them from the roots and rhizomes, an action that makes a popping sound. The bulrush stems are often pulled in bunches and sometimes pulled singly. PHOTO BY CAREN CRANDELL.

(Hajda 1990:507; Halliday and Chehak 2002:125; Nordquist and Nordquist 1983:12; Porter 1990:8; Thompson and Marr 1983:21; Turner 1998:37; Turner et al. 1983:79). By harvesting sweetgrass from or near the canoe, gatherers might have been able to avoid walking in mucky sediments.

In Grays Harbor, sweetgrass for use in basketry is harvested mostly in July and August but sometimes in September (K. James and Martino 1986:72; Nordquist and Nordquist 1983:13; Peck and Peck 1977:2; Thompson and Marr 1983:24). Harvesting time and stem selection are linked to stem length, stem color, suppleness, and blemish-free surface. Stems harvested too early or too late are said to be too soft or too brittle when dry (Dyler 1981:13; K. James and Martino 1986:76; J. M. Jones 1977:3; Lamberson 1996:8; Peck and Peck 1977:i; Thompson and Marr 1983:24). The stems of this perennial plant begin senescence—or dying back—as early as August, turning yellow and then brown from the tips down through the lengths of the stems. In August, patches of stems begin lodging (leaning over) at various stages of dieback and are then considered unusable (Peck and Peck 1977:i, 3; B. L. Ryan 2008a). Timing of sweetgrass harvesting was also said to coincide with the ripening of red

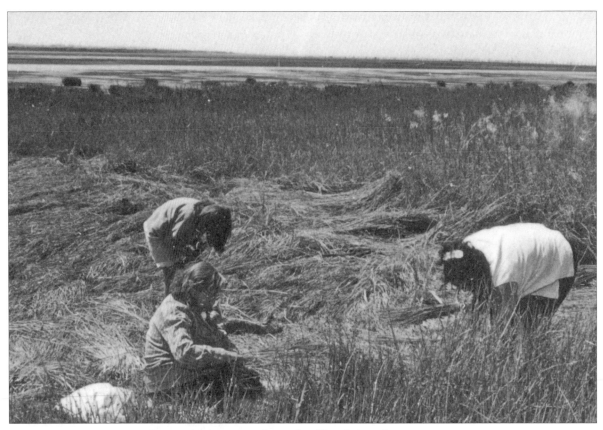

Figure 9.7. Sweetgrass gatherers, bundling their stocks. COURTESY CHARLES AND ELIZABETH PECK COLLECTION OF NORTHWEST COAST INDIAN LIFE, MANUSCRIPTS, ARCHIVES, AND SPECIAL COLLECTIONS, WASHINGTON STATE UNIVERSITY LIBRARIES, PULLMAN, WASH. (20-3).

elderberries (Thompson and Marr 1983). Baskets made of sweetgrass and lined with bigleaf maple leaves were used to store these just-boiled berries underwater (K. James and Martino 1986:85).

Quinault tribal member Florine Shale-Bergstrom (2003) described the stem-pulling process and recalled that men often accompanied women to harvest sweetgrass: "We took the guys out with us when we got sweetgrass. . . . [Y]ou stand in mucky water and you have to pull them out from the root—and it's like a suction cup. And you stand in ankle-deep muck . . . [W]hen you pick, you have to lean towards the bottom—otherwise it breaks."

The traditional method of harvesting sweetgrass is to use both hands to simply pull stems from the substrate. The stems separate from the roots and rhizomes with a pop. The height, weight, and amount of sweetgrass are not negatively affected if the stems are harvested selectively (i.e., less than 25 percent of the stems in a patch) or if a recovery period of at least one year between harvests is allowed (Crandell n.d.). Sweetgrass stores energy for growth in underground tissues. As long as these underground portions of the plant are left intact, energy is available for the growth of new stems the following year, and nutrients and energy can pass from existing stems to new stems through these connections.

Stems are sometimes harvested by cutting, which leaves a portion of the stem—

and therefore weaving material—in the ground (K. James and Martino 1986:72; T. L. Ryan 2000:110). Florine Shale-Bergstrom (2001) contrasted traditional pulling with cutting: "The better material is closer to the water"—that is, farther from shore. Harvesting these stems was "muddy business compared to cutting—cutting was lazy." Cutting has a negative effect on stem height, aboveground stem weight, and stems per square foot in the sweetgrass stand for at least one year (Crandell n.d.).

Once harvested, the stems are prepared to become weaving fiber. Muck and sand are washed from the stems at the gathering area if possible, using tidewater or nearby freshwater inflow (K. James and Martino 1986:72–74, 91; Peck and Peck 1977:i). The short, narrow leaves at the base of the stems are generally removed in the field. This practice keeps plant nutrients in the marsh and reduces moisture and mold in the harvested material (K. James and Martino 1986:73; Peck and Peck 1977:i, 2; B. L. Ryan 2008a, 2008b; T. L. Ryan 1999, 2008). Furthermore, if the leaves are not removed, the base of the stem develops a reddish color rather than the desired natural golden color upon drying; and if the muck is not cleaned from the stems, the fresh, white base of the stem becomes stained (K. James and Martino 1986:73; Peck and Peck 1977:5).

Harvested stems are bundled with string or cloth strips so they will not bend; small bunches of stems may be tied loosely on themselves in a single-loop knot (K. James and Martino 1986:73; Nordquist and Nordquist 1983:11,13; Peck and Peck 1977:5, 9). Since different baskets require different lengths and diameters of material, stems are sorted by length and bundled either in the field or just before drying (Lamberson 1996:12; Peck and Peck 1977:4; Thompson and Marr 1983:24). At the gatherer's home, the stems are washed again to remove salt, silt, and potential contaminants. Washing is important not only for the fiber's appearance but also for the weaver, since she will have direct contact with this and other plant materials, sometimes holding them in her mouth while working (Nordquist and Nordquist 1983:14, 15; T. L. Ryan 1999, 2000:100–101).

Drying techniques vary. Some weavers hang sweetgrass bundles in the shade to dry slowly and retain suppleness. Other weavers, especially those living in inland areas, lay the stems on rocks, sand, or boards to dry in the sun, and others dry them indoors (K. James and Martino 1986:73; Nordquist and Nordquist 1983:13; Turner et al. 1983:82).

Although sweetgrass leaves and their sheaths are usually removed in the field or very shortly thereafter, some leaf tissue may remain on the stem. After initial drying or shriveling, this residual tissue was traditionally removed by running the stems between the thumb and a mussel shell, a clamshell, or a deer leg bone. One Skokomish weaver working in the mid-1900s was known to have scraped and crushed several stems at a time with a spoon handle to remove the leaf sheaths, weaken stiff fibers, and promote flexibility. These flattened stems were then dried thoroughly, bundled, and hung or loosely coiled for storage (K. James and Martino 1986:73; Nordquist and Nordquist 1983:13; Thompson and Marr 1983:24; Thompson 2008).

The color of dried sweetgrass varies from creamy gold to muted green, and fast drying is said to result in a brighter, lighter color (K. James and Martino 1986:73). Drying in the sun for three or four days causes the plant's green pigment to break down, resulting in "bleached" stems that are preferred by some weavers (Thompson and Marr 1983:24; T. L. Ryan 1999). Sweetgrass from different locations may vary in color; stems from one location might dry greener than stems from another location

that dry more golden (B. L. Ryan 1999). The plant material is generally not dyed and is even said not to take dye well (K. James and Martino 1986:73; Thompson and Marr 1983:24), although at least one researcher found a basket made with sweet-grass dyed brown (T. L. Ryan 2000:189). Sweetgrass does not have the glossy sheen that is typical of bear-grass, and these characteristics can be used to distinguish between the plants, as can their use in different weaving techniques.

Figure 9.8. Coast Salish basket of sweetgrass and beargrass. Note the shine of the beargrass. COURTESY OF THE BURKE MUSEUM OF NATURAL HISTORY AND CULTURE, CATALOG NO. 2.5E1147.

Sweetgrass stem quality is a combination of length, width, color, and suppleness. Although different baskets may require different lengths of stems, weavers seem to prefer the tallest stems they can find (K. James and Martino 1986:72; J. M. Jones 1977:3; Thompson and Marr 1983:24; T. L. Ryan 1999). Generally, the lower the substrate salinity, the taller the stems (Crandell n.d.). Longer strands of weaving material create a more uniform appearance because new strands do not have to be spliced into the woven piece. Long but moderately thin stems are typically preferred over short and stocky stems (Lamberson 1996:23). If a stem is long but too thick, a weaver might split the partly dried stem lengthwise with her fingernail (Thompson and Marr 1983:24; B. L. Ryan 1999). For woven work requiring a set of stems with consistent width, stems are trimmed by cutting off one of the three edges along the length of the stem, or a gauge with a pair of parallel blades is used to cut away unwanted width along a portion of the stem (Nordquist and Nordquist 1983:15; B. L. Ryan 2008a, 2008b).

The ideal sweetgrass stem is supple as well as long (K. James and Martino 1986:73, 76; B. L. Ryan 1999). Supple stems are sturdy and do not break during weaving, and they are more easily trimmed lengthwise for uniform size (B. L. Ryan 2008a, 2008b). Stems become more brittle as the season progresses (Dyler 1981:13; J. M. Jones 1977:3; Thompson and Marr 1983:24). In addition to stem age, suppleness may also be a result of shaded growing conditions (Crandell n.d.; see also Nordquist and Nordquist 1983:13 for beargrass and Turner et al. 1983:79 for slough sedge, *Carex obnupta*). In parts of Grays Harbor, shade is created by steep forested hillsides and by eroded sandstone promontories that cast afternoon shadows on the adjacent marsh. Sweetgrass stems in these stands were found to be more pliable than those collected in the full-sun conditions of the Skagit River delta (B. L. Ryan 1999, 2008a, 2008b).

As an important weaving material on the Olympic Peninsula, sweetgrass has been the focus of concern for decades (K. James and Martino 1986:75; Lamberson 1996:11; Nordquist and Nordquist 1983:13; T. L. Ryan 2000:8, 114). Questions about the health of sweetgrass on the Olympic Peninsula can be addressed in terms of habitat (suitable growing conditions) and access to that habitat.

Twentieth-century harvesting grounds on the Olympic Peninsula include the Skokomish River delta in Hood Canal and shores with western exposure and river mouths in Grays Harbor (Dethier 1990:33; K. James and Martino 1986:72; Nordquist and Nordquist 1983:13). Both of these areas have been subjected to enormous change. In the last century, the Skokomish River delta has been greatly modified

through diking, which eliminates tidally influenced habitat, and the construction of a hydroelectric dam, which alters seasonal patterns of freshwater flows that dilute salty water. What sweetgrass remained in the Skokomish estuary is said to have been overharvested, resulting in diminished quality of the weaving material (Nordquist and Nordquist 1983:13). In Grays Harbor during the twentieth century, more than two square miles of intertidal habitat near Hoquiam and Aberdeen was eliminated through the filling of marshes and mudflats with sawdust from timber mills, soil from hills that were washed away in efforts to flatten the landscape, and sediments dredged to deepen the shallow bay (J. L. Smith, Mudd, and Messner 1976:F-97; Van Syckle 1982:229–31). Sweetgrass habitat at the mouths of the Hoquiam and Chehalis rivers was undoubtedly reduced by these activities as well.

Not only has habitat diminished, but access to remaining stands of sweetgrass has been limited by historical changes. After the mid-1800s, settlement of Grays Harbor by nonindigenous people replaced communal use of gathering grounds with private property ownership (K. James and Martino 1986:74). In Grays Harbor, the use of canoes in general—and presumably to harvest sweetgrass—dropped precipitously as white settlers claimed land, as the cities of Hoquiam and Aberdeen filled in tidelands, and as railroads and roads were laid down along shorelines and carved into dense forests (Capoeman 1991:106; Van Syckle 1982:228, 279, 350). Today weavers travel by car to sweetgrass gathering grounds that are found near and alongside highways (Lamberson 1996:9; K. James and Martino 1986:74, 76; Nordquist and Nordquist 1983:13; Peck and Peck 1977:2, 4, 5).

Development of a road network has concentrated the harvesting efforts of many tribal groups previously spread more widely across the landscape. Road construction in the early 1900s created access to distant coastal plant populations for tribes that had previously relied mostly on trade to obtain sweetgrass and for the Skokomish, whose local sweetgrass populations had declined and who then harvested farther from their home waters (K. James and Martino 1986:75–76; Nordquist and Nordquist 1983:13).

As a result of these ownership and transportation changes, only one site in Grays Harbor is now considered accessible by Native weavers, and sweetgrass gathering efforts have converged on a few stands here (K. James and Martino 1986:74). Some weavers have expressed concern about the decline of sweetgrass quality in this intensively used location (Lamberson 1996:11; T. L. Ryan 2000:8; B. L. Ryan 1999, 2008a, 2008b). Some worry that water pollution is causing changes; others wonder if the decreasing stem height is due to overharvesting. Studies prompted by concern among weavers and resource managers indicate that changes in sweetgrass stand size and stem characteristics result from both environmental factors and human activity (Crandell n.d.).

Discussion of potential harvesting effects must first be put into historical context. Indigenous populations on the Olympic Peninsula were many times greater 250 years ago than they are today (Boyd 1999:264). It is reasonable to assume that basket production and the demand for basketry materials would also have been greater than at present. More harvesting might have been conducted in total, but it would have been spread across the coastal landscape rather than localized in a very few stands. Long-term use of this plant would indicate that sweetgrass populations can withstand some levels of harvest and be gathered by successive generations of weavers. When approached by canoe, harvesting locations may have been rotated intentionally

or simply as a result of preference for the tallest stems visible in a given season. To-day rotation does not occur on a scale beyond short walking distances, so particular patches may experience more harvesting pressure than they did in the past.

On a broader landscape level, sweetgrass populations are currently threatened by habitat loss, land uses, and invasive plants. Filling and diking of estuarine areas have abated in the three to four decades since the enactment of major environmental legislation, such as the Clean Water Act and the Endangered Species Act, but land uses upstream and upslope in watersheds have had negative effects. Some sediment accumulation happens naturally in estuaries and even helps marshes develop, but land uses such as forestry practices have accelerated sedimentation rates. In response to accumulated sediments, sweetgrass grows in a shorter form less desirable for weaving, and the plant community changes in favor of other species. Construction of buildings removes vegetation from hillsides and increases impervious surfaces, in turn altering water flow within watersheds and affecting freshwater inputs to estuarine areas downstream. Proximity of highways to sweetgrass stands leaves them vulnerable to additional disturbance from road construction, adjacent utility corridor retrofit, and human recreation. Invasive plants pose direct and indirect threats. Saltmarsh cordgrass (*Spartina alterniflora*) has recently appeared in Grays Harbor. This aggressive species establishes populations at elevations also occupied by sweetgrass and may prevent sweetgrass stands from expanding or becoming established. Furthermore, applications of herbicide on cordgrass stands may negatively affect sweetgrass stands in the vicinity. In addition, common reed (*Phragmites australis*) grows just upslope of some major stands of sweetgrass. This nine-foot-tall species may alter the local ecology and negatively affect adjacent sweetgrass stands. Control of common reed through herbicide and mowing may also have unintended negative effects on sweetgrass.

In the last two centuries, the fate of sweetgrass has paralleled the fate of estuaries in general: as estuarine habitat was eliminated, sweetgrass was eliminated. What can be done now? Before more estuarine marsh, which includes sweetgrass, is lost, the importance of the plants and gathering grounds to the survival of traditional material culture and Pacific tribal lifeways must be acknowledged. Management decisions must consider the whole ecosystem and the forces that create it. Sweetgrass habitats can be reestablished if marsh habitat, especially at low elevations, is restored in coastal areas with significant freshwater input.

One restoration opportunity exists in the Skokomish River. The diminished quality of sweetgrass in this river delta is said to have resulted from overharvesting (Nordquist and Nordquist 1983:13). However, the diking of the delta and the construction of a dam altered the hydrology, or seasonal flows, of the system and eliminated some of the original elevations occupied by sweetgrass. This sweetgrass habitat may be restored through breaching dikes and returning former agricultural land to tidal influence. In September 2007 the Skokomish Tribe began a dike removal project that will eventually return three hundred acres to historic tidal influence (Grimley 2007:1). The tribe is realizing its goal of reestablishing sweetgrass populations in these home waters (Lamberson 1996:23).

Restoration of sweetgrass habitat could be expanded through removal of dikes, dams, and fill in other Pacific Northwest estuaries. Watershed plans being encouraged by the State of Washington Department of Ecology should consider sweetgrass populations where environmental conditions are appropriate. The conservation plan being developed by the U.S. Fish and Wildlife Service for a wildlife refuge in

Grays Harbor incorporates the health of sweetgrass populations into its goals. These early efforts hold promise and may serve as examples to other land managers on the Olympic Peninsula.

Conclusion

Throughout this chapter, we highlighted two species used as basketry materials to illustrate that cultural traditions and local natural resources are closely linked. Indigenous people have resided on the Olympic Peninsula for generations and depend upon the resources of this homeland for the survival of their traditions (Turner, Ignace, and Ignace 2000:1275). Some culturally significant plants were collected from habitats in ways that did not drastically alter the ecosystems. Other plants and their habitats were directly manipulated by Native Americans to maintain and increase their abundance so that they could meet their cultural needs (Anderson 2005). The in-depth knowledge and careful management and harvesting of these plants resulted in continuity of resources from one generation to the next (Turner, Ignace, and Ignace 2000:1275).

To confront current threats facing culturally significant species such as beargrass, traditional land management practices can be reintroduced. Human-set fires played a role in ensuring the occurrence of beargrass by limiting competition with shrubs and increasing vegetative reproduction of beargrass. Once burning was stopped as people moved onto reservations and the government established policies for fire suppression, the prairies and savannas with culturally important plant populations became lost to succession and the advance of trees (Anderson 2005). As a result, beargrass in the low elevations of the Olympic Peninsula has declined in abundance.

For sweetgrass, careful harvesting in existing plant communities ensured a supply of the resources for continued use. However, land management changes that have occurred since non-Native settlement have altered the habitats of these species and limited weavers' access to the few remaining plant populations. The weaving traditions that rely on these plants are compromised or threatened as a result. Ecosystems must be managed to ensure the survival of this and other native species. For sweetgrass, water patterns characteristic of estuaries—that is, the ebb and flow of the tide and the seasonal mixing of salty seawater and fresh river water—must be preserved and restored. Sweetgrass harvesting practices might again include the rotation that was probably achieved when harvesting grounds were approached by canoe.

To conserve what remains of these two culturally significant species and restore them where possible, we have to manage estuaries, forests, prairies, and savannas with the whole ecosystem in mind. Preservation and restoration must proceed with concern not only for these species and habitats but also for the indigenous cultures that have used and managed the plant species for generations.

Without the plants discussed in this chapter, Olympic Peninsula basketry would be remarkably different. Beargrass and sweetgrass have defined not only the baskets of the Olympic Peninsula tribes for thousands of years but also many of the traditions of the people as well. The practices of managing and harvesting these plants are part of the culture. Just as the plants woven within a basket are tight and remain intact, so are the lives of the people, the plants, and the environment. Preserving these connections will enable the basket weaver to continue to create baskets as her or his ancestors have for generations.

CHAPTER TEN

Basketry Today

JANINE BOWECHOP, VICKI CHARLES-TRUDEAU, DALE CROES,
CHARLOTTE KALAMA, CHRIS MORGANROTH III,
THERESA PARKER, VIOLA RIEBE, LETA SHALE, and JACILEE WRAY

Basketry holds an extremely prominent place among the tribes of the Olympic Peninsula. It is part of a living art form of the Elwha Klallam, Jamestown S'Klallam, Port Gamble S'Klallam, Skokomish, Quinault, Hoh, Quileute, and Makah tribes that has been passed on over thousands of years. In this book we have focused mostly on the period since the treaties in 1855–56 to the 1960s. In the life of the basket weaver, weaving was an important part of daily activities, and through it the weaver created achievements in objects of utility and beauty. Tribal members' accounts of making baskets and learning from other weavers demonstrate the importance of the craft through time to the present day—and for the future.

Quileute basket weaver Suzie, or *Kʷá·let*, was born around 1870 at Shuwah on the Sol Duc River to George Towleno (*Toweládox*) and *Ká-sa-Kíwats*. Suzie learned basket weaving at a very early age from her mother and continued to weave baskets up until her very last days in 1952.[1]

Suzie raised two of her three grandchildren, Chris Morganroth III and Lela Mae Morganroth, from the time they were babies. According to Chris:

> Wherever my grandmother went—up and down the rivers in her canoe gathering—she would take my sister Lela and me with her. She always had a workbasket with a tumpline, and in it she carried food and other things. . . . We would sit down and eat bread and dried salmon while she was gathering her basketry materials. She was really a strong lady for being only five foot three, but she could carry a hundred-pound flour sack on her back with no qualms. Sometimes she would put both Lela and I in the carrying basket and take us to the beach in the wintertime, where we would help her collect firewood. She'd put the firewood in the basket, and we would have to walk back. (C. Morganroth 2009)

Suzie would search along the coastline for eelgrass, which she sometimes used in her basketry in lieu of beargrass. She also collected spruce roots to use where basket strength was needed, in the burden basket, for instance, or for the rim or handle of large decorative baskets. She preferred spruce roots over cedar roots and would take her canoe up the Quillayute and Dickey rivers to find them close to the bank. All she had to do was dig a little bit with her digging stick to find a root and pull up on the end toward the tree until she had her length. "She would clean the outer bark of the root while it was still green and soft," Chris recalls. "It was just like a piece of rope, so soft and pliable" (ibid.).

The root was split just as cedar bark was, by putting it between both thumbs with the knuckles together and pulling from the thumbs up toward the little fingers. The

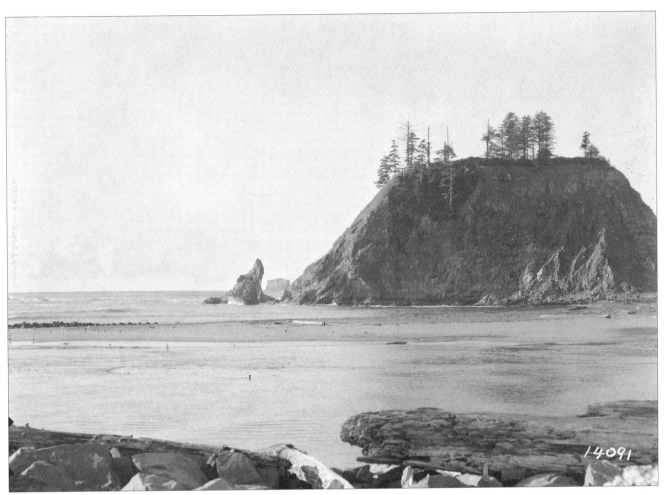

Figure 10.1. According to photographer Lawrence Denny Lindsley, Dahdayla (*dá·dila*) Island (*not pictured*), to the north of James Island at La Push, is known as Indian Woman Basket Maker, and Cake Rock, in the far distance, is the "basket she's working on." Information and photo by Lawrence Denny Lindsley, 1964. COURTESY UNIVERSITY OF WASHINGTON LIBRARIES, SPECIAL COLLECTIONS, LINDSLEY 14091C.

roots would then be dried until needed, when they were soaked in a container of water to make them pliable. Sometimes rainwater was used, making the roots shiny.

My grandmother and her friends Kokotay [Ella Hudson], which means "bracelet," and Tabacus did everything together. They even dyed their basketry materials at the same time so the colors would all be exactly the same. Whenever she was sitting down with her friends weaving baskets, they would talk and talk in Quileute. They did not use English; that is how I learned Quileute. When I was five, I remember my sister Lela and I going up the river with the three of them. They had their own canoe, and we'd go and stay overnight on the riverbank. We went to the places that they had names for based on the kinds of materials they got there, like the places for berry picking and for getting cedar bark and spruce roots. There were times when my grandmother would wrestle a piece of cedar bark. She would flip it back and forth trying to get it to break off, and the ladies would swing on it

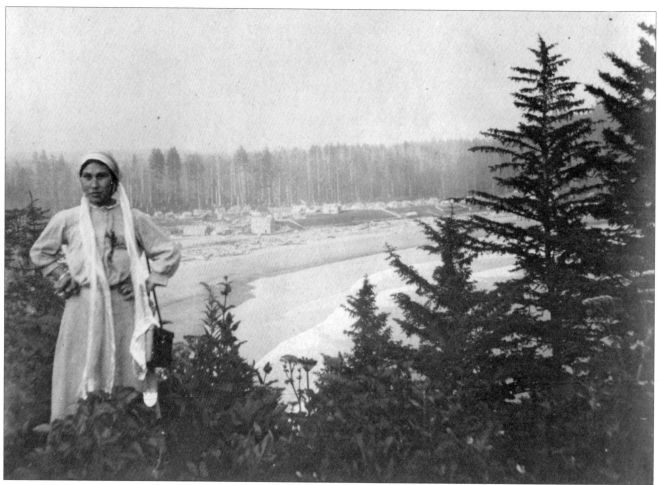

Figure 10.2. Suzie
Morganroth, standing
on James Island and
holding Fannie Taylor's
camera case, circa 1914.
COURTESY OLYMPIC
NATIONAL PARK, FANNIE
TAYLOR PHOTOGRAPH
COLLECTION (TAY.012.006).

until it broke loose. There were some words I didn't know spoken in Quileute that I don't think were very nice. (Ibid.)

Memories of collecting basketry materials have endured through the generations. In the past twenty to thirty years the vitality of basketry has expanded among the peninsula tribes. The styles, symbols, and techniques of peninsula basketry continue today to a great extent, but given the weaver's incredible innovation, perseverance, and traditional knowledge that goes into each basket, we find each artist is unique and her symbolism spiritual. The Pueblo Indians believed that religious symbols gave them "ample space for the unfolding of personality more satisfactory than that of a man in our own civilization who . . . will remain nothing more than an underdog with no inner meaning to his life" (Goodman and Dawson 2008:231).

Probably one of the best examples of the importance that basketry is gaining in the Northwest is the current annual gatherings of the Northwest Native American Basketweavers Association (NNABA), established in 1996; often a thousand Native weavers from Washington, Oregon, Idaho, Montana, and British Columbia attend these gatherings. The goal of NNABA is to preserve, promote, and perpetuate traditional and contemporary weaving. The teaching of basketry traditions to the youths

is a vital part of these gatherings. In this way the youths learn leadership skills and the importance of transferring cultural knowledge, as their teachers were taught by their elders.

Bruce Miller, a Skokomish basket maker, was the NNABA founding president. Mary Leitka, a basket maker from Hoh, is also a founding board member. They both retired from the board in 1999.

Elaine Grinnell of the Jamestown S'Klallam Tribe recalls that in the 1990s Northwest weavers recognized that weaving is a large part of the history, culture, and tradition of Northwest tribes, and they committed to "bringing the basket people together" to keep the art alive. She is also a founding member of the NNABA, a past president, and a current member. Many Klallam weavers have taken part in NNABA workshops and annual meetings.

When the NNABA conference was hosted by the Squaxin Island Tribe in 2004, Dale Croes was asked to present a slide show on ancient Northwest Coast wet-site basketry. The audience was pleased to see the important documentation of this archaeological evidence preserved for the future, and was invited to present updates at three later meetings. Dale met a Queets master weaver, Charlotte Kalama, here and began visiting her and her family in Queets while traveling to Neah Bay. Dale recognized the stability of the Olympic Peninsula basket weaver's personal style and tradition when he found a West Coast–type basket at an antique store and opened the lid to find a faded piece of paper that said Charlotte Kalama, $5.95. The antique store wanted $65 for the basket (less than Charlotte sells her baskets for today), and Dale was anxious to show Charlotte. She immediately recognized her basket from the 1950s, especially her signature green-dyed beargrass in decorative rows, but she could not remember ever selling her baskets for under $10.

Charlotte was born in 1924. Her mother, Mabel, died when Charlotte was about two years old, so she grew up with her grandmother Julia Lee. It was Julia who taught Charlotte to weave. Charlotte said that when she was young, she did not have the patience that weaving took, but in her twenties she began to weave in earnest. When her grandmother said that Charlotte's basket lid was better than her own, Charlotte felt "pretty proud" of her work. She mostly made lidded twined baskets with canoe, whale, and bird designs, and for a while she made woven vases. She had to stop weaving in 2010, the last year of her life, because of difficulty using her hands, so finding a basket made by Charlotte today is rare.

Leta Williams Shale is Charlotte's cousin. Leta who was born in 1928 is Quileute, but she married into the

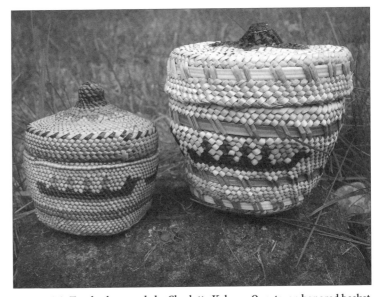

Figure 10.3. Two baskets made by Charlotte Kalama, Queets, an honored basket weaver at the NNABA meeting at Squaxin Island Tribe in 2004. On the left is one of her baskets from the 1950s and on the right a recent creation, half a century of consistency and personal style later. For more than fifty years she has incorporated her unique rows of green-dyed beargrass. PHOTO COURTESY DALE CROES.

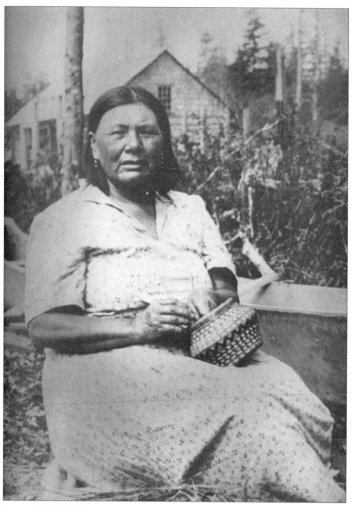

Figure 10.4. Julia Lee.
COURTESY LETA SHALE WILLIAMS.

Quinault Tribe and lives at Queets. Leta's mother was killed in a car accident when Leta was twelve, and she went to live with her grandmother Julia Lee. Charlotte Kalama was already living there, so they both were taught to make baskets together. They helped Julia Lee gather beargrass, sweetgrass, cedar, and cattail. But mostly it was Julia's husband, Robert Lee, who gathered for her and helped her dry the material and prepare the cedar.

Leta felt as if it took her forever to perfect her skill in basketry. She started out mostly making small beargrass baskets, sometimes with a lid, and some of the larger shopping bags with handles. She learned several designs, but Charlotte ended up using just one design: "it was always the whale and the birds" (Kalama 2009). Julia used several different designs on her baskets.

Today Leta's children gather the sweetgrass and cedar bark for her. She finds that beargrass has been getting difficult to collect over the last ten years or so because harvesters for the floral market pull out the plant by its roots and then it doesn't come back. "It is getting harder and harder for anyone to get beargrass," she notes. Leta says that beargrass is as sharp as a razor, and weavers get cut a lot: "We learned how to put a piece of leather on the end of our finger to keep from cutting ourselves. I remember Julia always used a sock" (Shale 2009).

Leta sells her baskets from home, as that is the only way to make a profit. None of Leta's children have had the time to take up basket weaving. Besides Leta, Alvira Pulsifer, who married Chet Pulsifer from Skokomish, is also an elder basket weaver on the Quinault Indian Reservation.

At the sixth annual "Weavers Teaching Weavers" workshop at Northwest Indian College on the Lummi Reservation in 2009, Pacific Northwest weavers, including many from Canada, gathered to teach and learn basket-weaving skills. The camaraderie and enjoyment of the participants was evident in the room. As each student finished a basketry object, the weaver's instructor announced the accomplishment, and everyone applauded. Theresa Parker of Neah Bay was effortlessly teaching ten or more students. One seventeen-year-old girl from Cowlitz was proud to show off a cell phone case she had woven.

Doris Parker, Theresa's sister, is the eldest living daughter of Leah Smith and David Parker. All six of the Parker children are basket weavers, including two brothers

David and Bill. Theresa said she was told that "if you come from a long line of basket weavers, it runs through your blood." At the workshop Doris helped a weaver who was making earrings, while Doris's son Chip wove next to her.

Theresa Parker first learned to make cedar mats at the age of five from her grandmother Bertha, who always said that "making a good mat will help you to make a good basket," meaning that if you can make a nice, tight cedar mat, then when it comes time to make basket bottoms, you will already know how to make a good foundation for your basket. Theresa always felt blessed by having her mother, Leah Smith Parker, her maternal grandmother Bertha Lane Smith from Lummi, and her paternal grandmother Hazel Butler Parker from Makah as teachers. As a tribal education specialist, Theresa dedicates her time to teaching basketry—locally, nationally, and internationally. "By carrying on the traditions of the ancestors and sharing the elders' knowledge, this keeps their spirit alive," she says. "They will always be with us."

Figure 10.5. Doris Parker. Photo by Jacilee Wray. COURTESY OLYMPIC NATIONAL PARK.

Makah Cultural and Research Center executive director Janine Bowechop learned to weave from the Allabush sisters: Ruth, Isabell, Lena, and Margaret. "Those ladies always told me how we were related," she remembers. "They told me I was a good weaver because my grandma Ada Markishtum was such a good weaver. Those were wonderful old women. I really miss them still, and it's been seven years now since Ruth died. She was the last one of the sisters alive. She and Isabell were so funny. I think the older you get, the funnier you get. You sharpen your humor skills over time."

In October 2007, Chinese delegates visited members of the Makah Cultural and Research Center (MCRC). The next year, Janine Bowechop, Theresa Parker, and MCRC trustee Meredith Parker traveled to China and gave presentations at the Southwest University for Nationalities, Sichuan University Museum, and Jiuzhaigou National Park in southwestern China. While there, they also visited Tibetan villages in the Jiuzhaigou Valley. The valley became a national park in 1982, a World Heritage Site in 1992, and a World Biosphere Reserve in 1997, yet the Tibetan villagers continue to live there and have kept their traditional knowledge and languages in place.

It was here that Theresa met two Tibetan sisters, Zashangwu and Zezhuzuo, who are also weavers. For Theresa, the feel of their soft weaving materials, the spokes, the wefts, and the vibrant colors were grand and familiar: "I watched their expertise as

they taught me their weaving style and I, too, led the strands back and forth. Now it was my turn to teach them how to make cedar cordage for a bracelet. Their interest piqued as they felt the cedar bark. The younger sister first smelled the cedar bark and then each of them twisted, wrapped, and tied the knots to make the bracelet." Through an interpreter, Janine explained the many uses of cedar rope, and when the two Tibetans finished their bracelets, they giggled at each other as the one with the playful smile was tugging at the other's wrist bracelet, leading her forward.

Weaving is universal. The basic techniques are used worldwide, and the Tibetan experience was a testament to that. Without speaking the same language or using the same materials, the two cultures were able to communicate by demonstrating the common bond of weaving.

Basket weaver Viola (Vi) Riebe of the Hoh Tribe was eight years old when she was taught to weave by her grandmother Amy Fisher, her aunt Mary Fisher, and her mother, Nellie Fisher. Vi's weaving influences come from the places where she has lived—Queets, Hoh, and La Push. She also learned from her maternal grandmother, Mary South of Ozette, whom she frequently visited. While Vi was in Ozette, they gathered resources together at their favorite harvesting sites.

Today Vi gets her red cedar from Rayonier timberland near the Hoh River and trades it for yellow cedar from Canada. She had hoped to trade some at the weavers workshop, but the woman from Canada did not attend. Vi stayed to learn how to make a woven cuff bracelet.

Also at the workshop was Vicki Charles-Trudeau, an accomplished Elwha Klallam weaver. Currently she resides at Quinault and sells her work from her home and at the Quinault Mercantile. Vicki has been weaving only since 2000, and she says she has much more to learn. Her earliest memories of weaving are with her aunt Beatrice Charles of the Elwha. When Vicki was in her teens, Bea taught her how to make a

Figure 10.6. Vi Riebe, making a bracelet at a weavers workshop.

PHOTO BY JACILEE WRAY.

COURTESY OLYMPIC

NATIONAL PARK.

mat from cattail at a cultural teachings course.

Today Vicki acknowledges her husband, Richard J. Trudeau, for encouraging her to weave, and Leilani Chubby, June Parker, Charlotte Kalama, Lisa Telford, and Loa Ryan for teaching her about traditional weaving and gathering. "One must constantly pursue the masters for their little secrets," Vicki advises, and she is grateful for all the time they have spent with her to bring their culture back into the forefront and for the work that NNABA does to protect gathering rights.

Using both native and store-bought materials, including raffia, artificial sinew, cane, beargrass, sweetgrass, and yellow and red cedar, Vicki experiments with basketry and makes visors, ball caps, traditional hats, baskets, potlatch pouches, and kerosene lamp covers.

Annie Ross, a Mayan weaver and a professor at Simon Fraser University in British Columbia, spoke to the group at the weavers' meeting about the power of weavers. She reminded them that even when there were restrictions on creating Native arts in Canada before the Anti-Potlatch Law was repealed in 1951, weavers kept weaving and continued an unbroken chain. "It is this spiritual power of the unbroken chain that will be carried on by your grandchildren," she asserted.

Basketry is not going away; it is just changing as more tribal members learn and share designs, styles, and patterns. The sharing of designs has been done for centuries, but there are still some specific spiritual baskets that only certain family members can continue to carry on. The weaver invents new baskets for everyday use, such as the cell phone case, a bracelet, or a sun visor. New and experienced weavers have individualized and changing styles, but the core knowledge is the same. This is basketry today—the sharing of thoughts and processes to keep basketry art alive.

Figure 10.7. Vicki Charles-Trudeau, weaving a loon pattern on a potlatch pouch. PHOTO BY JACILEE WRAY. COURTESY OLYMPIC NATIONAL PARK.

Figure 10.8. LaTrisha Suggs of the Jamestown S'Klallam Tribe, wearing a contemporary cedar visor made by Linda Wiechman (Elwha Klallam). PHOTO BY KAREN M. JAMES.

Note

1. Suzie married Chris Morgenroth, who came from Germany, and they had three children. They lived on the Bogachiel River at the Morgenroth Ranch until they divorced and Suzie moved to La Push.

Basket Construction Techniques

JOAN MEGAN JONES

The weaver and the warp lived next to the earth and were saturated with the same elements.

—Mary Austin, "The Basket Maker," 1903

Figure A.1. Triangle-shaped twined Makah basket with a patch of checker weave on the lid. Collected by Leo Frachtenberg, 1917. COURTESY NATIONAL MUSEUM OF THE AMERICAN INDIAN, SMITHSONIAN INSTITUTION (059910). PHOTO BY NMAI PHOTO SERVICES STAFF.

Basket Construction Techniques

Baskets created by tribal weavers of the Olympic Peninsula over the past two hundred years show a variety of construction techniques. Although weavers appear to have worked with many techniques, these can be defined as variations and elaborations of two basic construction elements. At the elemental level, the basket maker either weaves or sews her baskets. Each basket is built up, stitch by stitch, whether woven or sewn. Basket makers among the peninsula tribes make several woven varieties, and some weavers make coiled (sewn) baskets, most commonly found among the Coast and Interior Salish.

The following descriptions and illustrations outline the techniques used in basket construction. Weavers also have techniques for starting and finishing baskets. Rim finishes, seen in some of the examples here, function to give a firm edge that holds and secures the weaving materials and, sometimes, lids.

Each basket is the unique product of a creative individual. Although styles and methods of working were shared by weavers in an area, there was also experimentation and innovation.

Figure A.2. Wrapped-twined basket with purple deer motif (5 in. diameter, 2 in. deep). COURTESY OLYMPIC NATIONAL PARK (72/471).

179

Varieties of Weaving

Weaving consists of at least two elements: vertical pieces, known as warps or uprights; and horizontal pieces, known as wefts or weavers. The weft strands are worked in several different ways around the warps to create a basket surface.

PLAITED WEAVES—CHECKER AND TWILL

Plaiting is a simple weaving technique using a single weft element worked around the warp strands. In checker weave, a form of plaiting, the single weft is woven over or under each warp in alternation. The basic weave may be varied by using a weft twice the width of the warps, or by placing the warps on an oblique line rather than a horizontal-vertical orientation.

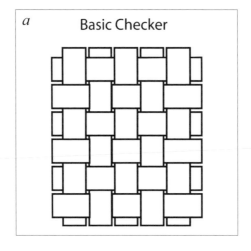

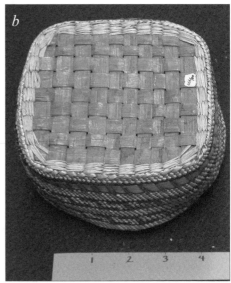

Figure A.3. *a*, Basic checker weave. *b*, Basic checker weave on a basket bottom (5 1/2 in. diameter, 3 in. deep). COURTESY OLYMPIC NATIONAL PARK (72/450).

Figure A.4. *a*, Unequal checker weave (different widths). *b*, Makah folding cedar bark bag or wallet—unequal plaited or checker weave. Collected by Leo Frachtenberg, 1917. COURTESY NATIONAL MUSEUM OF THE AMERICAN INDIAN, SMITHSONIAN INSTITUTION (059895). PHOTO BY NMAI PHOTO SERVICES STAFF.

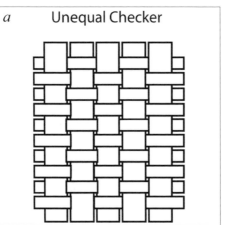

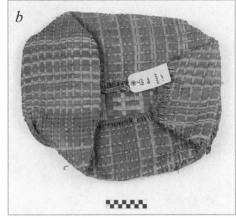

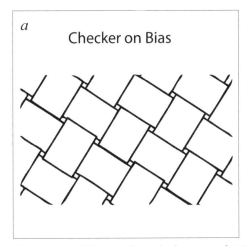

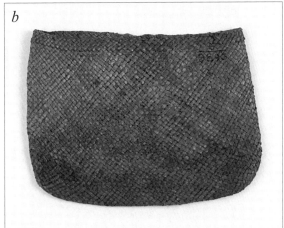

Figure A.5. *a*, Oblique, or bias, checker weave. *b*, Makah fishing or sealing bag—oblique, or bias, checker weave. Collected by Leo Frachtenberg, 1917. COURTESY NATIONAL MUSEUM OF THE AMERICAN INDIAN, SMITHSONIAN INSTITUTION (059893). PHOTO BY NMAI PHOTO SERVICES STAFF.

Twill weaves are similar to checker varieties in having warp and weft elements of the same thickness and flexibility, but these are woven over two warps at a time. A diagonal appearance results from the starting point as the rows progress. Twilling can be varied by placing the warps on an oblique line and weaving on the bias. The direction of the twill line, either right or left, can be alternated to produce herringbone or diamond patterns.

TWINED WEAVES

Twined weaves make use of more than one weft element at a time, worked around each warp or upright piece.

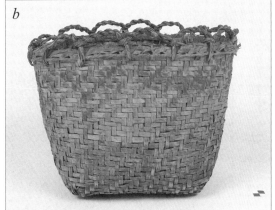

Figure A.6. *a*, Regular twill. *b*, Quileute basket—regular twill made of "vine maple splits." Collected by Leo Frachtenberg, 1916. COURTESY NATIONAL MUSEUM OF THE AMERICAN INDIAN, SMITHSONIAN INSTITUTION (057851). PHOTO BY NMAI PHOTO SERVICES STAFF.

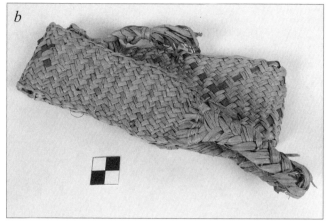

Figure A.7. *a*, Oblique twill on bias. *b*, Quileute burden strap or tumpline—twill on bias. Collected by Leo Frachtenberg, 1916. COURTESY NATIONAL MUSEUM OF THE AMERICAN INDIAN, SMITHSONIAN INSTITUTION (057598). PHOTO BY NMAI PHOTO SERVICES STAFF.

Plain-Twined Weave

For plain twining, the weaver works two weft strands around each warp in turn. Weaving continues in a spiral to form the walls of the basket. The stitching direction, working from right to left, or left to right, and methods of beginning a basket may vary among area weavers. Depending on how the weaver turns the wefts around the warps, the pitch of these stitches appears to slant slightly upward or downward, and the same slant is usually maintained throughout the entire basket. Occasionally the pitch is changed on alternating rows to produce a decorative chained effect.

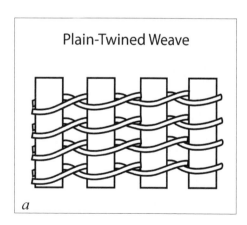

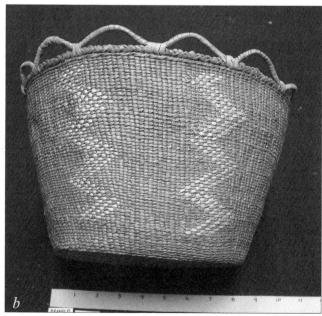

Figure A.8. *a*, Plain-twined weave. *b*, Quinault basket—plain-twined weave (10 in. diameter, 6 1/2 in. deep). COURTESY OLYMPIC NATIONAL PARK (73/358).

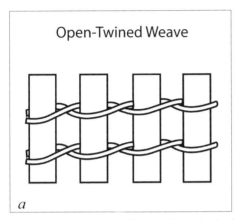

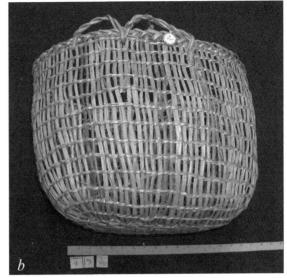

Figure A.9. *a*, Open-twined weave. *b*, Burden basket for clam digging—open twined weave (16 in. wide, 12 1/2 in. high). COURTESY OLYMPIC NATIONAL PARK (39/392).

Open-Twined Weave

This weave is worked in the same manner as plain twining, but space is left between each row or round. This is one of the weaves used in the burden basket.

Alternating Twined and Checker Weave

Plain twining may be used in combination with checker weave, alternating rows of each, throughout all or just part of the basket.

Crossed-Warp Twined Weave

For another variety of twining, the weaver slants the warps, each diagonally to the preceding one. Two strands are twined around the junction of the slanted warps,

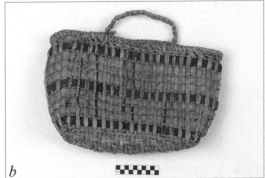

Figure A.10. *a*, Alternating twined and checker weave. *b*, Makah bag—alternating twined and checker weave. Collected by Leo Frachtenberg, 1917. COURTESY NATIONAL MUSEUM OF THE AMERICAN INDIAN, SMITHSONIAN INSTITUTION (059927). PHOTO BY NMAI PHOTO SERVICES STAFF.

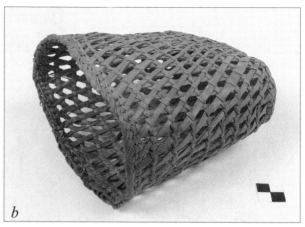

Figure A.11. *a*, Crossed-warp twined weave. *b*, Quileute basket—crossed-warp twined weave. Collected by Leo Frachtenberg, 1916. COURTESY NATIONAL MUSEUM OF THE AMERICAN INDIAN, SMITHSONIAN INSTITUTION (057855). PHOTO BY NMAI PHOTO SERVICES STAFF.

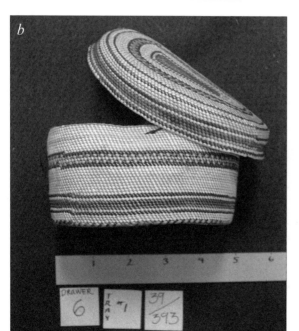

and space is left between the rows. This weave may be used as a decorative open-weave band on a plain-twined basket or may be used throughout the entire body.

For a simple method of applying decoration on a twined basket, the weaver substitutes weft strands of a different color from that of the main body stitches. The design color is visible on both inside and outside surfaces of the basket and becomes a structural part of the basket wall. Another method uses a third element for the desired color, which is worked around the outside of each twined stitch. This is the overlay stitch, which has the same pitch or slant as the twined stitch but does not show on the inside surface.

WRAPPED-TWINED WEAVES

Wrapped twining, like plain twining, has two weft elements, but they are worked in an entirely different manner in wrapped twining. One weft is placed behind the warps at a right angle, and then the weaver wraps the other weft around the juncture where they cross each other.

Close-Wrapped Twining

In this method the wrapped stitches are pulled tightly together, and no space is left within or between rows or

Figure A.12. *a*, Close-wrapped-twined weave. *b*, Makah fancy basket—close-wrapped-twined weave (5 in. long, 3 in. wide, 2 1/2 in. deep). COURTESY OLYMPIC NATIONAL PARK (39/393).

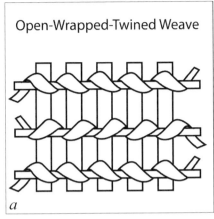
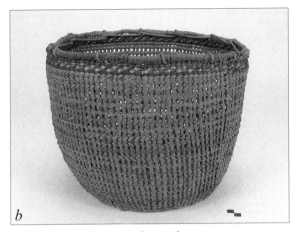

Figure A.13. *a*, Open-wrapped-twined weave. *b*, Makah basket—open-wrapped-twined weave.
Collected by Leo Frachtenberg, 1917. COURTESY NATIONAL MUSEUM OF THE AMERICAN INDIAN,
SMITHSONIAN INSTITUTION (059935). PHOTO BY NMAI PHOTO SERVICES STAFF.

rounds. As the weaving progresses, the warps are bent slightly to one side, giving a diagonal appearance to the surface. Depending on the wrapping direction, the stitches lean in a diagonal line either to the left or to the right. Decoration is woven in by substituting a contrasting weft strand.

Open-Wrapped Twining

Another wrapped technique is used to make strong open-weave carrying baskets. The warps and horizontal weft pieces can be thin peeled twigs of vine maple or cedar; roots of cedar or spruce are also used. The same wrapped stitch of the close weave is used to secure the warp and the horizontal weft, but the wrapping direction may be reversed frequently on the widely spaced rows.

Cross-Stitch Wrapped Twining

This variety of wrapped-twined weaving has the same basic beginning of a horizontal weft wrapped around its intersections with the vertical warps, but is carried one step further. At the end of a row the wrapping is reversed to cross back over the previous stitches creating an alternating weave direction.

COILED OR SEWN VARIETIES

In addition to the varieties of woven techniques used by basket makers, sewn or coiled baskets are made by Twana, Klallam, and Quinault weavers, using a

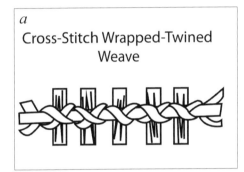
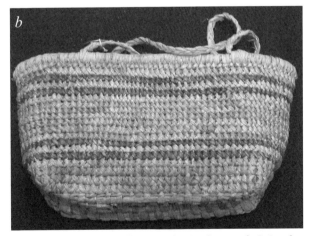

Figure A.14. *a*, Cross-stitch wrapped-twined weave. *b*, Quinault basket—cross-stitch wrapped-twined weave. Decoration is woven in wrapped-twined baskets by substituting a contrasting weft strand, being visible on both the inner and outer surfaces **(10 in. long, 7 in. deep).** COURTESY OLYMPIC NATIONAL PARK (72/478).

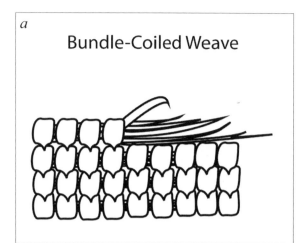

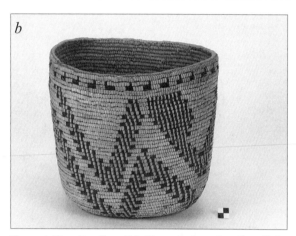

Figure A.15. *a*, Bundle coil. *b*, Twana basket—bundle-coiled, with imbricated salmon gill design. Collected by Leo Frachtenberg, 1916. COURTESY NATIONAL MUSEUM OF THE AMERICAN INDIAN, SMITHSONIAN INSTITUTION (057918). PHOTO BY NMAI PHOTO SERVICES STAFF.

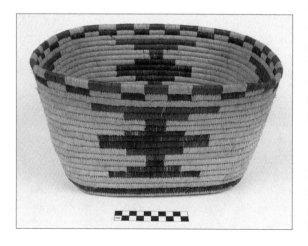

different mode of construction. Instead of fibers being woven and interlaced together, coiled baskets are made by sewing some kind of foundation materials into a shape with successive rows of closely spaced stitches.

Bundle Coil

The bundle coil is an older style of coiled basket that consists of a foundation coil made up of bunches of finely split pieces of cedar or spruce root, sewn in place with a smooth flat outer piece of root. The bundle coil is sewn in a continuous spiral, round and round, to create the basket body. The basket maker uses a sharp-pointed awl to pierce the foundation coil and then threads the sewing strand through that hole, piercing the center of the stitch on the row directly below.

Coiled Raffia

A newer style of sewn basket appeared in the early 1900s, nearly replacing the older coiled cedar root technique. When raffia (a foreign fiber from the raffia palm tree, native to Madagascar and grown in tropical Asia and the Pacific Islands) was introduced as a packing material on trading ships, basket makers soon saw the advantage of substituting this material for the native cedar root. Raffia is first seen in Makah baskets around 1910 (Andrews and Putnam 1999:12). Raffia caught on quickly because it was ready to use and required no extra preparation. Use of the prepared fibers greatly reduced the weavers' work, which had previously required gathering and processing cedar roots. With the use of raffia, weavers developed a different technique of sewing the coils and adding decoration. The foundation coil could also be made from bunches of raffia. A steel needle replaced the traditional bone awl; it was threaded with a long strand of raffia and was used to sew the continuous coil together. Strands of raffia that were pre-dyed in contrasting colors were substituted for hand-dyed native plant materials to create the design.

Figure A.16. Twana basket—coiled raffia. Collected by Leo Frachtenberg, 1916. COURTESY NATIONAL MUSEUM OF THE AMERICAN INDIAN, SMITHSONIAN INSTITUTION (057885). PHOTO BY NMAI PHOTO SERVICES STAFF.

Pre-1960s Basket Weavers

The Native names included in the following table are private property and can be passed on only by elders representing that family, through naming ceremonies where invited guests serve to remember the event and the names.

When reading the "Basket weaver's name" column, please keep in mind that these genealogies are subject to reevaluation. There are a lot of challenges in interpreting the various names that appear in census reports and other records. Often two completely different names appear for the same person. For example, "Mary," "Susie," "Jennie," and "Lucy" were commonly used when the woman's Native name could not be spelled out, a practice that leads to misidentification. Native names are sometimes all that are used, and the name can appear in unrecognizable forms from one census to the next. Note that basket weavers are listed in the table under either their maiden or married name but not both.

Ages are also often unclear. Unless otherwise noted, a year (when given) in the second or last column of the table is the year of birth. A range of dates indicates a life span.

Abbreviations used in the "Relations" column are as follows: C, children; F, father; GC, grandchildren; GF, grandfather; GP, grandparents; H, husband; M, mother; MGGP, maternal great-grandparents; MGP, maternal grandparents; P, parents; PGGP, paternal great-grandparents; PGP, paternal grandparents; S, siblings; W, wife.

The editor and contributors have checked as many sources as possible to make this table accurate, but there will undoubtedly be errors. Given the discrepancies in source material, we hope that readers will report errors to us so that we can correct them and update the table. Comments can be made by writing to Olympic National Park, Cultural Resources, 600 East Park Avenue, Port Angeles, Washington, 98362.

Basket weaver's name	Year born and year died (if known)	Tribe	Place of longest residence	Relations
Adams, Betsy or Betsy Old Sam *kayasiTSa*	ca. 1826	Skokomish Twana	Skokomish	H: Sam Adams or Old Sam
Adams, *di'day* and *si7a'hLt3blu* (sisters)	ca. 1842 and ca. 1840	Hoodsport Twana	Tahuya; Skokomish	H: Mowitch Man S: Billy Adams (ca. 1846)
Allabush, Agnes (Beale) (Penn)	1894–1970	Makah	Neah Bay	H: Jack Beale H: William (Big Bill) Penn P: Jesse Allabush and Mary Napoleon (Suquamish) MGP: Louis and Susie (Parker) (Ozette Klallam) Napoleon
Allabush, Ida (Smith) (Hanks)	1903–1958	Makah	Neah Bay	H: John Smith, Jr. H: John Hanks P: Jesse Allabush and Mary Napoleon
Allabush, Isabell (Ides)	1899–2001	Makah	Tsoo-yess	H: Harold Ides P: Jesse Allabush and Mary Napoleon
Allabush, Lena (Mc-Gee) (Claplanhoo)	1906–1999	Makah	Neah Bay	H: Dewey McGee H: Harry Claplanhoo P: Jesse Allabush and Mary Napoleon
Allabush, Margaret (Irving)	1913–1999	Makah	Neah Bay	H: Raymond Irving P: Jesse Allabush and Mary Napoleon
Allabush, Ruth (Claplanhoo)	1902–2002	Makah	Neah Bay	H: Arthur Claplanhoo P: Jesse Allabush and Mary Napoleon
Allen, Emma (Johnson)	1871	Klallam	Jamestown; Neah Bay	H: Henry Johnson (Klallam) P: William Allen and Sally
Allen, Mary	ca. 1840	Klallam	Skokomish; Dungeness Bridge	H: Jim Allen
Anderson, Alice *We-le-shos-tub* (Kalappa)	1876–1955	Ozette	Tsoo-yess	H: Charlie Anderson H: Landes Kalappa P: *Sow-a-sub* Lewis and *Que-le-sha*
Anderson, Charlie or *Hedowa*	1869–1937	Makah	Ozette	W: Alice Wellish Anderson Holden *Wil-C-shilts* P: Charlie *Heda-tuk-batler* and Lucy Skookum GC: Helma Swan
Anderson, Elliott *Qui ook tsit*	1877–ca. 1950	Makah	Ozette	W: Annie Scott P: Charlie *Heda-tuk-batler* and Lucy Skookum MGP: Lucy Skookum Wyacht

Basket weaver's name	Year born and year died (if known)	Tribe	Place of longest residence	Relations
Anderson, Fred B.	1896–1966	Makah	Ozette	W: Alice Barker Anderson Balch P: Charlie Anderson and Alice Wellish Holden *Wil-C-shilts*
Anderson, Ruth (Swan) (Johnson)	1893–1979	Makah/Ozette	Neah Bay	H: Charlie Swan H: Samuel Johnson P: Charles Anderson and Alice Taylor (Quileute)
Baker, Louise	1850	Quilcene Twana	Quilcene	H: Charles Baker
Bennett, Nina *Ya-chis-duc* (Bright)	1874–1940s	Quileute	La Push	H: John Bright P: *Thlic-a-tose* and *A-hos-both* D: Edna Matilda
Bennett, Rebecca *Tasha* (Coe)	1886	Quileute	La Push	H: Leven Coe P: *Thlic-a-tose* and *Koko-loos-tea*
Bertrand, George and Helen—both are weavers and use seagrass	1919 (George)	Quinault	Queets	P (of George): Henry Bertrand and Anne S. S. Eaton
Bill, Katy or Mrs. Old Bill	1840	Klallam	Jamestown; Dungeness Bridge	H: Dr. Bill (Old Bill) *Wa-hu-lat-sutm*
Black, Anna		Quinault	Queets	H: George Black (son of Beatrice Black)
Black, Elsie *Al-tse-tsa* (Payne)	1871	Quileute	La Push	H: Thomas Payne
Black, Jennie	1852	Quileute		H: Jim Black
Black, Ruth (Ward)	1910	Quileute	Neah Bay	H: Kenneth Ward, Sr.
Black, Sally	1872–1904	Quileute	La Push	H: Carl Black
Bowechop, Mary (Green)	1917	Makah	Neah Bay	H: Hamilton Green P: Augustus Bowechop and Annabel Butler PGP: Maggie Ladder MGP: Mary Hunter
Bright, Annie *Hoskea* (Butler)	1873	Quileute	Pysht	H: Old Man Bright H: Charlie Butler P: *Thlou-wit-ka* and *Kub-e-so-is* S: Gideon

Basket weaver's name	Year born and year died (if known)	Tribe	Place of longest residence	Relations
Bright, Josie (Kuklinski)	1902	Quileute	La Push	H: Jesse Kuklinski
Bright, Ruth (Hobucket)	1909	Quileute	La Push	H: Tyler Hobucket C: Helen (Harrison) (1935), Gladys Lee-Bright-Obi P: Gideon and Hazel Bright
Brown, Lucy	ca. 1851	Makah	La Push	H: Peter Brown (1835)
Brown, Mrs. Tom *A we has tub* or *How-Wilth-Luklth*	ca. 1867	Quileute	La Push	H: Tom Brown *Sha-Ke-A-Kub*
Butler, Hazel R. (Parker)	1893–1962	Makah	Neah Bay	H: Thomas C. Parker P: Thomas Butler (Klallam) and Mary Hunter
Butler, Lyda (Hottowe) (Colfax)	1902–1990	Makah	Neah Bay	H: Archie Hottowe H: Roger Colfax P: Thomas Butler and Mary Hunter
Charles, Beatrice	May 14, 1919–April 20, 2009	Klallam	Elwha	H: Elmer Charles P: Ernest Sampson and Sadie Elliott
Charles, Elizabeth (Swan) (Colby) (Ulmer)	1886–1952	Klallam/ Quileute	Neah Bay; Clallam Bay	H: Charles J. Swan H: Harold Colby H: Sam Ulmer
Charles, Martha (John) *siʔám'tən*	1891	Klallam	Port Gamble	H: Lewis John P: Sammy Charles and Nancy S: William, Clarence, Frank, Herbert, and Sammy
Charles, Susan	1884	Klallam		H: Thomas
Charley, Irene (Shale)	1908	Quinault	Taholah	H: Malcom Shale P: George Allen Charley and Carolyn Matell
Charley, Kitty *tS3baq3lw3d*	ca. 1830	Skokomish Twana	Skokomish	H: Doctor Charley S: Old Peter
Charley, Lena *Hebalakp* (Bastian)	1877	Quinault	Taholah	H: James Lewis Bastian
Charley, Lucy, Eliza *Klanʼ-a-hum-o*, and Kitty (3 wives/ sisters)	Lucy, 1845; Eliza, 1832; Kitty, 1813	Klallam	Clallam Bay	H: Hoko Charley

Basket weaver's name	Year born and year died (if known)	Tribe	Place of longest residence	Relations
Charley, Maggie (Kalama)	1870	Quinault	Hoquiam	H: William Kalama
Charlie, Kate	ca. 1856	Steilacoom/ Sahewamish	Skokomish	H: Tenas Charlie
Charlie, Sarah	1835	Klallam	Port Angeles	H: Skookum Charlie
China, Mary (or Jane) *Mar-tar-wuelle*	1837– December 25, 1929	Quileute	Queets	H: China P: Carter
Chips, Mary—made thimble-size baskets (Duncan 2000:202)	ca. 1857	Quileute or Quinault	Puyallup; La Push	H: John?
Chubby, Maggie *Ah-Us-Sum-A-Alt*	1842	Klallam	Jamestown	H: *Toom Tum* Chubby
Chubby, Martha (Dick) (Collier)	1877	Klallam	Jamestown	H: James Dick H: Robert Collier P: *Toom Tum* Chubby and *Ah-Us-Sum-A-Alt* Maggie Johnson
Clark, Ruth Imogene (Ward)		Makah	Neah Bay	H: William W. Ward
Cleveland, Emily (Penn)	April 2, 1929	Quinault	Queets	H: Thomas "Ribs" Penn P: Dewey and Frances Cleveland
Cliff (Clip), Lilly (Ford)	1865	Quinault	Neah Bay	H: John Cliff H: Thomas Ford
Coe, Amy (Fisher)	1870	Hoh	Hoh	H: Frank Fisher C: Mary, Nellie, and Herbert GC: Viola Riebe
Coe, Eleanor (Wheeler) (Kaikaka)	1923–1987	Quileute	Hoh	H: Wheeler H: Al Kaikaka P: Leven Coe and Rebecca Bennett
Colby, Elizabeth (Hansen)	1882–1964	Makah	Hoko	H: Clark Hansen P: Aurelius Colby and Eliza Obalsa S: Harry Colby
Cole, Minnie (Fisher) (Hopkins)	1889	Quileute/Hoh	Hoh	H: Scott Fisher H: Hopkins P: Hoh Joe Cole and Molly
Collier, Abby	1868	Klallam	Jamestown	H: Robert Collier P: Lord James Balch and Mrs. Balch

Basket weaver's name	Year born and year died (if known)	Tribe	Place of longest residence	Relations
Cook, Nora	1857–1930	Klallam	Jamestown	H: John Cook P: Sam and *Niawut*
Cultee, Richard	1931	Skokomish/ Quinault	Skokomish	P: Henry Harry Cultee and Louise Miller
Curly (Charley?), Sarah	1835	Klallam		H: Skookum Charley
Cush, Alvira (Pulsifer)	1924	Lummi	Queets	H: Chet Pulsifer P: Daniel and Justina Cush
Eastman, Jenny *Hog-eye*	1870	Quileute	La Push	H: Talacus Eastman (1864) C: Edith Payne and Minnie Cole
Eliza *Se-ké-mut* or *Sip-kay-nis-st*	1855–1930	Klallam	Jamestown	H: Tenas Joe C: Susie
Fanny	ca. 1855 to 1863	Klallam	Clallam Bay	H: *Kwa'i-mi-ak* Jim C: Ellen, Susie
Fisher, Leila (Penn) (Sailto)	1912	Hoh	Hoh	H: Charles Sailto H: Herbert Fisher P: Essau Penn and Mary South
Fisher, Mary or Lilly Belle (Sailto) (Pullen) (Williams)	April 23, 1901	Hoh	Queets	H: John Sailto H: Perry Pullen H: Taft Williams P: Frank Fisher and Amy Coe
Fisher, Nellie (Penn)	1912	Hoh	Hoh	H: Stephen Penn P: Frank Fisher and Amy Coe S: Lilly Belle Fisher (Williams) C: Vi Riebe (1934)
Garfield, Agnes (Hudson)	1894	Quinault	Taholah	H: Edward Hudson P: William Garfield and Fannie
George, Clara (Jones)	1903	Klallam	Port Gamble	H: Foster Jones P: William George and Ellen
George, Ellen	1886	Klallam	Port Gamble	H: William
George, Emily *Kub-c-so-is*	1831	Klallam	Pysht	H: Old George *A-mau'a-ta* or Old Man Bright *Thlou-wit-ka* C: Annie Bright *Hoskea* (1873) (mother of Tom Butler)
George, Martha	1893	Klallam	Port Gamble	H: Bennie
Gray, Frances (Cleveland)—made baskets from ash tree	1900	Quileute	La Push	H: Dewey Cleveland P: Stanley Gray and Carrie C: Emily

Basket weaver's name	Year born and year died (if known)	Tribe	Place of longest residence	Relations
Greene, Louisa or Louise	1883–1914	Makah	Neah Bay	H: James Hunter P: Francis Greene and *Si-yuk-ka*
Guy, Viola	1908–1999	Makah	Neah Bay	H: Johnson Barker H: Covey Davis H: Corbett Johnson H: Abner Johnson H: Hans Johnson P: Walter Guy and Rosie Yokum
Hall, Celia *Wal si-mo*	1830	Klallam	Jamestown	H: Thomas (Old) Hall C: Charlie, Fred, Billy, and Mary
Hall, Ida	1840	Jamestown	Klallam	H: William C: Harvey, Wallace, Lovey, and Hazel (Sampson)
Hammond (or Herman), Katie (Colfax) (Butler) (Hunter)	1886–1985	Ozette	Neah Bay	H: Schuyler Colfax H: Eugene Butler H: Martin Hunter P: Charles Hammond (or Herman) (1886) and Evalina Weberhard (1865) S: Ida White (1895)
Hawk, Lucy (Allen)	1887	Steilacoom	Skokomish	H: Henry Allen
Hayte, Hattie (Weic)	1870	Makah	Neah Bay	H: Edwin Hayte P: *Siaha and Nei-sub* (1830) MGP: Leuim (1806) C: Esther, Johnson, Alfred, and Vivian
Hayte, Mary Ann	ca. 1862–1928	Makah	Tsoo-yess; Jamestown	H: Charley Raub (Klallam) H: Dr. John H: Frank Jackson (Klallam) H: Emil Nelson H: Billy Palmer
He-ba-la-kop, Ba-lo-lock or *Huth-la*	1861	Quileute	La Push	H: William Hopkins or *He-ba-la-kop* C: Lena *Chooch-Bi-Itl*
Hobucket, Clara *Kitkis* (Eastman)	1871	Quileute	La Push	H: Ben Hobucket H: Grant Eastman
Hobucket, Josie *Tsol-e-tsa* or *Ha-wa-let-tsa*	1865	Quileute	La Push	H: California Hobucket

Basket weaver's name	Year born and year died (if known)	Tribe	Place of longest residence	Relations
Hopie, Jennie *Tal-i-kus*	1861–1933	Klallam	Elwha	H: James *Tal-i-kus* (Makah) (1851) P: Alberni Jack *Kichum* and Ethel *ƛəmŭmą́* S: Charlie Hopie C: Frank, Louis, and Willie
Hopkins, Annie (or Susan)	1867	Quileute	La Push	H: John Hopkins (or Harold Johnson)
Hottowe, Norma (Goodwin) (Pendleton)	1925–2002	Makah	Neah Bay	H: William Pendleton P: Archie Hottowe and Lydia Parker
Howeattle, Eva *A-Da-de-Duc*	1882–December 26, 1918	Quileute	La Push	H: Arthur Howeattle P: Jones?
Howeattle, Mabel *Chil-leth-how*	1858–1890	Quileute	Deep Creek; La Push	H: Bob Pope (m. 1889) H: John Bright (m. 1892) H: Jacob Louter (m. 1895) H: Pysht Jack *yəwin'tən* (m. 1908) P: Albert Howeattle and *Tse-loth-seeth-how* S: Percy and Nancy
Howeattle, Pansy (Hudson)	1909–1994	Quileute	Hoh	H: Theodore Hudson P: Charlie Howeattle and Adelia Wheeler
Howe *How ow ith*, Jennie *Su why ith*	1855–1913	Quileute	La Push	H: Jimmie *How ow ith* S: Bessie and Robert Lee
Hudson, Agnus (Ward)	December 30, 1888	Quileute	Neah Bay	H: Herman Ward
Hudson, Ansy (Hyasman)	1890	Hoh	Taholah	H: Jonas Hyasman (1878)
Hudson, Carrie *Hic* (Gray)	1879	Quileute	La Push	H: Stanley Gray P: *Os-toch-it* and *Ka-lo-wa-se-thla* (Hudson)
Hudson, Elsie *Al-tse-tsa* (Payne)	ca. 1871	Quileute	La Push	H: Tommy Payne P: *Os-toch-it* and *Ka-lo-wa-se-thla* S: Carrie, Billy, Sherman, Nancy, and Sam Hudson

Basket weaver's name	Year born and year died (if known)	Tribe	Place of longest residence	Relations
Hudson, Jane (James)	1912	Quileute	La Push	H: Harvey James P: William Hudson and Demer Cole S: Jack and Sherman Hudson
Hunter, Eva (Silk) (Aiken)	1899–1975	Makah	Neah Bay	H: Mitchell Silk H: Gerald Aiken P: *Shobid* Hunter and Flora Markishtum
Hunter, Irene (Ward) (Claplanhoo)	1910–2001	Makah	Neah Bay	H: Oliver Ides-Ward H: Charley Claplanhoo P: James Hunter and Louisa Green
Hunter, Josepha (Irving) (Dilley)	1903–1968	Makah	Neah Bay	H: Fred Irving (1890) H: Raymond Dilley P: James Hunter and Louise Green
Hunter, Mary (Butler)	1868–1946	Makah	Neah Bay; Clayoquot	H: David Hunter P: Old Man Hunter *Yawisi* and *Ke-keh* (Clayoquot) C: Lyda
Ides, Lizzie *Haqwatlup* or *Hopu-t-sup* (Mrs. Young Doctor)	ca. 1851–1914	Makah	Neah Bay; Tsoo-yess	H: Young Doctor H: Lighthouse Jim H: Saxie M: *Ya-ka-pe-suks* S: Jack Ides
Inapoo, Annie	1827	Klallam	Jamestown	H: *Hatl-ken* Inapoo
Irving, Serena (Ulmer)	1884–1928	Makah	Neah Bay Elwha	H: Sam Ulmer (1901) P: Albert Irving and Mary
I sitc tin, Mary	1823	Klallam	Port Angeles	H: Jim *Kle-ci-a*
Jack, Emily	1844	Klallam/ Quileute	Pysht	H: Tenas Jack
Jack, Nancy, and Mary Jack (2 wives)	Nancy, 1854; Mary, 1832	Klallam	Jamestown	H: Lame Jack
Jackson, Agnes *Ka-ta-la-lo* (Markishtum)	1888–1966	Quileute	La Push; Neah Bay	H: Herman Ward H: John Markishtum P: Jack Hudson *Sheesh-ta-kup* and Jennie Payne *Hi-yuc-to-utl* or *kah-TOH-ohlh*

Basket weaver's name	Year born and year died (if known)	Tribe	Place of longest residence	Relations
Jackson, Hazel *Ya-lo-was-tub* (Bright)	1885–1971	Quileute	La Push	H: Gideon Bright P: Jack *Sheesh-ta-cop* and *Hi-yic-to-utl* C: Ruth
Jackson, Virginia (Kates) (Tucker) (Halder)	1892–1980	Makah	Neah Bay	H: Daniel Tucker H: Thomas G. Halder (Holden) H: Ralph LaChester P: Peter Jackson and Katie Moses *Hay-with* or *Kwa-with-bi* S: Walter Kates
James, Frances (Bowechop)	1905–1972	Quinault/ Quileute	Neah Bay	H: Harry Bowechop P: Harry James and Edith Hobucket GP: Charles James and Sarah Shileba/Shalber Legg (Sally Freeman) MGP: California Hobucket
James, Maggie (Wain) (Kelly)	1886	Quinault/ Quileute	Queets	H: Robert Wain H: Bert Kelly P: Charles James and Sally Freeman (Sarah Shileba/Shalber Legg) S: Nancy Hobucket GP: John Shuwul and Sally Chepalis
James, Nora (Barker)	1904–1979	Makah/ Quileute	Neah Bay	H: James Peterson H: Earl Ivor Ulmer H: Johnson Barker P: John James and Annie Jones
Jesse, Mary (Wanderhard)	1875–1947	Makah	Neah Bay	H: Chester Wanderhard *Weberhard* P: Jesse Cheeka and *Ko:ko-wa-to-lub*
Jette, Anna (Jackson)	1889	Quinault	Taholah	H: Cleve Jackson P: Adolph Jette and Mary Jane Weston
Jimmy, Maria (Hopie)	1883–1900	Klallam	Sooke	H: Charlie Hopie
Joe, Eliza	1855	Klallam	Jamestown	H: Tenas Joe
John, Martha	1891	Klallam	Port Gamble	H: Old John H: John Lewis
John, Mary	1848	Klallam	Jamestown	H: Tenas John (stepfather of Henry Johnson)

Basket weaver's name	Year born and year died (if known)	Tribe	Place of longest residence	Relations
John, Mary	1858	Klallam	Jamestown	H: Doctor John
Johnson, Lillie	1868	Klallam	Jamestown	H: Joseph Johnson
Johnson, Martha (Mason)	1830	Klallam	Jamestown	H: Old Johnson H: Captain Mason
Johnson, Martha	October 19, 1896	Klallam	Jamestown	H: Old Johnson P: George and Alice Bates
Johnson, Mary (Howeattle) (Yokum) (Hudson)	1887–1956	Makah	La Push	H: Charles Howeattle H: Louis Yokum H: Bill Hudson P: *Selwish* Johnson and Annie Jones
Johnson, Mary Ann	1850	Klallam	Port Angeles; Elwha	H: Bob *Yái-a-hum* P: Arthur Johnson and Belle Holmes
Johnson, Matilda (McCarty)	1893–1961	Makah	Neah Bay	H: Jerry McCarty P: Arthur Johnson and Belle Holmes
Johnson, Mollie *She-cha-atl* (Claplanhoo) (Holden)	1865–1960	Makah	Neah Bay	H: Horace Claplanhoo H: Gilbert Holden (1890) P: *Che-ya-ba* Johnson and *Chu-cha-squax*
Jones, Bernice	d. 1980	Quileute	La Push	H: Casey Jones
Jones, Jenny	ca. 1856	Klallam	Port Gamble	H: Jacob Jones P: Claisquam and Mrs. Claisquam
Jones, Lucy	1868	Penelakut	Skokomish	H: Charles Jones
LaChester, Polly or Pauline (Jackson) (Irving)	1920–1981	Makah	Neah Bay	H: Melvin Jackson H: Hillary Irving P: Sebastian LaChester and Jessie Ward
Lahash, Matilda (Old Mary?) (Mrs. Mike)	b. ca. 1809 to 1815	Klallam		H: Old Lahash *Whu-chah-tak Quah-Yah-Cha-Tuw la-Hash* C: Lahash *Kwe-itc-tan*
Lahash, Sally	1845	Klallam	Jamestown	H: Lahash *Kwe-itc-tan*
Lane, Bertha (Smith)	1886	Lummi	Neah Bay	H: Frank Smith
Lazzar, Mary (Hopie)	1846–1916	Sooke	Elwha	S: Charlie Hopie P: Chief Jack Lazzar C: Francis, Louis, Theresa, and Mary

Basket weaver's name	Year born and year died (if known)	Tribe	Place of longest residence	Relations
Lazzar, Susan (Johnson)	1910	Sooke	Neah Bay	H: Webster Johnson P: Andrew Lazzar and Annie Jones S: Ida, William, Mary, Alec, Andrew, Archie, Ann, Joseph, Susan, and Nancy
Lee, Bessie (Gray)	ca. 1875; m. 1894	Hoh	Hoh	H: Schuyler Gray (d. 1896) P: *Kithiss* and *Siu-uc* S: Jennie and Robert
Lee, Deede (Williams) (Cleveland)	1905	Hoh	Queets	H: Taft Williams H: Marshall Cleveland P: Robert E. Lee and Julia Obi
Legg, Dora (Hudson)	1873–1900	Quileute	La Push	S: *Hog-eye* and Nancy
Leonard, Rachel	1839	Klallam	Jamestown	H: Leonard Bob or Port Discovery Bob (Swinomish)
Lester, Mollie	1861	Quileute	Quileute	H: Doctor Lester P: Mrs. Bucket Mason
Lewis, Ida (Cheeka)	1882–1967	Klallam	Neah Bay	H: Gallic Cheeka P: Charley Lewis and Lucy GF: Tim Pysht
Lewis, Susan *Tsa'l-tse-tsa*	ca. 1855	Skokomish	Skokomish	H: Dick Lewis
Limpy "Old"	ca. 1829	Skokomish	Skokomish	S: *Le'k-swai*
Loc [Locks], Mary	1830	Klallam	Dungeness	H: Dick Locks
Locke, Mary (Eastman)	1870	Quileute		H: Talcus Eastman (1865) P: Charley Locke
Major, Mary (Howeattle)	1875	Quileute	Queets	H: Walter Major H: Arthur Howeattle S: Eliza Charley and Mary P: China
Markishtum, Martha (Moore) (Hanks) (Jimmy)	ca. 1845–1918	Makah	Neah Bay	H: Quata Moore H: Cyrus Markishtum H: Tommy Hanks H: Quileute Jimmy P: *sadi-klewac* and Mary *Tcu tcu me utl*
Mary	1825	Klallam	Jamestown	H: Snohomish John
Mary	1830	Klallam	Clallam Bay	H: Jack *Klo-ta'-si*
Mary	1830	Klallam	Clallam Bay	Brother-in-law: Hoko Charley

Basket weaver's name	Year born and year died (if known)	Tribe	Place of longest residence	Relations
Mary	1835	Klallam	Jamestown	H: Sequim Jimmy
Mary, "Old" *Hwud-hwe̓d-ûb-a-lo*	ca. 1816	Skokomish	Skokomish	S: Big Bill?
Mason, Hannah (Bowechop) (Saux) (Payne)	1895–1971	Quinault	Taholah	H: Augustus "Gus" Bowechop H: Toby Saux H: Payne H: Payne P: William Mason and Annie Chow Chow
Mason, Martha *Yooshk* (Hudson) (Kowoosh)	1871	Quileute	La Push	H: Henry Hudson H: Peterson Kowoosh P: *Ya-hut-up* and *Kle-wha-chut-a*
Mason, Mary	1837	Klallam	Port Angeles	H: Captain Mason
McCarty, Emma *Sha-at-le* (Smith)	1882–1911	Makah	Neah Bay	H: Frank Smith P: John McCarty and Lizzie *Che-lub*
McKissick, Mary *Wewhykone* or *Pepiskomo* (*Ste'-hum*) (Waterman)	1847	Klallam	Dungeness; Port Discovery; Skokomish	H: William McKissick, Ireland P: Joseph (Ireland) and Mary McKissick S: Rebecca, David, and Joseph H: (Charles Waterman) *Ste'-hum*
Mike, Mrs.	1840	Klallam	Jamestown	H: Robert Mike C: Rosa
Mike, Louisa E. or Louise (Sampson)	1890–1973	Klallam	Port Angeles; Pysht River; Deep Creek	H: Robert Sampson P: John Mike and Susie *QueQueawt*
Mike, Susie	1887	Klallam	Pysht; Hoko?	P: John Mike and Susie *QueQueawt*
Miller, Emily Elizabeth "Biddy" (Estrada) (Hernandez) (Henry)	1935–1986	Skokomish		H: Tony Estrada H: Paul Hernandez P: Charles Miller and Emily Purdy
Miller, Gerald Bruce *Subiyay*	1944–2005	Skokomish	Skokomish	P: Fred and Georgia Miller
Morganroth, Lela Mae	1937	Quileute	La Push	P: Chris Morganroth II and Ivy Wheeler MGP: Johnny Wheeler PGP: Chris Morgenroth I and Suzie *Kʷá·let*

Basket weaver's name	Year born and year died (if known)	Tribe	Place of longest residence	Relations
Morganroth, Suzie *Kʷá·let*	ca. 1870–1952	Quileute	Sappho; Bogachiel; La Push	H: Chris Morgenroth I P: Towleno or *Toweládox* and *Ká-sa-Kíwats* GC: Chris Morganroth III and Lela Mae Morganroth
Moses, Agnes—fine oval baskets with gulls, fish, swastikas, and whales (Duncan 2000:202)	ca. 1864–1934	Makah	Neah Bay	H: Henry McAlmond H: James Thompson H: Spot White H: Oliver Brown P: Thomas Ward and *Mo'Dah-qua-die* C: Ada Thompson
Moses, Elizabeth "Lizzie" (Capoeman)	1902–1981	Queets	Taholah	H: Herbert Capoeman P: Louis Napoleon and Susie Parker
Moses, Quaddie *Ha-la-oh* or *Dah Qua Dih* or Quaddie (Ward)	b. ca. 1832 to 1848	Makah	Ozette	H: Jack Moses H: Thomas Ward H: *Tak-os-sook* F: Antone Wispoo *Kla-chit* C: Daniel Tucker, Agnes Ward (1864) GC: Ada Markishtum
Mowitch, Blanche	1908	Quinault	Taholah	H: Johnson Mowitch
Mullholland, Lucy		Makah/ Duwamish	Neah Bay	Mahone-related
Nancy, "Old" *Tsûs-pŏt-ėd-wĭt*	1821	Skokomish	Skokomish	S: "Old" Mary
Napoleon, Emma (Capoeman)	1909–1988	Squaxin Island/ Makah/ Klallam/ Suquamish	Taholah	H: Horton Capoeman P: Louis Napoleon (Suquamish) and Susie Parker (Klallam/Makah)
Napoleon, Mary (Allabush)	1872–1970	Makah	Neah Bay	H: Jesse Allabush P: Louis Napoleon (Suquamish) and Susie Parker (Klallam/Makah)
Niesub	1838–1913	Makah	Neah Bay	H: *siaha* H: Cyrus *sai'ï̀asat* (1792) H: *Quatsino* H: Jacob Wotkus C: Hayte, Hattie (Weic)

Basket weaver's name	Year born and year died (if known)	Tribe	Place of longest residence	Relations
Obi, Jennie (Cleveland) *How wa thlus*	1858–1941	Quileute	La Push or Mora	H: Kowoosh *Kol-lou-oosh* H: *Yakalada* Obi P: Hoko Charlie and Ceilia (or Kitty)
Obi, Julia *Chitaha* (Bennett) (Lee)	b. ca. 1871	Quileute	Queets	H: Louis Bennett H: Robert E. Lee S: Laura Sam, *Yakalada* Obi
Obi, Laura (Sam)	1864	Quinault	Queets	H: Bill Sam P: Obi and *Yu'-sos-tub* S: Julia Lee, *Yakalada* Obi
Parker, Marilyn (Edminsten)	1943–2004	Makah	Neah Bay	H: Edminsten P: David Parker and Leah Smith
Payne, Ethel "Rosie" (Black)	January 10, 1902–1980	Quileute	La Push	H: Roy Black
Payne, Jennie *Hi-yic-to-utl* or *Ka-to-olth* (Hudson) (Brown)	b. 1861	Quileute	La Push	H: Jack *Sheesh-ta-kup* Hudson S: Isabel Payne
Payne, Lillian (Pullen) (Penn)	1912–1999	Quileute	La Push	H: Christian Penn (1897) H: Pullen P: Wilson Payne and Susanna Ross PGP: Tommy Payne and Elsie Hudson
Penn, Charlotte (Kalama)	January 14, 1924– February 17, 2010	Quinault	Queets	H: Fred Kalama P: Christian Penn and Mabel Lee MGP: Robert Lee and Julia Obi PGP: Essau Penn and Mary South MGGP: Obi and *Yu'-sos-tub* PGGP: Old Man Penn and *La-loo* (d. 1904; he married *U-bos-tub*, 1905) S: Morris
Penn, Viola (Riebe)	August 5, 1934	Hoh	Hoh	H: Phil Riebe P: Stephen Penn and Nellie Fisher PGP: Essau Penn and Mary South MGP: Frank Fisher and Amy Coe
Peter, Mary *gaY* (Smith)	b. ca. 1839	Twana/ Nisqually	Skokomish	H: Smith (white) H: Clallam Peter

Basket weaver's name	Year born and year died (if known)	Tribe	Place of longest residence	Relations
Peterson, Helen	1905–ca. 1970	Makah	Neah Bay	P: *Chestoqu* Peterson and Minnie James
Peterson, Mabel (Balch) (Soeneke) (Robertson) (Sigo)	1892	Makah	Neah Bay	H: Frank Balch H: Albert Soeneke H: Robertson H: William Sigo P: *Chestoqua* Peterson and Minnie James
Phillips, Meredith (Parker)	1909–1987	Makah	Neah Bay	H: Paul Parker P: Simon Phillips and Annie Anderson
Prince, Elizabeth	April 19, 1890–1973	Klallam	Jamestown	H: Prince David (1886–1960) P: David Hunter and Mary Hall C: Lillian, Oliver, Ruby, Mildred, Mary Elizabeth, and Lyle
Pullen, Beatrice (Black)	1890	Quileute	Taholah	H: Johnson Black P: Harry Pullen and Anna
Pulsifer, Louisa (Jones) (Charley)	1886–1978	Skokomish/ Twana/ Penelakut/ Upper Skagit	Skokomish	H: Doctor Charley H: Tom Pulsifer P: Charles Jones and Lucy
Pulsifer, Zetha (Cush)	1921–2007	Skokomish	Skokomish	H: Cush P: Louisa and Tom Pulsifer
Purdy, Emily (Miller)	1894–1975	Skokomish	Skokomish	H: Charles Miller P: Lewis Purdy and Elizabeth "Liza" Lewis GP: Dick Lewis and Susanah Charley S: Hazel Purdy
Purdy, Hazel (Underwood)	1908	Quinault/ Skokomish	Taholah	H: Frederick Pope H: Robert Underwood P: Lewis Purdy and Elizabeth "Liza" Lewis S: Emily Purdy Miller
Pysht, Annie (Ward) *Ké-hu-wé-ûl-tûm* or *šášk'wuʔ*	1856	Klallam/ Quileute	Pysht; Port Angeles	H: Jim or *Hai-ma'i* Pysht S: Max Ward P: Makah
Pysht, Kitty *xʷiʔác* or *tətásc̓aʔ*	1825	Klallam	Pysht	H: *č̓ʷáctən* C: Tim Pysht *ləmtiyáč̓aʔ* (1855)

Basket weaver's name	Year born and year died (if known)	Tribe	Place of longest residence	Relations
Pysht, Shuda	1860	Klallam	Pysht	H: Jack Pysht (1860) S: Max Ward
Pysht, Susie (Sampson) *tičímət*	1875–1937	Klallam/ Quileute	Pysht; La Push	H: Charlie Sampson P: Tim Pysht and *yuyáw'* (This is Tim Pysht's second wife; his first wife died giving birth to Susie in 1875.) C: Ernest, Bill, Ethel, Elsie, Andy, Joe, Harold, and Adeline (Smith)
Pysht, *yuyáw'* (died giving birth to Susie in 1875)	1844–1875	Klallam	Pysht; Port Angeles	H: Tim *ləmtiyáčaʔ* Pysht (1825) C: Susie Pysht (Sampson) (Gideon Bright's mother, *Ka sa la tsa*, breast-fed Susie.)
Quedessa, Bertha *Kla-la-whe*	1866–1938	Makah	Neah Bay	H: Daniel W. Quedessa
Quedessa, Sally (Wheeler) (Tyler)	1870–1934	Makah	Neah Bay	H: Hayes Wheeler (ca. 1892) H: Willie Tyler (1900) C: Iva Tyler (1901)
Queen Anne *Omaks* or *O-ax* (Green) (Jim) (Johnson)	b. ca. 1826 to 1846; d. 1914 (There may have been two women named Queen Anne.)	Makah		H: *Kalchute* H: *Waklah* H: John Green or King John H: Russian Jim H: Andrew Johnson
Quinn, Grace *Wa-a-ha* (Jackson)	1888	Quileute	La Push	H. Walter Jackson P: Dick Quinn (father), Albert Howeattle (stepfather), and Mattie *Ta-as-tub* S: Charlie, Jay, Silas Quinn, and Myra
Quinn, Myra *E-Sal* (Hobucket)	1894	Quileute	La Push	H: Harry Hobucket M: Mattie Howeattle
Robinson, Ellen *Sleal-A-Com* (Young)	1860	Steilacoom/ Sahewamish	Skokomish	H: Joe L. Young
Ross, Susanna (Payne)	ca. 1865	Quileute	La Push	H: Wilson Payne
Sailto, Alice (Eastman) (Pullen)	1872	Quileute	La Push	H: Grant Eastman (d. 1945) H: Joe Pullen

Basket weaver's name	Year born and year died (if known)	Tribe	Place of longest residence	Relations
Sailto, Helen (Lee) (Logan) (Mike)	August 25, 1928	Hoh	Queets	H: Warren Lee H: Howard Logan H: Richard Robert Mike P: John Sailto and Mary (Lilly) Fisher S: Bud and Ross
Sailto, Joan (Johnie) H.		Hoh	Hoh	P: Leila and Charlie Sailto
Sam, Sarah (Sotomish)	1880–1986	Queets	Taholah	H: Gilbert Sotomish
Sampson, Emily	1838–1936	Klallam	Elwha	H: Joe Sampson
Satsop, Ann or "Big Ann"	ca. 1844	Skokomish	Hoodsport; South Bend	S: Mary Armstrong and Susan
Saux, Ada (Jones)	1874	Quileute	La Push	H: Jerry Jones P: *Wa-hub* Saux and *Tsa-Tsi-Ith* S: Toby
Scott, Beatrice *Ka-la-bus-tub* (Hobucket) (Ward)	1892	Ozette	La Push	H: Harry California Hobucket H: Ward
Sequim Jimmy, Mrs.		Klallam	Sequim	H: Sequim Jimmy
Shale, Blanche Lila (McBride)	1925	Quinault	Taholah	H: Charles McBride P: Harry Shale and Eliza Charles
Shell, Lucy (Allen)	1854	Skokomish	Skokomish	H: Frank Allen P: Old Shell
Sherwood, Mary *We-h'à*	ca. 1848	Skokomish	Skokomish	C: Peter, Ada, and Lizzie
Sherwood, Sarah (Susie) (Minath)	1853	Skokomish	Skokomish	H: Kimball Sherwood GC: Lucy Allen
Shileba Hobucket, Ella *Wa-uc* or *Wa-bas-tub* "Old Lady Bracelet"	1865	Quinault/ Quileute	La Push	H: David Hudson (1856) P: Shileba Hobucket and *Chits ha a tsal* S: Sally Freeman and Nancy Shalber Legg
Shileba/Shalber Legg, Sarah or Sally (James) (Mason) (Freeman)	1865	Quinault/ Quileute	Lake Quinault; Taholah	H: Charles James H: Chief Mason or Charles Mason (Chief Taholah) H: Jake Freeman P: Shileba California Hobucket and *Chits ha a tsal* S: Eunice, Nancy, and Helen (Ella)

Basket weaver's name	Year born and year died (if known)	Tribe	Place of longest residence	Relations
				C: Harry, Mitchell, Maggie, Emma (Amy), and Sarah GC: Earl, Alfred, Cleveland (David), and Maggie James
Sigo, Ellen (George)	1884	Klallam	Port Gamble	H: William George, Sr. P: John and Nancy Sigo
Simmons, Joyce (Cheeka)	1901	Quinault	Neah Bay	H: Ernest Cheeka P: John D. Simmons
Simmons, Nellie (Capoeman) (Ramirez)	1907	Quinault/ Squaxin	Taholah	H: Glenn Capoeman H: Ramirez
Skokomish Dick, Mrs. Hannah *Kwa-A-Le-Led*	ca. 1837	Skokomish	Skokomish	H: Skokomish Dick
Skookum, Mary *Le'k-swai* or Molly	1867	Skokomish	Port Gamble	H: Skookum John
Slaze, Mrs. "Old"	1830	Klallam	Jamestown	H: *Sle'z* or Old Slaze
Smith, Kate (Pulsifer)	ca. 1873	Skokomish	Skokomish	H: Joseph Pulsifer
Smith, Leah (Parker)	1918	Makah	Neah Bay	H: David C. Parker (1918) P: Frank Smith and Bertha Lane (Lummi)
Snohomish John, Mrs (Jane) *Yah-Soh-Lit-Säh*	1823	Klallam Twana	Jamestown	H: Snohomish John
Solomon, Susie	ca. 1861	Klallam	Port Gamble	H: John (King) Solomon F: Doctor John S: Lewis and Peter C: Alice, David
South, Mary *How WA Elus*	ca. 1873	Quileute/ Makah	La Push	H: Essau Penn P: George William *Quy-i-ax* (Makah) and *Tse-a-tse-tsa* (Quileute)
Strom, Ida (Law)— learned weaving from Mattie Howeattle	1898	Quinault/Hoh	Taholah	H: Frank W. Law P: Otto and Mary S: Charles, George, Ole, Jennie, and Elfrida
Swan, Bessie (Ward) (Daniels) (Balch)	1928–2004	Makah	Neah Bay	H: Herman Ward H: Herb Daniels H: Joseph Robert Balch P: Charley Swan and Ruth Anderson

Basket weaver's name	Year born and year died (if known)	Tribe	Place of longest residence	Relations
Swan, Helma (Parker) (Hunter) (Ward)	1918–2002	Makah	Neah Bay	H: O'Day Parker H: Lyle Hunter H: Oliver Ward P: Charlie Swan and Ruth Anderson
Swan, Katherine (Johnson) (Fernandez)	1912–1970	Makah	Neah Bay	H: Corbet Johnson H: Fernandez P: Charlie Swan and Ruth Anderson
Taholah, Alice (Jackson)	1853	Quinault	Taholah	H: James Jackson P: (Chief Taholah) Mason
Talikus, Mrs. Henry *Hi-da'-hu-alt*	1830	Makah	Hoko	H: Henry Talikus
Tate, Mary—made baskets and mats		Quileute	Potage–La Push	
Thompson, Ada (Markishtum)	1888–1968	Makah	Neah Bay	H: Luke Markishtum (1875) P: Henry McAlmond (white) and Agnes *pho-what* MGP: *Dah Qua Dih* (Quaddie) (Mrs. Thomas Ward) GC: Janine Bowechop
Tom, Annie *Ah-de-Pa-sux*	ca. 1843	Canadian Indian/ Klallam	Clallam Bay	H: Long Tom C: Spot White
Tucker, Annie (Fisher)	1938	Makah	Neah Bay	F: Frank Fisher and *Da-A-Le-Tsa* PGP: Daniel Tucker and Virginia Kates
Tucker, Fay		Makah	Neah Bay	P: Allen Tucker and Delia Allabush or Mary Cultee
Tucker, Florence (Greene)	1900–1946	Makah	Port Angeles	H: Walter Greene P: Dan Tucker and Theresa Preston
Tyler, Iva	1901–1973	Makah	Neah Bay	H: Joseph Lawrence H: Hans Lund P: Willie Tyler and Sallie Quedessa
Waddish, Annie (Phillips)	1885–1904	Makah/ Clayoquot	Neah Bay	H: Simon Phillips P: John Waddish and Lucy *Ke-dis-botl*
Wài-litċ-ċ	1801	Skokomish	Skokomish	C: Old Mary and Old Nancy
Walker, Jenny *Ya-Kul-Ho*	1847	Skokomish	Skokomish	H: Johnny Walker

Basket weaver's name	Year born and year died (if known)	Tribe	Place of longest residence	Relations
Wanderhard, Sarah (Markishtum)	1888–1945	Makah	Neah Bay	H: John Markishtum P: Edward Wanderhard and Edna (*shitz-she-it*)
Ward, Cecil *Da-i-a-pus* (Pullen)	1882	Quileute	La Push	H: Joseph H. Pullen P: *Se-ic-tiss* Ward and Mary *Hi-a-le-tsa*
Ward, Jube or Alva Amelia	December 9, 1936	Makah	Neah Bay	H: Bill Williams H: Joseph Ware H: Oliver Cummins H: Leonard Tyree P: Oliver Ides-Ward and Irene Hunter
Ward, Kathy		Hoh		
Ward, Maggie (Harlow) *Tso-ba-dook*	ca. 1886	Quinault	Queets	H: Frank Harlow P: *Se-ic-tus* Daniel Ward and Mary *Hi-a-le-tsa* (1830) S: Cecil (Pullen), Mildred, Jack, and Rex
Ward, Sarah (Woodruff) (Hines)	1910	Quileute	La Push	H: Fred Woodruff H: Hines P: *Se-ic-tus* Daniel Ward and Mary *Hi-a-le-tsa*
Waterman, Annie	1847	Skokomish		H: Anthony James
Watson, Phoebe Moses *Wadshib* (Charley)	ca. 1851	Satsop/Twana	Skokomish	H: Tenas Charley M: *wiʔila*
Weberhard, Evalina (White) *Oothc-kootl* or *Qatchkootle*	1861	Ozette	Mora	H: Daniel White H: Charlie Herman P: *Wit-si-a-tid* and *Da-out-ze* S: Charlie Weberhard or *Satahub* C: Ida White (1897) and Katie Herman
Webster, Emily	1883	Klallam	Port Gamble	H: Jimmie Webster
Webster, Susan (Jackson)	1889	Makah	Jamestown	H: Frank Jackson P: Webster Johnson and Susan Lazzar (Sooke)
Weisub, or *Weassub*, Mrs., or *Xedatu'k! baix* or *He-da-took-ba-yitl*	1850–1924	Makah	Neah Bay	H: *We-ah-sub* H: *Ka-kwal* Simmons H: Lighthouse Jim M: *Kodoe* Great-grandniece: Helma Swan Ward

Basket weaver's name	Year born and year died (if known)	Tribe	Place of longest residence	Relations
Wellington, Martha	1835	Klallam	Jamestown	H: Duke of Wellington
Wheeler, Adelia *Ka-KS-Thlnd* (Howeattle)	1888	Quileute	La Push	H: Charlie Howeattle P: Howard Wheeler *Chee-oo* and Mary *Ba-le-lok*
Wheeler, Flora (Logan) (Shale)	1901	Hoh	Queets	H: Howard Logan H: John Ray Shale P: Beacher Wheeler and Ida S: Nellie Wheeler
Wheeler, Mattie (Howeattle) *Ha-thla-kooth*	April 2, 1861– April 21, 1967	Hoh	Taholah	H: Washington Howeattle P: Chief John *Bachalowsuk* and Betsy Wheeler
White, Ethel (Claplanhoo)	1912–1988	Quileute	Neah Bay	H: Thomas Claplanhoo P: Charley White and (Amy) Emma Gray
White, Ida (Taylor) (Penn)—used fish, gull, canoe, and swastika designs (Duncan 2000:202)	1895; adopted Quileute	Quileute/ Ozette	Mora	H: Henry Taylor H: Morton Penn P: Daniel White and Evalina Weberhard
Williams, Amy (Allen)	1887–1973	Klallam	Jamestown	H: Joseph Allen P: Bill Williams and Maria Lincoln S: William, Seilles
Williams, Annie (Waukenas)	1859–1951	Quinault/ Chehalis	Taholah	H: Johnson Waukenas
Williams, Emily	1877	Klallam	Jamestown	H: Johnson Williams
Williams, Leta (Shale) (Sailto)	1928	Quinault	Queets	H: John Shale II H: Charles Sailto P: Taft Williams and Deede Lee (Jennie) MGP: Robert Lee and Julia Obi PGP: Conrad and Nancy Williams
Williams, Nancy	ca. 1875	Quileute	La Push	H: Conrad Williams
Williams, Nellie (Richards)	August 8, 1908	Quileute	La Push	H: James Richards P: Conrad and Nancy Williams S: Taft Williams GC: Nellie Williams
Wood, Mary Hunter	1840	Klallam	Jamestown	H: Dan Wood

Basket weaver's name	Year born and year died (if known)	Tribe	Place of longest residence	Relations
Wood, Mary Hunter	1840	Klallam	Jamestown	H: Dan Wood
Yokum, Rosie—"covers bottles and makes baskets with covers" (Duncan 2000:202)	1876–1931	Makah	Neah Bay	H: James Hunter (1890) H: Walter Guy (1871) P: William Yokum and Anne *Zinehaha* Holden

Bibliography

The first section below contains published articles and books, unpublished manuscripts and letters, interviews, and personal communications. Following that are sections listing newspapers and archives consulted.

Adamson, Thelma

n.d. Unarranged sources of [Upper] Chehalis ethnology [1926–27]. Melville Jacobs Collection, Manuscripts and Special Collections, University of Washington Libraries.

Agee, J. K.

1993 *Fire Ecology of the Pacific Northwest Forests*. Washington, D.C.: Island Press.

AMNH (American Museum of Natural History)

1935 Image of Elwha Basket and original page of manuscript catalog. Catalog no. 50.2, accession no. 1921-63. www.anthro.amnh.org/anthropology/databases/.

Anderson, M. Kat

2005 *Tending the Wild: Native American Knowledge and the Management of California's Natural Resources*. Berkeley: University of California Press.

Andrews, Rebecca

2010 Telephone conversation with Jacilee Wray, June 15.

Andrews, Rebecca, and John Putnam

1999 Makah Trinket Baskets: A Unique Enterprise. Document prepared for the Burke Museum, Seattle.

Archer, David J. W., and Kathryn Bernick

1990 Perishable Artifacts from the Musqueam Northeast site. MS on file, [British Columbia] Archaeology Branch, Victoria.

Atwell, Ozzie, and Gary Woods

2007 Interview with Jacilee Wray, May 22.

Austin, Mary

1903 The Basket Maker. *Atlantic Monthly* 91:235–38.

Bancroft Library, University of California, Berkeley

[1859] Stereoscopic photograph of sketch by Swan. Stereo Views from Alaska to Mexico, ca. 1859–1902, collection no. BANC PIC 1987.011—STER.

Beckwith, Gina, Marie Hebert, and Tallis Woodward

2002 Port Gamble S'Klallam. In Wray 2002, 51–63.

Berkes, Fikret, Johan Colding, and Carl Folke

2000 Rediscovery of Traditional Ecological Knowledge as Adaptive Management. *Ecological Applications* 10:1251–62.

Berlo, Janet Catherine, ed.

1992 *The Early Years of Native American Art History: The Politics of Scholarship and Collecting.* Seattle: University of Washington Press.

Bernick, Kathryn

2003 A Stitch in Time: Recovering the Antiquity of a Coast Salish Basket Type. In *Emerging from the Mist: Studies in Northwest Coast Culture History*, edited by R. G. Matson, Gary Coupland, and Quentin Mackie, 230–43. Vancouver, B.C.: UBC Press.

Borden, Charles E.

1976 A Water-Saturated Site on the Southern Mainland Coast of British Columbia. In Croes, 233–60.

Boyd, Robert T.

1999 *The Coming of the Spirit of Pestilence: Introduced Infectious Diseases and Population Decline among Northwest Coast Indians, 1774–1874.* Seattle: University of Washington Press.

Bridges, Trina, and Kathy Duncan

2002 Jamestown S'Klallam. In Wray 2002, 35–49.

Bsumek, Erika Marie

2003 Exchanging Places: Virtual Tourism, Vicarious Travel, and the Consumption of Southwestern Indian Artifacts. In *The Culture of Tourism, the Tourism of Culture*, edited by Hal Rothman, 118–39. Albuquerque: University of New Mexico Press.

Burke Museum of Natural History and Culture (Seattle)

2001 Makah Baskets. Entwined with Life: Native American Basketry. http://www.washington.edu/burkemuseum/baskets/artists/trinket.html.

Capoeman, Pauline K., ed.

1991 *Land of the Quinault.* Taholah, Wash.: Quinault Indian Nation.

Castile, George Pierre

1985 Editor's preface in Myron Eells' *The Indians of Puget Sound: The Notebooks of Myron Eells*, edited by George Pierre Castile, 5–6. Seattle: University of Washington Press.

Charles, Bea, and Adeline Smith

1994 Notes from interview by Barbara Lane and Karen James on June 13. Cultural Center, Elwha Klallam Tribe, Port Angeles, Wash.

Clark, Brenda, Nicole Kilburn, and Nick Russell, eds.

2008 *Victoria Underfoot: Excavating a City's Secrets.* Madeira Park, B.C.: Harbor Publishing Co.

Clark, Deborah L., and Mark V. Wilson

2001 Fire, Mowing, and Hand-Removal of Woody Species in Restoring a Native Wetland Prairie in the Willamette Valley of Oregon. *Wetlands* 21(1):135–44.

Cohodas, Marvin

1992 Louisa Keyser and the Cohns: Mythmaking and Basket Making in the American West. In Berlo 1992, 88–133.

Colasurdo, Christine
2003 Erna Gunther: Author of *Ethnobotany of Western Washington. Bulletin of the Native Plant Society of Oregon* 36(7):73.

Cole, Douglas
1985 *Captured Heritage: The Scramble for Northwest Coast Artifacts.* Norman: University of Oklahoma Press.

Collis, Septima
1890 *A Woman's Trip to Alaska.* New York: Press of American Banknote Company.

Costello, J. A.
1895 *The Siwash: Their Life Legends and Tales; Puget Sound and Pacific Northwest.* Seattle: Calvert Co.

Crandell, Caren J.
n.d. The Ecology and Ethnobotany of Sweetgrass (*Schoenoplectus pungens* [Vahl] Palla var. *badius* [J. Presl & C. Presl] S. G. Smith) in the Estuarine Marshes of Grays Harbor, Washington. Ph.D. dissertation in progress, University of Washington, Seattle.

Croes, Dale R., ed.
1976 *The Excavation of Water-Saturated Archaeological Sites (Wet Sites) on the Northwest Coast of North America.* National Museum of Man Mercury Series, no. 50. Ottawa.

Croes, Dale R.
1977 Basketry from the Ozette Village Site: A Technological, Functional and Comparative Study. Ph.D. dissertation, Washington State University, Pullman.
1989 Prehistoric Ethnicity on the Northwest Coast of North America: An Evaluation of Style in Basketry and Lithics. In *Research in Anthropological Archaeology*, edited by R. Whallon, 101–130. San Diego, Calif.: Academic Press.
1991 Coil Basketry Fragment. Appendix 3 of *Clear Creek Hatchery Rip Rap Erosion Stop Cultural Resource Monitoring Report.* Report to Larson Anthropological/Archaeological Services (LAAS), Seattle.
1995 *The Hoko River Archaeological Site Complex: The Wet/Dry Site (45CA213), 3,000–2,600 BP.* Pullman: Washington State University Press.
2001 Birth to Death: Northwest Coast Wet Site Basketry and Cordage Artifacts Reflecting a Person's Life-Cycle. In *Enduring Records: The Environmental and Cultural Heritage of Wetlands*, Wetland Archaeology Research Project (WARP) Occasional Paper 15, edited by Barbara A. Purdy. Oxford: Oxbow Books.
2003 Northwest Coast Wet-Site Artifacts: A Key to Understanding Ancient Resource Procurement, Storage, Management, and Exchange. In *Emerging from the Mist: Studies in Northwest Coast Culture History*, edited by R. G. Matson, Gary Coupland, and Quentin Mackie, 51–75. Vancouver, B.C.: UBC Press.
2005 *The Hoko River Archaeological Site Complex: The Rockshelter (45CA21), 1,000–100 B.P. Olympic Peninsula, Washington.* Pullman: Washington State University Press.

Croes, Dale R., and Jonathan O. Davis
1977 Computer Mapping of Idiosyncratic Basketry Manufacture Techniques in the Prehistoric Ozette House, Cape Lava, Washington. In *The Individual in Prehistory: Studies of Variability in Style in Prehistoric Technologies*, edited by James Hill and Joel Gunn, 155–65. New York: Academic Press.

Croes, Dale R., Katherine Kelly, and Mark Collard

2005 Ancient Basketry and Cordage versus Stone, Bone-Antler, and Shell (SB-AS) Artifacts on the Northwest Coast of North America—Phylogenesis (Branching) versus Ethnogenesis (Blending) of Ancient Ideas and Practices. Wet Sites Connections, special edition 1 of *Journal of Wetland Archaeology*, ed. Dale R. Croes.

Croes, Dale, Rhonda Foster, Larry Ross, Melanie Diedrich, Nea Hubbard, Katherine Kelly, Mandy McCullough, Tom McCullough, Karen Myers, Cassandra Sharron, Barbara Vargo, Rebecca Wigen, and Lauren Valley

2007 Qwu?gwes—A Squaxin Island Tribal Heritage Wet Site, Puget Sound, USA. In *Archaeology from the Wetlands: Recent Perspectives*, edited by SWAP, compiled by Catherine Green. *Proceedings of the 11th International Wetlands Archaeological Research Project Conference, Edinburgh, Scotland*, 135–56. Edinburgh: Society of Antiquaries.

Croes, Dale, John L. Fagan, and Maureen N. Zehendner

2009 Sunken Village, Sauvie Island, Oregon, USA: A Report on the 2006–2007 Investigations of National Historic Landmark Site 35MU4. Special edition 9, *Journal of Wetland Archaeology*.

Curtis, Edward S.

1913 *The Salishan Tribes of the Coast. The Chimakum and the Quilliute. The Willapa.* Vol. 9 of *The North American Indian: Being a Series of Volumes Picturing and Describing the Indians of the United States, the Dominion of Canada, and Alaska*. Norwood, Mass.: Plimpton Press.

1916 *The Nootka. The Haida.* Vol. 11 of *The North American Indian: Being a Series of Volumes Picturing and Describing the Indians of the United States, the Dominion of Canada, and Alaska*. Norwood, Mass.: Plimpton Press.

Dalby, Ethel M.

2000 *Tales of Hood Canal.* Edited by Valerie Abrams Johnson. Long Beach, Calif.: Self-published by Johnson.

Densmore, Frances

1939 *Nootka and Quileute Music.* Bureau of American Ethnology Bulletin 124.

Dethier, Megan N.

1990 *A Marine and Estuarine Habitat Classification System for Washington State.* Washington Natural Heritage Program. Olympia: Washington State Department of Natural Resources.

Devine, Sue E.

1980 Nootka Basketry Hats: Two Special Types. *American Indian Basketry Magazine* 3:26–31.

Drachman, Gaberell

1969 Twana Phonology. *Working Papers in Linguistics* 5. Columbus: Department of Linguistics, Ohio State University.

Duncan, Kate

2000 *1001 Curious Things: Ye Olde Curiosity Shop and Native American Art.* Seattle: University of Washington Press.

2003 1001 Curious Things: Tales from Ye Olde Curiosity Shop. *Columbia Magazine* 17(2).

Dyler, Harry

1981 Mabel Taylor—West Coast Basket Weaver. *American Indian Basketry Magazine* 4:12–22.

Eells, Myron

1889 The Twana, Chemakum, and Klallam Indians of Washington Territory. In *Annual Report of the Board of Regents of the Smithsonian Institution, 1887, Part I*. Washington, D.C.: Government Printing Office.

1972 *Ten Years of Missionary Work among the Indians of Skokomish, Washington Territory,*
[1886] *1874–1884*. Reprint, Seattle: Shorey Publications.

1985 *The Indians of Puget Sound: The Notebooks of Myron Eells*. Edited by George Pierre Castile. Seattle: University of Washington Press.

Elmendorf, William W.

1958 An Almost Lost Culture. *Washington State Review* 2(2):2–6.

1960 *The Structure of Twana Culture*. Monographic supplement 2, *Research Studies* 28(3). Pullman: Washington State University.

1993 *Twana Narratives: Native Historical Accounts of a Coast Salish Culture*. Seattle: University of Washington Press.

n.d.a Unpublished Skokomish genealogical charts.

n.d.b Unpublished Twana field notes. Bancroft Library, University of California, Berkeley.

Erikson, Patricia Pierce

2004 "Defining Ourselves through Baskets": Museum Autoethnography and the Makah Cultural and Research Center. In *Coming to Shore: Northwest Ethnology, Traditions, and Visions*, edited by Marie Mauzé, Michael E. Harkin, and Sergei Kan, 339–61. Lincoln: University of Nebraska Press.

Espinoza y Tello, José

1930 *A Spanish Voyage to Vancouver Island and the Northwest Coast of America, Being the Narrative of the Voyage Made in the Year 1792 by the Schooners Sutil and Mexicana to Explore the Strait of Fuca*. Translated by Cecil Jane. London: Argonaut Press.

Ewing, Kern

1986 Plant Growth and Productivity along Complex Gradients in a Pacific Northwest Brackish Intertidal Marsh. *Estuaries* 9(1):49–62.

Farrand, Livingston

1900 Basketry Designs of the Salish Indians. In *The Jessup North Pacific Expedition: Memoir of the American Museum of Natural History*, vol. 1, part 5, edited by Franz Boas. New York.

Fedje, Daryl, W., Alexander P. Mackie, Rebecca J. Wigen, Quentin Mackie, and Cynthia Lake

2005 Kilgii Gwaay: An Early Maritime Site in the South of Haida Gwaii. In *Haida Gwaii: Human History and Environment from the time of Loon to the Time of the Iron People*, edited by Daryl W. Fedge and Rolf W. Mathewes, 187–203. Vancouver, B.C.: UBC Press.

Frachtenberg, Leo J.

1916a Correspondence to Franz Boas from Leo Frachtenberg, Mora, August 12. No. 328, American Philosophical Society, Philadelphia.

1916b Correspondence to Dr. Rathbun, Asst. Secretary, Smithsonian National Museum, from Leo Frachtenberg, Mora, November 19. NMNH Accession 60982, Smithsonian Institution, Washington, D.C.

1916c Correspondence to Dr. Rathbun, Smithsonian National Museum, from Leo Frachtenberg, Mora, November 24. NMNH Accession 60982, Smithsonian Institution, Washington, D.C.

1916d Quileute Ethnology; La Push, Washington. Washington, D.C.: Bureau of American Ethnology. Boas collection W 3a.9, American Philosophical Society.

1917a Correspondence to George Heye [on Smithsonian Institution, Bureau of American Ethnology letterhead], Mora, January 3.

1917b "Ethnological Researches in Oregon and Washington." In *Explorations and Field-Work of the Smithsonian Institution in 1916*. Smithsonian Miscellaneous Collections, vol. 66, no. 17, publication 2438. Washington, D.C.

n.d. "Description and Prices of Specimens" [Quileute basketry circa 1917]. No. OC127.2, accession no. 7847 [057847 new inventory number], Frachtenberg Collection, Smithsonian Institution, Washington, D.C.

Frauenberger, Michelle M.

2005 Personal communication, e-mail from Registrar, FDR Library, to Jacilee Wray, July 12.

George, Ivan

2005 Interview courtesy of Port Gamble S'Klallam Tribe, August 31.

Gibbs, George

1877 Tribes of Western Washington and Northwestern Oregon. *Contributions to North*
[1855] *American Ethnology* 1(2):157–361. Edited by John Wesley Powell. Washington, D.C.: U.S. Geographical and Geological Survey of the Rocky Mountain Region.

Gill, Steven J.

1983 Ethnobotany of the Makah and Ozette People, Olympic Peninsula, Washington (USA). Ph.D. dissertation, Washington State University, Pullman.

Gogol, J. M.

1980 The Twined Basketry of Western Washington and Vancouver Island. *American Indian Basketry Magazine* 1(3):4–11.

1981 Nootka/Makah Twined Fancy Baskets. *American Indian Basketry Magazine* 1(4):4–11.

Goodell Judson, Phoebe

1984 *A Pioneer's Search for the Ideal Home*. Lincoln: University of Nebraska Press.
[1925]

Goodman, Linda J., and Helma Swan

2003 *Singing the Songs of My Ancestors: The Life and Music of Helma Swan, Makah Elder*. Norman: University of Oklahoma Press.

Goodman, Susan, and Carl Dawson

2008 *Mary Austin and the American West*. Berkeley: University of California Press.

Grimley, Brynn

2007 Dike Removal Project Frees Tides. *Kitsap Sun* (Bremerton, Wash.), September 10. www .kitsapsun.com/news/2007/sep/10/moving-to-higher-ground/.

Grinnell, Elaine

2009 Interview with Jacilee Wray, April 13.

Gunther, Erna

1927 Klallam Ethnography. *University of Washington Publications in Anthropology* 1(5):171–314.

1935 The Modern Basketry of the Makah. *Indians at Work* (Office of Indian Affairs) 2(20):36–40.

1965 Oral history interview with Dr. Erna Gunther, University of Washington, Seattle, April 23, by Dorothy Bestor. Smithsonian Archives of American Art, http://www.aaa .si.edu/collections/interviews/oral-history-interview-erna-gunther-11966.

1972 *Indian Life on the Northwest Coast of North America, as Seen by the Early Explorers and Fur Traders during the Last Decades of the Eighteenth Century.* Chicago: University of Chicago Press.

1974 *Ethnobotany of Western Washington.* Seattle: University of Washington Press.
[1945]

n.d. Unpublished field notes (1929, 1934–35, 1939). Erna Gunther Collection, Special Collections Division, University of Washington Libraries, Seattle.

Haeberlin, H. K., James A. Teit, and Helen H. Roberts. under the direction of Franz Boas
1928 *Coiled Basketry in BC and Surrounding Region.* 41st Annual Report, Bureau of American Ethnology, 1919–24. Washington, D.C.: Government Printing Office.

Hajda, Yvonne
1990 Southwestern Coast Salish. In *Handbook of North American Indians,* vol. 7, *Northwest Coast,* edited by Wayne Suttles, 503–517. Washington, D.C.: Smithsonian Institution.

Halliday, Jan, and Gail Chehak
2002 *Native Peoples of the Northwest: A Traveler's Guide to Land, Art, and Culture.* Seattle: Sasquatch Books.

Hansis, Richard
1998 A Political Ecology of Picking: Non-Timber Forest Products in the Pacific Northwest. *Human Ecology* 26(1):67–86.

Harrington, John Peabody
1981 *The Papers of John Peabody Harrington in the Smithsonian Institution, 1907–1957.* Vol. 1, *A Guide to the Field Notes: Native American History, Language and Culture of Alaska/ Northwest Coast.* Edited by Elaine Mills. Millwood, N.Y.: Kraus International Publications, 1981–89.

Hawes, Kathleen L.
2009 Personal communication, e-mail, Laboratory Director, Southern Puget Sound Community College Anthropology Lab, to Jacilee Wray, July 21.

Henry, John Frazier
1984 *Early Maritime Artists of the Pacific Northwest Coast, 1741–1841.* Vancouver, B.C.: Douglas and McIntyre.

Herzog, Melanie
1996 Aesthetics and Meanings: The Arts and Crafts Movement and the Revival of American Indian Basketry. In *The Substance of Style: Perspectives on the American Arts and Crafts Movement,* edited by Bert Denker, 69–91. Delaware: Henry Francis du Pont Winterthur Museum.

Hess, Thom
1990 A Note on Nitinaht Numerals. *International Journal of American Linguistics* 56(3):427–31.

Hitchcock, C. Leo, Arthur Cronquist, Marion Ownbey, and J. W. Thompson
1969 *Vascular Plants of the Pacific Northwest, Part 1: Vascular Cryptogams, Gymnosperms, and Monocotyledons.* Seattle: University of Washington Press.

Hodge, F. W.
1919 Report of the Bureau of American Ethnology. Appendix 2 of *Annual Report of the Board of Regents of the Smithsonian Institution, 1917,* 45–61. Washington, D.C.: Government Printing Office.

Holm, Bill

1987 *Spirit and Ancestor: A Century of Northwest Coast Indian Art at the Burke Museum.*
 Thomas Burke Memorial Washington State Museum Monograph 4. Seattle: University
 of Washington Press.

Hough, Walter

1917 Correspondence to Professor Holmes from Curator of Ethnology, Smithsonian National
 Museum, May 23. NMNH Accession 60982, Smithsonian Institution, Washington, D.C.

Hunn, Eugene S.

1990 *Nch'i-Wana, "The Big River": Mid-Columbia Indians and Their Land.* Seattle: University
 of Washington Press.

Hutchinson, Ian

n.d. *Salinity Tolerance of Plants of Estuarine Wetlands and Associated Uplands.* Washington
 State Shorelands and Coastal Zone Management Program: Wetlands Section, contract
 no. C0088137. Olympia: Washington State Department of Ecology.

Jacknis, Ira

1992 "The Artist Himself": The Salish Basketry Monograph and the Beginnings of a Boasian
 Paradigm. In Berlo 1992, 134–61.

2007 Personal communication, e-mail to Jacilee Wray, February 22.

James, George Wharton

1903 *The Basket: Or, The Journal of the Basket Fraternity or Lovers of Indian Baskets and Other
 Good Things* 1(8). Pasadena, Calif.: The Basket Fraternity.

1904 *Indian Basketry and How to Make Indian and Other Baskets.* Glorieta, N.Mex.: Rio
 Grande Press.

1972 *Indian Basketry.* Pasadena, Calif.: Henry Malkan. Reprint, New York: Dover
[1909] Publications.

James, Justine, Sr.

2007 Interview with Daniela Shebitz, August.

James, Justine E., Jr.

2002 Cultural Resources. In *Raft River Watershed Analysis*, edited by Raft River Watershed
 Analysis Team, 2.4, 1–36. Taholah, Wash.: Quinault Indian Nation.

2009 Personal communication, e-mail to Jacilee Wray, February 19.

James, Justine E., Jr., and Lelani A. Chubby

2002 Quinault. In Wray 2002, 99–117.

James, Karen, and Victor Martino

1986 *Grays Harbor and Native Americans.* Report for U.S. Army Corps of Engineers, Seattle
 District, October. Contract no. DACW67-85-M-0093.

Johannesson, Kathy

1984a Making Cedar Bark Mats. *American Indian Basketry Magazine* 4(3):12–17.

1984b Making Openwork Burden Baskets. *American Indian Basketry Magazine* 4(3):4–11.

John, Martha

1975[?] Interview with Port Gamble S'Klallam Tribe.

Jones, Joan Megan

1976 Northwest Coast Indian Basketry: A Stylistic Analysis. Ph.D. dissertation, University of
 Washington, Seattle.

1977 *Basketry of the Quinault.* Taholah, Wash.: Quinault Indian Nation.

2006 Basketry Project, rough draft, August.

Jones, William, and Gene Jones

2005 Interview courtesy of Port Gamble S'Klallam Tribe, November 21.

Kalama, Charlotte

2003 Interview with Daniela Shebitz, June 18.

2009 Interview with Jacilee Wray, April 27.

Kane, Paul

1968 *Wanderings of an Artist among the Indians of North America from Canada to Vancouver's*
[1859] *Island and Oregon through the Hudson's Bay Company's Territory and Back Again.* Reprint, Rutland, Vt., and Tokyo: Charles E. Tuttle.

Keddie, Grant

2003 *Songhees Pictorial: A History of the Songhees People as Seen by Outsiders, 1790–1912.* Victoria, B.C.: Royal BC Museum.

Kelly, Maggie

1973 Interview with Elizabeth Peck, March 29. Peck Collection of Northwest Coast Indian Life, Washington State University Collections.

Kirk, Ruth

1986 *Tradition and Change on the Northwest Coast: The Makah, Nuu-chah-nulth, Southern Kwakiutl and Nuxalk.* Seattle: University of Washington Press.

Kirk, Ruth, and C. Alexander

1990 *Exploring Washington's Past: A Road Guide to History.* Seattle: University of Washington Press.

Kramer, Becky

2001 Dangerous Harvests? Natural Resources: Forest Service Studying Whether Popularity of Beargrass Is Harming Ecosystem. *Spokesman-Review* (Spokane, Wash.), June 5.

Kreisman, Lawrence, and Glenn Mason

2007 *The Arts and Crafts Movement in the Pacific Northwest.* Portland: Timber Press.

Kuipers, Aert H.

2002 *Salish Etymological Dictionary.* Missoula: Linguistics Laboratory, University of Montana.

Lamberson, Gail

1996 *Scirpus americanus*: A Cultural and Physical Assessment of the Plant. Manuscript for Evergreen State College internship as research assistant for Skokomish Indian Tribe's Fisheries Office.

Lane, Barbara S.

1951 Cowichan Knitting Industry. *Anthropology in British Columbia* (Victoria) 2:14–27.

1975 Identity, Treaty Status and Fisheries of the Lower Elwha Tribal Community. Prepared for the U.S. Department of the Interior and the Lower Elwha Tribal Community, July 25.

1977a Identity, Treaty Status and Fisheries of the Jamestown Clallam Indian Community. Prepared for the U.S. Department of the Interior and the Jamestown Indian Community, August 25.

1977b Identity, Treaty Status and Fisheries of the Port Gamble Indian Community. Prepared for the U.S. Department of the Interior and the Port Gamble Indian Community, July 25.

Langford, Theresa

2008 Personal communication, e-mail to Jacilee Wray, October 15.

Lepofsky, Dana, Emily K. Heyerdahl, Kenneth Lertzman, D. Schaepe, and Bob Mierendorf
2003 Historical Meadow Dynamics in Southwest British Columbia: A Multidisciplinary
 Analysis. *Conservation Ecology* 7(3):5. www.consecol.org/vol7/iss3/art5.

Linzee, Jill
2008 Interview of Edith Hottowe. Northwest Heritage Resources. http://washingtonwomens
 history.org/about/participants/localgrants/nhr/hottowe.aspx.

Malin, Edward
1963 Memo from Edward Malin, Arts and Crafts Specialist, to Robert G. Hart, General
 Manager, July 29, 1963. Edward Malin archive.
1967 Evaluation Northwest Area Field Program to Robert Hart, General Manager.
 March 24. Courtesy of Edward Malin.
2007 Interview with Jacilee Wray, August 8.

Malloy, Mary
n.d. Chinook and Clatsop Hats. www.lewis-clark.org/content/articles/Chinookand
 ClatsopHats.txt.

Mapes, Lynda V.
2001 Makah Tribe's Matriarch Dies at 101: "She Taught So Many People So Much." *Seattle
 Times*, 24 June.
2007 "Hunter Not Ashamed of Killing Whale without a Permit." *Seattle Times*, 10 September.

Marr, Carolyn J.
1984 Salish Baskets from the Wilkes Expedition. *American Indian Art Magazine* 9(3):44–51.
1987 *Portrait in Time: Photographs of the Makah by Samuel G. Morse, 1896–1903*. Neah Bay:
 Makah Cultural Research Center.
1988 Wrapped Twined Baskets of the Southern Northwest Coast: A New Form with an
 Ancient Past. *American Indian Art Magazine* 13(3):54–63.
1990 Continuity and Change in the Basketry of Western Washington. In *The Art of Native
 American Basketry: A Living Legacy*, edited by Frank W. Porter III, 267–80. New York:
 Greenwood Press.
1991 Basketry Regions of Washington State. *American Indian Art Magazine* 16(2):40–49.
2008 Objects of Function and Beauty: Basketry of the Southern Coast Salish. In *S'abadeb—
 The Gifts: Pacific Coast Salish Art and Artists*, edited by Barbara Brotherton, 198–225.
 Seattle: Seattle Art Museum.

Mason, Otis Tufton
1904 *Aboriginal American Basketry: Studies in a Textile Art without Machinery*. Annual Report
 of the Board of Regents of the Smithsonian Institution for the Year Ending June 30, 1902:
 Report of the U.S. National Museum. Washington, D.C.: Government Printing Office.
1905 *Indian Basketry: Studies in a Textile Art without Machinery*. Vol. 1. London: William
 Heinemann.

McCurdy, James G.
1961 *Indian Days at Neah Bay*. Edited by Gordon Newell. Seattle: Superior Publishing Co.

McNickle, D'Arcy
1941 The Art of Basketry. *Indians at Work* 8(5):14–16. Office of Indian Affairs, U.S.
 Department of the Interior, Washington, D.C.

MCRC (Makan Cultural and Research Center)
 Neah Bay, Wash.

Miller, Bruce
2004 Interview with Daniela Shebitz, November 4.

Mitchell, Donald H.
1971 Archaeology of the Gulf of Georgia Area: A Natural Region and Its Cultural Types. *Syesis* (Victoria, B.C.) 4, supplement 1.
1990 Prehistory of the Coasts of Southern British Columbia and Northern Washington. In *Handbook of the North American Indians*, vol. 7, *Northwest Coast*, edited by Wayne Suttles, 340–58. Washington, D.C.: Smithsonian Institution.

Montler, Timothy
2008 Personal communication to Jacilee Wray.
n.d.a [in preparation] Klallam Language Dictionary.
n.d.b Klallam Language website. www.lingtechcomm.unt.edu/~montler/klallam/.

Morgan, Murray C.
1955 *The Last Wilderness*. New York: Viking Press.

Morganroth, Chris, III
2009 Interview with Jacilee Wray, April 28.

Morganroth, Lela Mae
2005 Interview with M. Kat Anderson and Jacilee Wray, March 4.

Munsell, David A.
1976 Excavation of the Conway Wet Site 45SK59b, Conway, Washington. In Croes 1976, 86–121.

Museum of History and Industry
1985 Transcription of Clara Young diary. Collection no. 1985.40.43.

Nordquist, Delmar L., and G. E. Nordquist
1983 *Twana Twined Basketry*. Ramona, Calif.: Acoma Books.

NPS (National Park Service)
1958 Memorandum to Superintendent[,] Mt. Rainier, from Superintendent Olympic, Subject: J. B. Montgomery Collection of Indian Handiwork [Accession 39], October 21.

Olson, Ronald L.
1967 *The Quinault Indians and Adze, Canoe, and House Types on the Northwest Coast.*
[1927, Reprint, Seattle: University of Washington Press.
1936]

Onat, Astrida R. Blukis
1976 A Fishtown Site, 45SK99. In Croes 1976, 122–45.

O'Neale, Lila M.
1995 *Yurok-Karok Basket Weavers*. Reprint, Berkeley, Calif.: Phoebe A. Hearst Museum of
[1932] Anthropology.

Pavel, Michael
2004 Interview with Daniela Shebitz, November 4.

Pavel, Michael, Bruce Miller, and Mary Pavel
1993 Too Long, Too Silent: The Threat to Cedar and the Sacred Ways of the Skokomish. *American Indian Culture and Research Journal* 17(3):53–80.

Peabody Museum of Archaeology and Ethnology, Harvard University
n.d. "Onion Dome" Knob-Top Whaling Chief's Hat. *The Ethnography of Lewis and Clark.* http://140.247.102.177/Lewis_and_Clark/hat.html.

Peck, Charles

1975 Swan Prairie Essay. Special Collections, Washington State University Pullman.

Peck, Charles, and Elizabeth Peck

1977 Gathering and Weaving with Sweetgrass: A 35 mm Slide Set. Manuscript from the series Indian Basket-making in the Pacific Northwest. Washington State University Libraries, Pullman, November.

Peter, David, and Daniela J. Shebitz

2006 Historic Anthropogenically Maintained Beargrass Savannas of the Southeastern Olympic Peninsula. *Restoration Ecology* 14(4):605–615.

Peterson, Melissa, et al.

2002 Makah. In Wray 2002, 151–67.

Pettitt, George A.

1950 *The Quileute of La Push, 1775–1945.* Anthropological Records, vol. 14, no. 1. Berkeley and Los Angeles: University of California Press, May.

Porter, Frank W., III

1990 Introduction to *The Art of Native American Basketry: A Living Legacy,* Contributions to the Study of Anthropology 5, edited by Frank W. Porter III, 1–16. New York: Greenwood Press.

Port Gamble S'Klallam Tribe

1994 *Pride Is Our Heritage: Photographic and Oral History of the Port Gamble S'Klallam Elders.* Bulletin for exhibit cosponsored by the Port Gamble S'Klallam Tribe and the Washington State Commission on the Humanities.

Powell, Jay

1976 *Quileute: An Introduction to the Indians of La Push.* Seattle: University of Washington Press.

Ramirez, Nellie

2000 Interview with Caren Crandell, December 7.

Rathbun, Dr. R.

1917 Correspondence to Dr. Leo Frachtenberg, Bureau of American Ethnology, from Asst. Secretary, Smithsonian National Museum, June 9. NMNH Accession 60982, Smithsonian Institution, Washington, D.C.

Reagan, Albert B.

1906 Correspondence to Edwin Minor [Superintendent Neah Bay Agency], April 23. Brigham Young University, MSS 250, box 1, bolder 1.

Renker, Ann M., and Erna Gunther

1990 Makah. In *Handbook of North American Indians,* vol. 7, *Northwest Coast,* edited by Wayne Suttles, 422–30. Washington, D.C.: Smithsonian Institution.

Rentz, Erin

2003 Effects of Fire on Plant Anatomical Structure in Native Californian Basketry Materials. M.S. thesis, San Francisco State University, San Francisco.

Riebe, Viola

2006 Personal communication to Jacilee Wray.

Rushing, W. Jackson

1992 Marketing the Affinity of the Primitive and the Modern: Rene d'Harnoncourt and the "Indian Art of the United States." In Berlo 1992, 191–236.

Ryan, Balumna'ech Loa

1999 Interview with Caren Crandell, July 25.

2008a Interview with Caren Crandell, May 19.

2008b Personal communication, e-mail to Caren Crandell, May 19.

Ryan, Teresa L.

1999 Interview with Caren Crandell, July 25,

2000 Defining Cultural Resources: Science, Law, and Resource Management for Sweetgrass, *Shoenoplectus pungens*, in Grays Harbor. M.S. thesis, Central Washington University, Ellensburg.

2008 Personal communication, e-mail to Caren Crandell, May 4.

Schevill, Margot Blum

1992 Lila Morris O'Neale: Ethnoaesthetics and the Yurok-Karok Basket Weavers of Northwestern California. In Berlo 1992, 162–90.

Schrader, Robert Fay

1983 *Indian Arts and Crafts Board: An Aspect of New Deal Indian Policy.* Albuquerque: University of New Mexico Press.

Shale, Leta

2003 Interview with Daniela Shebitz, June 18.

2009 Interview with Jacilee Wray, January 23.

Shale-Bergstrom, Florine

2001 Interview with Caren Crandell, August 12.

2003 Interview with Daniela Shebitz, June 18.

Shebitz, Daniela J.

2005 Weaving Traditional Ecological Knowledge into the Restoration of Basketry Plants. *Journal of Ecological Anthropology* 9:51–68.

2006 The Historical Role and Current Restoration Applications of Fire in Maintaining Beargrass (*Xerophyllum tenax* [Pursh] Nutt.) Habitat on the Olympic Peninsula, Washington State. Ph.D. dissertation. Seattle: University of Washington.

Shebitz, Daniela J., and Caren Crandell

2008 Weaving Cultural and Ecological Diversity: Beargrass and Sweetgrass. In Hands of a Weaver: Olympic Peninsula Basketry through Time. Unpublished first draft.

Shebitz, Daniela J., Sarah H. Reichard, and Woulde Woubneh

2008 Beargrass on the Olympic Peninsula, Washington: Autecology and Population Status. *Northwest Science* 82(2):128–40.

Skokomish Culture and Art Committee

2002 Skokomish: Descendants of Twana. In Wray 2002, 64–81.

Slaughter, Mary Lou

2006 Interview in *Northwest Native Basketweavers: Honoring Our Heritage.* Produced by Patricia Courtney Gold. DVD. Los Angeles: Mimbres Fever.

Smith, Adeline

2009 Personal communication to Karen James, May 22.

Smith, Galen S.

1995 New Combinations in North American *Schoenoplectus*, *Bolboschoenus*, *Isolepis*, and *Trichorphorum* (Cyperaceae). *Novon* 5:97–102.

2002 *Schoenoplectus*. In *Flora of North America*, edited by Flora of North America Editorial Committee, vol. 23, 44–60. New York and Oxford.

Smith, J. L., D. R. Mudd, and L. W. Messmer

1976 Impact of Dredging on the Vegetation in Grays Harbor. Appendix F of *Maintenance Dredging and the Environment of Grays Harbor, Washington*. Seattle: U.S. Army Corps of Engineers.

Smith, Marian W.

1940 *The Puyallup-Nisqually*. Columbia Contributions to Anthropology 32. New York: Columbia University Press.

Smithsonian Institution

1917 U.S. National Museum of Natural History card catalogue record for cat. no. 299.004, donation of Fannie Taylor, March 30.

Smythe, Charles W., and Priya Helweg

1995 *Summary of Ethnological Objects in the National Museum of Natural History Associated with the Quileute Culture*. Repatriation Office. Washington, D.C.: Smithsonian Institution.

1996 *Summary of Ethnological Objects in the National Museum of Natural History Associated with the Salish and Salishan Groups*. Repatriation Office MRC-138. Washington, D.C.: Smithsonian Institution.

Storm, Jacqueline

1985 *Quinault Culture: Charlotte Kalama, Basketmaker*. Taholah, Wash.: Quinault Natural Resources.

Suttles, Wayne

1990 Central Coast Salish. In *Handbook of North American Indians*, vol. 7, *Northwest Coast*, edited by Wayne Suttles, 453–75. Washington, D.C.: Smithsonian Institution.

Swan, James G.

1857 *The Northwest Coast: Or, Three Years' Residence in Washington Territory*. Seattle: University of Washington Press.

1964 *The Indians of Cape Flattery, at the Entrance to the Strait of Fuca, Washington Territory*.

[1870] Smithsonian Contributions to Knowledge, vol. 16, no. 8. Reprint, Seattle: Shorey Publications.

Thom, Ian M., and Charles Hill, eds.

2006 *Emily Carr: New Perspectives on a Canadian Icon*. Vancouver, B.C.: National Gallery of Canada.

Thompson, Nile

1989 Petition for Federal Acknowledgment [to the Bureau of Indian Affairs]. Spanaway, Wash.: Steilacoom Tribe of Indians.

1994 Skokomish. In *Native America in the Twentieth Century*, edited by Mary B. Davis, 600–601. New York: Garland Publishing.

2008 Personal communication, e-mail to Caren Crandell, May 27.

n.d. Unpublished Twana field notes, 1975–80. Nile Thompson Collection, Manuscripts and Special Collections, University of Washington Libraries, Seattle.

Thompson, Nile, and Carolyn Marr

1983 *Crow's Shells: Artistic Basketry of Puget Sound*. Seattle: Dushuyay Publications.

Thompson, Nile, Carolyn Marr, and Janda Volkmer

1980 The Twined Basketry of the Twana, Chehalis and Quinault. *American Indian Basketry Magazine* 1(3):12–19.

Trennert, Robert A.

1993 A Resurrection of Native Arts and Crafts: The St. Louis World's Fair, 1904. *Missouri Historical Review* 3(87):274–92.

Turner, Nancy J.

1979 *Plants in British Columbia Indian Technology*. British Columbia Provincial Museum Handbook 38. Victoria, B.C.

1998 *Plant Technology of First Peoples in British Columbia*. Royal British Columbia Museum Handbook. Vancouver: UBC Press.

2008 Personal communication, e-mail to Jacilee Wray, October 14.

Turner, Nancy J., and Marcus. A. Bell

1971 The Ethnobotany of the Coast Salish Indians of Vancouver Island. *Economic Botany* 25(1):63–104; 25(3):335–39.

1973 The Ethnobotany of the Southern Kwakiutl Indians of British Columbia. *Economic Botany* 27(3): 257–310.

Turner, Nancy J., and Barbara S. Efrat

1982 Ethnobotany of the Hesquiat Indians of Vancouver Island. Cultural Recovery Papers, no. 2. Victoria: British Columbia Provincial Museum.

Turner, Nancy J., Marianne Ignace, and Ronald Ignace

2000 Traditional Ecological Knowledge and Wisdom of Aboriginal Peoples in British Columbia. In Traditional Ecological Knowledge, Ecosystem Science, and Environmental Management, edited by J. Ford and D. R. Martinez, special issue, *Ecological Applications* 10(5):1275–87.

Turner, Nancy J., John Thomas, Barry F. Carlson, and Robert T. Olgilvie

1983 Ethnobotany of the Nitinaht Indians of Vancouver Island. Occasional Papers, no. 24. Victoria: British Columbia Provincial Museum.

U.S. Census

1880 Enumeration sheets for S'Klallam Tribe, population schedules, Myron Eells, enumerator, sheets 21–145, December. Enumeration sheets for Twana Tribe, population schedules, Myron Eells, enumerator, sheets 1–13, Skokomish Reservation, December 1880; John W. Givens, enumerator, sheets 1–53, Skokomish Reservation, March 1881. National Archives, Seattle, RG 75, microfilm P 2193.

U.S. Forest Service

2003 *Olympic National Forest Annual Report*. (Prairie Restoration Project Implemented). http://www.fs.fed.us/r6/olympic/03annual/index.html#prairie.

Valadez, Jamie

2002 Elwha Klallam. In Wray 2002, 20–33.

Valadez, Jamie, ed.

2008 *The Elwha River and Its People*. Elwha Klallam Tribe.

Van Syckle, Edwin

1982 *The River Pioneers: Early Days on Grays Harbor*. Seattle: Pacific Search Press.

Waterman, T. T.

1920 Indian Place Names. Unpublished manuscript. MS no. 1864. National Anthropological Archives, Smithsonian Institution, Washington.

1973 *Notes on the Ethnology of the Indians of Puget Sound.* Indian Notes and Monographs:

[1921] Miscellaneous Series, no. 59. New York: Museum of the American Indian, Heye Foundation.

Wilkes, Charles

1845 *Narrative of the United States Exploring Expedition: During the Years 1838, 1839, 1840, 1841, 1842.* 5 vols. and atlas. Philadelphia: Lea and Blanchard.

Wray, Jacilee, ed.

2002 *Native Peoples of the Olympic Peninsula: Who We Are.* By the Olympic Peninsula Intertribal Cultural Advisory Committee. Norman: University of Oklahoma Press.

Wray, Jacilee, and Doreen Taylor, eds.

2006 *Postmistress, Mora, Wash. 1914–1915: Journal Entries and Photographs of Fannie Taylor.* Seattle: Northwest Interpretive Association.

Wright, Robin K.

1991 Masterworks of Washington Native Art. In *A Time of Gathering: Native Heritage in Washington State*, edited by Robin K. Wright, 43–151. Seattle: University of Washington Press.

NEWSPAPERS

Mason County Journal (Shelton, Wash.)

1900 News Notes Hood Canal. September 21.

1902a News Notes Hood Canal. May 16.

1902b News Notes Hood Canal. May 30.

Oregonian

1986 Indian Woman Wove Bit of History into Every One of Her Baskets. June 6.

PAEN (*Port Angeles* [Wash.] *Evening News*)

1931 Chief Howeattle Gives Coastland to Palefaces as Thousands Cheer Opening of New Olympic Loop. August 27.

1953 Pioneer Neah Bay Postmaster and Trader Dies. December 21.

Quileute Independent (La Push, Wash.)

1908 Local News. Edited by W. H. Hudson.

Seattle Post-Intelligencer

1892 September 16.

1963 Basket Weaving: A Vanishing Indian Art. By William Shulze. Pictorial review. July 14.

1983 Grass Roots: Memories of Childhood Are Woven into Baskets. By Judith Blake. November 12.

Seattle Times

1954 Port Angeles Greets Tourists Indian Style. By Lorraine Wilcox Ross. August 15.

1963 Northwest Is Emerging as Center for Indian Arts and Crafts. By Janice Krenmayr. Pictorial review. June 23.

1967 Keeping Alive the Ancient Art of Indian Basket Making: Harvesting Basket Grass at Hoh Village. By Ruth Kirk. Pictorial review. September 17.

1979 Indian Basket Weaver, 88, Forced to Retire. By Kathy Spears (*Aberdeen Daily World*).
 September 30.

ARCHIVES

AR. Superintendent's Annual Narrative and Statistical Reports from Field Jurisdictions of the BIA,
rolls 90 and 91, Neah Bay School 1910–33, and rolls 145, 146, 147, and 148, Taholah School 1915–38.

1911 Annual Report Narrative, Neah Bay Indian School.
1913 Annual Report Narrative, Neah Bay Indian School.
1920 Annual Report Narrative, Neah Bay Indian School. August 31.
1929 Annual Report, Taholah Indian Agency. By Superintendent Sams. June 21.
1933 Annual Report, Taholah Agency.
1934 Annual Report, Neah Bay Indian School. March 27.
1935 Annual Report, Taholah Agency. By Superintendent Nicholson.

ARCIA. Annual Report of the Commissioner of Indian Affairs.

1900 Report of Agent for Neah Bay Agency, by Samuel G. Morse, July 28.
1902 Report of the School Superintendent in Charge, Neah Bay, by Samuel Morse, July 21.
1903 Report of the School Superintendent in Charge, Neah Bay, by Claude C. Covey,
 August 26.
1905 Neah Bay, by Edwin Minor, August 16.
1906 Neah Bay, by Edwin Minor. August 15.

NADC RG75. National Archives, Washington, D.C., RG 75, Bureau of Indian Affairs.

1909 Report of S F O'Fallon, General Inspection, Neah Bay Agency. November 16, 85428,
 decimal 920, box 45.
1911 Washburn Letterhead. November 17, 93642, decimal 124.1, box 3.
1916 Inspection of Neah Bay Schools, June 29–July 10, Report of the Neah Bay Schools and
 Agency, by Otis B. Goodall, Supervisor. July 9, 77928, decimal 910.
1919 October 18, 111807, decimal 910, Employment of Indians.
1933 March 8, decimal 913, Schools and Religion, box 45.

NADC RG435. National Archives, Washington, D.C., RG 435, Indian Arts and Crafts Board.

1956 December 19, entry 21, Native American Hand Crafts, box 1.
n.d. Julia Lee, entry 21, box 12—11E, row 37, comp. 22.

NASP RG75. National Archives, Sand Point, Seattle, RG 75, Bureau of Indian Affairs.

1929 May 6, decimal 47, Taholah Agency, box 71.
1930a November 4, decimal 904, Native Arts, box 168.
1930b December 15, decimal 904, Native Arts, box 168.
1931a February 27, decimal 904, Taholah Agency, box 168.
1931b April 8, decimal 961, Taholah Agency, box 172.
1931c April 11, decimal 961, Taholah Agency, box 172.
1931d September 2, decimal 904, Chemawa, box 32.
1931e September 17, decimal 904, Taholah Agency, box 168.
1932a May 5, decimal 904, Native Arts, box 168.
1932b July 23, decimal 961, Taholah Agency, box 172.
1933 n.d., 11835, decimal 930, Taholah Agency, box 177.
1934a January 18, decimal 904, Chemawa, box 32.
1934b January 23, decimal 904, Chemawa, box 32.

1934c January 29, decimal 904, Native Arts, box 168.

1934d January 30, decimal 904, Native Arts, box 168.

1934e February 5, decimal 904, Native Arts, box 168.

1934f February 17, decimal 904, Native Arts, box 168.

1934g April, decimal 904, Native Arts, box 168.

1936a January 8, decimal 994, Native Arts, box 178.

1936b January 30, decimal 994, Native Arts, box 178.

1936c March 23, decimal 961, Taholah Agency, box 172.

1936d April 3, decimal 961, Taholah Agency, box 172.

1936e May 15, decimal 961, Taholah Agency, box 172.

1936f June, decimal 994, Makah Home Economic Report, box 178.

1936g July 23, decimal 904, Native Arts, box 168.

1937a January 18, decimal 961, Taholah Agency, box 172.

1937b April 29, decimal 904, Native Arts, box 168.

1937c May 3, decimal 961, Taholah Agency, box 172.

1937d May 5, decimal 904, Native Arts, box 168.

1937e June, decimal 994, Makah Home Economic Report, box 178.

1937f July 9, decimal 961, Taholah Agency, box 172.

1937g August 9, decimal 961, Taholah Agency, box 172.

1937h October 20, decimal 904, Native Arts, box 168.

1937i December 7, decimal 904, Native Arts, box 168.

1938a June, decimal 994, Makah Home Economic Report, box 178.

1938b August 18, decimal 904, Native Arts, box 168.

1938c November 25, decimal 961, Taholah Agency, box 172.

1938d December 9, decimal 961, Taholah Agency, box 172.

1939a August 22, decimal 904, Native Arts, box 168.

1939b August 25, decimal 904, Native Arts, box 168.

1939c September 8, decimal 904, Native Arts, box 168.

1939d October 18, decimal 904, Native Arts, box 168.

1939e October 19, decimal 904, Native Arts, box 168.

1939f October 30, decimal 904, Native Arts, box 168.

1939g November 22, decimal 904, Native Arts, box 168.

1940 June 10, decimal 904, Taholah Agency, box 168 (Collier).

1943 November 30, decimal 994, Taholah Agency, box 178.

1944a January 4, PAO, Taholah Agency, box 1509.

1944b January 31, decimal 994, Taholah Agency, box 168.

1945a May 10, decimal 49, Taholah Agency.

1945b June 9, decimal 994, Taholah Agency, box 178.

1945c June 15, decimal 994, Taholah Agency, box 178.

1946 February 2, decimal 994.5, Taholah Agency, box 178.

NASP RG435. National Archives, Sand Point, Seattle, RG 435, BIA Indian Arts and Crafts Board.

1963a May 9, box 6.

1963b May 27, Portland Field Office.

1963c June 5, box 6.

1963d June 10, boxes 6 and 7.

1963e July 29, box 7, Hart/Malin.

1963f July 31, box 6, Hart/Malin.

1963g August 10, box 6.

1963h August 26, box 6.

1963i August 30, box 6, Malin/Felslan.

1963j September 5, box 6, Hart/Malin.

1963k September 9, box 6, Malin Fieldtrip.

1964a January 3, box 6, Malin/Fedoroff.

1964b January 8, box 6, Fedoroff/Malin.

1964c February 10, box 2, Hart/Malin.

1964d April 3, box 2, Hart/Malin.

1964e September 1, box 6, August Fieldtrip.

1964f November 30, box 8.

1965 September 9, box 6, Hart/Malin.

1967a September 13, box 7, Hart/Malin.

1967b September 29, box 6, Gray/Malin.

Index